ROME

Spanning the entire history of the city of Rome from an Iron Age village to a modern metropolis, this is the first book to take the long view of the Eternal City as an urban organism. Three thousand years old and counting, Rome has thrived almost from the start on self-reference, supplementing the everyday concerns of urban management and planning by projecting its own past onto the city of the moment.

This is a study of the urban processes by which Rome's people and leaders, both as custodians of its illustrious past and as agents of its expansive power, have shaped and conditioned its urban fabric by manipulating geography and organizing space; planning infrastructure; designing and presiding over mythmaking, ritual, and stagecraft; controlling resident and transient populations; and exploiting Rome's standing as a seat of global power and a religious capital.

RABUN TAYLOR is Associate Professor of classics at the University of Texas at Austin. He has published articles in the *American Journal of Archaeology*, the *Journal of the Society of Architectural Historians*, the *Journal of Roman Archaeology*, and *Memoirs of the American Academy in Rome*. His books include *Public Needs and Private Pleasures: Water Distribution, the Tiber River, and the Urban Development of Ancient Rome* (2000) and *Roman Builders: A Study in Architectural Process* (2003).

KATHERINE WENTWORTH RINNE is an independent scholar and Lecturer at the University of California at Berkeley and Adjunct Professor of architecture at California College of the Arts. Her book *The Waters of Rome: Aqueducts, Fountains, and the Birth of the Baroque City* won the 2011 John Brinkerhoff Jackson Prize for Landscape History from the Foundation for Landscape Studies and the 2012 Spiro Kostof Award for Urban History from the Society of Architectural Historians. She is Project Director for *Aquae Urbis Romae: The Waters of the City of Rome*.

SPIRO KOSTOF (1936–1991) was Professor of architecture at the University of California at Berkeley and one of the foremost architectural and urban historians of the twentieth century. His books include *A History of Architecture: Settings and Rituals* (1985), *The City Shaped: Urban Patterns and Meanings through History* (1991), and *The City Assembled: Elements of Urban Form through History* (1992). His previously unpublished Mathews Lectures at Columbia University, delivered in 1976, form the foundation of the middle section of this book.

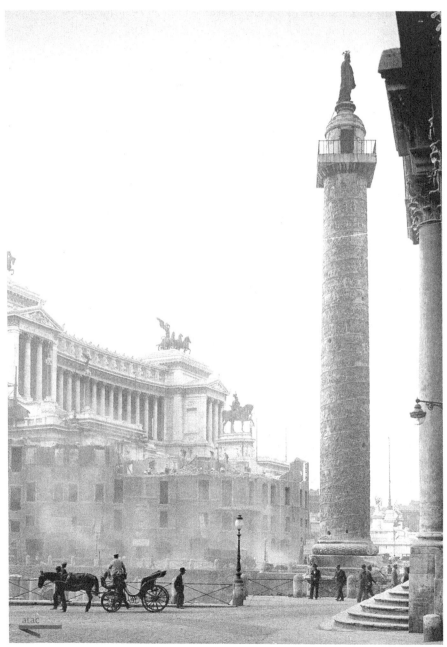

Column of Trajan and monument of Vittorio Emanuele II during demolition of medieval palaces for construction of Via dell'Impero, 1931. Archivio Storico Fotografico ATAC 4955.

ROME

AN URBAN HISTORY FROM ANTIQUITY TO THE PRESENT

RABUN TAYLOR

University of Texas at Austin

KATHERINE WENTWORTH RINNE

California College of the Arts

SPIRO KOSTOF

University of California at Berkeley

CAMBRIDGE
UNIVERSITY PRESS

CAMBRIDGE
UNIVERSITY PRESS

University Printing House, Cambridge CB2 8BS, United Kingdom

One Liberty Plaza, 20th Floor, New York, NY 10006, USA

477 Williamstown Road, Port Melbourne, VIC 3207, Australia

314-321, 3rd Floor, Plot 3, Splendor Forum, Jasola District Centre, New Delhi - 110025, India

79 Anson Road, #06-04/06, Singapore 079906

Cambridge University Press is part of the University of Cambridge.

It furthers the University's mission by disseminating knowledge in the pursuit of
education, learning and research at the highest international levels of excellence.

www.cambridge.org
Information on this title: www.cambridge.org/9781107601499

First published 2016

A catalogue record for this publication is available from the British Library

Library of Congress Cataloging in Publication data
NAMES: Taylor, Rabun M. | Rinne, Katherine Wentworth. | Kostof, Spiro.
TITLE: Rome: an urban history from antiquity to the present / Rabun Taylor
(University of Texas, Austin), Katherine Wentworth Rinne (California College
of the Arts, Berkeley), Spiro Kostof (University of California, Berkeley).
DESCRIPTION: New York, NY: Cambridge University Press, 2016. |
Includes bibliographical references and index. Identifiers: LCCN 2016008186 |
ISBN 9781107013995 (hardback) | ISBN 9781107601499 (paperback)
SUBJECTS: LCSH: City and town life – Italy – Rome – History. | Public spaces – Italy –
Rome – History. | City planning – Italy – Rome – History. | Architecture and society –
Italy – Rome – History. | Christianity – Social aspects – Italy – Rome – History. |
City dwellers – Italy – Rome – History. | Rome (Italy) – Social life and customs |
Rome (Italy) – Social conditions. | Rome (Italy) – Geography.
Classification: LCC DG 809. T 39 2016 | DDC 945.6/32–dc23
LC record available at http://lccn.loc.gov/2016008186

ISBN 978-1-107-01399-5 Hardback
ISBN 978-1-107-60149-9 Paperback

In memory of
Terry Rossi Kirk
(1961–2009)

Nunc quoque Dardaniam fama est consurgere Romam,
Appenninigenae quae proxima Thybridis undis
mole sub ingenti rerum fundamina ponit:
haec igitur formam crescendo mutat et olim
inmensi caput orbis erit!

Even now, rumor says, Trojan Rome is rising –
Who, by the waters of Apennine-born Tiber,
Beneath her mighty hills, lays the foundations of things:
For her aspect changes as she grows. One day
She shall be the head of the wide world!
– Ovid, *Metamorphoses*

CONTENTS

ILLUSTRATIONS

All photographs are by Rabun Taylor unless otherwise noted in the captions.

ACKNOWLEDGMENTS

This book engages with many fields of scholarship, all of them bustling with activity; indeed the scope of our thanks to the countless scholars working in and around Rome, geographically and conceptually, could easily occupy a volume. Necessity, however, demands brevity. Our readers, Mirka Beneš, Nicola Camerlenghi, Penelope Davies, Nicola Denzey Lewis, Richard Etlin, Diane Favro, and John Hopkins, have kindly but punctiliously rooted out inaccuracies, inconsistencies, and incoherencies. Ann and Olin Barrett, Marco Cenzatti, Brian Curran, Hendrik Dey, Mark Henry, Lynne Lancaster, Pamela O. Long, Roberto Meneghini, Lisa Reilly, Paulette Singley, and Christine Theodoropoulos deserve special thanks, as do Richard Ingersoll, who made his unpublished writings about contemporary Roman politics available, and Greg Castillo, the literary executor of the Spiro Kostof estate. Ben Crowther lent some of his ideas about Forum security in Chapter 4; Marco Cenzatti educated us on the complexities of Italian politics in the 1960s and 1970s. With the support of an Undergraduate Research Apprenticeship Faculty Grant, Nathan Carmichael provided bibliographic research and produced our original base map of Rome. Ted O'Neill, archivist extraordinaire, opened many doors for us in Rome and from afar. Our research assistant Natsumi Nonaka created numerous final maps, pursued elusive images, gathered permissions, developed bibliographies, and proofread the text. This book would not exist without her diligence, dedication, and intelligence. Their generous efforts to keep us on track allow them to share any success this book might enjoy, but they hold no blame for our errors or omissions, for which we are entirely responsible. Furthermore, we made every effort to reconstruct Spiro Kostof's bibliography, but lacunae are inevitable, and we apologize for any unintentional oversights.

Humanities funding is always elusive, and so we rely on the kindness of strangers and colleagues alike. Two Franklin Grants from the American Philosophical Society and three grants from the University of Texas at Austin (a Title VI Faculty Research Grant from the Center for European Studies; discretionary funding from the Department of Classics; and a Faculty Research Assignment from the College of Liberal Arts) provided leave time or funding for research and travel. The Canadian Centre for Architecture furnished travel funds to consult the Spiro Kostof Archive housed there. The

Archivio Storico Fotografico ATAC, the British Museum, the Getty Center, the Library of Congress, the Metropolitan Museum, the Museo della Civiltà Romana, the Rijksmuseum, and the Victoria and Albert Museum provided images to us without cost, as did Roberto Meneghini, Lorenzo Quilici, and Vincent Buonanno, who kindly allowed us to reproduce images from their collections of seventeenth- and eighteenth-century books and prints. The Brown University Digital Library facilitated their generosity. Google Maps and Wikimedia Commons were indispensable image archives, as were many agencies and institutes in Rome, individually acknowledged in the captions. Thanks to the kind ministrations of Ulf Hansson, the Swedish Institute in Rome offered an ideal venue – and a superior library – for the production of several early chapters in this book. Finally, as any scholar of Rome knows, the American Academy in Rome is an invaluable resource. We benefited greatly from the generosity of its staff, many lively discussions with its artists and scholars, the depth of its library and photographic archive collections, and the quality of its kitchen.

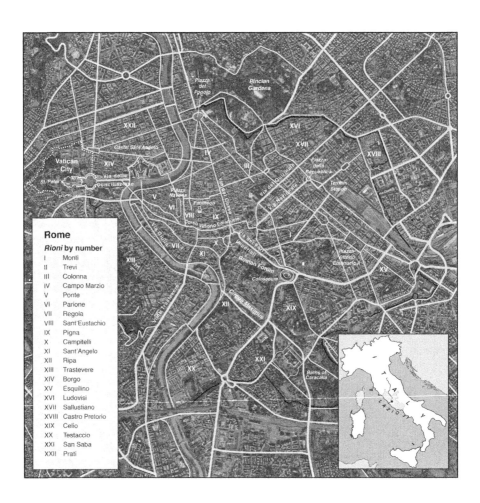

Rome

Rioni by number

I	Monti
II	Trevi
III	Colonna
IV	Campo Marzio
V	Ponte
VI	Parione
VII	Regola
VIII	Sant'Eustachio
IX	Pigna
X	Campitelli
XI	Sant'Angelo
XII	Ripa
XIII	Trastevere
XIV	Borgo
XV	Esquilino
XVI	Ludovisi
XVII	Sallustiano
XVIII	Castro Pretorio
XIX	Celio
XX	Testaccio
XXI	San Saba
XXII	Prati

INTRODUCTION

T HAT ROME, THE ETERNAL CITY, IS THE SUBJECT OF MORE SCHOLARLY inquiry than any other urban center in the world, past or present, should surprise nobody. Its importance was established early; its political power long predominated and the cultural residue of that power has endured. Its physical fabric, a sumptuous palimpsest, pleases the eye and rewards scrutiny. Its admirers have always been legion, and the presence of hundreds of institutes, libraries, museums, archives, study-abroad programs, archaeological digs, and foreign academies in the city ensures that Rome's unmatched capacity for regenerative grandeur will continue *in perpetuo*.

That Rome, the Eternal City, should never have received an urban biography spanning its three millennia of human occupation – *that* might suitably provoke surprise. Yet it is true. Perhaps those closest to the subject, knowing well the divine density and sheer amplitude of the city's flesh and blood, have avoided the long view for fear that even their best efforts would serve up a flavorless, skeletal carcass. After all, how many subjects, at the very minimum, must an urban historian broach? Politics, architecture, industry, commerce, trade, planning, infrastructure, demographics, geography, ecology, roads and connectivity, relations to the hinterland and other cities? Ideas, arts, salons, literary circles, and patronage networks? Crime, grime, gangs, poverty, invasion, flood, fire, famine, plague, and displacement? Should the city's past life be expressed as journalism, biography, documentary, or social, economic, intellectual, or political history?

"All of these things and more," a conscientious scholar might reply, while looking urgently for the door. Rome may simply prove too big, venerable, and variable to confront over the *longue durée*. Authors have understandably preferred the periodic approach, privileging a single, cohesive historical era. In recent decades several fine studies have focused on Rome under various political leaders (Augustus, Hadrian, certain popes, Mussolini) or periods (prehistory, Republican or imperial Rome, the Middle Ages, the Renaissance, the Risorgimento, Fascism). Some are genuinely urbanistic in their approach – that is, they have sought to characterize the city as an organism that interacts intensively with the people it hosts. But others present Rome simply as a passive or indistinct venue of events – as a place that was great only because of the great individuals who animated it. Ironically, this most palpably historical of cities is vulnerable to such inattention precisely because of its historical supremacy. Conceptually, Rome as capital city is a universal symbol, an abstraction standing in for an ancient empire, on the one hand, and the Catholic Church, on the other – both of which encompass a universe of human experience.

This book has little of the abstract about it. Rome, the physical place, serves as the protagonist, and its most powerful citizens are agents in its perpetual state of realization. By necessity we paint with a broad brush and view from a distance, seeking out connections, movements, and interventions writ large on the landscape. Our approach moves to the rhythms of an urban environment over time. It is the perpetual process of shaping and reshaping that environment – and the fact that Rome's urban processes are so often anchored to tangible monuments of the past – that persuaded us to take the long chronological view, daunting as it seemed.

The core idea of this book, and indeed the chronological core of its narrative too, belong to the late Spiro Kostof. A pioneer of the environmental approach to urban history, he sketched out a compelling and original vision of medieval Rome, from Constantine to the fourteenth century, for the annual Mathews Lectures at Columbia University in 1976. These twelve unpublished lectures, presented here in modified and updated form as Chapters 15–23 and 25, adopt several broad themes: the physical and experiential nature of the medievalization of Rome, the gradual consolidation of the urban and suburban fabric under the Church, the imprint of ethnic and political enclaves on the city, and the fundamentally ritual, performative character of medieval Rome, both for residents and for pilgrims. The two living authors have extended the narrative chronologically forward (Rinne) and backward (Taylor) in a manner that seeks to honor Kostof's spirit of bold inquiry and his knack for lively narrative. If any theme predominates, it is that of the city *as theater* and of the purposive human acts that unfold therein – concepts articulated memorably by Lewis Mumford.

One benefit of taking the long view is that it tends to magnify the importance of continuity while diminishing the significance of the categories by which

European history is periodized (Iron Age, Roman, medieval, Renaissance, etc.). Nevertheless, we recognize the usefulness of such categories for orienting the reader, and we use such broad labels (inoffensively, we hope) throughout. Indeed for teaching purposes the book can be easily divided by period: ancient (Chapters 2–14), medieval (15–25), and modern (26–35). But Rome's perpetual inclination to return to its reimagined past strongly recommends starting at the beginning. Even veterans of Rome, we hope, will find the book engaging and provocative. Translations of primary texts are by the authors unless otherwise noted. The references in the Works Cited section are necessarily abridged, but we are confident that the ideas and topics we present are well and fairly represented there, as encapsulated in the citations concluding each chapter.

ONE

A BEND IN THE RIVER

δὶς ἐς τὸν αὐτὸν ποταμὸν οὐκ ἂν ἐμβαίης.

You could not step twice into the same river.

–Heraclitus

WHATEVER THE GENEALOGY OF ROME'S GREATNESS, IT IS NOT PREMISED on geography. The city's physical advantages are undeniably significant, but hardly peremptory; when all is said and done, the natural setting seems a poor match for such a glorious destiny. Ancient Rome had no natural seaport and never dominated Mediterranean trade or transport in the manner of Carthage, Rhodes, Syracuse, or Alexandria. Nor did it command a fabulously fertile hinterland. It enjoyed no natural resources of note except clay, tolerably decent building stone, several small springs, and (we may presume) some quickly depleted timberland. Its hills were defensible but its valleys marshy or flood-prone. In its favor, Rome stood near the middle of the bustling Mediterranean basin at an important intersection of land routes and the Tiber, the largest and most navigable river in the region. This was an important, if hardly decisive, catalyst for the city's rise. The city occupies the lowest viable location for a major settlement in the river basin. Along its final run to the sea, the Tiber's banks are low, unstable, and prone to shifting during heavy floods. The ruins of Ostia, the ancient port town at the river's mouth 25 km below Rome, tell a cautionary tale: it was gradually buried in alluvium over time and its northern district was washed away by the sidewinding current.

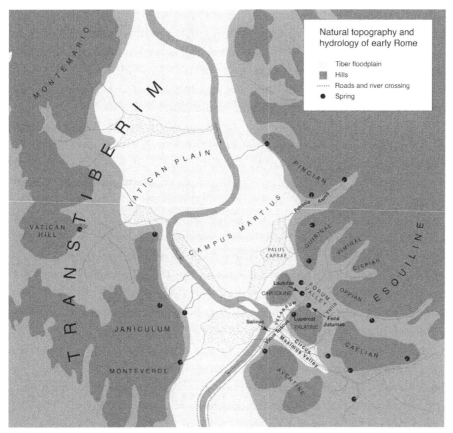

1. Topography of early Rome.

Between Ostia and Rome, no bridge could have kept a grip on the river's wandering banks. Only inland – at the cluster of hills by which the world knows Rome – can some stability be found. Here the Capitoline, Palatine, and Aventine Hills are nested around the outer edge of an easterly elbow bend in the Tiber (Fig. 1). River bends tend to amplify into loops over time, but here the barrier of hills thwarts this tendency, providing a short zone of equilibrium that permits bridging. The loop contains a stable island as well, a rarity for the Tiber. Yet the island provides no advantages for a permanent crossing; in fact, the earliest recorded bridges of Rome, the wooden Pons Sublicius and the stone Pons Aemilius, were both downstream from it. The whole Transtiberim ("trans-Tiber," modern Trastevere) region was foreign territory, controlled by the Etruscans until around 396 B.C.E. If the island had any strategic importance at all, that was because of its vulnerability. The divided river, fordable in low water, had to be watched and if necessary defended.

Rome's principal resource was thus its command over the movement of people and goods. As the population center closest to the Tiber's mouth, it was in a position to police and tax boat traffic heading downstream from a

large, ramified drainage basin (more than 17,000 km²) to the Tyrrhenian Sea routes and to defend the hinterland from either unwanted river crossings or river invasions from the sea. It also controlled desired movement across the Tiber. Doubtless there was a ferry near the river's mouth to serve a coastal road, but most merchants and travelers needing to turn inland from the sea or to reach the coast from the interior would have crossed the river at Rome. Early Rome profited especially from tariffs on salt transport. Precious coastal saltpans existed on both sides of the Tiber's mouth, but they were especially abundant on the right (west) bank. The salt mined there would be packed or towed upriver to the customs zone at the crossing, where presumably a tariff was assessed. At the foot of the Aventine Hill near the crossing was a district called the Salinae, meaning "saltworks" or "salt depots." The tariff was probably collected in kind and stored there for processing, distribution, or sale. The later consular highway called Via Salaria ("Salt Road") ran north from Rome into Latium and Sabine territory, paralleling the Tiber for some distance and eventually traversing the Apennines, the great ridge that forms the backbone of Italy. That road and many others radiating from ancient Rome survive today as modern highways sharing the names of their ancestral routes.

The hills of Rome east of the Tiber consist of eroded remnants of a massive tuff plateau overlying a thick layer of permeable river sand and gravel atop impermeable clay stones – a geomorphology congenial to springs, which have helped to sustain the city's population since prehistory (see Fig. 1). The tuff (called *tufo* in Italian, or, inaccurately, "tufa" in many English texts) is a soft, easily quarried igneous building stone. It derives from massive superheated ash flows of volcanic eruptions occurring some 600,000 to 300,000 years ago in the Alban Hills, southeast of Rome, and in the lake district to the northwest. The eruptions also produced basaltic lava, the much harder, charcoal-colored rock that Romans have always preferred for their paving stones. Very little of this *selce* (Latin *silex*) appears naturally in Rome itself. However, a huge lava flow extends from the Alban volcanoes to the famous tomb of Caecilia Metella along the third mile of Rome's most famous consular highway, Via Appia. It was still being quarried in the nineteenth century.

The Capitoline, Palatine, and Aventine Hills hedge in the river's island bend from north to south. Around this cluster rise several lesser hills (see Fig. 1): the Caelian east of the Palatine, and then north of these, four spurs projecting south or southwest from the tuff plateau called the Esquiline: the Oppian, Cispian, Viminal, and Quirinal. The valley that would become the Forum Romanum – or simply the Forum, as we will call it – starts at the southeastern foot of the Capitoline and runs southeast from there between the Palatine and the Esquiline. West of the hills is a large floodplain the ancients called the Campus Martius ("Field of Mars") with yet another spur bounding it to the north: the Pincian, famous to this day as the "Hill of Gardens." Across the river, in the Transtiberim district, rose the city's highest hill, the Janiculum.

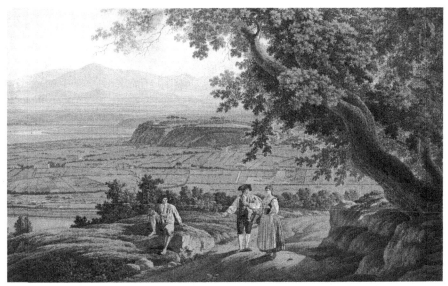

2. 1781 watercolor of G.B. Lusieri showing view of Tiber valley from Montemario, with Via Flaminia in distance.
Source: British Museum 1980, 1213.7AN256668. © The Trustees of the British Museum.

Extending from it are the Vatican Hill to the north and Monteverde to the south. Monteverde is noted for its distinctive building tuffs, but the Janiculum, along with Montemario, which hems in the Vatican plain to the northwest, primarily comprise sedimentary mudstones and sandstones formed a million years ago when this region underlay a shallow sea. Montemario, the most imposing mass in the vicinity (Fig. 2), also provides a fine gray clay that has been quarried now for more than two and a half millennia.

The Tiber is a fairly old river. Consequently Rome's three great floodplains, the Campus Martius, the Vatican plain, and the lower Transtiberim, along with all the connecting valleys, are bedded with thick layers of sediment. In some places the alluvial bed can exceed 60 m, as it does under the Column of Marcus Aurelius in the heart of the Campus Martius; more commonly, it is 10–20 m thick. Human activity – the result of building collapses, leveling, terracing, excavation, etc. – has radically altered the terrain further, displacing hills and even creating them. For example, Monte Testaccio, a sizable hill southwest of the Aventine, consists entirely of discarded olive oil amphoras deposited over three centuries in antiquity, whereas the Velia, a natural saddle of land crossing the Forum valley from the Palatine to the Oppian, was excavated away during Mussolini's interventions in the 1930s. The volume of manmade debris within the ancient walls has been estimated to approach 93,000,000 m³. The hills have also been extensively quarried for building stone and occasionally *pozzolana*, the volcanic sand that constituted an essential ingredient of ancient Roman concrete. Every hill is honeycombed with tunnels and pillared galleries. Occasionally a new one is discovered when a sinkhole collapses into it.

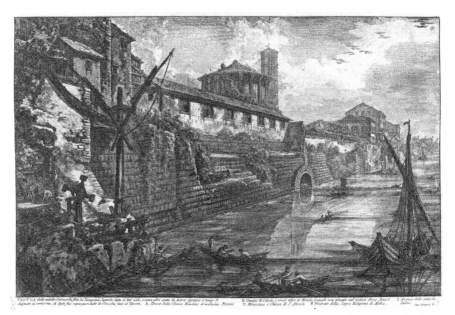

3. View of ancient Tiber embankment in mid-eighteenth century with mouth of Cloaca Maxima.
Source: Piranesi 1747–1778. Wikimedia Commons/PD-Art.

Numerous local springs and brooks drained into the Tiber and adjacent swamps of the Campus Martius, Trastevere, and Forum valley. Some have ancient names: Cati Fons, Petronia Amnis, Lautulae, Camenae, Fons Iuturnae. Others have appeared since antiquity. Thanks to its fairly high water table and permeable strata of sand, gravel, and tuff, Rome was a naturally well-watered locale for a modest population. Where springs did not suffice, wells generally yielded good results until modern times, when the groundwater grew too polluted for safe consumption. But there was a price to pay for such a well-watered site. Exposed to the river's vast drainage basin upstream, the city has always been prone to flooding. In fact Rome's core foundation myth, the tale of Romulus and Remus, begins with a flood that deposits the two infant twins onto the shores of the Lupercal, the wolf's lair beneath the Palatine.

Even under ordinary circumstances ancient Rome was well watered, and in places downright marshy. The Velabrum, a valley extending from the Tiber between the Palatine and Capitoline as far as the Forum (the Vicus Tuscus formed its southeastern boundary), was probably watered by the Lautulae, thermal springs at the north corner of the Forum valley, and other minor springs such as the Lupercal and the Fons Iuturnae. The Forum Brook, later enclosed within the Cloaca Maxima, a great stone-vaulted drain that still operates today (Fig. 3), also emptied into the Tiber here. Ancient authors report that at times the Velabrum could only be crossed by boat, but recent investigations show no geological evidence of a permanent swamp there. An unnamed

brook in the Vallis Murcia between the Palatine and Aventine would later be systematized into a drain running lengthwise under the Circus Maximus. Another ran southwest between the Quirinal and the Pincian; it is called today the Aqua Sallustiana. Farther south, the Petronia Amnis stagnated into a swamp called the Palus Caprae, a site associated with the apotheosis of Romulus. So goes one version of Romulus's tale: Having arrived at Rome in a flood, the founding hero made his exit in a swamp.

Strategically sited though it was from a macroscopic perspective, Rome could not have grown and prospered without mastering its own local landscape. In addition to the necessary skills in trade, diplomacy, and war, this required intensive water management and land reclamation, fortification of the inhabited hills, and the local production and provisioning of food. Such was early Rome's success at achieving these objectives that by the seventh century B.C.E. a tiny federation of hilltop settlements had grown together into a substantive town with pretentions to architectural monumentality, social and geographic cohesion, and the structures of civic life.

MAJOR HILLS OF ROME

Latin	Italian	English
Arx (spur of Capitolium)	Arce	Arx, Citadel
Mons Aventinus	(Monte) Aventino	Aventine
Collis Caelius	Celio	Caelian, Celian
Capitolium, Mons Capitolinus	Campidoglio	Capitoline, Capitol
Mons Esquilinus	Esquilino	Esquiline
Janiculum, Ianiculum	Gianicolo	Janiculum
Palatium, Mons Palatinus	Palatino	Palatine
Mons Oppius	(Colle) Oppio	Oppian
Mons Pincius	(Monte) Pincio	Pincian
Mons/Collis Quirinalis	(Colle) Quirinale	Quirinal
Mons Velia	Velia	Velia, Velian
Collis Viminalis	(Colle) Viminale	Viminal

BIBLIOGRAPHY

Aldrete 2007; Ammerman 2012; Ammerman/Filippi 2004; Funiciello/Praturion/Giordano 2008; Heiken/Funiciello/De Rita 2005; Rodríguez Almeida 1984; Thomas 1989.

TWO

A STORYBOOK BEGINNING

THE STORY OF ROME'S ORIGINS IS SURELY THE WORLD'S MOST FAMOUS foundation myth. After centuries of revision, its received version developed into a bricolage of lively tales calculated to favor early Rome with a sense of destiny. According to the familiar narrative, the twin sons of Mars and descendants of Aeneas's royal line, Romulus and Remus, were set afloat on the flooded Tiber by the usurping king of Alba Longa. Landing beside the Palatine, they were taken in and nursed by a wolf dwelling in the Lupercal, a cave overlooking the Velabrum, and later raised by shepherds. In adulthood the pair resolved to found a community but quarreled over its location, Romulus favoring the Palatine and Remus the Aventine. Each ascended his hill to seek auspicious signs from the skies. More by vehemence than logic, Romulus declared his own augury superior, and in April 753 B.C.E. (the date varies by source) he founded his town on the Palatine by plowing a furrow around it to create the *pomerium*, which he fortified with a gated wall. This quasi-magical protective boundary, but not the wall, would be expanded repeatedly in future centuries.

Mythical Rome in its infancy confronted many difficulties and ferocious foes, but Romulus, designated king of his people, overcame them all by force or diplomacy. Emphatically, his people had no special ethnicity. By any means necessary, he drew them from various peoples in the region, as when he invited the Sabines to games held in the Vallis Murcia (later the Circus Maximus) between the Palatine and Aventine, only to have his men snatch the young

women from the crowd and forcibly marry them. Thus began a series of con-
flicts and accommodations with peoples of central Italy under Romulus and
six successive kings, each distinguished for particular character traits and mate-
rial contributions to the growing city.

Despite its undeniable mythic cast, a few influential modern scholars take
the story of the kings seriously, seeking to match its general outlines, if not
every detail, with the archaeological record of the early settlement. This school
of thought will not detain us. We are satisfied to observe only that the stories
themselves became embedded early in Rome's identity, and thus – because
embryonic greatness must be anchored to landmarks – influenced its urban
development.

The archaeological record tells its own story. In fact, Rome has been occu-
pied more or less continuously since at least the seventeenth century B.C.E.
Excavations in the Giardino Romano adjoining the Capitoline Museum show
that even in the earliest phases occupants of this hill were working metal – first
bronze, later iron – and terracing the hilltop, presumably for both convenience
and defense. By about 1000 B.C.E., a clearer picture emerges on the Palatine
and Capitoline of farming or herding communities living in thatched oval
huts. Evidence of butchering facilities in the Giardino Romano demonstrates
a local proclivity for raising or trading animals, activities implied in the name
of Rome's earliest port district – the Forum Boarium, "cattle court," and the
local myth of Cacus, a fearsome cowherd-king whose cave was somewhere
on the western Aventine. Plow marks scoring the slopes and valleys seem
to indicate small farm plots. That a sense of communal cohesion and taboo
existed among the hilltop settlements is evident in the fact that adult burials
were concentrated in the valleys between them, notably at the Sepulcretum,
an early cemetery on the Forum's northeast side (Fig. 4), and a site recently
excavated under the Forum of Caesar. Stone construction developed as early
as the mid-eighth century B.C.E. but became common only in the second
half of the seventh.

Continuous occupation does not imply cultural continuity. At the Giardino
Romano settlement people lived among adolescent burials, a practice other-
wise unattested at Rome. The valley cemeteries underwent radical changes
in burial practice and reveal that the widespread regional taboo against vio-
lating burials was breached. In the Iron Age (ca. 1000–600 B.C.E.), dwell-
ings were built directly over some of the Forum of Caesar graves; later, in
the Archaic Period (ca. 600–480 B.C.E.), houses covered the Sepulcretum.
What this all means for the living is uncertain, but broadly it follows a pat-
tern in the dominant Latial culture between the tenth and seventh centuries
B.C.E.: the nucleation of small clusters of habitation into urban centers and
the sequestering of burials farther out, in this case, on the Esquiline, Viminal,
and Quirinal Hills.

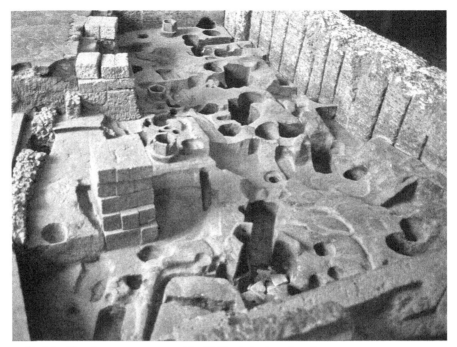

4. Model of Sepulcretum as excavated by G. Boni. Antiquarium Forense.
Source: Courtesy of Ministero dei Beni e delle Attività Culturali e del Turismo – Soprintendenza Speciale per il Colosseo, Museo Nazionale Romano e l'Area Archeologica di Roma.

Like any venerable city, Rome is a layer cake of history. In the valleys the ground level has risen, through alluviation, destruction layers, and intervention, by as much as 17 meters (55 feet) since urbanization began. The hilltops have risen far less or even sporadically been shaved down, creating more debris to fill the valleys. The riverbed has ascended only modestly; thus the canyon formed by its modern embankments had no ancient analog. In the seventh century B.C.E., the left bank at the Forum Boarium, at the sharp rightward bend after the island, was about 100 m inland from its modern position, engulfing the area where two republican-era temples still stand today (Fig. 5; see Fig. 16). At about 7 meters above sea level (the river in equilibrium was around 5 m.a.s.l.) the two valleys branching off from this place – the Velabrum and the Circus Maximus depression – would have flooded almost annually. The Forum valley too suffered regular inundations.

After nucleation, the second phase of Rome's protourbanization happened between about 650 and 600 B.C.E. with the systematic elevation of the Forum valley floor to the level of 9 m.a.s.l., situating its gravel-paved surface above normal flood levels. Meanwhile the Velabrum, if anything, was being *lowered*, its clay extracted to make roof tiles – the newfangled technology signaling an age of architectural monumentalization. An open drain, the Cloaca Maxima, ran through the raised Forum and the quarry. Perhaps financed by successful local

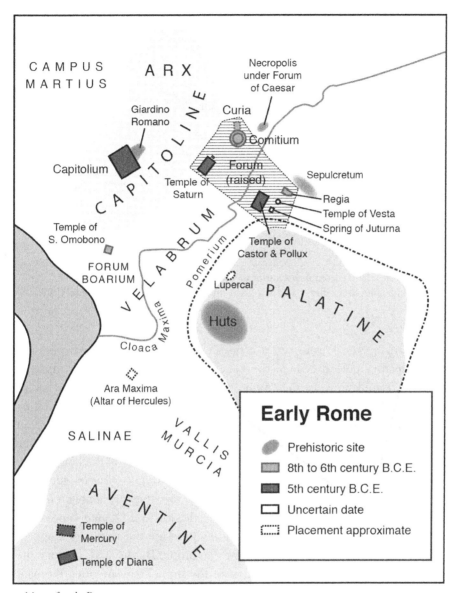

5. Map of early Rome.

industries, these works seem to suggest a communitarian impulse, though a purely authoritarian origin cannot be discounted. Visitors disembarking at the Forum Boarium to enter a new civic center would have first gazed on an open clay pit and saltworks at the nearby Salinae – blights to modern eyes, maybe, but potent signs of Rome's specifically *riverine* vigor. One way or another, clay, salt, trade, and the visitors themselves all arrived by way of the Tiber. At a time when many comparable towns remained cloistered in fortifications, Rome took a calculated risk in becoming a river city.

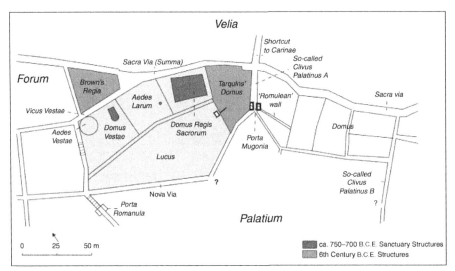

6. Map of zone where Forum meets northeast slope of Palatine in the Archaic period.
Source: Fulminante 2014, after Carandini 2011, fig. 40. Courtesy of Cambridge University Press.

Regularizing the Forum was a civic act possibly marking the beginnings of participatory government in the Greek manner. Large buildings made of tuff-block foundations, earthen walls, and timber-and-tile roofs rose on its Palatine side. A heavy gated wall on the lower Palatine slope accompanied by human burials has been interpreted (notoriously) as the original Romulean fortification of the mid-eighth century marking the primordial *pomerium* (see Fig. 5), and the fragmentary buildings below it as residences of the kings or the undisputed later occupants of the site, Vestal Virgins (Fig. 6). But the identities of these structures are contested. Functionally, too, they are ambiguous and remain effectively mute about Rome's early civic structure. Despite some imaginative interpretation, they do not specifically proclaim the agency of kings.

What they bespeak, perhaps, is Rome's ambition. By the sixth century, the town's monumentality would rival that of the great Etruscan cities. Romans seem to have celebrated their debut on the world stage by favoring architectural eclecticism; parallels can be seen at Corinth, Athens, Sicily, Etruria, and elsewhere. Around 620, a sacred building known as the Regia ("king's place," whether for an actual king or a priest is uncertain) went up at the southeast end of the raised Forum over a burn layer recording Rome's first known destructive fire. Some decades later, at the Forum's north corner, the Comitium – the citizens' assembly place – took shape over the fallen debris of a tile-roofed building. An inscribed marker and a U-shaped altar may have indicated where kings or priests made public sacrifices (Fig. 7). Both places lived on in various iterations over the ensuing millennium. Rome's oldest archaeologically confirmed temple went up between the Capitoline and the river near the modern church of S. Omobono in about 580 B.C.E., and it was

7. Archaic altar and markers on south side of Comitium excavated by G. Boni in 1901.
Source: P. G. Goidanich, "L'iscrizione arcaica del Foro Romano e il suo ambiente archeologico,"
Atti della Reale Accademia d'Italia, Memorie della Classe di Scienze Morali, ser. 7, vol. 3, fasc. 7 (1943),
317–501.

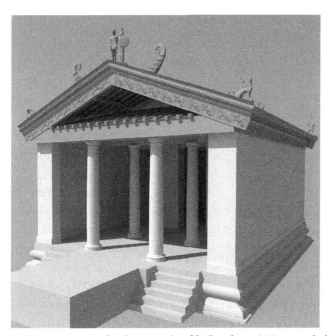

8. Reconstruction of archaic temple of S. Omobono in its second phase, ca. 530 B.C.E.
Source: 3-D reconstruction and imaging by Zichu "Will" Wang, with John Hopkins. Published
by Permission of John Hopkins.

magnificently refurbished with terra-cotta revetments and crowning statues
about half a century later as Rome approached a critical moment in its history
(Fig. 8).

As tradition has it, that moment was the overthrow of Rome's seventh
and final king, the Etruscan Tarquin the Proud, leading in 509 B.C.E. to the
republic. The radical new order developed into an uneasy partnership between
the aristocratic Senate and the *comitia*, or citizen assemblies, institutions that
had previously played secondary roles in government. The tyrannical Tarquin
(so it is said) had undertaken two urban projects with forced citizen labor: the

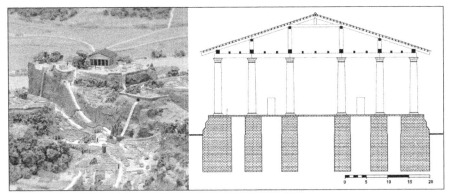

9. Model of Archaic Rome, Museo della Civiltà Romana. Reconstructed elevation drawing of Capitolium.
Source: Drawing by Janis Atelbauers with John Hopkins and Richard Beacham. Published by permission of Richard Beacham.

systematization of the Cloaca Maxima and the construction of the colossal temple of Jupiter, Juno, and Minerva on the Capitoline. Called the Capitolium, like the hill itself, the temple acquired this name after the discovery of a miraculously preserved human head (*caput*) during excavations for the temple's foundations. Etruscan sages took this as a sign of Rome's future role at the head of the inhabited world. Thus the Romans of the new republic – or so later authors would claim – saw the project out, regarding it not as a hated emblem of past tyranny but as guarantee and confirmation of Rome's glorious destiny.

Archaeology confirms at least the material and chronological outlines of this story, though the political circumstances remain clouded. At the Giardino Romano, artisanal activity petered out by 550 and was supplanted late in the century by the titanic temple precinct. Meant to rival the largest temples of the Greeks, the Capitolium dwarfed even the greatest Etruscan temples whose style it emulated (Fig. 9). Its enormous tile roof may have been the largest and heaviest ever successfully completed in that Mediterranean age of architectural gigantism and stood as an advertisement of Rome's ambition. Though the temple burned and was rebuilt in later centuries, acquiring a more modern appearance each time, it never deviated from its original footprint.

The fifth century B.C.E. saw the Forum paved in stone, robust growth, and the beginnings of the mythologization of the urban landscape to construct an international identity befitting the city's ambitions. The first important temple on the Forum was probably that of Vesta, primordial goddess of the city's hearth and keeper of its life flame, but the repeated destruction and murky archaeology of its later incarnations at the Forum's south corner have obscured its origins (see Fig. 6). Like its descendants, it was probably cylindrical to emulate the simple huts of the early settlement. In the 490s the Temple of Castor and Pollux, divine twins of Greek legend, was built beside a small spring, the Fons Juturnae,

on the Forum's southwest side. It affirmed the myth of their intervention in a critical military victory of the early republic, which they announced to Rome as they watered their horses at the spring. At about the same time the Temple of Saturn went up to its northwest. This edifice amplified Rome's aspirations in its home region of Latium, where Saturn's cult was strong, but also emphasized local mythic associations with Hercules. The Greek hero's local legends revolved around an altar of Saturn he had founded here; the nearby Forum Boarium, where his own cult places would later be established; and the connecting Velabrum, where he had foiled Cacus, the troglodytic herdsman.

What kind of urban fabric emerged among these isolated structures is unknown, but it seems that gradually commercial and artisanal shops developed along the Forum's frontage. Interspersed among the built-up areas were sacred groves or trees; most of these had disappeared, but for their names, by the late republic, probably decimated more by fires or blights than by indifference or amnesia.

The young republic quickly hardened into an oligarchy of patrician families claiming descent from Romulus's original Senate, and their rigid exclusion of the majority stoked resentment. Chroniclers report a plebeian secession to the Aventine Hill in the early fifth century. Thereafter, that hill would hold special meaning for Rome's commoners. Prominent plebeians restored or founded temples there: to Diana, to Mercury, and a third to the Greek-inspired triad of Ceres, Liber, and Libera — a kind of antiaristocratic answer to the Capitoline triad. Its foundation may have been inspired by Greek democracies emerging at the dawn of the classical age in southern Italy and Sicily.

Then, in the first half of the fifth century, Rome's overheated engines abruptly went cold. Facing a fierce class struggle within and aggressive invaders without, the town endured a century of crisis during which public dedications slowed to a trickle. Grave goods disappear altogether in this period too; we are confronted with an archaeological dark age that extends all along the Tyrrhenian coast of Italy. And at its end, there occurred Rome's darkest hour of all: its sack and destruction by invading Gauls in 387 B.C.E.

The Gallic invasion was remembered as a watershed moment. Only the Capitoline and the Arx (Citadel), its eastern spur, were fortified to withstand the attack. Nursing the precious flame of Vesta salvaged from her temple, many fled to nearby Veii, a once-powerful Etruscan city recently subdued by Rome. After the sack, Livy relates in his history of Rome, the Romans rebuilt their city in haste, curiously indifferent to either precedent or planning.

> Tiles were provided at public expense; all were granted the right to cut stone and timber wherever they wished, if they provided surety that their structures would be finished within the year. Their haste admitted no provision for straight avenues, for by disregarding property lines, they built in a void. This is why old drains, originally laid out on public land,

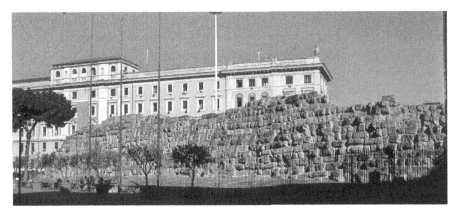

10. Section of Servian Wall near Stazione Termini.

now frequently run under private property and the city plan suggests
continuous occupation, not rigid planning.

Yet Rome had not been annihilated. Even Livy remarks that the burning
was sporadic; in fact, no evidence of a corresponding burn layer has ever been
found archaeologically. If any physical corroboration of this event exists at all,
it is the "Servian" wall, later erroneously attributed to the sixth king, Servius
Tullius (Fig. 10). This sprawling 11-km circuit consisted of tuff blocks quar-
ried in the territory of Veii, which presumably could only have been acquired
after Rome's conquest of the city in 396 B.C.E. Its salients thrust outward to
find the most defensible heights; where no heights availed, a massive ditch and
rampart were built. Most of the radial roads that would later become paved
highways were probably already in place, and the wall's many gates admitted
them all. Thus it encompassed far more than the contemporary *pomerium* or
even the much larger built-up area, which now occupied numerous hills and
several valleys. The Servian Wall would prove useful in later conflicts, but at
this moment it may have played more of an ideological than a defensive role,
enclosing one of the largest areas of any existing city. Rome was back in the
game of urban development – and of global aspiration.

BIBLIOGRAPHY

Albertoni/Damiani 2008; Ammerman 1990, 1996, 2012; Ammerman/Filippi
2004; Ammerman et al. 2008; Ampolo 2013; Carafa 1998; Carandini 2011;
Cifani 2008; Coarelli 1988, 1992, 2011, 2012; Cornell 1995, 2000; Cristofani
1990; Davies 2006; De Santis et al. 2010; Edlund-Berry 2012; Fortini/Taviani
2014; Fulminante 2014; Gjerstad 1953–1973; Holloway 1994; Hopkins 2012b,
2016; Le Gall 1953; Meneghini/Santangeli Valenzani 2007; Mura Sommella
2000; Smith 2000, 2005; Terrenato 2010, 2011; Torelli 2006; Winter 2009;
Winter/Iliopoulos/Ammerman 2009; Wiseman 2008.

THREE

IDEOLOGICAL CROSSFIRE

THE NEWLY WALLED CITY WAS A RAGGED THOUSAND-ACRE QUILT OF medium-density development patched about by sacred groves, sanctuaries, and tracts of suburban farms that would later be absorbed into *horti*, great aristocratic garden estates (see Chapter 11). Most of its area, hosting perhaps 40,000 residents in all, was subdivided into four large regions, each corresponding to an urban tribe of citizens: Subura, Esquilina, Collina, Palatina. Westward lay the lonely extramural expanse of the Campus Martius – "Field of Mars." Its only man-made precinct was the Villa Publica, where at a venerable altar of the war god, the Ara Martis, the general census was periodically taken and soldiers were conscripted. In time, the magistrates overseeing these duties, the censors, would also come to dominate secular construction in Rome.

The fourth century B.C.E. witnessed profound changes in Roman social and political life, mostly along two intertwined paths: proletarization and militarization. Against fierce patrician opposition, the plebeians won the right to hold Rome's premier magistracy, the consulship, in 367. To mark the uneasy class realignment a new goddess was contrived in the abstract, allegorical manner characteristic of the Greeks: Concordia. Her temple was built on the Forum's northwestern rise, perched watchfully over the people's Comitium and the Curia, or Senate house, adjoining it (Fig. 11). Henceforth former consuls of both classes would erect temples at Rome. As military commanders, they conventionally vowed a new temple to a tutelary god while on campaign.

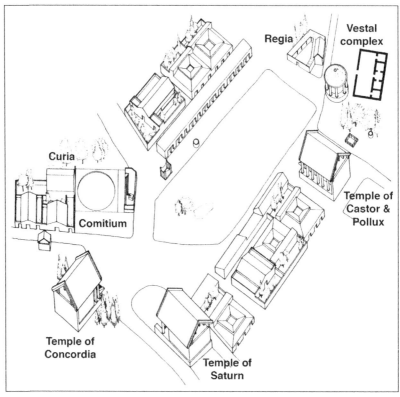

11. Forum in fourth century B.C.E. Temple of Concordia at bottom left.
Source: Illustration by E. Riorden. Stambaugh 1988, p. 108, fig. 7. © 1988 The Johns Hopkins
University Press. Reprinted with permission of The Johns Hopkins University Press.

If victorious, they fulfilled the vow (*votum*) at Rome afterward from the pro-
ceeds of war spoils. Temples of this sort are called *votive*.

Roman success in the Samnite Wars of the second half of the fourth century
precipitated a flurry of victory temples back home. By 270 Rome controlled
peninsular Italy, and the consequent influx of slaves had swelled the city's pop-
ulation to as much as 200,000. The dedication of votive temples was in full
spate (Fig. 12). New kinds of war monuments emerged as well. In 338, the
conqueror of the Latins, the plebeian Gaius Maenius, celebrated Rome's first
naval victory by mounting a speaker's platform on one side of the Comitium.
Perhaps from the very start it bristled with the bronze battering rams of ships
Maenius had conquered. Called the Rostra ("beaks"), this platform and later
imitations would become fixtures of Roman forensic politics. Maenius also
raised a column nearby surmounted by his statue. Such heroic portraits, like
naval victory monuments, were Greek-inspired novelties introduced in the
fourth century. Only later did a local innovation – the freestanding honorific
arch – emerge at prominent spots along the triumphal route, the traditional
parade course for victorious generals (see Chapter 6).

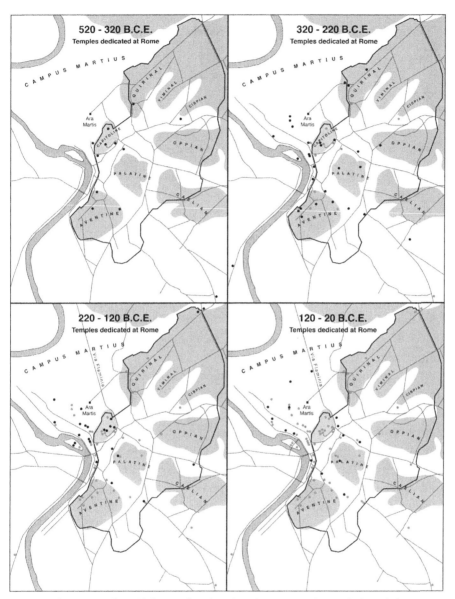

12. Map plotting temples with known locations (precise or approximate) dedicated during successive phases of the republic.

A singular man dominated the latter fourth century: Appius Claudius Caecus, a patrician with strong plebeian leanings. He is the first genuinely historical figure to whom we can attribute major engineering works at Rome: Via Appia, Rome's first long-distance graveled highway, running from Porta Capena southeast through conquered Samnite territory; and the Aqua Appia, its first aqueduct, both undertaken during his censorship in 312 with Gaius Plautius Venox. The aqueduct's subterranean channel originated

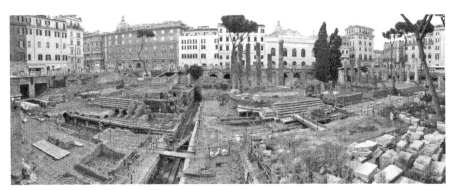

13. Temples at Largo Argentina.

eight miles east on Via Praenestina and terminated at the Salinae below the
Aventine's north corner; originally it delivered about 20 to 30 million liters
of water per day. This may be Rome's first recorded instance of public works
responding directly to the needs of a growing population. In 272 B.C.E., the
city required another, larger aqueduct, this one tapped directly from the Anio
River. Its distribution area seems to have complemented the Appia's, but its
murky waters were inferior.

The city's population and its repertoire of victory temples increased through
the third century as Roman armies traversed the Mediterranean through the
Punic and Macedonian Wars (see Fig. 12). Most victory temples from the
fourth through the second century occupied the southern Campus Martius
on or near the triumphal route. Several clusters of them are known, though
the identities of specific temples are often contested. At Largo Argentina a row
of east-facing temples gradually developed along the triumphal route (Fig. 13).
Among these, the earliest foundation may date to around 300 and the lat-
est, a Greek-style cylindrical temple, to 101 B.C.E. Just north of the Forum
Boarium, a smaller market called the Forum Holitorium ("vegetable court")
acquired four temples along its west side between 260 and 191. Three of these
are still embedded, in later iterations, in the fabric of the church of S. Nicola
in Carcere (Fig. 14).

The zone connecting these two clusters became known as the Circus
Flaminius. Laid out in 220 by the censor Gaius Flaminius Nepos, it was orga-
nized around an open plaza along a northwest-southeast axis. More a venue
for markets and public speaking than for spectacle, it had no racetrack or
grandstand like those of a conventional circus. Adjoining temples were said
to be *in Circo* − some arranged around its flanks, others nearby. Flaminius
was a self-made man and a fierce opponent of the aristocracy, so it has been
suggested, provocatively, that his circus was intended as an anti-Forum to glo-
rify plebeian achievements. If so, then patrician conservatives later assailed its

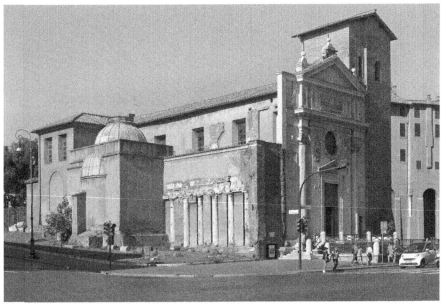

14. Church of S. Nicola in Carcere, with remains of Roman temple embedded in south wall.

identity by packing its northeast flank with their own temples – to Hercules Musarum in 189, Jupiter Stator in 187 – and a sumptuous enclosing portico, the Porticus Metelli, in 146.

Also in 220, Flaminius laid out Via Flaminia on a north-northwesterly path through the Campus Martius, up to the Milvian Bridge, rebuilt in 109 B.C.E. (Fig. 15) and wending northward across the peninsula to Rimini. This too has a good claim as a monument to Flaminius' advocacy of the plebs, for it was around Rimini where, by his signature legislation, many poor families were settled on Roman public land. Its initial tract – today's Via del Corso and Via Flaminia – marched ramrod-straight all the way from Porta Fontinalis to the river (see Fig. 2), suffering no encumbrances along the deserted landscape of the northern Campus.

By 200, Rome was a global superpower, but the city remained an antiquated salmagundi devoid of the rational splendor of modern Hellenistic cities. Returning from their campaigns in the Macedonian Wars of the second century, Roman leaders increasingly recognized their capital's deficiencies and sought to moderate the archaic chaos; but their system of government, with its short-term magistracies, impaired opportunities for a grand urban plan. Only a dictator for life could embark on such a plan – in short, only Julius Caesar, a century and a half later.

Meanwhile, Rome's luminaries continued their uncoordinated campaigns of self-promotion, building dynastic temples and (increasingly) extramural

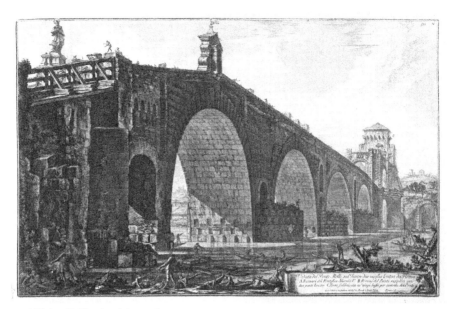

15. Milvian Bridge in eighteenth century.
Source: Piranesi 1747–1778. Wikimedia Commons/PD-Art.

family tombs such as that of the Scipios on Via Appia. The two most prolific builders of the age, however, were genuinely interested in urban improvement: Marcus Fulvius Nobilior and Marcus Aemilius Lepidus, joint censors in 179. Collaboratively or singly, these patrician generals made significant urban improvements, but their ambitions outran their authority. Their attempt to introduce a third aqueduct to Rome was foiled by recalcitrant landowners. Focusing on the riverfront, Fulvius Nobilior consolidated the port from the Forum Holitorium down to the Salinae, adding embankment walls along the unstable eastern river bend and probably the island too. At the Forum Boarium – cult center of Hercules, his patron god – he laid down the stone pilings for a bridge across the Tiber, thereafter named (unaccountably) Pons Aemilius, for his cocensor; this carried a wooden superstructure until its completion in stone in 142. Its flood-ravaged remains are called Ponte Rotto today ("broken bridge"; Fig. 16).

Most significantly, the pair popularized an architectural staple of Hellenistic cities: the long colonnaded portico (Greek *stoa*). As aedile in 193, Lepidus and another member of the Aemilian family had introduced the Porticus Aemilia along the Aventine riverfront, probably a wooden colonnaded façade for shops and storerooms, and developed the quay to its south called the Emporium. They extended another into the Campus Martius along the path between Porta Fontinalis and the Ara Martis (Altar of Mars), site of the census. In 179, Fulvius Nobilior augmented the original Porticus Aemilia. Meanwhile, up on

16. Satellite view of Forum Boarium area with Ponte Rotto just above modern bridge.
Source: © 2014 Google.

the Forum, he added a novel building type to the northeast flank, the Basilica Fulvia.

As a type, the basilica, though its etymology is Greek ("royal"), seems to be a Roman invention. Cato the Elder had raised the oldest known prototype, the tiny Basilica Porcia, on the Forum's northwest flank in 184; Fulvius Nobilior's larger filiation set the precedent for what would become a popular civic building form throughout the Roman world, and the standard model for churches of Christendom: an oblong building with a central nave flanked by two lower aisles. Nobilior's innovation was to deploy the southwest aisle as a colonnaded façade, thereby inserting a stroke of Hellenic modernity in among the old Etruscan-style temples, motley shopfronts, and atrium houses on the Forum. Within a decade, a great plebeian dynast, Tiberius Sempronius Gracchus, answered Nobilior's gesture with the Basilica Sempronia on the Forum's southwest side. We may recall a similar kind of class rejoinder on the Circus Flaminius' northeast flank, where a Fulvius, an Aemilius, and a Caecilius Metellus – patricians all – had claimed one side of the square to plant their ideological flag in opposition territory. Gracchus' basilica would later yield to the Basilica Julia of Julius Caesar, who probably sought to tie his own dynasty to the memory of the Gracchi, the greatest popular reformers of their age. And the opposing Basilica Fulvia eventually gave way to the larger and grander Basilica Paulli/Aemilia (Fig. 17).

The rest of the second century B.C.E. saw a proliferation of porticoes around town, mimicking the unified columnar schemes of Hellenistic urbanism. More

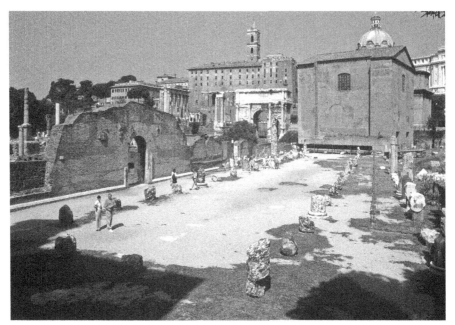

17. Remains of Basilica Paulli/Aemilia, expanded and rebuilt in Augustan era.

fundamentally, Rome partook of an Italy-wide eruption of urban monumen-
talization in the Greek manner. Yet at home, senatorial conservatism rarely let
this impulse off the leash. Temples continued to go up, now often displaying
the upright profile of the Greek orders, and – in the second half of the cen-
tury – occasionally made of imported Greek marble. One can still be seen
today: the cylindrical Corinthian temple in the Forum Boarium, perhaps
the Temple of Hercules Victor (see Fig. 16). Its columns and revetment were
of white marble from Athens. Another round temple nearby, excavated and
dismantled in the Renaissance, may have been part of improvement projects
in the Forum Boarium in 142 that included completing the wooden Pons
Aemilius in stone.

Experimentation with architectural concrete began at Rome in the sec-
ond century. By midcentury, perhaps, the new technology was enabling daring
vaulting schemes, best exemplified at Rome by the remains of a mammoth
fireproof and water-resistant 487-meter-long structure on the Emporium
waterfront plausibly identified as the Navalia, a naval ship shed (Fig. 18). In
retrospect, the potential for creative urban applications of concrete at this
moment seems almost limitless. Yet once again, the capital's engine of creativity
was held in check. Magnificent concrete-vaulted architecture emerged in sur-
rounding towns such as Palestrina and Tivoli toward the century's end; Rome's
contributions to this trend were less extravagant. Ever fearful of upstart tyrants,
the Senate curtailed unconventional gestures of self-aggrandizement. Concrete
was used to good effect, but mostly for terracing, vaulted substructions of

18. Model of ancient Rome with so-called Porticus Aemilia, Museo della Civiltà Romana.
Actual remains of same building.

temples, and narrow-chambered warehouses. Above floor level it may have
been confined mostly to small private baths.

The urban population continued to grow unabated, as can be surmised
from the introduction of two new aqueducts in quick succession: the Aqua
Marcia in 144–140 and the Aqua Tepula in 125. Still, the unprecedented influx
of humanity – Rome may have held well over half a million by now – led the
city to a political crisis. The stage was set for the ambitious sons of Tiberius
Sempronius Gracchus – the younger Tiberius and Gaius – to enact a radical
program of wealth and land redistribution and to grant public farmland, much
of it far from Rome, to the urban poor for resettlement.

From Tiberius Gracchus' eventful year as tribune of the plebs in 133, when
he rammed through his agrarian law, Rome was beset by bitter partisan strug-
gles. Its public spaces became stages for high-stakes political theater. For exam-
ple, in 123 his brother Gaius, now a tribune himself, slyly reversed the direction
of the Rostra without moving a stone: bucking tradition, he simply turned
his back on the Senate house and faced southeast to address the people, with
Maenius' battering rams directly at his feet. This must have filled his reac-
tionary enemies with foreboding. Not only did it encourage larger crowds
to gather out in the Forum square, but it implicitly made a Comitium of the
whole Forum, dwarfing the Curia by comparison; and should Gaius Gracchus'
partisans be incited to riots, his father's dynastic basilica, looming on their left,
offered cover. Following in his brother's footsteps, Gaius provoked astounding
judicial and legislative reforms in 123–122 as tribune of the plebs. The most
tangible of these was the *lex frumentaria*, a law requiring the state to procure
and distribute highly subsidized grain for many of Rome's urban citizens. The
distribution would later become a free dole to hundreds of thousands – as it

19. Tabularium.

remained, variably, for half a millennium. Gaius' penchant for brinkmanship
led to his death in 121 amid a wave of partisan violence. As a final snub, his
archenemy Lucius Opimius immediately restored the Temple of Concordia by
the Comitium on the pretense of renewed concord between the classes – an
infuriating taunt to Gaius' bereaved partisans.

Nobody could forestall the convulsions of an ailing republic. The radi-
cal reforms of the Gracchi set off a century of civil war, often pitting, in
some fashion, populists against aristocrats. A new breed of political bosses like
Marius and Sulla gave lip service to the old traditions, but wielded unprec-
edented power. Busy tending their private armies and mafialike patronage
networks, they gave little heed to the city's health or appearance. Sulla's brutal
dictatorship from 82 to 79 erased many of the popular party's advances and his
proscriptions sent thousands to their deaths. The machinery of state-sponsored
depravity often operates behind a contrived architecture of bloated pieties,
so it is striking that Sulla, granted the extraordinary privileges of a dictator,
undertook little public building in Rome. He did restore the Capitolium after
a fire in a more vertical Greek style, but the one surviving example of an
original Sullan building is the Tabularium, dedicated in 78 by a political ally
(Fig. 19). Echoing the great hillside sanctuaries of Latium, it forms an impres-
sive backdrop to the Forum's northwest end by encasing the Capitoline slope
in a tiered, arcaded façade. Clad in muscular rusticated stone, the underly-
ing concrete form revived the vaulted virtuosity exhibited by the imposing

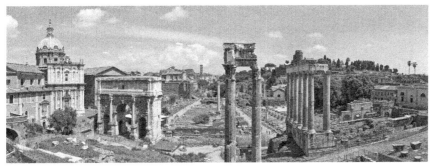

20. View of Forum from Tabularium.
Source: Photo: BeBo86. Title: *The Forum Romanum in Rome*. Wikimedia Commons/CC BY-SA
3.0 (creativecommons.org/licenses/by-sa/3.0/deed.en). Converted to B&W.

Navalia of the previous century. This was supposedly an administrative archive;
but its great arcaded gallery, echoed probably in lost upper stories where the
Palazzo Senatorio rests today, is an awe-inspiring space, commanding a magis-
terial view of the Forum (Fig. 20).

Rome devolved at times into a gangland of bosses and their roving body-
guards, yet the city maintained its physical composure throughout. Magistrates
continued to be elected and civic duties discharged – though the elections,
lawmaking, and court decisions were often swayed by violence or corruption.
Public building slowed, but never ceased. Fires had always plagued the city,
but the precarious balance of political powers warded off the worst effects of
urban warfare. There were no heavily fortified partisan enclaves of the sort
that would encumber Rome during later conflicts (see Chapter 25). The typi-
cal urban atrium house opened inward and was well protected – often even
windowless – on its street frontage.

During Sulla's dictatorship, an ambitious young general named Gnaeus
Pompeius proved himself a ruthless asset to the strongman. But ever the oppor-
tunist, he gradually reinvented himself as the restorer of democratic checks
and balances, reviving the powerful plebeian tribunate in 70 as consul with
Marcus Licinius Crassus. And with every military success abroad he cultivated
the self-image of Pompey the Great, the avatar of Alexander. Joining forces
with Crassus and Julius Caesar, he formed the First Triumvirate, among whose
earliest political achievements was a Gracchan-style agrarian law in 59. By
now, Rome's population was probably approaching a million, and the city was
again hard pressed to accommodate its multitudes even as politicians competed
fiercely for their allegiance. Pompey surely had these hordes in mind when
around 55–52, against fierce opposition, he introduced Rome's first permanent
theater. Only crumbs of it remain, so it is hard to imagine just how miraculous
this immense crag of pure, unencumbered artifice, forming like a thunderhead

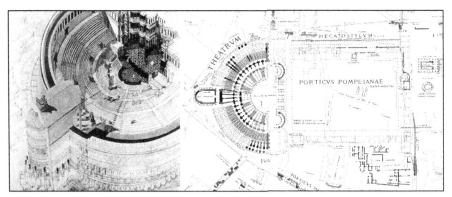

21. Theater of Pompey.
Source: Reconstructed view by A. Limongelli: "Parere dell'On. Prof. G. Q. Giglioli," *Capitolium* 12 (1937), 105–106. Plan: *FUR*.

over the plain of the central Campus Martius, must have seemed at the time, its arcaded stone façade enclosing an intricate concrete cage of interlocking corridors and stairways for an audience of perhaps 11,000 (Fig. 21). Pompey overmatched the moralists by crowning the seating area with shrines to five gods, foremost among them Venus Victrix, and styling the whole complex as a votive sanctuary in the manner of the famous theater-sanctuaries at nearby Palestrina and Tivoli. An allegorical statue series of Pompey's 14 conquered nations foreshadowed later extravagances of triumphal architecture. Behind the stage was an adjoining rectangular portico accommodating sculpture displays, a garden grove, and even a second Curia. This was the first unified monumental building program at Rome, and the fact that it was annexed to Pompey's residence must have presented the unsettling prospect of a quasi-private compound in which the great man could script and enact his political wishes on a stage before selected hordes of followers.

The reality was more mundane, for Pompey's influence was already waning. The theater was a magnificent amenity, nothing more. Granted, Caesar's assassination would later unfold, as a final symbolic riposte to this onetime ally turned enemy, in Pompey's Curia; but the rest of the complex would enjoy broad and benign popularity for centuries. None of this was obvious in 49, when the city stood at a crossroads. The bitter dissolution of the First Triumvirate, Caesar's march on Rome, and his defeat of Pompey the following year again hurled the city into the embrace of dictatorship.

BIBLIOGRAPHY

Albers 2013; Albers et al. 2008; Ashby 1935; Beard/North/Price 1998; Coarelli 1971–1972, 1977, 1988, 1992, 1997a, 2012; Cornell 1995, 2000; Cozza/Tucci 2006; Davies 2007, 2012a, 2012b; Dyson 2010; Gagliardo/Packer 2006; Gleason

1994; Gros/Torelli 2007; Jacobs/Conlin 2014; Kuttner 1999; La Rocca 1990; *LTUR*, "Forum Romanum [The Republican Period]" (N. Purcell); Millar 1998; Morstein-Marx 2004; Mouritsen 2001; Pensabene 2002; Rutledge 2012; Stambaugh 1988; Steinby 2012; Torelli 2006, 2007; Tucci 2004, 2011–2012; Welch 2003; Wiseman 1974, 1993; Zanker 1988; Ziolkowski 1992.

FOUR

BIG MEN ON THE CAMPUS

I N JANUARY OF 52 B.C.E., A FANATICAL FOE OF THE ARISTOCRACY, PUBLIUS Clodius Pulcher, was murdered by a rival gang. The populist demagogue had recruited neighborhood and trade associations to pass his inflammatory legislation and enforce his violent tactics. His success relied not just on shrewd advocacy for the urban poor, but on an apparatus of neighborhood leaders whose patronage networks enabled mass mobilization of political gangs. Clodius' final muster occurred at his funeral. His enraged followers cremated his body on a makeshift pyre at the Curia – the main one, on the Forum – which promptly went up in flames. The Comitium and its dependencies were also destroyed.

Apt symbol of the wreckage of the Roman state, the seat of government lay in ruins for four years. It fell to Julius Caesar to rebuild it during his dictatorship (48–44 B.C.E.). He did it on his own terms and at fabulous expense, seizing the opportunity to purchase private property just north of the Forum for a new rectangular civic temple enclosure, the Forum of Caesar. Land prices in this exclusive neighborhood, long an enclave of senatorial residences, were exorbitant. Out in the public area of the Comitium, the Rostra was detached from the Curia and placed roughly on the central axis of the short northwest end (Fig. 22). The Curia, now aligned with the old Forum's northeast side, anchored the south corner of the Forum of Caesar, the first of an eventual cluster of five "imperial fora" (Fig. 23). To look at, the new forum was not particularly original, being a hybrid of the temple cum portico already

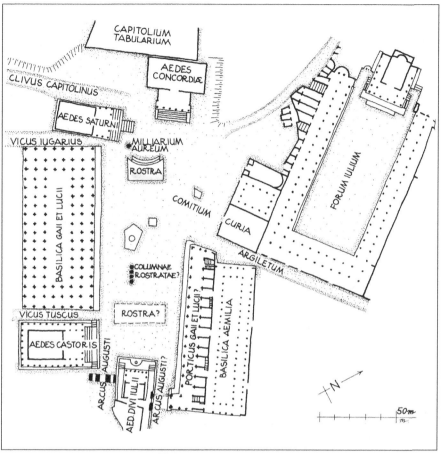

22. Plan of the Forum ca. 10 B.C.E.
Source: Zanker 1988. After a schematic drawing by M. Pfanner. © University of Michigan Press.

familiar on the Circus Flaminius and the colonnaded hillside temple precincts
in famous sanctuaries around Latium. Even the notion of appending a *curia* to
an enclosed portico had been anticipated in Pompey's alternate Senate cham-
ber attached to his theater-portico complex. (Caesar's artful assassins would
ensure that he himself fell in his fallen rival's *curia*, before a statue of Pompey.)
The novelty resided in the forum's intended civic function – specifically, as a
new kind of venue for law courts – and its profoundly dynastic cast. Pompey's
patron goddess, Venus Victrix, had been something of an abstraction. Caesar's,
Venus Genetrix, was by contrast known to everyone as the mother of the
founder-hero Aeneas, whom the Julian clan claimed as a direct ancestor.
The temple's cult thus carried a mythic appeal and symbolic continuity with
Roman identity that Pompey's lacked. Octavian, the son Caesar adopted in his
will, learned a valuable lesson from this. Later, as Caesar Augustus, he would
gamely complete this prototype "imperial forum," left unfinished at his adop-
tive father's death, and then upstage it with his own.

23. Forum of Caesar.

In 46 B.C.E. Caesar put on an extravagant triumph to celebrate his accu-
mulated military victories preceding the dictatorship. His most extensive
civic projects were barely under way, but one of his more ephemeral ones,
undertaken specifically for the celebration, merits attention: his *naumachia*, a
terrestrial venue for the first staged naval battle in history. This was mortal
engagement by prisoners of war and convicts, just like the gladiatorial contests
held in the Forum and Circus Maximus during these festivities, but on ves-
sels replicating warships. The *naumachia*'s basin must have been huge, because
we are told there were 4,000 oarsmen and 1,000 combatants manning a vari-
ety of ships – two veritable navies, demanding acres of maneuvering room.
Dug from the earth in an unidentified sector of the Campus Martius called
Codeta Minor, it may have relied for its water supply on the plain's naturally
high groundwater and soggy disposition. Nothing is known about its shape or
dimensions, but it probably had little if any freestanding architecture. A sur-
rounding grandstand was needed, but this could have been nothing more than
an embankment made from the excavated earth. After the games it degener-
ated into a stagnant public nuisance and was backfilled three years later.

Caesar had also enlarged the Circus Maximus, now a massive freestanding
arena for chariot races nested into the Vallis Murcia, to a capacity of 150,000.
To this he added another hydraulic novelty: a canal, 10 feet wide and deep,
encircling the track to insulate the spectators from the action. Blood spectacle,
for lack of a permanent arena, was traditionally held in the Forum. Tunnels
were now excavated beneath it to allow gladiators, for the first time, to emerge

into battle straight from underground. These measures raised the stakes in the perpetual rivalry among Rome's politicians to serve the people with unprecedented entertainments – a trend that continued unabated in the following decades despite the concentration of power into the hands of a few men, and ultimately just one man.

Caesar's murder in March of 44 B.C.E. stoked partisan frenzy afresh. From the moment when the teenaged Octavian learned he had been named Caesar's adoptive son and heir, there began another 13 years of intense rivalry. Members of the so-called Second Triumvirate – Octavian, Mark Antony, and Marcus Aemilius Lepidus – and powerful freelancers such as Pompey's vengeful son, Sextus, marked this rivalry with small-scale urban gestures. In 42 B.C.E., a deeply divided Senate voted to grant the murdered dictator the status of a god. The scion of a goddess, Venus, had reverted to godhood as Divus ("deified") Julius. A new temple was raised on the Forum's southeast end in the place where his body had been cremated (see Fig. 22), and a cult established for his worship. This was an audacious and radical maneuver. Its only Roman precedent was the mythical apotheosis of Romulus, who had been worshiped as the god Quirinus at a temple on the Quirinal Hill for centuries. Caesar's temple squared off against his Rostra on the far end of the plaza, setting the hero-god, the greatest populist of his age, in perpetual dialogue with the people's platform. It unceremoniously cut off the venerable Regia, whose antiquarian quaintness suited its lack of definition as a landmark. For the first time, the Forum had clearly defined frontage on all four sides.

Octavian made the most of these developments, proclaiming himself the son of a god. As his relationship with his fellow-triumvir Antony deteriorated through the 30s B.C.E., both men launched into a contest of "rival images" centered at Rome, largely in the form of self-serving statuary. But in these years of civil war, neither Caesar's surviving right-hand man (Antony) nor the heir to his fortune (Octavian) had the capacity or opportunity to impose substantial or lasting improvements upon the city. Matters began to change in the mid-30s, and when Octavian and his loyal adjutant Marcus Vipsanius Agrippa decisively defeated Antony in the Battle of Actium in 31, they already had momentum on their side.

The Augustan program of urban renewal emerged, naturally enough, out of the projects Caesar had left uncompleted at his death in 44 (Fig. 24). Perhaps its most propulsive moment occurred with the expiration of the exhausted Second Triumvirate in 33. Earlier that year, Agrippa had assumed an aedileship, the magistracy that oversaw urban maintenance and improvement. As aedile he undertook a restoration of the aqueduct system, neglected for more than a century. He completed a large new aqueduct, the Aqua Julia (begun presumably by Caesar), and restored a smaller old one, the Aqua Tepula; he also added or upgraded distribution tanks and water outlets throughout the city. Later,

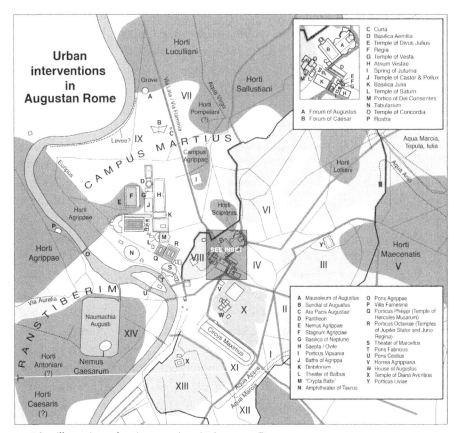

24. Map illustrating urban interventions in Augustan Rome.

in 19, at the pinnacle of his illustrious career and against all precedent, he resumed the aedileship to introduce another aqueduct – the Aqua Virgo – and complete an ambitious urbanization program integrated with it, centered on the Campus Martius.

Throughout the republic the vast Campus had been little more than an open tract of meadows and marshes. Here a sluggish stream fed by hillside springs swelled into a slough, the Palus Caprae, the storied site of Romulus' apotheosis. Scholars have presumed the *palus* occupied a great basin at the plain's center, exactly where Agrippa would plant his watery wonderland; but a recent coring campaign has shown instead that much of this area, including the Largo Argentina temples, Pompey's theater complex, and Agrippa's major monuments, stood on tolerably high ground. The bottomland lay eastward, closer to the hills (Fig. 25). Long associated with Mars and the military sphere, the Campus served as the city's drilling grounds. Its other principal features were votive temples and porticoes built by Rome's triumphant warriors in the southern reaches; near the center, the Saepta or Ovile ("Enclosure," "Sheepfold"), where the Comitia Centuriata ("Centuriate Assembly"), nominally the citizen

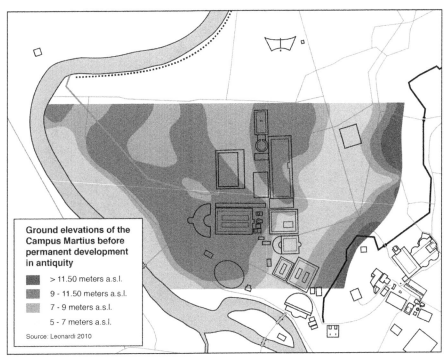

Ground elevations of the
Campus Martius before
permanent development
in antiquity

■ > 11.50 meters a.s.l.
▨ 9 - 11.50 meters a.s.l.
▦ 7 - 9 meters a.s.l.
▨ 5 - 7 meters a.s.l.
Source: Leonardi 2010

25. Ground elevations of Campus Martius before permanent development in antiquity.

militia, voted; and Via Flaminia, running north–northwest on an arrow-straight embankment toward the distant Milvian Bridge. Simple and severe was how the Senate liked it. Pompey excepted, the few wealthy magistrates permitted to erect extravagant temporary theaters in open areas of the Campus had been compelled to dismantle them at the conclusion of their sponsored games. And the scarcity of tombs may suggest that only those with extraordinary honors were granted burial here.

Pompey alone, by force of his unique stature, succeeded in breaching the tradition, and his precedent opened the floodgates to permanent urbanization of the Campus. Caesar floated a fantastic scheme to divert the Tiber westward around the Vatican and fully incorporate the Campus into the developed city, but this came to nothing. Still, he made inroads on the ground: his plan to transform the Saepta into an immense rectangular courtyard enclosed in a mile-long colonnade was realized by Agrippa. In the temple-studded southern extremity of the Campus Caesar started work on Rome's second permanent theater, which Augustus completed in 19 B.C.E. in the name of his deceased heir, Marcellus (Fig. 26). Nearby, athwart the west end of the Circus Flaminius, Rome's first stone amphitheater was dedicated in 29 by Statilius Taurus, Octavian's commander of land forces at Actium.

It was Octavian's naval commander, Agrippa, who in the years between 23 and 18 left the greatest personal imprint here. Obviously Agrippa's enterprise

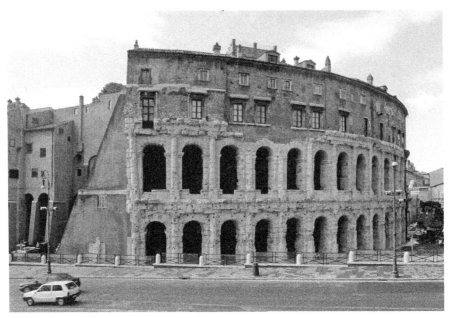

26. Theater of Marcellus and the superimposed Palazzo Orsini.

enjoyed his patron's blessing – and why not? It had qualities of a vast exposi-
tion grounds shrewdly dedicated to advancing the nonspecific, nonpartisan
propaganda style of Octavian – now Rome's first emperor, Caesar Augustus –
and his Julio-Claudian dynasty. Scant decades later, the geographer Strabo
would exalt the Campus as a place of unparalleled splendor with a strongly
public character. Yet this character could not have been achieved without a
preliminary phase of aggressive privatization. Apart from a villa or two on the
Campus' fringes, the modest gardens of Scipio dating back to the 160s B.C.E.,
and a partitioned zone near the Capitoline attested during Sulla's dictatorship,
we hear little about private landholdings in this grassy vastness until the sudden
emergence of Pompey's extensive grounds in the 50s B.C.E. They consisted of
his theater and portico, "upper" and "lower" *horti* (urban gardens) of unknown
extent, and a new residence attached to the theater complex "like a boat in
tow." After Pompey's downfall in 48, Antony acquired the gardens. When he
tumbled in turn, everything went to Octavian or his allies, though the name,
Horti Pompeiani, remained.

Octavian also acquired a sector of the extreme northern Campus, a wedge
of land between Via Flaminia and the river, where around 29 B.C.E. he laid
out the dynastic mausoleum that so impressed Strabo along with a parklike
public grove behind it (Fig. 24, Fig. 27). Named after the famous tomb of
the Carian king Mausolus, this extravaganza drew together influences rang-
ing from Etruscan tumuli to war trophies. A huge earthen mound planted
with trees rose over a multichambered concrete core, culminating in a colossal

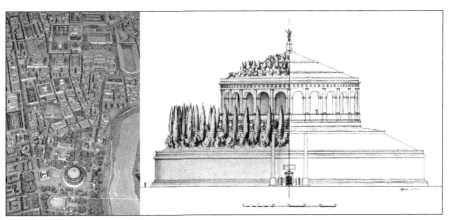

27. Left: model of ancient Rome in Museo della Civiltà Romana with Mausoleum in fore-
ground. Right: reconstruction drawing of Mausoleum.
Source: Reconstruction by G. Gatti, "Il Mausoleo di Augusto: studio di ricostruzione," *Capitolium*
10 (1934), 457–464.

gilded statue of Octavian. Unusually, the tomb's monumental entrance did
not front upon the highway but faced the Campus and the city to the south,
from which it enjoyed unobstructed views. Par excellence, this was a *monu-*
mentum in its original sense: a looming admonition to the city from its savior,
governor, and judge. And it was a singleton, with no rivals in sight: that fact
alone would harangue the average Roman's sensibilities, so accustomed to
long rows of roadside tombs. Later, after numerous intended heirs had died
and been entombed within, the durable Augustus, who lived to age 76, posted
at the entrance a famous inscription enumerating his achievements (*res gestae*).
Prominent among them were his urban improvements at Rome.

Farther down Via Flaminia, Augustus later laid out a huge sundial, or calen-
daric meridian, adjoining his famous altar of peace, the Ara Pacis, all on land he
had acquired. We also hear about Agrippa's immense properties in the Campus,
most of them ceded to the public after his death (see Fig. 24). The acquisition,
development, and flaunting of urban and suburban real estate had always been
a rich man's game, but the land lust among Rome's elite in the years between
republic and empire had a peculiarly strategic character. The strategy played
out as an improvisatory calculus of advance and withdrawal in which appease-
ment sometimes trumped audacity. Take, for example, the aqueduct Agrippa
introduced to Rome in 19 B.C.E., the Aqua Virgo. Unlike its predecessors,
it ran into insuperable problems of land acquisition as it approached Rome
from the east, forcing an immense northerly digression (Fig. 28). Evidently
even the mighty Agrippa could not, or would not, breach the wall of resistance
among landowners in the eastern suburbs. Once rebuffed, his agents must
have contrived an agreement with landowners north of the city, stringing
his conduit mostly underground through public property (now controlled by

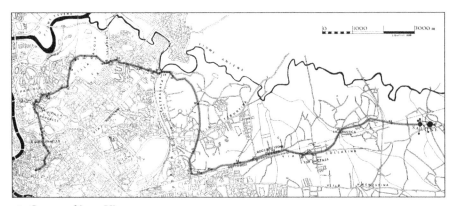

28. Course of Aqua Virgo.
Source: By permission of Lorenzo Quilici.

Augustus through the Senate) and private landholdings of allies, either willing or induced. Arcing homeward from this detour, the low-lying conduit entered the Campus by tunneling through the Pincian Hill.

As it happens, the owner of the hillside estate under which the aqueduct made its final approach to the Campus was Messalla Corvinus, a wealthy two-time turncoat who had gained Augustus' clemency in exchange for allegiance. His estate was the fabulous Horti Luculliani, once owned by the plutocrat Lucullus, commanding a panoramic view of the Campus (see Figs. 24, 81). Messalla became the first water commissioner of Rome after Agrippa bequeathed the apparatus of his aqueduct network to Augustus in 12 B.C.E. Coincidence or not, this high-level perquisite was probably a career-capping reward for Messalla's assistance with the Aqua Virgo. (In 1574, on the very site of Messalla's gardens – now the Villa Medici – Cardinal Giovanni Ricci, *also* urban water commissioner, tapped this imperishable aqueduct with an ingenious water-lifting device designed by another man named Agrippa.) From this point southward, Pompey's former *horti*, now in friendly hands under Augustus, may have provided the crucial insulating corridor leading to Agrippa's properties in the central Campus.

Directly or through Augustus, Agrippa bestowed the following assets upon the city, and more (see Fig. 24): the Aqua Julia, the Aqua Virgo, and his private outfit for operating Rome's aqueducts, including 240 skilled slaves; some 700 curbside water outlets, 500 bigger fountains with statuary, and 130 distribution tanks; Rome's first monumental baths, fed by the Virgo; a great ornamental pool, the Stagnum Agrippae, accompanied by a grove; the now-indistinct Basilica Neptuni and Porticus Argonautarum, full of artworks; the Diribitorium, a long hall for tallying votes at Caesar's Saepta; the riverside Horti Agrippae, probably bounded on the northeast by a curious open canal of unadulterated aqueduct water, the Euripus; a bridge to the Transtiberim, the Pons Agrippae, giving

easy access to a magnificent villa presumed to be Agrippa's home, called Villa Farnesina after the Renaissance property on which it was found during the systematization of the river in the nineteenth century; the Campus Agrippae, with its famous Porticus Vipsania displaying a map of the known world; and the Pantheon, a unique temple aligned precisely with the Mausoleum of Augustus far to its north.

These amenities blended familiar ideas with novelty. The world map may have aimed to upstage a map of Italy displayed in the temple of Tellus (Earth) on the Esquiline Hill. The Baths of Agrippa, the first great *thermae* of Rome, married Italian concrete technology to Greek gymnastic traditions on a newly monumental scale. The Stagnum was probably intended not just for display, but for swimming. Romans knew about swimming pools – the city had a smaller *piscina publica* – but on this scale it resembled the expansive rectangular swimming venues of Near Eastern palaces, to which Agrippa had a direct connection through his friend Herod the Great. To all appearances, the elegant but puzzling Euripus was unprecedented; it created an urban barrier with its pure, flowing water, necessitating masonry bridges at intervals.

Agrippa's district followed an orthogonal grid oriented almost, but not quite, to Pompey's portico and the temples of Largo Argentina. With new blocks came new streets, new public fountains, and a successful new drainage system. Indeed the entire Campus Martius at this time underwent a triumphal campaign of land reclamation. How it was accomplished remains unknown. Not only was the marshland eliminated, its disappearance coincided with the introduction of *more* water, the Aqua Virgo, sequestered from the natural hydrological environment to supply the Baths and fountain outlets throughout the Campus, then crossing the river in pipes on the Pons Agrippae. The recent geophysical survey for a new subway line suggests that even the Stagnum, whose surrounding wall originally rose above ground level, and the Euripus too, sat too high to assist in groundwater management. Caesar's pestilent *naumachia* had taught a cautionary lesson: sheets of water on display must be constantly circulating. The Campus was probably drained by an improved network of underground conduits. In his second aedileship, Agrippa inspected and probably augmented this network, touring its largest sewers in a boat; he liked big challenges and big solutions. Some of his drains may even have run *under* the Euripus to the river.

Little of this infrastructure is visible today, but ancient authors repeatedly singled it out for extravagant praise. "Rome, what cities would dare contend with you in their heights when they cannot even match you in their depths?" gushed Cassiodorus. This seems a bit much, but if we consider the system's capacity to drain the city quickly after a flood, when any standing water, fouled by sewage, would threaten the public health, its utility shines brighter.

BIBLIOGRAPHY

Albers 2008, 2013; Albers et al. 2008; Aldrete 2007; Ashby 1935; Ceen 2009; Coleman 2003; Dyson 2010; Evans 1985, 1994; Favro 1996, 2005; Haselberger/ Romano/Dumser 2002; Jacobs/Conlin 2014; La Rocca 1984; Le Gall 1953, 2005; Leonardi et al. 2010; Lott 2004; Meneghini/Santangeli Valenzani 2007; Millar 1998; Rehak 2006; Roddaz 1984; Schröter 2008; Shipley 1933; Stambaugh 1988; Taylor 2000, 2014; Zanker 1988.

FIVE

RES PUBLICA RESTITUTA

I DENTIFYING HIMSELF AS "FIRST CITIZEN" (*PRINCEPS*), AUGUSTUS HAD THE common touch, conveying at least the semblance of modesty and accessibility. His house on the Palatine was not lavish by aristocratic standards, though this point is often exaggerated: it probably matched any other in that exclusive neighborhood, enjoying a lordly overlook on the Circus Maximus and Aventine and abutting the venerable sanctuary of Cybele, a goddess favored by the patrician elite. In 28 B.C.E. he dedicated a new temple on the other side of his house, this one to Apollo; to it was attached a library that would gain enduring fame. His residence could hardly have been less secluded, wedged between two public religious sites overlooking the largest venue of spectacle in Rome. But visibility and nominal accessibility suited his style. Throughout his career he seems to have augmented his landholdings on the Palatine, perhaps including most of its northern quadrant, which his successors Tiberius and Caligula would develop into a vast new palace block. His holdings crept southward down the slope, connecting the residence to a new imperial box in the circus, which he also expanded and beautified.

Once he was firmly in power, Augustus styled himself the savior and restorer of the old republic. His soft, conciliatory style of autocracy led him to ardently cultivate the fiction of *res publica restituta*, "republic restored": thus the unruly old Forum did not escape his silken backhand. The restoration was purely curatorial. The viscera were removed, but the exterior was rehabilitated

in amplified glory. Damaged by repeated fires but refreshed by the emperor and his aristocratic allies, the Forum looked better by the end of his rule than ever before (see Figs. 22, 24). Caesar's project on the northwest end was complete. Gleaming new basilicas lined both long sides; the Basilica Aemilia's breathtaking polychrome marble nave now displayed a sculptural frieze depicting Roman foundation myths. Resplendent temples at each end, those of Concordia and the deified Julius Caesar (Divus Julius), were crammed with plundered artworks on display. The ancient Temples of Saturn and Castor and Pollux were rebuilt to the highest standards. But functionally, the Forum was losing its civic relevance – becoming more a museum, less an engine, of Roman self-determination and expansionism. The two major *comitia*, relics of the defunct republican system, were now little more than rubber-stamp assemblies. The Senate was a club of aristocratic survivors and opportunists, many of them bought and paid for by the emperor himself, with little appetite for political risk.

Haunted by the old specter of strongmen in strongholds commanding mobile networks of henchmen, Augustus choked off the old political apparatus and took a frankly authoritarian view of urban security. The enclosed Forum of Caesar, with few and narrow exits, was designed with crowd containment in mind. Augustus did nothing so extreme to the old Forum Romanum, but its incremental changes, in aggregate, had some of the same effect. A second *rostra* projecting from the porch of the Temple of Castor and Pollux, where speeches were given and votes cast, had been a constant flashpoint of siege, seizure, and disruption in the late republic. It was consequently moved to the Temple of Divus Julius, or directly in front of it, on axis with the systematized Rostra at the Forum's opposite end (see Fig. 22). Augustus added two important tactical features: honorific arches spanning the chokepoints on each side of Caesar's temple. These served equally as dynastic and military propaganda – and probably as gates, controlling movement in and out of that end of the Forum and the lateral ramps leading to the temple podium. If necessary (in Augustus' lifetime, it never was), their doors could be closed and a rioting crowd pressed up against them.

Its potency permanently diluted, the Forum was a far more decorous place than before. With dilution often comes expansion, and civic affairs indeed spread northward – first into the Forum of Caesar, and later – after delays evidently caused, as in the case of the Aqua Virgo, by recalcitrant landowners – into a new "imperial" forum adjoining it at right angles (Figs. 29, 30). This one too opened around an axial temple. But now solemn ranks of gods, heroes, damsels, and dynasts lined the court, the temple façade, and the four distinctive lateral exedras. For centuries thereafter, the asymmetrical back wall of the Forum of Augustus, over 30 vertical meters of rusticated tuff, sheltered this marmoreal enclosure, the emperor's last great monument in Rome and his

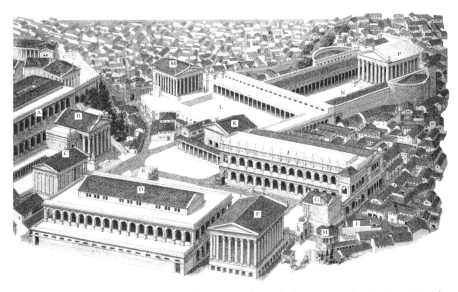

29. Reconstruction view of Forum of Augustus, drawn before a second pair of semicircular exedras flanking the Forum of Augustus were discovered. The exedras were eliminated to accommodate the adjoining imperial fora.
Source: Illustration: Peter Connolly. Akg-images, Ltd.

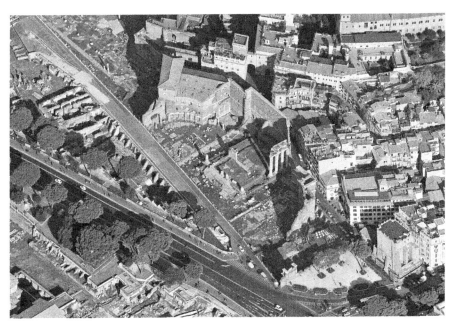

30. Aerial view of Forum of Augustus.
Source: Google Maps.

urban masterpiece, from the fires that ravaged the teeming Subura district on the Viminal Hill behind it (Fig. 31). But in true Augustan fashion it beckoned to the commoners, welcoming them in through a generously arched back

31. Rear firewall of Forum of Augustus.

door between the temple and the southeast colonnade. Thus it preserved some of the permeability of the old quarter it supplanted.

The Augustan urban reforms gave equal attention to Rome's vertical and horizontal social structures. Horizontally, Augustus worked through Agrippa, as in the initial improvements of the water supply and the provision of free amenities to the public at large. Augustus ingratiated himself to the city's hundreds of *vici* (neighborhoods) through his reorganization of the regionary system. Each neighborhood's local cult of *lares compitales*, their specific tutelary gods, was now woven into the burgeoning cult of the emperor. Each *vicus* was given some autonomy in matters of urban management. No less patronage-driven than the clubs and neighborhood gangs of the late republic, Augustus' policy was still a brilliant antidote to them: divide and conquer by putting neighborhoods in competition to demonstrate loyalty to him alone, integrating the old system into a centrally controlled religious structure, and prohibiting collective allegiance to any aristocrat other than Augustus. He maintained Gaius Gracchus' entitlement of the *frumentationes*, a lottery of free grain distributed for life to some 150,000–200,000 individuals on a rotating monthly schedule, occasionally expanding those numbers by temporary largesse. But

he also lavished attention on the battered aristocracy, offering political and material incentives in exchange for three things in particular: cooperation, sponsorship of building or beautification projects, and generous bequests to the imperial purse. These class-specific tasks could coincide. Augustus induced wealthy allies to restore temples favored by the plebs such as that of Diana on the Aventine Hill. Honor thereby accrued to the patrons, and (presumably) satisfaction to the beneficiaries; but benefaction could shade into calculated appeasement. After a tax riot by freedmen in 31 B.C.E. damaged another plebeian temple, that of Ceres on the Aventine, Augustus himself pledged to rebuild it; however, it took him another 48 years to complete the restoration.

In 11 B.C.E., the year after Agrippa's death, the Senate decreed that the number of public fountains he had established throughout the city – the source of daily water for average Romans – was to remain unchanged. The decree evidently was in force until the introduction of the Aqua Claudia in 52 C.E. Yet in the decade after the decree, while Messalla was water commissioner, Augustus restored or augmented four old aqueducts, the Aqua Appia, Anio, Marcia, and Tepula; the Marcia was doubled in volume. With a ban on new public fountains in place, where did this glut of water go? Most likely toward Augustus' own assets, including his carefully cultivated private alliances. The burgeoning gardens and groves around the city benefited, and a system of concessions – water piped directly to residences and baths of favored landholders – was probably established at this time.

In 7 B.C.E., amid these improvements, Augustus instituted a sweeping reorganization of city administration. The old *urbs* of 4 regions was expanded into 14, each encompassing preexisting *vici*. These new *regiones* extended out to the limits of urban development, far exceeding the Servian Wall and the *pomerium*, both of which still excluded most of the Campus Martius and all the Transtiberim. By now, the wall was a relic except as a symbol of the past and an easy quarry for building stone. Enduring peace had finally arrived in Italy, and while the wall may have legally remained inviolable, Romans readily dismantled large tracts of it to facilitate the city's natural expansion. The dense urban core – quite apart from the gardens – had expanded well outside the walls to the east, west, and northwest, especially along the radial highways. Now many of the city's garden parks (*horti*), the newly teeming Campus, and outlying neighborhoods were included within the official administrative city, including all of Agrippa's water outlets. This reorganization had many causes; one of them was probably the desire to place the greatly expanded water network, including the *horti*, more completely under the city's administrative control.

Between this active period and his death, Augustus established an extensive bureaucracy of public works, each branch (*cura*) headed by one or more prominent men of senatorial standing. The *cura aquarum* has already been mentioned. The *cura aedium sacrarum et operum publicorum* was tasked with maintaining the

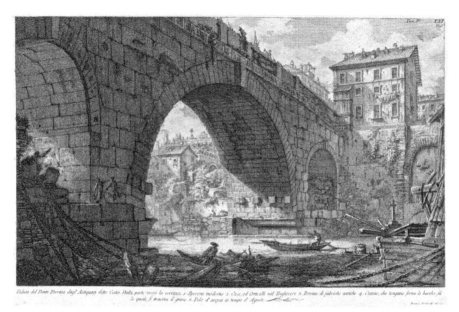

32. Pons Cestius.
Source: Piranesi 1756. Wikimedia Commons/PD-Art.

city's temples and buildings, but not its infrastructure; the *cura viarum*, with
maintaining streets and roads outside the city, especially the great consular
highways. Other tasks, such as street cleaning and maintenance within the
walls, were still handled by the aediles, magistrates of the *vici*, or minor offi-
cials. These were strictly for urban maintenance and repair, not building. Most
new construction, including that intended for the public, was undertaken and
funded by private parties, either the emperor himself or the city's elite, as an
act of munificence. A new monumental building by a private sponsor might
have required senatorial approval (a mere formality if Augustus favored it);
after completion it was deeded to the public. The Pons Cestius, probably built
by Gaius Cestius Epulo, a friend of Agrippa, can serve as an example (Fig. 32).
During the very years in which Augustus and Agrippa were transforming
Rome into the luminous metropolis that so impressed Strabo, the city suffered
several severe floods. In 32, 27, 23, and again in 22 B.C.E. the river swallowed
the lower city, causing widespread damage and loss of life (Fig. 33). If, as we
believe, this public bridge linking the Tiber Island to the Transtiberim resulted
from those floods, it was likely built privately at Augustus' behest. There had
long been a need to link the island to the right bank, and the floods – which
had washed out the other island bridge, the Pons Fabricius, in 23 – were a
reminder of the need for redundancy in river crossings.

Since the midrepublic, the Tiber had been Rome's lifeline, its indispensable
alimentary canal. But the river could also be a highway of misery. Until the
nineteenth century there was no solution to the problem of severe floods, but

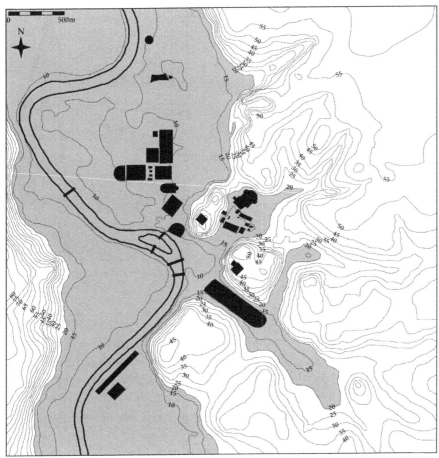

33. Map representing extent of a flood reaching 20 meters a. s. l. in Augustan Rome.
Source: Aldrete 2007, p. 49, fig. 1.10. © 2006 The Johns Hopkins University Press. Reprinted with permission of Johns Hopkins University Press.

measures could at least be taken to alleviate minor ones. Ideally, a mitigation plan should have balanced engineering with rezoning, building codes, and other restrictions. While engineering works can often be detected archaeologically, we know little about policies and patterns of habitation in ancient Rome. Were the drained lowlands of the Campus Martius, for example, now overrun with cheap, poorly regulated housing that would wash away with alarming regularity? We simply do not know. But one district, the Transtiberim, might offer a clue about how Augustus dealt with vulnerable areas.

The street that became Via Aurelia, Rome's westward highway, crossed the northern Transtiberim floodplain on a viaduct that underlies today's Via della Lungaretta (Fig. 34). The street itself attracted development; certainly by the second century C.E. its corridor was densely built up. But Augustus had different priorities. Directly south of the street, in an area now readily accessible from the urban core by bridges, he set aside a vast tract of land for a feature

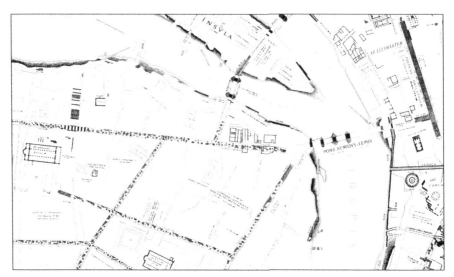

34. Map of Via della Lungaretta and environs showing Roman remains known in the late nineteenth century.
Source: FUR.

that must have struck many as a colossal waste of urban space. It was a permanent *naumachia*, an open basin measuring 1,800 x 1,200 Roman feet with its own water supply, expressly designed for the exceedingly rare event of a staged naval battle. Caesar's *naumachia* in the Campus Martius had proven a pestilent boondoggle. So what was Augustus thinking? His new venue hosted precisely one documented event over eight ensuing decades: a naval spectacle in 2 B.C.E. to mark the dedication of the Forum of Augustus. Close as it was to the city center, the Transtiberim floodplain should have been prime real estate, like the Campus. But the emperor may have envisioned the *naumachia*, in part, as a *deterrent* to development of this flood-prone region. Later, he surrounded the basin with a grove commemorating his deceased heirs, Gaius and Lucius Caesar (the Nemus Caesarum) – proof that he had reserved considerably more land than the space occupied by the basin alone. The *naumachia* had a large, navigable discharge channel to the river. If these sat empty most of the time, as seems likely, then both, by design, could have served double duty as a floodway and detention basin during minor inundations.

Augustus may have hoped this would compensate for protective interventions in the Campus Martius. His and Agrippa's engineers, with direct experience of the floods there, could see that the inertial force of floodwaters hurtling toward the city from the north naturally breached the left bank at the sharp river bend beside the Mausoleum, inundating the northern Campus. The only remedy was to raise a levee along the bank (see Fig. 24); this may have run westward as far as the mouth of the Euripus. The repeated raising of this area's ground level in subsequent centuries shows that it continued to

cause trouble; but in lesser floods, when the levee worked, the swollen waters, deflected from their natural point of release, would have rushed downstream, threatening the city's precious wharves. A large, usually empty reservoir along the way – the Naumachia Augusti – may have provided welcome relief.

That Augustus sincerely aimed to alleviate flooding is evident in his dredging of the Tiber and establishment of the *cura riparum et alvei Tiberis.* This commission, augmented by his successor Tiberius, was charged with clearing the river and managing its banks. Quite apart from flooding, both matters merited attention for at least three reasons: the Tiber was treated almost as a municipal dump, its accumulated debris obstructing navigation and exacerbating floods; unregulated private building encroached on the river; and flooding shifted its banks. This last problem was so serious that it caused the irreparable detachment and consequent removal in the third century of two bridges serving the Campus, those of Agrippa and Nero (see Chapters 7 and 10). Finely constructed embankments were built along short distances at wharves and at sensitive points on outer curves, as at the Forum Boarium (see Fig. 3). Singly these helped to stabilize the banks, but collectively, because they were not generally raised to form levees, they did nothing to control flooding.

Famously Augustus boasted that he had found Rome a city of brick and left it in marble. Fine words, but we should never suppose that Augustan Rome was leashed to one man's grand vision. We do history a disservice if we pretend the city at this moment was an ideological unity – a reification of a new golden age, or an elaborate metaphor of Augustus as a cosmic sovereign. It was much less, and much more, than that. Its story is full of false starts, disasters, contingencies, frustrations, fierce opposition and improvisation, compromises, blandishments, threats – and, yes, towering successes too.

BIBLIOGRAPHY

Albers 2013; Albers et al. 2008; Aldrete 2007; Ashby 1935; Beard/North/Price 1998; Berlan-Bajard 2006; Cariou 2009; Coarelli 1992, 2012; Davies 2000; Dyson 2010; Favro 1996, 2005; Geiger 2008; Haselberger/Romano/Dumser 2002; Hölscher 2009; Jacobs/Conlin 2014; La Rocca 1995; Lott 2004; Luce 2009; Meneghini/Santangeli Valenzani 2007; Rehak 2006; Robinson 1992; Rutledge 2012; Stambaugh 1988; Taylor 1997, 2000, forthcoming; Tomei 2004; Ungaro 2007; Walker 2000; Zanker 1988.

SIX

MEMORIALS IN MOTION: SPECTACLE IN THE CITY

I T HAS BEEN SAID THAT ANCIENT ROMAN CITY LIFE, FROM THE MOST ORDINARY human encounters to the grandest pageantry, was a perpetual spectacle. The powerful patronage system, ensuring that most free persons were in social debt to someone else, promoted the idea that one's own business was also the business of others. This system encouraged fierce competition for favor and resources, demanding social contact and mobility in numerous forms: traveling to greet, dine with, or bathe with one's patrons and fellow clients; providing bodyguards; running errands; conveying messages; soliciting votes; punishing criminals or slaves. Movement encouraged visibility. Nobody avoided the stage.

The physical setting pervaded everyday city life. To live in Rome was to perform against the backdrops of its fabric. Visible monuments of past glory were abundantly available to enrich the rhetoric of the moment. But fierce political competition guaranteed that *present* glory and its attendant monuments were only conferred with misgivings or downright resentment. Public figures felt and feared the seductive power of their rivals' proprietary monuments. In 381 B.C.E., a trial of Marcus Manlius Capitolinus was moved out of sight of the Capitoline after he invoked his famous defense of that hill during the Gallic invasion by calling it to the visual attention of his audience. In 58, Clodius tried to neutralize the exiled Cicero by publicly destroying the orator's house on the Palatine and replacing it with a shrine to the goddess Libertas. This was not so much an erasure as an exorcism: the spirit of Liberty would chase out the

demons of Cicero's perceived tyranny. Such was the power of the mind's eye; so vivid was the rhetoric of topography.

The earliest and most durable organized spectacles at Rome were religious processions accompanying sacrifices at urban or suburban sanctuaries on pre-scribed days (*fasti*) in the religious calendar. These followed specific routes designed, in effect, as progressive memorials to the local gods and heroes of antiquity. For example, the sacrifice of the Lupercalia festival took place at the Lupercal, a cave in the Palatine Hill where the wolf was said to have suckled Romulus and Remus. The route of the "procession," really a festive dash of loincloth-clad priests striking willing young women with their ritual goatskins to ensure fertility, traced the path of Romulus' original *pomerium* around the Palatine Hill.

Inevitably, spectacles were drawn into the vortex of political ambitions and rivalries. In the republic, the funerals of prominent citizens grew into elaborate affairs punctuated by loud, even raucous public processions from the home of the deceased to the Forum, where eulogies were delivered to the crowd. The final destination was the ancestral tomb; there the body was cremated and the ashes enshrined. Among the participants were musicians, professional mourn-ers, and masked actors playing the roles of the deceased and his ancestors. The historian Polybius describes the actors seated, like living statues, on the Rostra as the eulogist praised their achievements.

> For who would not be moved by the sight of images of men renowned for their excellence, all together as if alive and breathing? ...Thus by the constant renewal of the good report of brave men, the celebrity of those who performed noble deeds is rendered immortal, while the fame of those who did good service to their country becomes known to the peo-ple and a heritage to future generations [transl. Beacham].

Sulla's gargantuan funeral in 78 B.C.E. reportedly featured 6,000 "ances-tors" and 210 carts displaying the spoils of his military campaigns. Unlike religious processions, such funerary convoys lacked a prescribed route. But the traditional focal points – residence, Forum, and suburban tomb, along with portable memorials such as war trophies and military insignia – served for the requisite *monumenta* – literally, "admonitions" to follow the patterns of virtue being reenacted there. This kind of display was politically potent, and periodi-cally it was suppressed.

We have already seen, with the theater and portico of Pompey, how per-formance could be extended from the human activities within a venue to the venue itself, creating rich and evolving dialogues between flesh and stone. Even the carefully plotted murder of Caesar there, in Pompey's new Senate chamber before a statue of Pompey himself, was a grim act of stagecraft cali-brated for eternity: *sic semper tyrannis*. Public processions had their own ways

35. Arch of Titus along the Sacra Via, representing Titus in his
triumphal chariot.
Source: Photo: Rossella/Shutterstock.

of interacting with the built landscape. Their routes were permeated with
the symbolism of accumulated history and tradition, and the pageantry was
designed to maximize these associations. Ancient Rome enjoyed many pro-
cessions of varying character, most of them fixed in the religious calendar.
These followed designated routes, often concluding at the temple of the hon-
ored god with a sacrifice and a public feast.

The foremost ceremonial procession in Rome was the triumph. Some
images of this event place it within its physical setting, documenting impor-
tant monuments along the way (Fig. 35). Like the Lupercalia, the triumphal
procession may have originated as a purifying ritual involving the counter-
clockwise circuit around the primeval Palatine city. But from early times
it emphasized the victorious army with its leader in a chariot, breaching

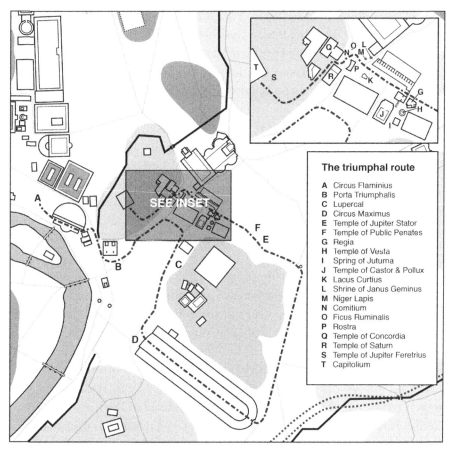

The triumphal route

A Circus Flaminius
B Porta Triumphalis
C Lupercal
D Circus Maximus
E Temple of Jupiter Stator
F Temple of Public Penates
G Regia
H Temple of Vesta
I Spring of Juturna
J Temple of Castor & Pollux
K Lacus Curtius
L Shrine of Janus Geminus
M Niger Lapis
N Comitium
O Ficus Ruminalis
P Rostra
Q Temple of Concordia
R Temple of Saturn
S Temple of Jupiter Feretrius
T Capitolium

36. The triumphal route.

the *pomerium* through the Porta Triumphalis near the Forum Boarium – a highly charged rite of passage marking the soldiers' readmission into civil society.

The procession began outside the *pomerium* in the Campus Martius among the temples of the Circus Flaminius. Spectators lined the streets and filled the open venues along the way. The entire route was studded with landmarks evoking the city's history (Fig. 36). Once inside the Porta Triumphalis, the procession looped left and back again past the Lupercal, the cave where the she-wolf had nursed Romulus and Remus, and the Scalae Caci, associated with the brutish antagonist of Hercules, Cacus; it traversed the Circus Maximus, where the primeval Romans had seized the Sabine women. Emerging from the circus' eastern end, the army turned left along the southeastern flank of the Palatine. After the next left turn, on the Sacred Way (Sacra Via), were the temple of Jupiter Stator ("Founder"), another landmark of the Sabine War, and the temple of the public *penates*, tutelary gods of the city. The procession then passed the Regia, the Temple of Vesta, and the Spring of Juturna,

where Castor and Pollux had reportedly made an appearance after a decisive battle of the early republic. Beside this stood the temple of the twin heroes itself. Now they were in the Forum, riddled with famous toponyms. In quick succession appeared the Lacus Curtius, recalling (again) the Sabine War; the Niger Lapis or Volcanal, purported site of Romulus' tomb; the shrine of Janus, its open doors signifying Rome's almost perpetual state of war; the Comitium with the Ficus Ruminalis – the fig tree under which the wolf had found the twins – miraculously transported from her lair; the Rostra, displaying the bronze prows of defeated navies; the Temples of Concordia and Saturn; and much more. Finally, after an ascent of the Capitoline Hill, probably within sight of the tiny Temple of Jupiter Feretrius, where a triumphant Romulus had deposited Rome's first war spoils, the culminating sacrifice to Jupiter Optimus Maximus took place before the Capitolium, symbol of Rome as *caput mundi*, head of the world.

With senatorial consent, triumphant generals added their own memorials to this route, seeking to bestow material permanence on their achievements. They erected votive temples, many in the southern Campus Martius near the starting point of the procession. Occasionally the Senate even granted a victory monument in the Forum. The Rostra's bronze prows celebrated the first recorded Roman naval victory in 338 B.C.E. A column nearby bristled with more prows captured from the Carthaginians in 260 B.C.E. Displayed in their respective triumphal processions, then affixed to the monuments, the captive prows went from participants in the staged drama to permanent fixtures in its setting. Later triumphs would be confined to the emperors. Their preferred site-specific memorials were freestanding arches – some spanning the triumphal route, others close by – encrusted with the imagery of conquest. Sometimes depicting the emperor riding in pomp, these monuments were intended to participate in future triumphs and to influence them (Figs. 35, 37).

The earliest games at Rome would have looked familiar to Greeks and Etruscans. Tradition recognized the Circus Maximus as Rome's oldest permanent venue of public spectacle. Running along the narrow valley between the Palatine and Aventine Hills, it was best suited to races: first probably on horseback, later in chariots. Boxing and wrestling events were held here too. In Greece, games of this sort may have originated at funerals. From the midrepublic, funerary games (*munera*) gained currency in Rome, but initially they were dominated by competitions in the performing arts. In parallel, public games of a more athletic kind became attached to state festivals (*ludi*). Also, a *triumphator* could present votive games at Rome. Thus began an inexorable centuries-long escalation of urban display. All games and spectacles could be termed *monumenta*, their pageantry and competitions echoing the purported virtues of either their sponsors or their dedicatees.

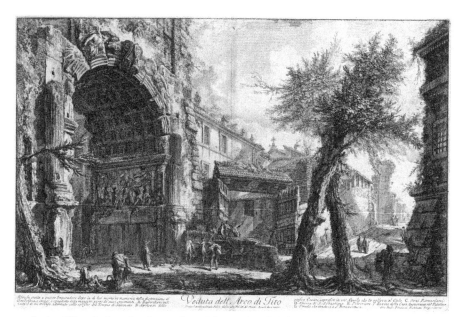

37. Arch of Titus before the destruction of the medieval defenses encasing it.
Source: Piranesi 1747–1778. Metropolitan Museum of Art/OASC; www.metmuseum.org. Gift of Mrs. Alfred J. Marrow, 1964.

Until the third century B.C.E., Rome had no organized blood sports. Only in 264, Livy says, was the first gladiatorial event staged there. The venue was the Forum Boarium; the occasion was the combat of three pairs of gladiators at a funeral. Bigger bloodbaths would soon follow. The growing popularity of staged mortal combat remained associated with irregular games (funerary or triumphal), not the *ludi*. The customary blood sports in *ludi* were the slaughter of animals; these grew more elaborate and exotic as Roman conquests piled up in the third and second centuries.

The Macedonian and Punic Wars prompted a sharp rise in entertainments at Rome. The Forum became the favored venue for gladiatorial contests, featuring scores or even hundreds of fighters. Special cantilevered balconies were attached to the façades of the surrounding properties for paying spectators. In the second century B.C.E. these yielded to wooden grandstands assembled for each event. Also in the third century, the games introduced Greek-style plays composed in Latin. These had no fixed venue, but sponsors circumvented the ban on permanent theaters by staging dramas on the porches of temples. In 192, Plautus presented his comedy *Pseudolus* on the Palatine, in front of the brand-new Temple of Cybele, for whom games were being inaugurated. Though *ludi*, not *munera*, provided the occasion, the venue evoked triumphalist sentiments: the foreign goddess had been introduced to Rome some years earlier because an oracle had promised that she would expel Hannibal from Italy.

Also, Rome was in the process of controlling Greek Asia Minor, Cybele's home, and Greek-themed plays staged in this "little Asia" on the Palatine would have kept Rome's expansionism in the foreground. The temple plaza may have served as Rome's main theater for decades; later it continued to host annual dramas during the Ludi Megalenses, dedicated to Cybele. When Augustus rebuilt the temple, its new pediment represented the goddess as a crown set upon a chair. These refer to the *sellisternium*, a ritual in which a chair adorned with divine symbols was solemnly conveyed to spectator venues to represent the honored deity's presence at the games. From her new vantage point high on the temple's façade, Cybele could preside over her home theater directly below. Other temples in Rome probably had similar theatrical arrangements; the combination was eventually formalized as the temple-theater, like Pompey's.

Significantly, the favored venue for the *ludi*, the circus, was a permanent structure. Yet until the end of the republic the Senate steadfastly refused to allow the erection of permanent buildings to accommodate the more politically potent shows attached to extraordinary games. Physical monuments carried greater symbolic weight than one-off events. Their durability in space, their potential to shape experience and recollection through iteration over time, was their strength and their menace. But this did not deter the construction of votive temples and honorific statues. Nor did the aristocracy most fear the moral decay brought on by idle spectacle, though it was their perpetual complaint. They feared self-selected partisan crowds. The builder of a permanent venue of spectacle would have owned it and controlled admission to it. This is one reason why Pompey's theater seemed so radical, and why he had to placate the Senate by incorporating a temple and a new Curia into his theater complex: it was a potential cradle of political sedition.

These were not idle fears. The great influx of population to Rome during the civil wars of the first century B.C.E. destabilized the old patronage system, generating thousands of political free agents. Demagogues like Clodius and Caesar courted these swing voters fervently. From 61 B.C.E. onward, political disruptions at spectacle venues, some of which spilled out into the streets, proliferated. During Cicero's exile, his partisans even staged dramas that would rally the audiences to his cause. Yet nobody could break the growing cycle of political dependency on spectacle; the sponsors were as addicted to the system as the people.

The late republic witnessed a frenetic escalation in the scale and magnificence of spectacles despite the Senate's continued unease. Pompey's third triumph in 61 B.C.E. was accompanied by extravagant games. Three years later, for his games Marcus Aemilius Scaurus built a temporary theater whose splendor beggars belief. Probably situated in the Campus Martius, it reportedly seated tens of thousands before a monumental stage backdrop of 360 columns and

some 3,000 bronze statues. In 52 B.C.E. another Roman luminary concocted a pair of full-scale wooden theaters that could be pivoted together to form an amphitheater for afternoon gladiatorial shows. The era culminated with Caesar's triumphal games in 46 B.C.E., punctuated by the world's first staged *naumachia* and startling new gladiatorial effects in the Forum (see Chapter 4).

Pompey had pried open a door of opportunity in Rome with his permanent theater and its sumptuous peristyle garden. His successors exploited the precedent to found other freestanding entertainment centers in concrete and stone. Caesar expanded the Circus Maximus to seat some 150,000 spectators, and Augustus monumentalized the structure further. In the extreme southern Campus Martius, in 29 B.C.E., Octavian's general Statilius Taurus dedicated the first permanent amphitheater for blood combat (see Fig. 24). A theater Caesar had planned nearby made only modest headway before his death, but Augustus co-opted the project, producing a venue even larger than Pompey's but lacking a peristyle. This he dedicated to his deceased heir presumptive, Marcellus, sometime after 23 B.C.E. (see Fig. 26). In 13 B.C.E., Lucius Cornelius Balbus dedicated a somewhat smaller theater-peristyle complex southeast of Pompey's and on the same orientation. Entertainments on a lavish scale, long feared for their potential to stir unrest, were now fully embraced and ratified in the city's fabric, especially in the Campus Martius.

Their durable venues would evince a utility far outlasting their initial purpose. As it happens, the cellular design and inherent defensibility of freestanding Roman theaters and amphitheaters, not their capacity to contain and engage audiences, proved most valuable over time. In effect, these bowls of humanity became sponges. Through the Middle Ages, long after the demise of classical entertainments, they would be reanimated into busy but closely controlled enclaves of industry, commerce, and housing.

BIBLIOGRAPHY

Arce 2010; Beacham 1999; Beard 2007; Beard/North/Price 1998; Coleman 1990, 2000; D'Ambra 2010; Favro 1994, 2014; Humphrey 1985; Kellum 1999; Millar 1998; Östenberg/Malmberg/Bjørnebye 2015; Russell 2014; Rutledge 2012; Sear 2006; Welch 2007.

THE CONCRETE STYLE

Aᴜɢᴜsᴛᴜs' sᴜᴄᴄᴇssᴏʀ, ᴛɪʙᴇʀɪᴜs (14–37 ᴄ.ᴇ.), sᴘᴏɴsᴏʀᴇᴅ ᴏɴʟʏ ᴀ ꜰᴇᴡ urban developments in Rome, the most significant being the expansion of the imperial Palatine compound into the Domus Tiberiana, a genuine palace designed to accommodate the growing imperial entourage, especially the Praetorian Guard. Other cohorts of the guard were quartered in a full-scale military camp, the Castra Praetoria, just northeast of the Servian Wall; this was later nested into the Aurelian Wall (see Fig. 80). Caligula (37–41) launched several aggressive building campaigns, some of which died prematurely with their patron. Others were completed by his successors. Claudius (41–54) focused on infrastructure rather than the city's monumental core. The splendid Porta Maggiore, doubling as an aqueduct arcade and a city gate, is his most enduring monument in Rome (Fig. 38). Over it flowed his two great aqueducts, one channel stacked upon the other: the Aqua Claudia and the Anio Novus above, both begun by Caligula. Their arcade of solid *peperino* stone still dominates the landscape east of the city. Together they augmented the existing water supply by as much as 40 percent. Claudius devised no known monumental baths, water play, or *naumachia* to justify or advertise them. Yet combined, Frontinus later tells us, the two lines were supplying all 14 city regions from 92 distribution tanks in his time (ca. 97 C.E.). In number, these tanks constituted 37 percent of the total urban network, and in volume 34 percent; the total brought in an astounding (but in Frontinus' opinion, scandalously underperforming) 333 million liters per day.

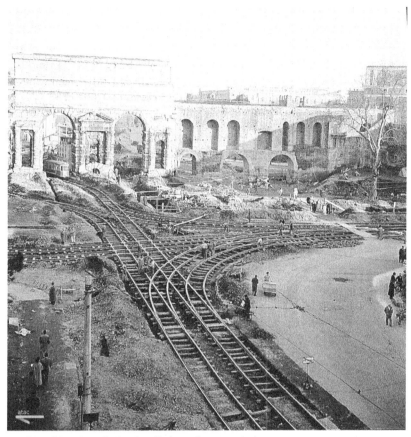

38. Porta Maggiore during installation of tram tracks in 1956.
Source: Archivio Storico Fotografico ATAC 6924.

This precious glimpse of Rome's "soft" structure at one moment in its his-
tory says little about its "hard" aspect, however. After Augustus, the first trace-
able and truly systemic changes to the urban fabric belonged to Nero (54–68),
who took concrete vaulted architecture not only to new heights of creativity,
but also into mass production. The central-Italian preference for concrete as
a monumental building material developed slowly and incrementally. Writing
early in Augustus' reign, Vitruvius provided a simple formula for this mirac-
ulous slurry that hardened into veritable stone, far stronger than any mortar.
Its key ingredients were chunks of stone aggregate and a matrix of water,
slaked lime, and *pozzolana* – a volcanic sand that gives concrete its extraordi-
nary strength. Probably invented on the Bay of Naples, where proximity to
pozzolana intersected with a thermal bathing culture that encouraged innova-
tions in vaulted architecture, concrete had gradually earned the confidence of
builders. Forming a core between facings of mortared stone, the material was
first used in Rome for simple temple podia around 200 B.C.E. Some decades
later, the Navalia – a long concrete ship shed with repeating transverse barrel

vaults – was built along the Emporium river wharf (see Fig. 18). By about the year 100 concrete was being applied to even more sophisticated vaulting schemes, if on a modest scale. Pompey's theater of the mid-50s B.C.E., with its multiple stories of intricate radial and circumferential passages, advanced the scale and complexity of concrete construction significantly, establishing a pattern for later freestanding theaters and amphitheaters. But the famous Roman architectural revolution, which took the medium to new volumetric heights, had to wait until Nero and particularly his extravagant and sprawling palace complex known as the Golden House, or Domus Aurea, designed by the architects Severus and Celer.

With its tendency to expand the limits of the buildable and its potential for quick and efficient execution, concrete held the promise of revolutionary change in the urban landscape. Yet certain applications developed slowly. The aqueducts of Augustus and Claudius employed concrete in the channels, but avoided it in arcades. Only with Nero was the material widely applied to arches, and with poor results. His raised extension of the Aqua Claudia across the Caelian Hill was a narrow, spindly arcade of brick-faced concrete, almost all of which needed shoring up later. Before Nero, large buttressed vaulted halls, derived from the bath architecture for which Romans are justly famous, developed only haltingly. The Baths of Agrippa, completed around 20 B.C.E., had probably carried the largest concrete domes in the city at that time, comparable in scale (we can only guess, since the baths were later rebuilt) to the roughly contemporary "Temple of Mercury" at Baiae, the oldest surviving concrete dome of significant size. This has a flattened profile, an inadvertent result of novelty and inexperience. We cannot know whether Agrippa's vaulting had comparable problems, but Rome's material record attests that the learning process for building large forms in concrete continued over centuries, not decades. The corridors of the Mausoleum of Augustus, despite appearing cautious and overbuilt, have suffered catastrophic vaulting collapses; the core of Hadrian's mausoleum, built a century and a half later, is much better preserved (see Fig. 65). Likewise, Hadrian's adjoining concrete-core bridge, the Pons Aelius, remains largely intact, while the nearby Pons Neronianus (Bridge of Nero) lasted barely two centuries. Not incidentally, the huge bath compounds of Trajan, Caracalla, and Diocletian, all built on similar plans, but isolated from one another by two century-long intervals, survive in profoundly different – and successively better – states of preservation.

In short, there was no sudden technological moment ushering in an era of broad, confident application of standardized techniques comparable to the emergence of reinforced concrete construction in the twentieth century. Something approaching this kind of systematization can be seen in Ostia in the second century C.E. – but that town was unique for many reasons, and suffered no known citywide disasters. We do not know whether Rome ever

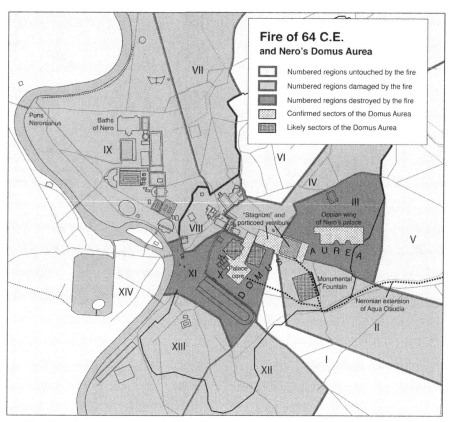

Fire of 64 C.E.
and Nero's Domus Aurea

☐ Numbered regions untouched by the fire
☐ Numbered regions damaged by the fire
■ Numbered regions destroyed by the fire
▨ Confirmed sectors of the Domus Aurea
▦ Likely sectors of the Domus Aurea

39. Map showing extent of fire of 64 C.E. by region

looked like Ostia, particularly in the neighborhoods destroyed in the conflagration of 64 C.E.; but much of ancient Rome's most transformative architecture emerged in the imperial period from the ashes of devastating fires. Centralized power; local concentrations of materials, talent, and labor; and imperial sponsorship of concrete construction all collaborated in the rebuilding campaigns following fires in 64, 80, 110, 192, 283, and 307 C.E. Big disasters can germinate the seeds of big ideas.

The fire of 64 C.E. devastated the city over the course of a week or more (Fig. 39). Loss of life in the early hours was great; material damage overall, almost unimaginable. According to Tacitus, 3 of Rome's 14 regions were leveled and 7 more badly charred, leaving only 4 intact. It was the worst physical disaster in the city's history, before or since. The building in its wake was prodigious. Not only did the sprawling Domus Aurea spring up with its fantastic gardens, pavilions, water features, peristyles, residences, and reception halls, but (Tacitus says) a stringent new building code altered the city's very fabric.

Yet the whole episode is so hedged about by legend and notoriety that we hardly know what evidence to trust. The claim by his detractors that Nero himself started the fire out of land lust for his palace seems too convenient.

40. Nero's Domus Aurea, octagonal hall.

Most of the land Nero commandeered had been acquired before the fire, and a palace project on a comparable scale, extending across the Forum valley, was already well advanced. Small parts of this preconflagration complex, known as the Domus Transitoria, survive under later buildings, and the quality of their architecture and decoration rivals that of their replacement. Admittedly the remains of the Domus Aurea on the Oppian Hill display particular novelty and daring (Fig. 40), but the genius evident in them did not emerge overnight. Already one of the most influential and innovative architectural designs had taken form independently on the Campus Martius a few years earlier: the Baths of Nero, the first great public bathing complex in Rome in eight decades (Fig. 41). Untouched by the fire, they served as the model for all the largest imperially sponsored bath buildings thereafter. Hot, warm, and cold bathing rooms, followed by a large open-air pool, were aligned symmetrically on a central axis. In mirroring pairs to each side were arrayed changing rooms, rectangular colonnaded *palaestrae* (exercise courts), and their dependencies. The cold room, or *frigidarium*, embodied one of the most memorable architectural forms in antiquity: two opposing rows of four massive piers, each fronted by a colossal column, supporting three giant cross-vaulted bays. Semicircular clerestory windows sealed the upper perimeter, while four bathing pools nestled between the outer pairs of piers.

 Never one to miss an opportunity, the emperor reacted to the fire with a thorough plan of urban renewal. Even Tacitus, a fierce critic of the emperor, seems to regard it with approval:

41. Plan of Baths of Nero after Palladio's drawing.
Source: D. Krencker, *Die Trierer Kaiserthermen* (Augsburg 1929).

Those other parts of the city spared by the palace were not built with-
out discrimination or randomly, as after the Gallic fire [in 387 B.C.E.],
but in measured ranks of streets and broad avenues, with height restric-
tions on buildings, open areas, and the attachment of porticoes to protect
the facades of apartment blocks. Nero promised to build those porticoes
with his own money, and to hand the cleared lots back to their owners....
The buildings themselves, built in certain parts of his property without
timbers, were tempered with Gabine or Alban stone, which is fireproof.
Custodians were assigned to reclaim water that had been intercepted
through private lawlessness, that it might flow more abundantly and to
more places for public use; and everyone kept fire-suppressing aids out in
the open. Party-walls were eliminated, each property standing clear on its
own perimeter walls. Undertaken for their utility, these things also made
the new city more attractive.

Tacitus' largely credible account merits attention for a number of reasons.
Neither the fire nor the physical response to it – except parts of the Domus
Aurea – is legible today archaeologically, so this narrative remains our best
source of information. Also, it records a phenomenon akin to city planning, a

rarity in the capital city. Particular aspects of Nero's ordinances find echoes in the second-century architecture of Ostia: gaps between properties, for instance, and avoiding flammable materials by vaulting the lower stories of apartment blocks (see Fig. 42). The "tempering" of the buildings with volcanic stone might be misinterpreted as a resumption of traditional stonemasonry of the sort seen in the firewall behind the Forum of Augustus (see Fig. 31). Yet Nero's builders heavily favored cheaper and comparably fire-resistant brick as a facing for concrete walls, and used it extensively in the palace complex both before and after the fire. Probably, then, Tacitus is referring to the fireproofing not of wall surfaces, but *of the concrete itself.* This material in general, and vaults in particular, because they had no protective facing on their undersides, were likely to fracture in extreme heat if they contained limestone aggregate or poorly mixed lime. Gabine and Alban stone (two types of *peperino*) were widely employed as concrete aggregate in Rome along with the more popular tuff, and now they were singled out as the best material to withstand extreme heat.

Tacitus presents the rebuilt city as a landscape of broad streets arranged in regimented blocks and buildings of few stories, constructed of solid masonry and a minimum of wood. But how would porticoes (presumably barrel-vaulted in concrete, and thus without the usual wood-framed shed roofs) protect the façades of city blocks? After all, additional space gained by their absence would have broadened the fire gap. That they may have served as balconies from which the *vigiles* could launch water to the ever-vulnerable eaves of the upper roofs, as Suetonius suggests, is not an entirely fanciful notion, but is still hard to take seriously.

More troubling is the lack of physical traces of this project of systematization. That may be due in part to the ultimate failure of Nero's building code – huge fires struck again 16 and 46 years later – and the subsequent breakdown of architectural uniformity. But maybe we have been looking in the wrong places. We rarely appreciate just how difficult it would have been even for an emperor to create a legal tabula rasa in the heart of Rome, even (or especially) after a disaster. Property boundaries cannot be disavowed with the wave of a hand, and Roman law prohibited expropriation for any reason other than public utility. Before the fire, Nero had found pretexts to seize many properties he coveted for his palace expansion. Even then, he could not have acted arbitrarily or summarily: every acquisition required a justification. By contrast, after the fire Nero "offered to hand over the cleared properties to their owners." There is nothing here to suggest that *existing* lots changed shape or orientation. Instead, Tacitus' immediate emphasis was on the new building code. For the entirely new neighborhoods with regular blocks and wide streets, then, perhaps we should look outside the previously inhabited core. Tacitus remarks on the decreased density of the rebuilt areas, so if we suppose that there was no great loss of population citywide, horizontal expansion was inevitable.

42. Actual-state model of *insula* on west slope of Capitoline Hill.
Source: Museo della Civiltà Romana.

Nero's reforms probably launched a modest prototype of the *insula*, a type of concrete apartment block best exemplified in a later form by surviving build-ings at Ostia and at the foot of the Capitoline Hill (Fig. 42). So where were his more modest housing blocks built? Two particular districts recommend themselves. These are the northern Campus Martius and the vast gardens in the Vatican, which Nero had inherited from his mother, Agrippina, and where he had recently completed a circus begun by Caligula. In both, Tacitus says, he gave shelter to the hordes of homeless and dispossessed immediately after the fire. He held games at the gardens to entertain the traumatized populace, and here he reportedly condemned Christians to public execution, scapegoat-ing them for the fire. A new bridge between this suburb and the Campus Martius, the Pons Neronianus, was the first to be added at Rome in at least seven decades. North of the pleasure district of baths and theaters in the Campus Martius, a degree of regularity can be found in Roman apartment blocks excavated along Via del Corso, which follows the ancient Via Lata/ Flaminia (Fig. 43). Plausibly, this area too was first systematized after the fire of 64. The buildings shown here are *insulae* of the second century, perhaps rebuilt on Neronian foundations after the fires of 80 and 110 had once again ravaged the district.

What little we know about the ancient Vatican Plain (today's Prati neigh-borhood) suggests that it was laid out orthogonally in approximate alignment

43. Plan of *insulae* found east of Piazza Colonna.
Source: E. Gatti, "Roma. Scoperte di antichità a Piazza Colonna," *Notizie degli scavi di antichità* (1917), 9–20.

with the circus, which ran roughly east-west, and Via Cornelia approaching it from the east (Fig. 44). It was transected in a north-northwest–south-southeast direction by Via Triumphalis, the ancient road to Veii. Via Cornelia, later hemmed in with tombs, would gain fame as the burial place of St. Peter, who according to tradition was crucified in Nero's persecution after the fire.

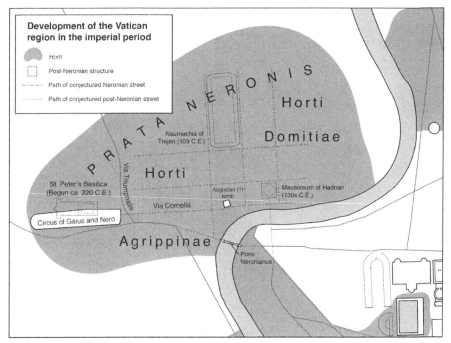

44. Development of Vatican district in imperial period.

As famous for his populism as for his cruelty and covetousness, Nero may have consigned this district to resettling Rome's displaced in new low-profile, brick-and-concrete apartment blocks. Tacitus remarks that Nero's fire-resistant buildings were "built in certain parts of his property," which might suggest precisely his vast inherited estate west of the Tiber. Abandonment of the district in the Middle Ages, combined with heavy alluviation of the plain, may account for its strange deficit of local memory, at least apart from its nomenclature: the Prata Neronis, "Plains of Nero." The eastern half of the plain remained undeveloped; open battles took place here repeatedly during the Ostrogothic siege of 537–538 C.E. But the area northwest of the loop anchored by Via Cornelia had residential neighborhoods at that time, as Procopius attests. The middle zone north of the loop, which had been surveyed to a grid, may have had pockets of residences, but large sectors of it lay available for major projects by later emperors.

In June 68, Nero reportedly made his exit from life with the words "What an artist dies in me." His artifice was everywhere visible in the city. But the Domus Aurea, so tainted by the emperor's megalomania, could not be left alone. Upon accession in 69 after a brief civil war, Vespasian wasted little time restoring some of its land to the former owners. An artificial pond in the valley between the Palatine and the Oppian Hills was drained and a monumental new amphitheater went up in its place (Fig. 45). This project was both pragmatic,

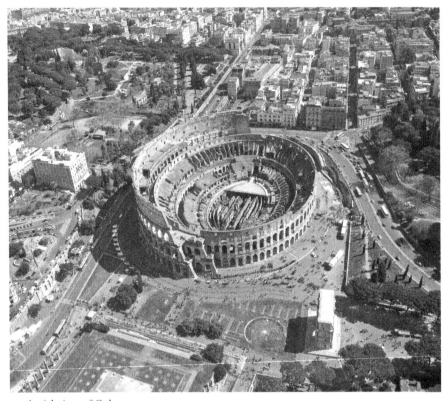

45. Aerial view of Colosseum.
Source: Photo: SF Photo/Shutterstock.

for Rome had been without a gladiatorial venue since Statilius Taurus' amphitheater had been lost in the fire, and symbolic, celebrating the victory of conservative Roman values over Nero's excesses. By now the building type was well represented around the Roman West, but this structure – we call it the Colosseum – was conceived on an unprecedented scale. Seating some 50,000 spectators, it was the largest amphitheater ever built in antiquity. Its 80 radial and 11 circumferential corridors, stacked in multiple tiers toward the exterior, hosted a bewildering aggregation of stair and vaulting schemes made possible by concrete technology. Pressurized drinking fountains were installed up to the third tier, and water-flushed latrines may have served the aristocratic sections. But the building's outer façade was sober and old-fashioned, its three continuous stacked arcades of solid travertine surmounted by a towering attic. The façade arches of the second and third tier framed statues. The arena was inaugurated in 80 by Vespasian's son and successor, Titus, with spectacular games around the city culminating in events at the amphitheater itself, including a miniature naval battle. Sober and overpowering, the Colosseum marked an ideological corrective to Nero's flamboyant aestheticism.

BIBLIOGRAPHY

Albers 2013; Albers et al. 2008; Ashby 1935; Ball 2003; Castagnoli 1992; Closs 2013; Coarelli 2007a; Cozza/Tucci 2006; Darwall-Smith 1996; Dyson 2010; Evans 1994; Gabucci/Coarelli 2001; Krause 2004; Lancaster 2005; Liverani 1999; MacDonald 1982; Newbold 1974; Priester 2002; Rubin 2004; Taylor 2000, 2002; Tomei/Liverani 2005; Ward-Perkins 1981; Welch 2007.

EIGHT

REMAKING ROME'S PUBLIC CORE: I

T HE NAME "COLOSSEUM" IS OF MEDIEVAL ORIGIN, REFERRING SIMPLY TO
the amphitheater by the Colossus – a towering gilded bronze statue,
more than 30 meters high, of Sol, the sun god. Originally erected farther
west, in an entrance court of the Domus Aurea, it began as a nude portrait
statue of Nero. This identity could not be allowed to stand, and probably under
Vespasian (69–79) it acquired the more generic features of Sol. Yet Sol was an
exotic import with little devotional value in Italy. Evidently the statue was
saved because it was an object of awe – a monument worthy of the *caput
mundi*, the head of the world, supplanting the long-collapsed colossal sun god
of Rhodes among the world's wonders. Hadrian later had it moved at great
expense to its place near the amphitheater.

Founder of the new Flavian dynasty, Vespasian confronted a delicate ideo-
logical task. It was not enough to put a new face on a statue; the city itself
needed somehow to shed its Neronian identity without needlessly destroy-
ing Nero's genuine achievements. The amphitheater was a hedge of sorts.
Its introduction constituted a symbolic erasure and emendation, but it was
also a building of high public value replacing an inessential amenity. Another
monument nearby, the baths later completed by his son, Titus, who would
succeed Vespasian as emperor (79–81), also contributed to this campaign. The
baths occupied a decommissioned sector of the Domus Aurea, yet they were
consciously modeled on Nero's splendid prototype in the Campus Martius.
Their most original feature was a gargantuan covered stairway thrust out from

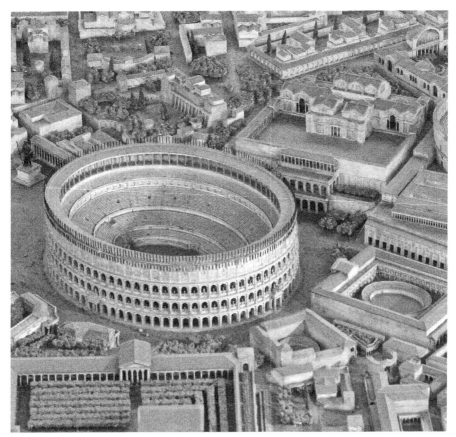

46. Model of ancient Rome, Baths of Titus and Colosseum.
Source: Museo della Civiltà Romana.

the slope almost up against the Colosseum (Fig. 46). Broad and hulking, it was a veritable cartoon of public accessibility, like the monument to Vittorio Emanuele II on the Capitoline Hill today. Whether or not inspired by some precedent, it was clearly intended as an ostentatious declaration: this place benefits and belongs to everyone.

Vespasian's priority was to break with Nero's cult of personality while emphasizing the continuity of traditional institutions in Rome. In the heart of the city, he achieved this with projects at opposite extremes of the Forum valley. The most urgent task lay at the northwest end, on the summit of the Capitoline Hill. Nero's downfall had led to a fierce war of succession that took to the streets in December 69. During an intense battle on the Capitoline between the Flavians and forces of Vitellius, the Capitolium was torched. This temple, the head of Rome's metaphorical body both in name and in religious significance, was so important in the life of Rome that in June 70, even before an unchallenged succession was certain, the Senate pledged to rebuild it. Vespasian soon co-opted the task with all the customary resources available

to earlier emperors. Religious scruple required that it be reerected on precisely the plan of the original, just like its Sullan predecessor. Even the tiny ancient open-air shrine of Terminus, the single god who shared this sanctuary with the Capitoline triad, was carefully restored on one side.

At the southeast end of the valley, overlooking the Colosseum, had emerged an enormous rectangular platform on the brow of the Caelian Hill. Here Agrippina, mother of Nero and last wife of Claudius, had commissioned a temple to her deceased husband early in Nero's reign. Having no more stomach for this project than for Claudius himself, Nero had abandoned it after the fire. Yet Claudius' deified status could not be denied; he was the only emperor since Augustus to have been granted this posthumous distinction by the Senate. Even Nero acknowledged this, but it was up to Vespasian to act. As with the Temple of Jupiter, he seized on a senatorial decision in order to consolidate his authority and legitimacy. This project too was a hedge, providing reassuring continuity in an unsettled time. The Flavian emperor legitimized the former dynasty while implicitly shaming its final prodigal son: Nero could not even be bothered to give the gods their due.

The Flavian ideological program in Rome was centered on the Jewish War, which was over even before Vespasian arrived in mid-70 to consolidate his status as emperor. That savage conflict culminated in Titus' destruction of Jerusalem and its famous temple. In April 71, father and son celebrated a spectacular triumph in Rome (see Figs. 35, 37). On parade with the booty and captives there were enormous, richly framed tableaux representing scenes of the war. At this moment the Jews must have seemed a particularly dangerous enemy within. Thousands of them lived in Rome (most in the Transtiberim) and like Diaspora Jews everywhere, they had customarily sent an annual contribution to Jerusalem to maintain the very temple that Titus had just annihilated. All professed Jews were now forced to divert their tithe to the rebuilding effort of the Capitoline temple, and those in Rome faced the added humiliation of seeing the most cherished treasures of their holiest shrine displayed as war spoils.

The intimidating stagecraft of domination having achieved its objective, the golden treasures of Jerusalem were soon put on display in a third "imperial forum," Vespasian's new Templum Pacis (Sanctuary of Peace), a place that otherwise seems to have avoided direct reference to the conquest (Figs. 47, 48). Oriented to the existing fora of Caesar and Augustus, but not directly attached to either, it probably occupied the site of the old Macellum, or central market, whose operations had moved elsewhere under the Julio-Claudians. Unlike the other civic fora, this had a subdued, contemplative atmosphere. Parallel reflecting pools lined with rose bushes enlivened its central courtyard. The complex was studded with Greek masterpieces of painting and sculpture, many removed from Nero's Domus Aurea; one author characterizes the place as an incomparable museum of world treasures. A broad, unpaved central esplanade led to the colossal façade of the Temple of Pax centered on the southeast side, within

47. Reconstruction of Templum Pacis with central garden.
Source: Courtesy of R. Meneghini/Inklink.

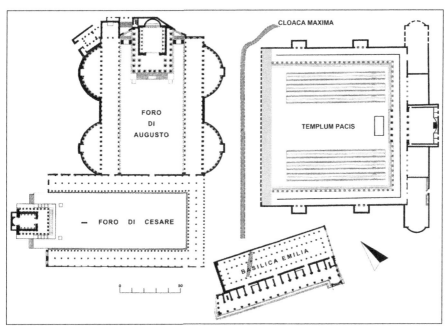

48. Plan of first three imperial fora.
Source: Courtesy of R. Meneghini.

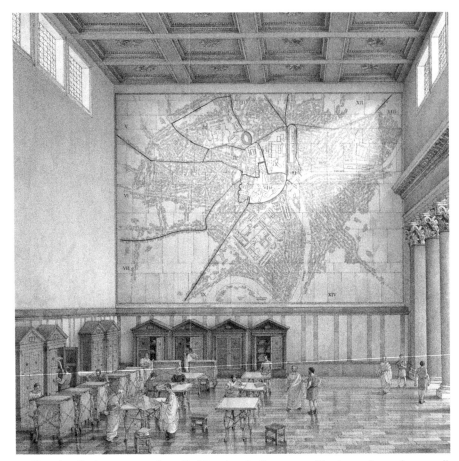

49. Templum Pacis, reconstruction of hall bearing the Severan marble plan on its southwest wall. *Source*: Courtesy of R. Meneghini/Inklink.

which the great statue of the goddess sat fully visible. This unenclosed space was more a monumental recess than a traditional temple. As such it was a suitable centerpiece for the library established within the complex, which became famous for its holdings in philosophy and medicine. In the southernmost of a series of halls flanking the temple were probably headquartered the geographic archives of the city prefecture. Mounted on one wall was, we presume, the first edition of a celebrated marble plan of the city of Rome (Fig. 49). Nearly 1,200 fragments of a revised version from about 205 C.E. have been found fallen from the wall. Oriented with the southeast upward, this city map seems to have cropped Nero's Vatican neighborhood out of its margins.

Lacking a continuously paved court and an attic above its colonnade, the Templum Pacis most resembled a large domestic garden – the sort of place that invited serene retreat. The architecture, artworks, and greenery encouraged visitors to stroll along the U-shaped peristyle in a cyclical, contemplative manner. Thematically, it may have evoked both the Garden of Epicurus and

50. Forum of Nerva with remains of Temple of Minerva shortly before it was dismantled. *Source*: Dupérac 1575. Courtesy of American Academy in Rome.

the Stoa Poikile at Athens. These places (the first a private refuge, the second a public colonnaded art gallery) were the respective birthplaces of Epicureanism and Stoicism, the dominant philosophical schools of the Roman aristocracy. Whether "soft" or "hard" in aspect, the early Flavian monuments reflected the duality of Roman culture itself. Severally they made a display of rendering private Neronian assets (an artificial pond, inessential branches of the palace, a Greek art collection) to the public, while signaling the new regime's strength, competence, and conservatism.

Domitian, the third and last of the Flavians (81–96), was nothing if not grandiose. His penchant for building schemes received an enormous boost even before his accession when a great fire swept through Rome in the spring of 80. Within a year and a half, his older brother, Titus, was dead and he was emperor. He commenced rebuilding Rome on a Neronian scale.

Not content with his father's Templum Pacis, Domitian developed the narrow zone between it and the Forum of Augustus into yet another imperial forum with a dominant, axial temple, this one celebrating his divine protectress Minerva (Fig. 50). In almost every way it contrasted with its predecessor. One was a still basin of reflection, the other a river of foot traffic. Built directly over an important artery running southwest to the Forum Romanum, this precinct – appropriately called the Forum Transitorium – did not try to mask its function as a glorified street. There was no peristyle, only a false colonnade down each side, the symmetry made possible by demolishing one of the lesser exedras of the Forum of Augustus. A visitor could pause to appreciate the rich Minerva-themed attic reliefs, but the gateway at the other end always beckoned. One might gawk at the shrine of a four-faced Janus in the middle, but a

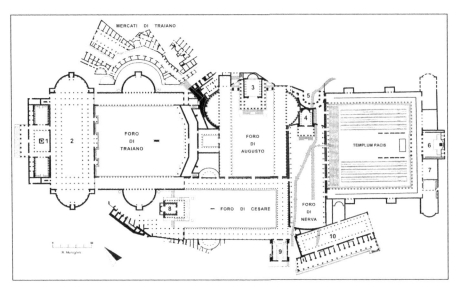

51. Plan of the five imperial fora.
Source: Courtesy of R. Meneghini.

single focal point, the temple at the northeast end, suited the fundamental sim-
plicity of the place. Like many of Domitian's projects, the forum was not com-
pleted before his death, and thus it acquired the name of an anti-Domitianic
successor. It is often called the Forum of Nerva, who completed it during his
brief reign (96–98).

Domitian was concurrently working on the fifth imperial forum, later
appropriated by Trajan (98–117; Fig. 51). The fire of 80 had damaged the
Forum of Caesar and probably had put additional land to the north at his dis-
posal. With the seemingly insatiable imperial appetite to expand civic space
in the urban core, level ground was growing scarce in this quarter. Part of the
Quirinal Hill was simply excavated away to prepare for the largest forum yet,
on the same orthogonal grid as the others. We cannot know specifically what
Domitian intended by this project or how far it had progressed by his death.
It seems to have advanced well beyond excavation, itself a task so prodigious
that the Column of Trajan later served explicitly as a public measuring rod to
approximate the 30 vertical meters of earth excavated from the Quirinal Hill
on the north side of the precinct (Fig. 52). As that column attests – its inscrip-
tion dates to 18 May 113, customarily understood as the time of the forum's
general dedication – Domitian's and then Nerva's successor, Trajan, inherited
the project and turned it to his own advantage.

The completed Forum of Trajan was ideologically the most single-minded
of the imperial fora. Everywhere was the imagery of conquest celebrating
Trajan's two Dacian Wars waged between 101 and 106. The new complex bor-
rowed ideas from its predecessors and introduced some of its own. At the

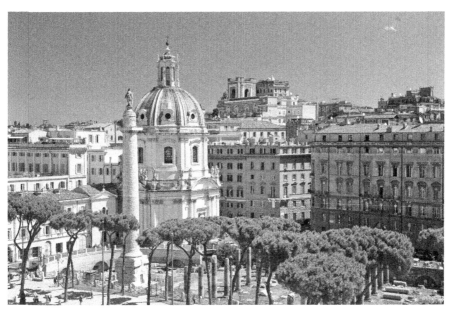

52. View of Column of Trajan with Quirinal Hill in background.
Source: Photo: Mikadun/Shutterstock.

southeast end, it was entered from the Forum of Augustus through a small
colonnaded forecourt, necessitating the destruction of the earlier forum's sec-
ond lesser exedra. This unique arrangement masked the irregular gap between
the two precincts. Taking a theme from its neighbor, the paved main square
featured a pair of opposing hemicycles on its long sides and carried a similar
attic with supporting figures, in this case, captured Dacians alternating with
portrait busts or martial reliefs (Fig. 53). The two hemicycles were repeated to
the northwest as the terminal apses of a gigantic transverse basilica: another
singular feature. Beyond the basilica was a small court flanked by rectangular
libraries. Rising at its center was the freestanding Column of Trajan, its snowy
marble exquisitely carved with a spiral relief, enhanced with paint, narrating
the two Dacian campaigns visually. To the northwest, in a configuration that
is still debated, a temple dedicated to the divine Trajan was completed after his
death. Several colossal granite column shafts have been unearthed here, gener-
ally but not universally thought to belong to the temple.

The forum's overpowering martial propaganda should not blind us to its
more interesting cultural dimensions. The Column of Trajan, though unique
in many ways, followed a long Greek and Italian tradition of memorializing a
divinized hero with a freestanding column. When Trajan died and was declared
a god by the Senate, his ashes were enshrined in the column base; probably
a statue of him already surmounted the Doric capital. Associating founding
heroes with learning was an old tradition. Plato's Academy was established
at a hero shrine on the outskirts of Athens, the grove of Akademos. At the

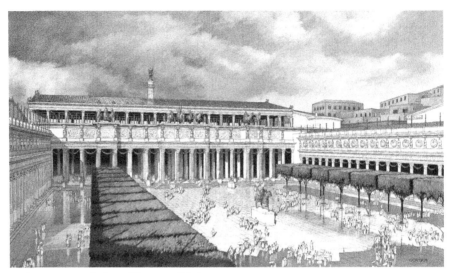

53. Reconstructed view of Forum of Trajan.
Source: Packer 1997. By permission of Gilbert Gorski.

54. Fragments of Severan marble plan showing Basilica Ulpia with [Atrium] Libertatis situated in one apse.
Source: Carettoni et al. 1960. Rome, Antiquarium Comunale.

tombs of notables, bench enclosures often evoked the seating arrangement at Greek gymnasia and philosophical schools. The idea of housing libraries here owes something to the Templum Pacis, but the proximate cause was the prior presence on the site of Rome's oldest public library and archive, the Atrium Libertatis, which may have been damaged in the fire of 80. This institution was reconfigured within the new forum, as the marble plan from the Templum Pacis' map room suggests (Fig. 54). Just as the goddess Peace was centered in an

apse at the Flavian forum, Liberty may have presided over the northeast apse of Trajan's basilica, the walls around her (perhaps) lined with scroll cabinets. The restoration of liberty after Domitian's troubled reign was a central theme for Nerva, who issued coinage representing the allegorical goddess. Naturally, he and his adopted son and successor Trajan would have seized on the preexisting symbolism of the Atrium Libertatis for their own ends. Some Romans would have recalled the incident long before when Clodius eradicated the Palatine home of Cicero, his bitter enemy, and replaced it (briefly) with a sanctuary of Libertas – an embodiment, in Clodius' thinking, of the anti-Cicero.

The imperial fora were multipurpose blends of urban beautification, propaganda, cultural enrichment, and civic or imperial administration. Several also served as archives or law courts. Yet their surprising proliferation in a single concentrated area is logical. Certain kinds of neighborhood-centered activities, such as regular worship and dining out, are best distributed widely around town. Others, such as art exhibitions, research, storage, government, and law, function well in clusters. The imperial fora specialized in cluster functions, which, compounded and concentrated over time, offered enduring urban improvements.

BIBLIOGRAPHY

Anderson 1984, 1985; Claridge 1993, 2007; Darwall-Smith 1996; Davies 2000; Dyson 2010; Hopkins/Beard 2005; Lancaster 1999; La Rocca 1995; *LTUR*, "Forum Nervae" (H. Bauer/C. Morselli); "Pax, Templum" (F. Coarelli); Meneghini 1991, 2002, 2009; Meneghini/Santangeli Valenzani 2007; Packer 1994, 1997, 2001, 2003, 2008; Panzram 2008; Rubin 2004; Rutledge 2012; Ungaro 2007.

NINE

REMAKING ROME'S PUBLIC CORE: II

T HE FIRE OF 80 CUT RIGHT ACROSS THE CITY'S MONUMENTAL CENTER FROM the Palatine Hill westward to the heart of the Campus Martius. The omission of secondary neighborhoods from admittedly sketchy surviving accounts may be merely prejudicial, but we can at least allow that Nero's residential building regulations did some good. Still, the list of high-value architectural casualties is long (Fig. 55). Titus had barely begun repairs before his death in September 81. The city's refashioning would belong to Domitian.

Domitian set about not just repairing or replacing, but augmenting. His architect, Rabirius, devised an entirely new scheme for the residential core of the palace on the southern and eastern Palatine, though we have no evidence that the fire touched this area. In its baroque intricacy and fecundity of volumetric ideas, with its banquet halls, baths, sunken gardens, and elaborate engagement with the Circus Maximus below, the palace became the new beacon of the Roman architectural revolution, outshining the fast-disappearing Domus Aurea (Fig. 56). Obsessively and redundantly, Domitian built monuments to his family: the temple of Vespasian and Titus and the Arch of Titus on the Forum; the Temple of the Flavian Family at his own birthplace on the Quirinal; and the Porticus Divorum, a large enclosure in the Campus Martius on the traditional site where the census was taken and soldiers were conscribed, again honoring his deified father and brother. Following long-standing custom, he was fond of anchoring memorials to events in the urban landscape.

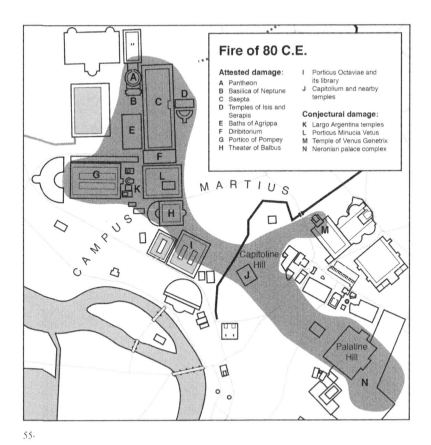

Fire of 80 C.E.

Attested damage:

A Pantheon
B Basilica of Neptune
C Saepta
D Temples of Isis and
 Serapis
E Baths of Agrippa
F Diribitorium
G Portico of Pompey
H Theater of Balbus

I Porticus Octaviae and
 its library
J Capitolium and nearby
 temples

Conjectural damage:

K Largo Argentina temples
L Porticus Minucia Vetus
M Temple of Venus Genetrix
N Neronian palace complex

55.

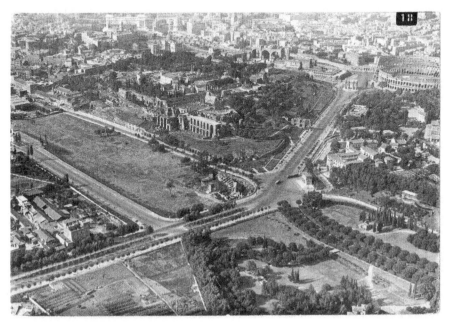

56. Aerial view of the Palatine Hill and Circus Maximus; Colosseum at far right.
Source: Aerofototeca AM,0,150 Prosp. 18.3.4650.0.

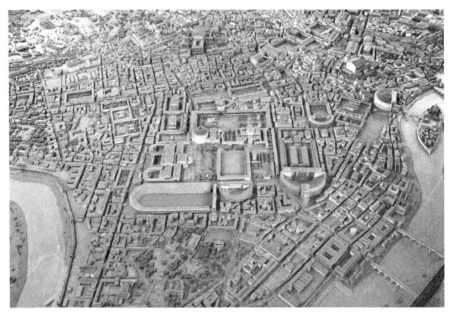

57. Model of ancient Rome: Campus Martius.
Source: Museo della Civiltà Romana.

If these dynastic monuments convey insecurity and megalomania in equal measure, Domitian can at least be excused for scrupulously appeasing the gods whose temples had been ravaged in Rome during his lifetime. In the city he dedicated another series of fixtures anchored in the landscape: "altars of the Fire of Nero," which had been vowed after 64 but never built. The inscription of one altar obliquely chastises Nero's negligence, implying that the fires of 69 and 80 resulted from his impiety. The emperor lavished special attention on Jupiter, whose temple – the Capitolium – had suffered from both calamities. Domitian's Capitolium was rebuilt with marble columns from Athens, and other shrines to Jupiter were erected or restored on the Capitoline and else-where. In 86 he established the Ludi Capitolini, Greek-style games dedicated to Jupiter Optimus Maximus. Nero had founded short-lived games in Rome, but without investing in permanent venues for the events. To accommo-date this Panhellenic-style quadrennial contest in athletics and performance, the monumental zone of the Campus Martius was expanded westward to include a stadium, within whose circuit the Piazza Navona lies today (Fig. 57). The Odeum, or covered theater, was added between it and the Theater of Pompey, their stages almost aligned. This pairing may have been modeled on the adjacent theater and *odeum* at Naples, the site of Italy's most prestigious Greek games, where Domitian himself won a prize in prose panegyric. East of the Odeum there now stood a tremendous peristyle enclosing a great swim-ming pool. Identified tentatively as the Gymnasium of Nero, companion to

58. Markets of Trajan.
Source: Photo: Leonid Andronov/Shutterstock.

that emperor's baths to the north, it seems to have subsumed the old Stagnum of Agrippa.

The Forum of Trajan, discussed in the last chapter, developed concurrently with the adjoining Markets of Trajan, also begun under Domitian. It was not enough for the imperial engineers to scoop away part of the Quirinal Hill to make a level floor for the forum. The hillside itself was encased in a cascade of innovative vaulted architecture lining several terraced streets along the contours of the terrain (Fig. 58). Today this hive of more than 150 rooms built of brick-faced concrete seems to be an integral extension of the imperial forum below, but that is an illusion. The two zones were virtually sequestered by the forum's perimeter street, a paved canyon lined with a tuff firewall on the forum side and the handsome brick-and-travertine façade of the markets on the other. Designed as a totality, the "markets" fit the modern concept of mixed-use development. Included within this complex were a few private houses, a residential *insula*, rows of shops or offices along the streets, a water distribution center, two semidomed auditoria, and the pièce de resistance on the north end: an enclosed mall vaulted in the manner of Nero's baths, but terraced and lined with rows of ample chambers at two levels (Fig. 59). A recent interpretation of this hall as the headquarters of the district fire brigade is unconvincing; the architecture is too daring and theatrical to suit the *vigiles*, whose known stations elsewhere in Rome and in Ostia are far more mundane. Yet the hall lacked adequate circulation for a public market and it even seems to have had guard posts outside. Either it was an exclusive boutique gallery, a

59. Great hall of Markets of Trajan.

wholesale market for luxury goods (spices, perhaps), or – less likely – an office building for high functionaries.

The consummation of this architectural golden age, however, was the remaking of the Pantheon (Fig. 60). The shape and extent of Agrippa's original temple remain unclear, but it certainly had a porch corresponding to its surviving successor, only broader; the outlines of its tuff and travertine perimeter were revealed by excavations in the 1890s, along with an older (Domitianic?) floor under the rotunda (Fig. 61). The fire of 80 did not destroy Agrippa's Pantheon altogether; thus Domitian was evidently satisfied to restore the existing building. But in 110 another fire, smaller but more intense, crippled the temple and its neighborhood irredeemably.

The Pantheon that rose from the ashes – in effect, the Pantheon as we know it – is still commonly attributed to Hadrian, the architect-emperor, but in fact its design and most of its construction occupied the final years of his predecessor Trajan. A giant coffered concrete dome springs from a thick cylindrical rotunda spanning 150 feet and fronted by a traditional temple façade, its foundations cutting through Agrippa's broad porch floor. To clear the way for the radial spray of ropes and pulleys needed to erect the dome's wooden formwork, fire-damaged surrounding buildings had to be cleared away and the porch superstructure built last. The new Pantheon rose up in solitude before the city closed in on it again.

The plan failed to anticipate one factor, which we will now present as a plausible hypothesis. Soil under heavy loads experiences a phenomenon called

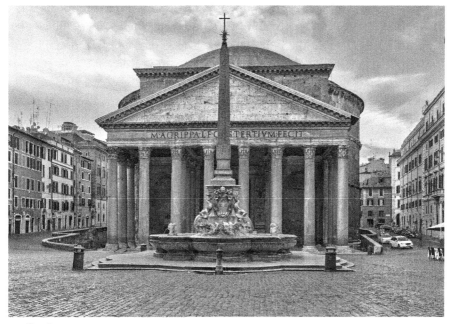

60. Pantheon.
Source: Photo: S. Borisov/Shutterstock.

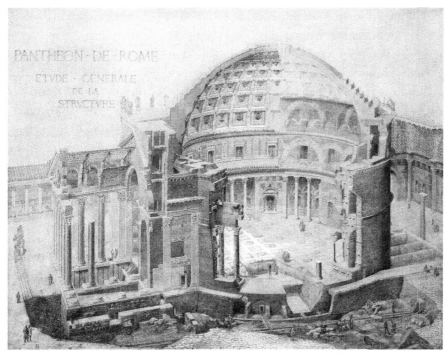

61. Analytical cutaway view of Pantheon by G. Chédanne from 1891 documenting excavations under porch and rotunda.
Source: © Beaux-Arts de Paris, Dist. RMN-Grand Palais/Art Resource, NY

surface vertical displacement: that is, as the load sinks into it, the surrounding earth rises. The phenomenon is most pronounced when soil combines high moisture content with low bulk density – the very conditions prevailing in the alluvial beds of the Campus Martius. Specifically, displacement is compounded when there are no countervailing loads. Just as one person sinks deeper into a mattress than two together, the new rotunda, whose foundations could not reach the remote bedrock, subsided deeper into the earth for lack of surrounding buildings, which had been cleared away. Fortunately the rotunda sank evenly, without tilting or distortion. But the old porch substructure, targeted for reuse to support multiple rows of 60-foot (or taller) columns weighing thousands of tons overall, pitched downward on the south, where it was now attached to the sinking rotunda. These conditions, compounded with the extraordinary challenge of tilting columns of this scale into position, extinguished all hope for the intended porch scheme. Deep concrete foundations for a smaller, lighter porch were cut down through the old substructure (see Fig. 61). By then, Hadrian (117–138) had succeeded Trajan and the management was evidently in a panic to finish. Forty-eight-foot columns were erected instead of the 60-plus-foot behemoths, 8 across the front rather than Agrippa's 10, and a chaotic pediment comprising a patchwork of modillion blocks scaled randomly to the larger and smaller schemes was thrown up above them, never to be corrected.

The urban identity of this neighborhood endured, but its physical character and architecture changed profoundly (Fig. 62). To the south, Agrippa's old Basilica of Neptune was reborn on the Neronian "imperial bath" pattern with a triple-cross-vaulted central nave; probably Agrippa's baths were reconfigured at this time too. The neighborhood lost some of its old permeability as large masses were piled one against the other, the Saepta abutting the Pantheon on the east, and the Basilica of Neptune annexed to the rotunda by an intermediate building. Northward, a clear but narrow view to the Mausoleum remained, framed by a rectangular forecourt with a triumphal arch in the center. As before, colossal statues of Agrippa and Augustus stood sentinel on the porch gazing toward the dynastic tumulus in the distance. The forecourt was already bordered on the west by the Baths of Nero. The east side was developed afresh, first with a sanctuary to Hadrian's deified mother-in-law, Matidia, and later with an adjoining temple to Hadrian himself.

While respecting the Pantheon's original reciprocity with the Mausoleum of Augustus, Hadrian created another axis of vision to the Pantheon from atop the Quirinal. On that hill's southwestern brow he founded the city's second temple to Serapis, an Egyptian patron god of the grain supply from Alexandria. Behind this Serapeum, part of which still towered over the city in the Renaissance, a multistory loggia descending the hillside faced the Pantheon to the west (Fig. 63; see Figs. 27, 57). Together the three monuments created

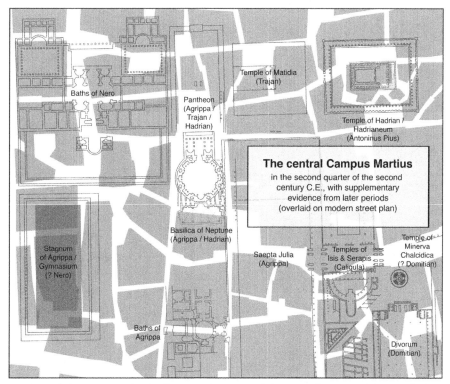

The central Campus Martius

in the second quarter of the second
century C.E., with supplementary
evidence from later periods
(overlaid on modern street plan)

62. Central Campus Martius in the second quarter of the second century C.E. (overlaid on modern street plan).

a right angle with the Pantheon at the elbow. A double stairway enclosed within the loggia descended from this vantage point down to the Campus Martius. This curious feature may have been inspired by the hilltop Serapeum at Alexandria, which had a famously long stair; another Italian Serapeum, at Pozzuoli, also sat atop a monumental axial ascent.

Serapis already had a temple, paired with that of Isis, in the Campus (the Iseum and Serapeum; see Fig. 62). New sentiment for the god sprang from Hadrian's attachment to Egypt and the resolution of a crisis afflicting the essential grain supply from the region. The strong visual axis emphasized his alignment of the foreign god with the Pantheon of traditional Roman gods he had recently completed on the plain below. The grain supply was the lifeline of the city's population. This temple, along with Hadrian's massive program of urban renewal at Ostia, was a beacon of its restored vitality. We know of no festivals or processions associated with the Serapeum, but its frontage on a large plaza to the east and the spectacular approach from the west betoken a lively ritual presence.

Like his predecessors, Hadrian added to the imperial residence on the Palatine Hill, but his interventions in the city's civic core were far from systemic. He completed the Column of Trajan and authorized the temple honoring that

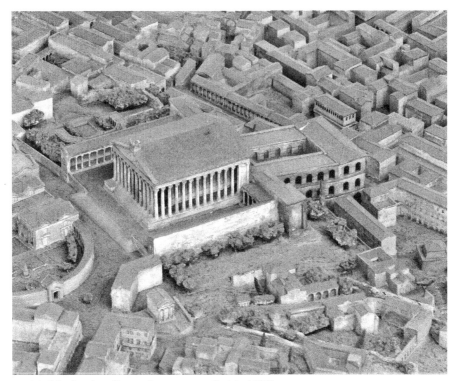

63. Model of ancient Rome: Serapeum on Quirinal Hill.
Source: Museo della Civiltà Romana.

emperor, newly deified, to its northwest. Audience halls and perhaps a library
were added west of the temple. His most significant contribution in the Forum
valley, however, was highly visible and continued the repurposing of the Domus
Aurea. This was a great temple positioned over the Neronian entrance vestibule
between the Palatine and the Oppian, where the Colossus stood. The statue
was removed to its final position by the amphitheater; a concrete platform,
roughly on axis with the Colosseum to the southeast, encased the vestibule.
Scaled to rival the Serapeum and the Capitolium, the new temple on this plat-
form had a particularly Greek appearance (Fig. 64). Uniquely for Rome, it was
fully bidirectional, having façades on both ends and back-to-back cult cham-
bers housing its two deities, Venus and Roma. Prominently situated along the
Sacra Via, it came to play a significant role in an old festival, renamed "Romaia"
in 121 and rededicated to the "Fortuna of the city of Rome" – that is, the city's
allegorical protectress (like the *tyche* of a Greek city), here presented in a mili-
tary guise. Venus was Hadrian's tutelary deity; selecting her as half of the divine
duo had both personal and political significance. In the early 130s he seeded a
rebellious Judaea with temples to this goddess; perhaps for this reason, she was
oriented eastward here. On Hadrian's coins, the epithet Felix, "fortunate," was
added to her name. So these two deities explicitly represent two sides of good
fortune: one aggressive, the other nurturing.

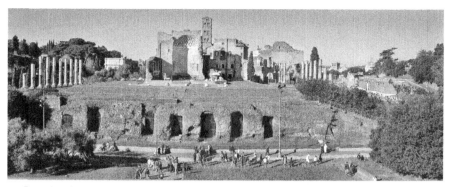

64. Temple of Venus and Roma.
Source: Photo: Ricardo André Frantz. Title: "Temple of Venus and Roma." Wikimedia
Commons/CC-BY-SA-2.5 (creativecommons.org/licenses/by-sa/2.5/). Converted to B&W.

Though absent from Rome for much of his career, Hadrian had a surpris-
ingly lively interest in its urban character. The temple's western half was the
first and only major cult center in the city dedicated to Roma. In her mili-
tarized, Minerva-like manner, Roma usually personified a broad construct of
empire, but here – specifically designated Roma Aeterna (Eternal Rome) on
Hadrian's coinage – she embodied the city itself: this was known explicitly as
the temple of the *urbs*. From her vantage point, the goddess had a direct view
up the old Forum to Eternal Rome's primordial places. The shrine of the city's
Penates (tutelary gods) stood nearby. The Romaia festival must have played an
important part in the city's symbolic life as it involved its many officials and
functionaries. The well-known Capitoline Base of 136, inscribed with a full
list of all the *vici* (neighborhoods) in the city, dedicated to Hadrian by their
magistrates, probably served this new cult of urban identity.

By Hadrian's time the opportunities seized by his predecessors to build new
monuments in the city's core were largely exhausted. He and the Antonine
emperors would focus on funerary monuments in the periphery, some of them
on the fringes of our hypothesized Neronian *insula* neighborhoods. One of
several features from which we can extrapolate the post-64 urban grid in the
Vatican is the mausoleum Hadrian built on the riverfront there with an axial
bridge offering a promenade to it, the Pons Aelius (Fig. 65). Altar precincts
and honorific columns of his successors appeared in the lightly developed sec-
tor of the Campus Martius west of the *insula* district along Via Lata/Flaminia
and south of Augustus' sundial (see Fig. 57). The Forum meanwhile acquired a
single new temple honoring the deified empress Faustina the Elder (d. 140) –
after which, for half a century, the city's creative pulse slowed.

BIBLIOGRAPHY

Albers 2013; Anderson 1984, 1985; André et al. 2004; Boatwright 1987; Darwall-
Smith 1996; Davies 2000; Davies/Hemsoll/Wilson Jones 1987; Dyson 2010;

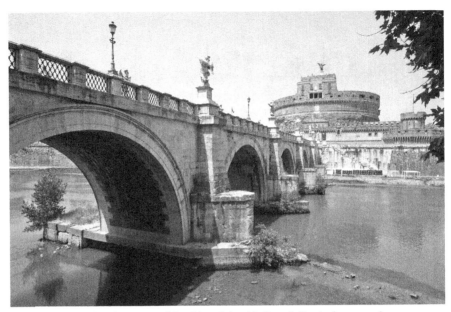

65. Mausoleum of Hadrian (Castel Sant'Angelo), with Pons Aelius in foreground.

Egidi 2010; Filippi 2010; Grasshoff/Heinzelmann/Wäffler 2009; Haselberger 1995; Hetland 2007; Jacobs/Conlin 2014; Lancaster 1998; MacDonald 1976, 1982; Marder/Wilson Jones 2015; Meneghini 2009; Richardson 1976; Rubin 2004; Rutledge 2012; Taylor 2000, 2003, 2004; Zanker 2004.

TEN

CRISIS AND CONTINUITY

THE QUIET REIGN OF FAUSTINA'S HUSBAND, ANTONINUS PIUS (138–161), HAS been characterized, rightly or wrongly, as an Elysium of stability and prosperity. That of his adopted successor, Marcus Aurelius (161–180), troubled by pandemics, barbarian invasions, and economic difficulties, epitomizes crisis and reaction. Yet at Rome, evidence of this contrast – whether drawn from historical accounts, cemetery data, building projects, or inscriptions – is mostly invisible. Under these two Antonine rulers the city suffered few discernible systemic difficulties. Pius built sparingly – his most famous works were temples, one for the deified Hadrian in the Campus Martius and one for his deified wife, and ultimately for himself, on the Forum. Marcus and his son and coemperor Commodus (177–192) built even less; but inscriptions throughout their successive reigns signal a fairly healthy and robust city life. That is not to say that decline did not occur; we simply cannot detect it. And while it is true that Rome was propped up economically with subsidies and other artificial inducements, it would be naïve to presume that a notorious plague that ravaged the empire between about 165 and 180 took no toll here. Nevertheless, the great age of urban expansion was over. Rome would again witness bursts of urban creativity and renewal, but those episodes gradually devolved into a zero-sum game of certain finite physical resources such as water, marble, and granite. By the early fourth century few monumental structures were built without ransacking others.

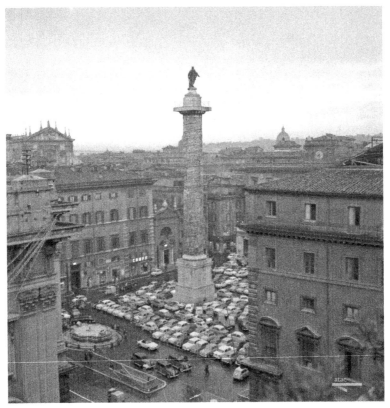

66. Piazza Colonna ca. 1960 with Column of Marcus Aurelius.
Source: Archivio Storico Fotografico ATAC STP 7057.

Some imperial marble quarries were closed during the plague, but the marble yards at Portus and Rome may have been adequately stocked to cushion the blow. Indices of a falloff in building activity we have in abundance: fewer new buildings, fewer dated brick stamps, no new aqueducts for a century after 109. A Trajanic river wharf at the Emporium specializing in building stone seems to have been derelict by the century's end (see Fig. 89). None of these things remotely signals urban decline; Rome had simply reached a saturation point of development. Not coincidentally, for eight decades after 110 there were no citywide fires to whet an emperor's appetite for intervention. It was an appropriate time to take stock. Around 175 or shortly thereafter, Marcus and Commodus expanded the old customs boundary established a century earlier to align it more with Rome's built-up area (see Chapter 13). This circuit was well outside the Servian Wall and must have been enforced at checkpoints on all the highways entering the city. Their most significant joint contribution to the monumental city was the Column of Marcus Aurelius, centered on a broad plaza near the confluence of Via Lata and Via Flaminia (Fig. 66). Depicting on its spiral frieze Marcus' Danubian wars with a forthright brutality exceeding

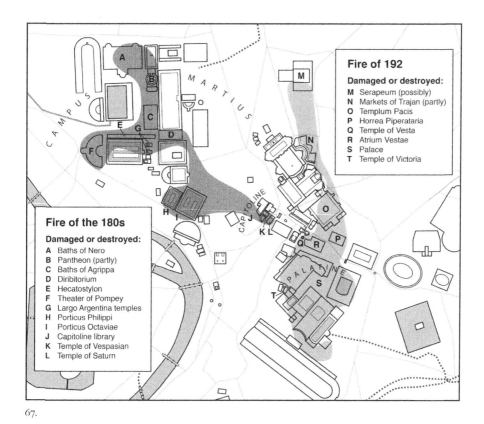

Fire of 192

Damaged or destroyed:
M Serapeum (possibly)
N Markets of Trajan (partly)
O Templum Pacis
P Horrea Piperataria
Q Temple of Vesta
R Atrium Vestae
S Palace
T Temple of Victoria

Fire of the 180s

Damaged or destroyed:
A Baths of Nero
B Pantheon (partly)
C Baths of Agrippa
D Diribitorium
E Hecatostylon
F Theater of Pompey
G Largo Argentina temples
H Porticus Philippi
I Porticus Octaviae
J Capitoline library
K Temple of Vespasian
L Temple of Saturn

67.

even its prototype, the Column of Trajan, it loomed as an uneasy beacon against a new darkness settling on Roman imperium.

The final Antonine emperor, Commodus (180–192), continued as sole emperor after his father's death. His rule, characterized by a turbulence not seen in more than a century, witnessed two large urban fires in short succession (Fig. 67). The first, sometime in the late 180s, burned an area from the western Forum over the Capitoline Hill, destroying its library, and into the Campus Martius as far as the Pantheon. The second, in 192, probably started on the Quirinal above the Markets of Trajan and swept southward. Rebuffed by the northeasterly firebreaks of the fora of Trajan and Augustus, it surged east and south through the lower Forum. Though less famous than its predecessors, this blaze may yet have wreaked the greatest cultural destruction. As under Nero and Titus, the Palatine was consumed; more significantly, its famous library, as well as the one at the nearby Domus Tiberiana, were incinerated. The Atrium and Temple of Vesta succumbed; so did Vespasian's Templum Pacis along with its art treasures and its two libraries. The psychic and cultural calamity of losing several great libraries and archives was far greater than the physical scope of the fires themselves. Galen, the renowned medical theorist and former personal physician of the coemperors, bitterly lamented his losses from the fire,

especially his irreplaceable personal library. Like others, he had entrusted his books and papers to the supposedly fireproof Horrea Piperataria, a famous depot for expensive imported spices. But to his fellow victims' horror, everything was lost:

> They justified their confidence on the grounds that [the structures] were not made of wood, save for the doors, they were not near any private house, and they were under military guard because the archives of four imperial procurators were kept there. And this is precisely why we paid a higher charge for renting the rooms in those warehouses, and stored our important possessions there in confidence [transl. Nicholls].

Arguably, the absence of similar conflagrations over the preceding generations was owed to effective prevention. Ostia, the vulnerable chokepoint for an immense volume of imports destined for Rome, had also been remodeled in the second century to a meticulous fire code to protect its valuable stores. It was now a city of brick and concrete, with double walls between newer properties and a fire brigade rotated in from Rome. To all appearances, the results paid off. But Rome's vast size and concentration of cultural treasures made it more vulnerable. Even the *vigiles* could not always stop a firestorm before it started.

Commodus' reign was politically chaotic; gradually he descended into delusion and megalomania, personally competing in blood sports and refashioning the Colossus of Nero in his own image, now bearing Hercules' attributes. He was assassinated in December 192 and there followed a measure of disarray not seen since the death of Nero. When Septimius Severus – the fifth man to be proclaimed emperor in a single year – marched into Rome in June 193, it was a crippled and sullen place, prostrated by flames, exhausted by mismanagement and bitter political warfare. But like Vespasian before him, who also had returned from abroad to seize the reins of state after a civil war of succession, Septimius (193–211) saw opportunity in the ashes. Something of a senatorial outsider – he was an African of Punic descent – he restocked the palace and the Praetorian Guard with his own loyalists and initiated a program of urban renewal. The infrastructure supporting Rome's water and food supplies was robust. What it lacked was adequate provision to combat corruption. Private grain hoarding by powerful ministers for personal profit was a sporadic problem, and in 190 it had even led to famine; an embarrassed Commodus had responded by executing a bevy of conspirators, real and purported. But no structural remedy ensued.

Now, after two fires, water was still arriving in its accustomed abundance but often with nowhere to go because parts of its distribution network were crippled by the fire damage. Septimius saw in these two seemingly unrelated conditions an opportunity to centralize both operations in a novel way – by

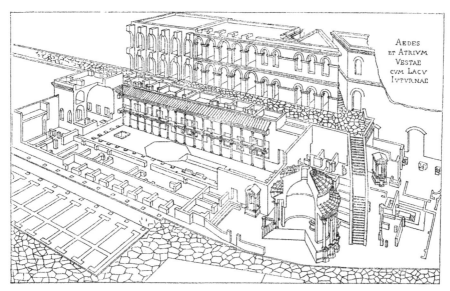

68. Reconstruction of late-imperial Atrium Vestae.
Source: Hülsen 1905.

putting the office of water commissioner in charge of grain storage and distri-
bution. What enabled this new *curator aquarum et Miniciae* to expand his over-
sight was a device that had been used elsewhere, but never before in Rome: the
aqueduct-powered flour mill. A single aqueduct was chosen for the task: the
Aqua Traiana, introduced by Trajan from the west in 109 C.E. Beginning at
the crest of the Janiculum Hill, a chain of compound mills was built astride the
fast-descending conduit. One of them, attached to a segment of the Traiana
running directly under the American Academy in Rome, was excavated and
published in the 1990s. Henceforth the old monthly grain dole (*frumentationes*)
would be distributed as flour at more frequent intervals. Because flour is much
more perishable than grain, Septimius' strategy was to mill the grain soon upon
its arrival at Rome, thereby minimizing the opportunity for seasonal hoarding.
As a bonus this policy boosted the fortunes of his fellow Africans. They, along
with Egypt, provided most of Rome's imported grain. His compatriots got a
further boost when Septimius instituted a public dole of olive oil, much of it
imported from his native Tripolitania.

Septimius' other great urban project, naturally, was rebuilding. The city's
damaged cultural patrimony never recovered from the loss of some of its
greatest libraries, but over the next decade and a half the physical fabric was
refreshed. The Pantheon was restored. Septimius refurbished Domitian's pal-
ace complex and appended to it a new southern wing overlooking the Circus
Maximus (see Fig. 56). To the north, he rebuilt the Atrium Vestae and its cylin-
drical temple (Fig. 68). And Vespasian's Templum Pacis rose again on its old
foundations, now displaying an updated version of the Flavian marble city plan

69. Reconstruction of Septizodium.
Source: C. Hülsen, *Das Septizonium des Septimius Severus* (Berlin 1886).

(see Fig. 49) – the emperor's public covenant, if you will, of his commitment
to the city's restoration.

In 202, down the Palatine slope from his new palace wing, Septimius
dedicated a monument that appears prominently on his marble plan: the
Septizodium, a gigantic theaterlike fountain facing southeast down Via Appia
(Fig. 69). Dedicated to the seven planetary gods, this kind of monument was
unprecedented in Rome but familiar in his native Africa; so there may be
truth in Septimius' ancient biography, which saw in it a greeting to his fellow
Africans arriving from the south. It formed the garish visual terminus of the
city's most famous highway and the anchor of a significant building program
that included new bathing facilities on each side of this approach: the Severan
Baths on the right, and on the left the colossal complex, closely modeled on
the Baths of Trajan, that would be dedicated by Septimius's son and successor
Caracalla (198–217; Fig. 70). To serve them, the nearby Caelian Hill branch of
the Aqua Claudia was refurbished and the Aqua Marcia augmented.

The Baths of Caracalla were so massive and opulent – alone they consumed
a new branch of the Aqua Marcia – that they perceptibly checked the powerful
crosstown pull of the Campus Martius on Rome's center of gravity. Something
like a neighborhood master plan was reaching its conclusion here in the south-
east, though only its monumental strip on a new street paralleling Via Appia
comes into focus. We conjecture that the strip anchored a well-appointed resi-
dential quarter developed in a sparsely inhabited part of town to accommodate
the many courtiers of the Severan dynasty lacking roots in Rome. It is unimagi-
nable that two sprawling, confronting bathing complexes arose only 15 years
apart purely to meet existing demand, either local or transient. In effect, the
baths created the demand. By so doing, they helped to create the neighborhood.

The brief reign of Elagabalus (218–222) was followed by that of Alexander
Severus (222–235). This emperor's interest in Rome took the form of significant

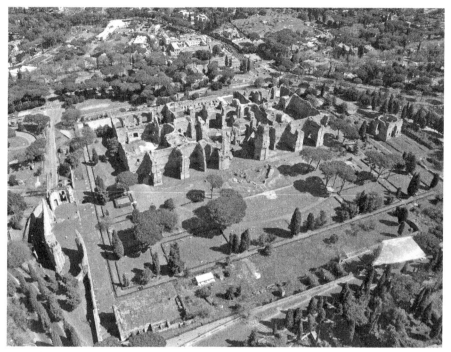

70. Baths of Caracalla.
Source: Photo: SF Photo/Shutterstock.

restorations or expansions, most notably of the Circus Maximus, Theater of
Marcellus, Colosseum, and Stadium of Domitian. His most significant monu-
ment was a massive reconfiguration of the Baths of Nero, now with an entirely
new aqueduct. But like Septimius before him, Alexander gave special atten-
tion to the food supply, building public warehouses in every *regio* of the city.
As authority over food grew more centralized, the distribution system became
ever more diffuse and flexible, a necessary condition for handling highly
perishable goods.

With the death of Alexander in 235, there began a half-century of empire-
wide crisis. This was the age of the soldier emperors: hard men facing the
hard job of stemming threats on the empire's borders and treachery in the
now-mobile imperial court and Praetorian Guard. Emperors were mostly
abroad and Rome suffered from their neglect. The sparse archaeological record
echoes the poor documentary sources for this period; sporadically we glimpse
a city in contraction despite a large and highly dependent population, its ser-
vices and infrastructure diminished though still intact. Urban events reported
from this period are mostly negative, such as the first systematic persecution of
Christians, ordered in absentia by the emperor Valerian in 257 and rescinded
after much bloodshed in 260 by his son, Gallienus.

Valerian's edict, like most others concerning the city's affairs, was enforced by
the Senate. Despite a depleted local aristocracy, this body carried on, providing

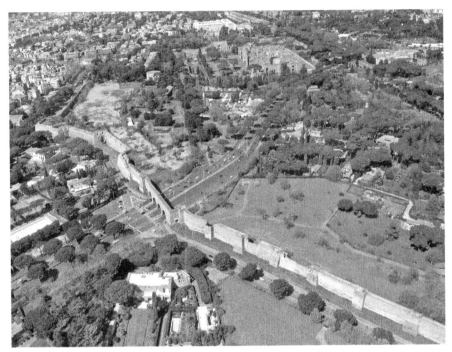

71. South sector of Aurelian Wall; Baths of Caracalla in background.
Source: Photo: SF Photo/Shutterstock.

magistrates to discharge civic duties as the emperor saw fit. Though capable
of police actions, the Senate lacked its traditional strength in benefaction and
the city suffered for it. Corruption was rampant; we glimpse it, for example,
in a bizarre revolt by the moneyers' guild on the Caelian Hill, evidently aris-
ing from fraud at the imperial mint, which reportedly left 7,000 dead in 270.
Taking Septimius Severus' policy to its logical conclusion, the emperor Aurelian
(270–275) replaced public distribution of flour with baked loaves. He modi-
fied another Severan policy, providing subsidized olive oil to the populace. And
most significantly, he did the same with wine, encouraging its production on
once-derelict properties around the region and then distributing the product
within the city at a reduced price. In later decades, this profitable enterprise –
the *vina fiscalia* – would help to fund public construction in Rome.

Money was tight everywhere and instability seemed an existential threat.
Quite apart from the unnerving radicalization of urban Christians at home,
the Rhine and Danube borders were growing porous. Numerous cities in
the Roman West may have built defensive circuits at this time. In 271, on
Aurelian's order, Rome marshaled its still-considerable resources to produce
its greatest monument of the century, a new city wall (Fig. 71). East of the
river, the Aurelian Wall remains largely intact today, an overwhelming pres-
ence to anyone entering or leaving the city by its roads. Made of brick-faced
concrete, it was initially 8 m high and fully 19 km long, ranging sometimes

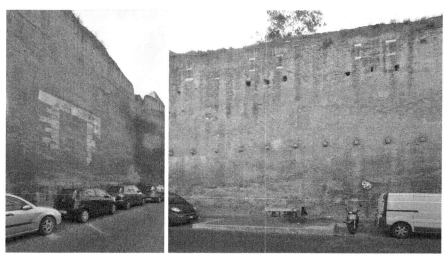

72. Sectors of Aurelian Wall along Via di Porta Labicana.

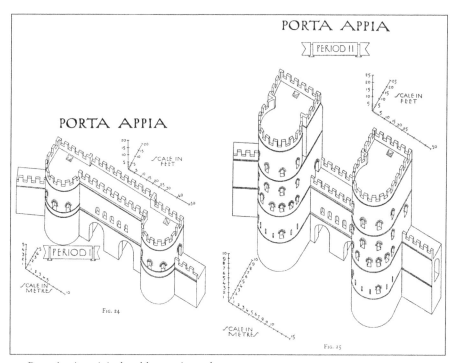

73. Porta Appia, original and late-antique phases.
Source: Richmond 1930.

well beyond the built-up area to enclose strategic heights and preexisting defenses such as the Praetorian camp in the northeast. Sporadically it barged through populous neighborhoods or cemetery districts, immuring their fabric within its own (Fig. 72). Where the wall met the river at its northern

and southern extremes it turned inward to follow the banks. The circuit was completed west of the river by a great triangular salient that ascended to Porta Aurelia atop the Janiculum. On the Tiber, two derelict bridges – the Pons Agrippae and Pons Neronianus – were moved to more protected positions within the wall's circuit and renamed. The city's great highways entered the wall at monumental gates flanked by semicircular turrets (Fig. 73); nearly as many lesser gates admitted smaller streets.

The utility of this immense, mostly civilian project extended well beyond its overtly defensive role. Through straitened times, it served notice to the world that Rome remained the center of power, majesty, and authority. The project boosted the regional economy, reviving brickmaking facilities and providing employment. Furthermore, it seems to have loosely followed the Antonine customs circuit. Enforcement of tariffs would now be much easier than before, and the enhanced income may have facilitated Aurelian's conversion of the public distribution of flour to bread.

BIBLIOGRAPHY

Albers et al. 2008; Ashby 1935; Boatwright 2010; Bruun 2003; Coarelli 1986, 1987; 1997a; Conway 2006; Daguet-Gagey 1997; DeLaine 1997; Dey 2011; Dyson 2010; Fant 2001; Fiocchi Nicolai 2009; Hoffmann/Wulf 2004; Hostetter/ Brandt 2009; Houston 2003; Liverani 2010; Lusnia 2004, 2014; Nicholls 2011; Palmer 1990; Palombi 1997; Richmond 1930; Royo 2001; Rubin 2004; Taylor 2000, 2010; Tucci 2008; Wilson 2001.

ELEVEN

RUS IN URBE: A GARDEN CITY

THE RELENTLESS HISTORICAL EMPHASIS ON ROME'S MASONRY CORE threatens to skew our understanding of the city's life. Arguably, ancient Rome's greatest urban investment was not in its streets and buildings, but in its staggering patrimony of cultivated greenspace. Two main types predominated: the formal peristyle garden and the more sprawling, less confined *horti*, commonly referenced in the plural, "gardens," to underscore their size and diversity. Both emerged roughly in parallel with the rise of luxury villas in the second and first centuries B.C.E.

The advent at Rome of the peristyle – a rectangular courtyard surrounded by an inner colonnade – dates to the Macedonian Wars of the second century B.C.E., when the Roman aristocracy was introduced firsthand to the Hellenistic aesthetic in the East. The earliest of these was the Porticus Octavia of 168 B.C.E. on the northeast side of the Circus Flaminius. The neighboring Porticus Metelli was added in 147 to enclose the existing temples of Juno Regina and Jupiter Stator. What we cannot say with any assurance is when gardens were introduced into either of these enclosures. The first was a sumptuous victory monument with bronze Corinthian capitals, but nothing is said about its plantings. The second served as a gallery for Greek sculpture, much of it war spoils; after later interventions, it appeared on the Severan marble plan – renamed the Porticus Octaviae (not to be confused with the nearly homonymous neighboring structure) because Augustus rededicated it to his

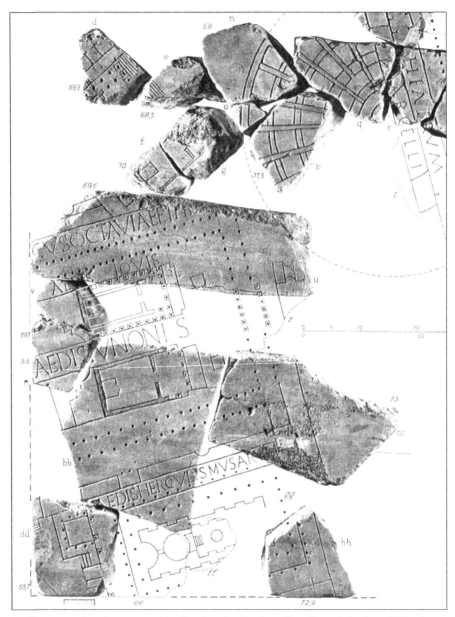

74. Fragments from Severan marble plan showing Porticus Octaviae and Porticus Philippi. *Source*: Carettoni et al. 1960. Rome, Antiquarium Comunale.

sister Octavia (Fig. 74). The two parallel temples within it adjoin fountains or planting beds placed in a curvilinear, symmetrical arrangement at the rear. But this flourish belongs to Septimius Severus' restoration after a fire in the 180s (see Chapter 10). In fact, Septimius' inscribed monumental entrance to the enclosure still stands, embedded in the church of Sant'Angelo in Pescheria. This complex also included a *schola*, a place for philosophic instruction, and a

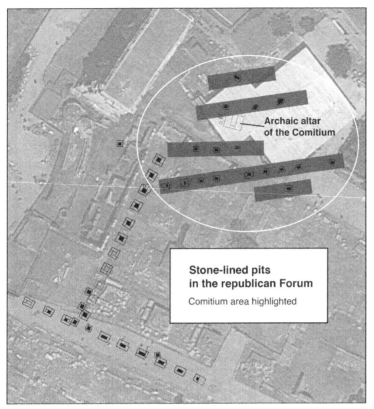

75. Diagram of known stone-lined pits highlighting possible grove in Comitium.
Source: Background map © 2014 Google.

curia, presumably to replace the one at Pompey's portico, which Augustus had
sealed off to expiate Caesar's murder.

The Porticus Metelli was a sanctuary: this fact is essential to understanding
its fashioning as a garden enclosure. The resident gods, Jupiter and Juno, were
often enshrined in groves. Wooded areas frequently accompanied temples in
Latium at this time; Rome itself had groves annexed to temples, most famously
that of Juno Lucina. While the Porticus Metelli was on the drawing board –
around 150 B.C.E. – the sanctuary of Juno at Gabii acquired a monumental
temple set within a U-shaped peristyle planted with ranks of trees, their plant-
ing pits cut into the bedrock. The Comitium at Rome had irregular rows of
pits perforating its republican pavement (Fig. 75). Though perplexing to many,
they strike us as the vestiges of a sacred grove, its trunks carefully sheathed in
stone as layers of paving accumulated around them. So the public peristyle
garden, soon to be a popular amenity even in private houses, probably began
its life in Rome through the traditional connection between sanctuaries and
trees. Strikingly, verdant plazas rarely took the name *forum*, a paved open space
with few plantings. Even the Templum Pacis, we note, is the only specimen of

76. Reconstruction view of Theater of Pompey from portico gardens as they may have appeared in late republic.
Source: Illustration by L. Cockerham Catalano. Courtesy of Kathryn Gleason.

the five so-called imperial fora to have been planted (with roses, probably) – and thus to have been called by a different name, one more befitting a garden sanctuary.

The most famous peristyle garden of late-republican Rome, the portico-theater complex of Pompey, also had the character of a sanctuary (Fig. 76). It was loosely inspired by hillside theater–sanctuaries like those at Gabii, Palestrina, and Tivoli. The entire precinct, including the great garden peristyle behind the stage building, alive with mythological sculpture and water play, may have been dedicated to Venus Victrix, whose temple was perched atop the theater on the western end. Its most prominent natural features were symmetrical rows of plane trees imported from the East: good shade trees, to be sure, but also sacred to the Persians, whose subjugation at Pompey's hands was a major theme of the complex. Rome's earliest peristyle garden, the Porticus Octavia, was rededicated in 29 B.C.E. as the Porticus Philippi. In this later adaptation, it was both a sanctuary, enclosing the older temple of Hercules Musarum, and a museum – literally so, since its attractions included statues of the nine Muses. On the Severan marble plan the courtyard featured an elaborate baroque parterre with fountains surrounding the circular temple (see Fig. 74). Around the perimeter, fronting the colonnade on all sides, was a border of trees or arbor posts.

The Porticus Philippi's near-contemporary, the Porticus Liviae, stood on the Oppian Hill (Figs. 24 (feature Y), 77). Dedicated in 7 B.C.E., it had no temple but was nonetheless deemed a sacred space dedicated to the empress Livia's patron goddess, Concordia. Preserved fragments of the Severan marble plan seem to represent its peristyle as a double colonnade, but the columns facing the courtyard probably supported an arbor instead, because by the Flavian

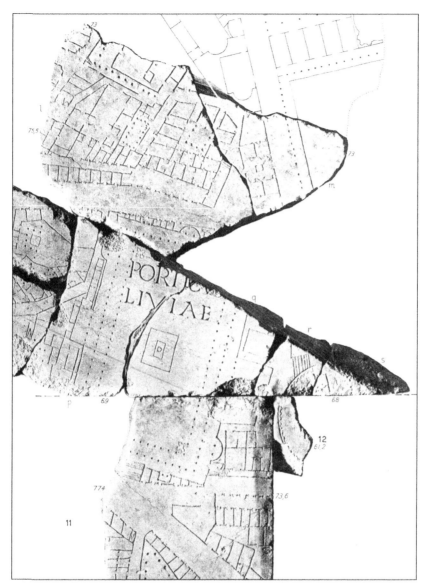

77. Fragments of Severan marble plan showing Porticus Liviae.
Source: Carettoni et al. 1960. Rome, Antiquarium Comunale.

period a single prodigious grapevine covered the entire portico. Fountains seem to have adorned the corners and center of the courtyard, but it may otherwise have been paved. Later peristyle gardens such as the Templum Pacis and the sanctuary of Elagabalus on a spur of the Palatine were paved, their planting beds or pits arranged in rows (Figs. 47, 78). The prevailing taste for symmetry, rectilinearity, and orthogonality in Roman gardens persisted over time, as several other fragments of the marble plan demonstrate: for example, the huge (36,000 m²) enclosure of the Temple of Deified Claudius on the Caelian,

78. Reconstructed garden in sanctuary of Elagabalus by J.-M. Gassend.
Source: Villedieu 2001. Courtesy of Soprintendenza Speciale per i Beni Archeologici di Roma.

with its nested U-shaped beds and paths, or the mysterious (and unlocated) Adonaea, with serried rows of beds flanking a reflecting pool, all surrounded by a pegboard pattern of trees or arbors (Fig. 79).

The earliest attested example of *horti*, those of Scipio Africanus in the north-eastern Campus Martius, enters the record in 163 B.C.E. The idea of *horti*, like that of the peristyle courtyard, seems to merge local circumstances with ideas arriving from the East in the same century: the leafy suburbs of Athens or Alexandria, with their evocative tomb-gardens and cultural centers along major approaches; but also, by way of the Hellenistic rulers, the Near Eastern *paradeisos:* a big enclosed hunting park adjoining a palace. Rome's *horti* were probably fenced, but their degree of accessibility would have varied greatly, as it does in the city today. (Compare the mostly open Pincian Gardens to the cloistered Villa de' Medici nearby.) Perhaps we can even trust Horace's parody of a coven of late-night necromancers who freely haunted the brand-new Horti Maecenatis on the Esquiline: its owner Maecenas, a powerful associate of Augustus, had appropriated a vast paupers' cemetery and laid out his splendid park over it. For all their amenities, gardens and parks were (and are) a potential source of mischief – that fact is a central premise of the *Priapea*, a collection of satiric Latin poems purportedly dictated by Priapus, the phallic god entrusted with the protection of gardens. But Priapus' existential anxiety could

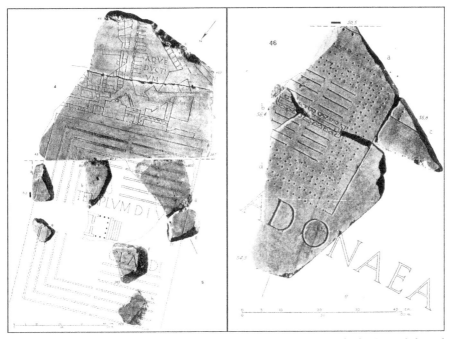

79. Fragments of Severan marble plan: Aqueductium with gardens of Claudium (left) and Adonaea (right).
Source: Carettoni et al. 1960. Rome, Antiquarium Comunale.

also reflect another very real phenomenon of the late republic: the disintegration of Rome's agricultural self-sufficiency as *horti* gobbled up innumerable small suburban market gardens and yeoman farms.

The word *horti*, meaning originally just "garden plots," was sometimes interchangeable with *nemus* or *lucus*, referring to the groves habitually included in gardens. Early Rome had many named groves, some sacred to gods – Camenae, Furrina, Juno Lucina, Venus Libitina, Stimula. But *horti* were not sanctuaries; they were more like leisure villas with a residential core, their greenery punctuated by pavilions, water features, art galleries, tombs, and the occasional temple. By the mid-first century B.C.E., Rome was enveloped in them. Some breached the *pomerium* and a few nested just within the Servian Walls, but most were outside both (Fig. 80). Initially, owning one was the prerogative of men who had distinguished themselves in the public or martial sphere such as Scipio Africanus and his son Aemilianus, the trendsetters in the Campus Martius; naturally, then, *horti* functioned simultaneously as elite retreats and public signifiers of power and ideology. Views from heights were especially prized: Maecenas had a tower on his Esquiline property from which Nero later observed the immolation of Rome. The plutocrat Lucullus established his Horti Luculliani on the Pincian Hill overlooking the Campus Martius. Perhaps under Messalla's ownership in the early Augustan period, a round temple and a garden theater

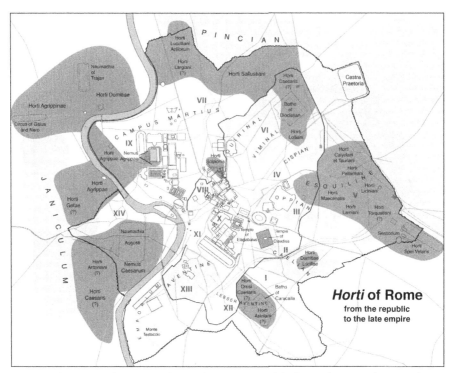

80. Cumulative map showing gardens and groves attested in Rome between the second cen-
tury B.C.E. and the fifth century C.E. Their physical disposition and size are conjectural; others
mentioned in epigraphic or literary sources cannot be located.

were set directly on axis with the Mausoleum of Augustus in the Campus
below. As with Agrippa's Pantheon to the south, the sight line from the ter-
raced gardens to the dynastic tomb, itself bedded in a grove, was a bold gesture
of ideological alignment with the new emperor (Fig. 81).

By Claudius' reign (41–54 C.E.), most of the *horti* had become either public
or, predominantly, imperial properties. Agrippa bequeathed to the people his
vast holdings in the Campus Martius, including the gardens and groves. Julius
Caesar had done likewise with his huge estate on the southern Janiculum along
with its art collection. Most others were absorbed into the emperor's patrimony
by bequest, confiscation, or acquisition. This monopoly was fundamentally stra-
tegic. First, it denied others the public trappings of a rival power; second, it
denied them cover for marshaling private armies, as had happened occasionally
in late-republican *horti;* and third, it subjected the city to the gentle chokehold
of surveillance. An additional, unforeseen advantage emerged when the Aurelian
Wall was laid out in the 270s C.E. (see Chapter 10), because long segments of the
defensive circuit could be run through the imperial *horti* without legal challenge.

The *horti* of Rome were suburban villas, not just open parks. Though their
residential function is well attested, their lack of identifiable villalike archi-
tectural cores is confounding. We are left occasionally with the ruins of ter-
races, porticoes, and cryptoporticoes, as at the Horti Sallustiani, or more or

81. Model of ancient Rome, Pincian Hill and Campus Martius.
Source: Museo della Civiltà Romana.

less isolated pavilions at the Horti Maecenatis, Sallustiani, and Liciniani; even granaries and wine production facilities have been identified at the Horti Domitiae Lucillae on the Caelian. The Horti Lamiani left many traces from their heyday in the high empire, including baths, a huge semicircular exedra, and a lavish double walkway with ambulatories at each end designed for strolling in a continuous narrow loop (Fig. 82). But no residential core has been identified. At the Horti Luculliani the basement level of a villalike compound is preserved, but as living space, it is unreadable. Agrippa's Villa Farnesina, presiding over a gracious riverfront estate, stands as the one shining exception (see Chapter 4). During Caligula's reign (37–41 C.E.) the Horti Agrippinae, his mother's vast Tiberside estate upstream from the Villa Farnesina, fronted the river in an equally impressive manner, with a portico and a promenade. There Caligula began work on a circus, which Nero completed; and there Nero held his notorious games after the fire of 64. As we have seen, he may have given part of these gardens over to the development of a new residential neighborhood for refugees of the fire (see Chapter 7).

Archaeology has revealed little about the organic landscapes of the *horti* of Rome. From literary references we know that groves were prominent. Vineyards are attested in places; certainly we should expect these gardens to have offered a token measure of productivity. But their main purpose was to furnish pleasure and delight. Conventionally, Romans abhorred the wild; the normative aesthetic of nature relied on an ethos of regulation, cultivation, and artifice. Realized on a large scale, *horti* were therefore full-on landscape architecture, undulating theaters of aristocratic power and beneficence. One index of their

82. Plan representing the known ancient remains associated with Horti Lamiani.
Source: Cima and La Rocca 1986. Courtesy of E. La Rocca.

horticultural abundance is the amount of water they consumed for irrigation
and display. Frontinus' statistics on the aqueducts of Rome indicate that by 97
C.E. the volume delivered to the 14 regions of the city from its nine aqueducts
totaled about 333 million liters per day. Of this, 44.2 percent was distributed
publicly, and the remaining 55.8 percent served a limited roster of businesses, a
few hundred private baths, and a handful of elite landowners, the emperor fore-
most among them. Two major aqueducts, the Aqua Claudia and Anio Novus,
combined were delivering 65 percent of their total to the same interests.

 We cannot know how much of these private and imperial apportion-
ments went to *horti* specifically, but anecdotal evidence suggests the amount

was massive. Frontinus relates that Augustus' Aqua Alsietina had once served two purposes: to supply the Naumachia (see Chapter 5) and to irrigate "the adjacent gardens" – that is, the Nemus Caesarum, the grove surrounding the Naumachia – and other private gardens. When a sector of the Aqua Claudia arrived on the Pincian Hill around 52 C.E., it seems to have rendered obsolete a vast web of cistern-fed underground irrigation tunnels at the Horti Lucullliani. The terraced hillside gardens may then have become a kind of water park listed in the regionary catalogs as the Nymphaeum Iovis: "Jupiter's fountain." And the recent subway excavations have uncovered a gigantic irrigation basin, perhaps the work of Frontinus' water commission, in an ancient peach orchard below the Lateran. To reiterate: *horti* were possibly the most prodigal investments in the urban fabric, especially when we take into consideration their perpetual need for maintenance and renewal. We conjecture that most of the groves within them were planted and dutifully replanted after blights or damaging fires. Sometimes massive requisitions of plants and trees are implicit in the sudden establishment of large gardens or groves. The most famous urban garden, at Nero's Domus Aurea, was entirely fabricated, and in short order:

> It was so ample that it had a triple portico a mile long, and even a pond resembling a sea circled about by buildings in the guise of cities, as well as tracts of country mottled with cultivated fields, vines, pasturage, and woods with a multitude of domestic and wild animals of every kind. (Suetonius, *Life of Nero*)

Nero died a mere four years after the fire, so this picture represents a moment in time only a year or two (at most!) after his new palace rose upon its foundations. Those "woods" were barely saplings when his successors began to uproot them. Even the vinestock was immature at best. What is remarkable, if only implicit, is that a system was already in place to fulfill such extravagant requisitions. Nurseries serving the city must have constituted a significant and long-standing industry in their own right, because Nero's appetite for novel rural landscapes was far from unique. Urban greenspace was a powerful political tool, its benefits evident to all and jealously guarded by an ever-diminishing few.

BIBLIOGRAPHY

Ashby 1935; Beard 1998; Boatwright 1987; Broise/Jolivet 1996, 1998; Carandini 1985; Cima 1998; Cima/La Rocca 1986; Cima/Talamo 2008; Coarelli 1993, 1997a; Dyson 2010; Evans 1994; Fortini/Taviani 2014; Gleason 1994, 2014; Grimal 1984; Hartswick 2004; Jolivet 1997; Kuttner 1999; La Rocca 1998; *LTUR* (various articles on *horti, lucus, nemus*); Purcell 1987a, 1987b, 2001, 2007; Scrinari 1991; Taylor 2014; Villedieu 2001; von Stackelberg 2009; Wiseman 1998.

TWELVE

ADMINISTRATION, INFRASTRUCTURE, AND DISPOSAL OF THE DEAD

L ET US PAUSE TO PONDER THE REMOTENESS OF ANCIENT ROME FROM OUR own urban experience. In the imperial period it was a city of unprecedented scale and complexity supporting about a million people. It had an incomparable infrastructure of roads, aqueducts, and sewers. Its supply systems and administrative apparatus were the most sophisticated in the ancient world. But if we contemplate the ancient city from our own urban experience, we see that it had no mayor, city council, or city hall; no urban planning commission; no sanitation department or public health service; no hospitals, public schools, or public transportation; no homeless shelters; no police crime units to prevent or investigate wrongdoing; and no prisons. (The famous *carcer* was merely a holding cell for condemned political prisoners.)

During the republic, Rome relied heavily on its citizenry to maintain infrastructure, uphold public order, and provide social amenities according to a patchwork code of laws and expectations. Outside this limited domain of private duty or initiative, the task of improving or maintaining the city fell mainly to the censors and the aediles, elected short-term magistrates whose most fundamental duty was to oversee public morals. Often the two censors undertook major public building and infrastructure projects of a nonsacred nature, while the two (later four) aediles saw to the city's maintenance, the proper execution of games, and the enforcement of personal modesty and restraint in public building. Their role was genuinely practical but also symbolic; the state of the *urbs* reflected their personal moral standing. The aedileship retained this

signification long after the censorship lapsed, as was demonstrated when the emperor Caligula, observing that some streets of Rome were unswept, ordered mud to be thrown onto the toga of Vespasian, who was an aedile at the time.

Prodded by various crises, Rome did develop a robust professional bureaucracy in the high empire, some of it publicly and some imperially financed. In one unique case, the water commission's staff was divided between 240 public and 460 imperial slaves, the latter contingent added by Claudius. The city kept extensive records in a variety of locales: maps of publicly owned property at the Atrium Libertatis, death records at the grove of Venus Libitina, imperial procuratorial archives at the Horrea Piperataria (those incinerated in 192), etc. A register of the several hundred thousand citizens eligible for the grain dole was carefully maintained, probably at or near the Porticus Minucia in the Campus Martius, where the distribution took place at least from Claudius' reign until the late second century C.E. A property tax for water consumption was assessed using some kind of formula applied, we conjecture, by categorizing the property according to its likely volume of water use, its proximity to a water source, and its size. This system required detailed maps and records (see Chapter 13).

The imperial bureaucracy was staffed mostly by trained slaves and freedmen. As for the public commissions, ancient authors tend to focus on the numerous revolving-door magistracies handed out to men of senatorial or equestrian rank: aediles, *curatores, subcuratores, procuratores, treviri, quattuorviri*, etc. But the real machinery of urban administration consisted of the permanent bureaucracies behind these titles, along with their personnel. In the high empire their ranks, including a growing police and security apparatus, must have swelled to upward of 20,000, not including the unskilled labor force at their disposal. In most cases the responsibilities of these commissions were real and their tasks substantive. Yet the position at the top was customarily decorative. Any top-down tendency toward reform or initiative, such as that demonstrated by Agrippa as aedile or Frontinus as *curator aquarum*, whose treatise on the city's aqueducts uniformly disparages his subordinates, probably stirred resentment among the rank and file and was tolerated only at the emperor's pleasure. Surely another preapproved agent of disruption was the first *curator aquarum et Miniciae* under Septimius Severus (see Chapter 10).

The inadequacy of relying on private citizens to maintain public order became painfully obvious in the chaos of the late republic. Finally dispensing with the ancient (and oft-violated) interdiction of weapons within the *pomerium*, Augustus expanded an existing military institution, the Praetorian Guard, into an elite imperial bodyguard with a prominent presence at Rome. He probably also instituted the *cohortes urbanae*, whose sole task was to police the city. Tiberius consolidated these institutions into nine Praetorian cohorts of 500 men each and three urban cohorts of uncertain size. Numbering perhaps 6,000

in all, they were mostly quartered together in the Castra Praetoria, a rectangular military camp in a defensible position outside the Servian Wall northeast of the city; it was later incorporated into the Aurelian Wall (see Fig. 80, upper right). The Praetorian and urban cohorts each answered to a civilian prefect of senatorial rank. The urban prefecture became a genuinely powerful senatorial magistracy and eventually the most powerful of them all, its remit extending in late antiquity to a 100-mile radius around the city. The urban prefect's role was both administrative and prosecutorial (thus exceeding a police chief's powers), and gradually he acquired supreme judicial authority as well.

Meanwhile, another Augustan institution was also accumulating police and judicial powers: the *vigiles*, the fire brigade of Rome. Organized into seven cohorts totaling either 3,500 or 7,000 men (the sources are unclear), they were divided among the 14 regions of Rome, 2 regions per cohort, and a rotating assignment at Ostia. The barracks of each consisted of a large station in one region and a smaller station in a neighboring one. Constantly on night patrol, they came by their augmented police duties naturally; their commander oversaw not only his agency, but also minor criminal court cases. The physical quarters of the *vigiles* can be inferred from the surviving station at Ostia and a partially excavated small station in the Transtiberim (see Fig. 34).

Obviously imperial Rome was full of officials with trained staffs and reams of records and archives. Yet their operational headquarters as working offices are practically invisible in the material record. It is one of the enduring mysteries of archaeology that very little dedicated office architecture from antiquity has ever been identified at Rome or other major Roman cities. We should not wonder that large office buildings of the modern kind are absent. But why is it so hard to trace bureaucracies, which require teams of people working and communicating in close quarters, their equipment and records close at hand? With some exceptions (commercial districts in particular), Rome's functionaries seem to have eschewed small, contiguous offices along porticoes or corridors in favor of large, impressive halls where they would presumably sit and confer at wooden tables. There are hints, for example, that the urban prefecture was located at the Templum Pacis, possibly in the vast room displaying the marble plan. Its records may have resided in the neighboring libraries of the complex. Recently it has been argued that the *cura aquarum* was headquartered at the Aqueductium, a locale on the Caelian inscribed on the Severan marble plan (see Fig. 79). Apart from the standard shops or storage units on street frontage and a couple of compact courtyards, there is no cellular architecture here. If the hypothesis is correct, then the headquarters may have simply been the grand apsidal hall facing the sanctuary of deified Claudius with its two flanking subsidiary rooms and an adjoining L-shaped fountain, its several niches watered by one of the huge distribution tanks behind it. Simple, monumental, and memorable, the tripartite hall imbued the water commission with

proper dignity. Claudius was the greatest of the aqueduct builders, and the arcade shown leading to this building was a Neronian extension of his Aqua Claudia – refurbished, incidentally, by the very emperor who updated the marble plan, Septimius Severus. Orienting the headquarters directly to Claudius' temple thus seems an entirely appropriate tribute. Perhaps a statue of him stood on the base prominently centered in the great hall's apse; he had, after all, augmented the staff of the water commission by nearly two-thirds.

Was there some kind of urban master plan that coordinated the information gathered by various commissions and agencies? Surely not, but we can expect high-level cooperation nonetheless. Imperial Rome probably had a periodic door-to-door census resembling one Julius Caesar had taken to reform the grain distribution. Caesar's was organized by neighborhood and relied on information from *insula* owners. Such a census would have yielded several benefits, particularly for assessing the water tax and adjusting water distribution. Rome may also have maintained a comprehensive death register. An inscribed law at Pozzuoli reveals that that town had a "grove of Libitina" modeled on Rome's. Pozzuoli's Libitina was a monopolistic college of undertakers who registered and buried all deceased residents of the city, including criminals and slaves. But what was the purpose of a death register? According to one attractive hypothesis, by enumerating age at death it supported an actuarial schedule for estimating life expectancy. Just such a "life table," preserved in the writings of the jurist Ulpian (d. 228 C.E.), was used for calculating an annuity tax in the Severan period. However, the inclusion of noncitizen residents in Pozzuoli's law commends a further, status-blind purpose: to estimate the size of Rome's annual grain requisition (*annona*) for the total human population including the majority of residents not registered for the free distribution (*frumentationes*). This information, as well as census enumerations of grain-consuming animals in Rome, would have been critically important to the *praefectus annonae*.

Registry of the dead at Rome, then, was probably a matter of acute importance to the central authorities. Their disposal was regulated to some extent – no ordinary, noninfant burials were allowed inside the *pomerium*, of course – but the nature of one's entombment was left to a radically free market. In the republic and empire alike it appears that the urban poor were simply inhumed in mass unmarked graves. From the late republic until the early second century, members of the middle class and elite – that is, those who could afford any kind of commemoration – favored cremation, a practice that had an effect both on architecture and on the nature of the funeral itself. In some cases, the burning of the body offered an opportunity for spectacle, even political display, as famous episodes in Roman history attest. Through the final centuries of the republic and the first century of the empire, aboveground tombs were arrayed in cemeteries along the highways leading out of town; these motley frontages, increasingly dominated by freedmen since Augustan times, proliferated into

83. "Temple tombs" of cemetery under St. Peter's in plan and restored elevation. Elevations represent the cemetery in the second- and third-century phases.
Source: Hesberg 1987. By permission of Bayerische Akademie der Wissenschaften.

sprawling, loosely regulated "neighborhoods of the dead" arranged in irregular, cluttered rows, as can be seen at the cemeteries in the Vatican and elsewhere (Fig. 83). Traditionally, urban cremations took place at a specially designated site in each cemetery precinct.

A particularly prominent phenomenon from the Augustan period through the mid-first century C.E. was the rise of the *columbarium* ("dovecote"), a new kind of tomb with a more introverted aspect, its ample interior wall space occupied from floor to ceiling by ranks of niches for cinerary urns. Single niches or groups of them might reflect family ties, as in traditional tombs, but the columbaria overall were organized socially according to broader, self-defining membership groups, the deceased sometimes numbering in the hundreds within a single tomb. A famous example on Via Appia accommodated a horde of the empress Livia's household, among others (Fig. 84). Most popular among the freed classes, *columbaria* were operated by organizations centered on specific professions or patronage networks. They were expensive to maintain, and over time their popularity diminished; however, freedmen and -women continued to dominate the funerary landscape, and professional, family, and patronage affiliation remained the paramount criteria for commemorating the dead. Tombs could take a bewildering array of forms, but by the end of the first century local taste favored the brick-faced "house tomb,"

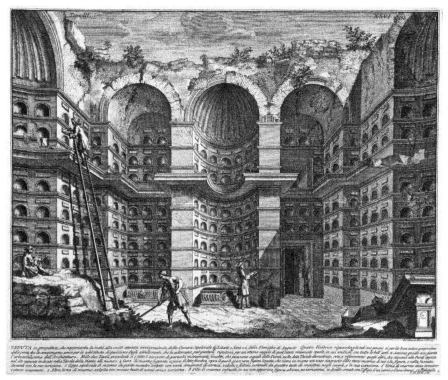

84. Columbarium of household of Livia.
Source: Piranesi 1756. Wikimedia Commons/PD-Art.

a gabled boxlike structure, often vaulted (see Fig. 83). People of modest means were buried in small graves interspersed among the buildings.

By around 100 C.E. a momentous, empirewide shift was taking place in commemorative burial practices. It would transform the extramural land-scape of Rome and influence the development of Christianity. For uncertain reasons, the long-standing tradition of cremation yielded to a preference for inhumation. For those who could afford it, a box to enclose the full body now became a vehicle for self-representation. Sometimes the interiors of older niche tombs were modified to admit sarcophagi in the floors and walls. Naturally sarcophagi – along with caissons or niches to accommodate them – are much larger than urns, and the difficulties of introducing them into an already crowded cemetery environment are obvious.

According to one estimate, over the three and a half centuries from Augustus to Constantine the city's suburbs would have hosted between 10.5 and 14 million burials, of which some 1.5 percent have left a trace in the mod-ern record. With so heavy a demand on limited land resources, alternatives to the traditional model had to be found. At Rome and elsewhere in Italy, the solution emerged from a geological convenience: the abundant substrate of soft volcanic stone, which could be excavated easily to create underground

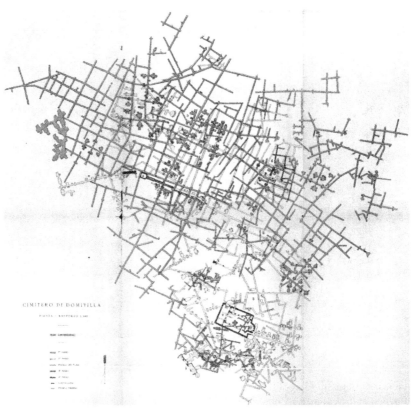

85. Plan of Catacomb of Domitilla on Via Ardeatina. Corridors are shaded to represent different levels.
Source: O. Marucchi, *Monumenti del Cimitero di Domitilla sulla via Ardeatina* (Rome 1909).

networks of galleries punctuated by rock-cut shelves for the arrangement of corpses, most without sarcophagi (Fig. 85). Mostly within three miles of the Aurelian Wall, these catacombs often commandeered preexisting quarries or hydraulic systems, and many were on imperial or aristocratic property. Possibly assisted by a widespread subsidence of groundwater levels, they appeared on a large scale at Rome in the third century and were quickly adopted by the urban community. It is demonstrably untrue, though often claimed, that early Christians insisted on segregated burial in the catacombs; if group cohesion can be identified at all, it follows the traditional networks of family, trade, or patronage. Religious groups are naturally cohesive, to be sure; but there were enough exceptions in every category of evidence to demonstrate that Christian doctrine at this time made no special provisions for group burial. If there was a single religious community practicing exclusion it was the Jews, who had been disposing of their dead in rock-cut catacombs at Rome since the mid-first century B.C.E. But even the existence of purely Jewish catacombs is in question.

We see only the tip of the iceberg. Mass graves of the poor, apart from those under the Horti Maecenatis, are badly documented. Before the rise of cata-comb burials, the elite withdrew from the culture of roadside display, choosing to bury their dead out of public view on suburban or rural estates. But ancient Rome, with its vast patronage networks and "panopticon" culture of status and shame, did not favor anonymity. We can plausibly maintain that few deaths of persons past infancy were completely ignored, and we may even conjecture that any death that was unregistered, or untended to, defied both law and custom.

BIBLIOGRAPHY

Administration, Infrastructure, Urban Demographics: Ashby 1935; Bruun 1991, 1999, 2006, 2007; Daguet-Gagey 1997; Davies 2012b; Dyson 2010; Eck 1992, 2009; Erdkamp 2013; Evans 1994; Frier 1982; Hodge/Blackman 2001; Lo Cascio 1990, 1997, 1998; Lott 2004; Marchetti-Longhi/Coarelli 1981; Mattingly/Aldrete 2000; Morley 1996, 2005; Nippel 1995; Palmer 1980; Panciera 2000; Panciera/Virlouvet 1998; Rainbird 1986; Reimers 1991; Rickman 1971, 1980; Robinson 1992; Scheidel 2003; Scobie 1986; Sinnigen 1957; Sirks 1991; Taylor 2002; Virlouvet 1985, 1995; Witcher 2005.

Disposal of the Dead and Demographics of Mortality: Bodel 1994, 2000, 2008; Borg 2013; Dyson 2010; Fiocchi Nicolai 2009; Harries 1992; Hesberg 1987; Hopkins 1983; Johnson 1997; Liverani 2010; Patterson 2000; Pergola 1998; Purcell 1987a; Rebillard 1999, 2009; Rutgers 1992; Scheidel 1994; Shaw 1996; Spera 1999, 2003; Steinby 1987; Toynbee/Ward-Perkins 1956; Virlouvet 1997; Wallace-Hadrill 2008.

THIRTEEN

MAPPING, ZONING, AND SEQUESTRATION

MEASURING THE LAND IS AN ART ALMOST AS OLD AS HUMAN SETTLEMENT, and among ancient peoples the Romans were its masters. The voluminous surviving Roman literature on the subject pertains mostly to partitioning rural plots. However, by the mid-first century C.E. at least, the surveying techniques developed for that purpose were also being used to map the more convoluted and irregular landscapes of towns. The need for urban maps seems obvious today. They facilitate the design, construction, maintenance, and modification of the entire urban prospect and its infrastructure. They clarify legal status, and thus simplify revenue collection and adjudication of land disputes. They assist in keeping track of individuals and families; they help fire brigades and police do their jobs. For a census-driven urban bureaucracy such as Rome's, grounded in the identification and enrollment of a million people or more according to their property status, maps would seem not only warranted, but indispensable.

This commonsense proposition is not universally accepted, yet we are fortunate to have strong evidence supporting it. First and foremost, there is the Severan marble plan of the city. Probably a revision of a fire-damaged Flavian antecedent, it was affixed to a wall of the Templum Pacis around 203 C.E. or slightly later (see Fig. 49). About 10 percent of the original 1:246-scale planimetric map survives today in nearly 1,200 incised marble fragments fallen from the wall, which still stands, though entirely stripped of its accompanying enclosure and adornment (Fig. 86). An overpowering display of technical

86. Wall from Severan phase of Templum Pacis bearing clamp marks for slabs of marble plan.

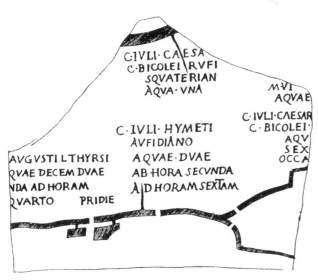

87. Fragment (now lost) of a schematic map representing an aqueduct and its fronting properties. *Source*: Fabretti 1680.

virtuosity, it is sometimes dismissed as a showpiece with purely rhetorical value like Agrippa's map of the known world in the Porticus Vipsania. Yet the use of maps for administrative purposes across the Roman world is well established. Vespasian's land cadasters at Orange, France, and a lost fragment of an aqueduct map from Rome marking private water concessions (Fig. 87), the second

rendered schematically rather than planimetrically, were certainly derived from archival originals. Fragments of other marble maps survive, too, several on the same scale as the Severan plan and sometimes indicating the peripheral measurements of properties in Roman feet.

To be sure, the Severan plan, its selective inscriptions enhanced with red pigment to improve visibility, was intended to impress a general audience. And as we have already noted, the map did not encompass the entire inhabited urban area even in Flavian times, let alone Severan. This was probably a composite display copy, trimmed to fit an oblong space, of a more extensive working original partitioned onto inscribed bronze tablets. Literary sources relate that the emperor possessed similar tablets of colonial land surveys and that bronze maps of publicly owned lands outside Rome were kept in the Atrium Libertatis. The customary scale of archival city maps, about 1:240–250, was preserved to simplify the task of reproduction; consequently, the Severan marble plan excluded the city's southeast and northwest extremities along the wall's short axis (see Fig. 49). A recently discovered fragment preserves traces of a thick red line that may have divided regions 10 and 11, suggesting that the marble plan was derived from a cadastral map displaying legal and administrative boundaries. Other details about the map are also suggestive. Because virtually every ground-level wall of every building is shown, separate properties can be inferred by tracing party walls. Moreover, stairways in residential properties sometimes carry a symbol that seems to represent the number of floors they served – a detail that would be pointless outside an administrative context.

The prototype of this map was probably commissioned during Vespasian's and Titus' joint censorship in 73–74. Their initiative seems to have addressed a number of administrative issues such as expanding the *pomerium*, reestablishing a customs boundary for the city, and updating numerical data for each region. It is no coincidence that Pliny the Elder could relay the precise number of neighborhoods (*vici*), 265, in Rome at this time. The customs boundary was important because duties on imported foodstuffs were a significant source of public income at Rome and Vespasian was trying to recharge the public and imperial coffers depleted by Nero. The border, which had no special relationship to the *pomerium* or the Servian Walls, would have been carefully controlled at all entry points and thus may have defined the outer boundaries of the regions. But the mother map also had other important functions, as we shall see.

Miscellaneous statistics about the city of Rome appear in a wide variety of ancient sources across time. Taken in sum, they bespeak a sophisticated and fairly coordinated bureaucracy, probably headquartered at the urban prefecture in the Templum Pacis but also engaging such offices as the water commission, the fire brigade, the grain distribution commission, and the curatorship of the roads. The most comprehensive collections of lists and statistics about the city

are the two regionary catalogs compiled in the third quarter of the fourth century C.E. They are full of useful data, but anyone who navigates them with serious purpose faces rough sailing. Comprising two approximately duplicate lists (there are many discrepancies), they enumerate named monuments within each of the 14 regions and provide numerical totals – first by each region, then in summary – of certain features and building types. Using a comparative source to emend textual corruptions, Coarelli arrives at a total of 323 *vici* (official neighborhoods) in the fourth-century city, a believable increase over the 265 registered by Vespasian's and Titus' census of 73/4 C.E. Region 14, which included all of the Transtiberim and the inhabited Vatican, alone had 78 *vici*.

A difficulty arises in accounting for the 46,000-plus *insulae* recorded in the catalogs, compared to a mere 1,790 *domus*. These are far too many to signify by *insula* a whole block-sized apartment building, as archaeologists tend to construe the term. It is best understood as a vertically defined unit under a single ownership interest with its own stair access from the street. A *domus*, on the other hand, seems to have been a single-family house of one or two stories, much as we define it at Pompeii or Herculaneum. Because many *domus* were holdovers from the republican era, they dwindled in numbers over time as buildings of higher density took their place. By the late first century C.E., the ancient streetscape resembled the modern one in Rome, its blocks lined with variegated but continuous façades of several stories behind which people worked and lived in patterns of property arrangements defined by the internal walls. Shops were concentrated along the street frontage; workshops or production facilities occupied larger, deeper zones on the ground floor; residences tended to be stacked vertically. Within Roman city blocks on the Severan plan, contiguous *insulae* are divided by single lines representing party walls. In reality some of these walls may have been double with a narrow fire gap between them, as dictated by Nero's building code and exemplified at Ostia.

Frontinus' treatise on Rome's aqueducts is another trove of information about the urban configuration of the city. He reports that a few privileged persons received imperially approved water concessions by pipe from the public aqueducts. The map represented in Figure 87 seems to have been a registry of this very network of concessions. An eclectic assortment of lead pipes discovered in Rome over the centuries are stamped with the names of worthies whose properties received these concessions. But the masses obtained their water by fetching it from public fountains. Frontinus relates that a maintenance tax was exacted from "places and buildings near the channels, distribution tanks, public water displays, and fountain basins." When he was writing, Rome contained 247 distribution tanks, 95 public water displays, and 591 public basins. Given that these numbers grew significantly with the later introduction of two more aqueducts (the regionary catalogs record 1,352 basins!) the tax must have had a very long reach.

It was a status-blind consumption fee based on the presupposition that almost everyone with access to public water used it regularly. To be fair or even functional it had to be bracketed according to criteria such as size of the property, its type (for example, a fulling or dyeing outfit would consume far more water than an ordinary residence), its distance from the water, maybe even its number of occupants. Though we should not expect the assessment to have been very sophisticated, the minimalist alternative – a flat rate for each property – is unlikely, given the great variation in *insula* sizes and water consumption of their occupants. To establish a formula accounting for such variables, city officials must have periodically conducted door-to-door surveys to assess changes in property sizes and configurations, if not numbers of occupants. We may even have composite evidence of the standard taxation formula: the stair symbols on the Severan plan and the wall measurements recorded on fragments of other marble maps, some of which also have stair symbols. The bronze originals belonging to the mother map, we postulate, had both. With the wall measurements, tax assessors could calculate the perimeter of each property in linear feet, or even approximate area. Using stair symbols, they could multiply that figure by the number of stories.

The only strict zoning ordinances in ancient Rome, as in most Roman cities, entailed the sequestration of the dead – and then only with regard to the city limits, since many catacombs coexisted with extramural villas and farms. As for the living, the model presented by Ostia and Pompeii is broadly confirmed by a miscellany of literary and epigraphic references to the capital too. On balance, by class and function, Rome was well integrated. Socially cohesive groups like the Jews may have formed self-selected communities, but we know of no enclaves comparable to the later Ghetto – and certainly no geographic sequestration of people by their identity. It is even possible, if not demonstrable, that imperial policy actively discouraged too much coalescence of the like-minded, especially after the Jewish War of 67–70, when an enclave of resentful Jews, many thousands strong, might have seemed threatening. Emperors occasionally banned from Rome certain activities or groups of perceived troublemakers (philosophers, exotic priests, etc.), but segregating people *within* the city, except in contractual confinements such as barracks or the Atrium Vestae, was unheard-of. Residences, industries, and businesses; natives and foreigners; the rich, the middling class, and the poor – all coexisted in most residential neighborhoods. Rome's pervasive patronage system helps to account for this interpenetration because patrons and their clients – especially their freedmen, the backbone of the business and artisan classes – benefited from physical proximity to each other. To be sure, aristocratic *domus* were concentrated on particular hills near the center (the Caelian, Aventine, Viminal, and Quirinal); but such houses could occupy swank and downscale districts alike.

The urban fabric was thick with neighborhood-oriented businesses, offices, and centers of activity. In addition to each neighborhood's proprietary shrines, the regionary catalogs count baths, warehouses, and bakeries in their summaries for each region. The robust distribution of all three categories speaks to their importance to local districts. The scatter of warehouses initially seems surprising, since topographers tend to focus on clusters of large ones at the river wharves; but in general their wide dispersal suits the ramified nature of supply networks in any large city before the age of high-speed transportation, let alone one that consumed vastly more goods than it produced. In fact, the compact 10th region, encompassing only the Palatine Hill, had more warehouses than any other, presumably little ones serving the palace and its guard. Many other concerns of local utility, such as smithies, fulleries, and supply shops, were likewise distributed around the city, as they were at Pompeii and Ostia.

Finally, it bears emphasizing (because the opposite is often claimed) that there was little identifiable *moral* zoning in Rome or any other Roman city. To the extent that sex for sale can be identified archaeologically, there are no discernible patterns to its geographical distribution. Certain places in Rome were notorious for soliciting, but their popularity was related more to convenience or anonymity – baths, wharves, shadowy *fornices* (arches) – than to the presence of a red-light district. If moral zoning existed at all, its objective was to exclude Eastern religious cults from the urban core. But this does not seem to have amounted to a consistent policy; the supposed sequestration of certain Eastern cults in the Transtiberim may pertain as much to proximity to their worshipers, or available real estate, as to squeamishness about the corrupting influences of exotic rituals. The imported cult of Mithras, it should be noted, had venues scattered all around town more or less indiscriminately, perhaps because they were always underground and their natural seclusion would have attracted little attention from the street.

For their own reasons, other kinds of urban places tended toward configurations of clusters or chains. Many civic, financial, and entertainment activities were clumped together in the fora or the Campus Martius as a way to concentrate expertise or maximize convenience. Money changers set up shop at the Forum Romanum; law courts, in the basilicas and imperial fora. The aqueduct-powered flour mills ran in chains down the steep gradient of the Janiculum. Aboveground tombs were clustered in tight, untidy ranks near the city, then thinned out into chains along the highways into the countryside. Eateries and inns were strung along major streets or clustered around city gates and popular places of public resort – such was the case at least in Pompeii. Whether by ordinance or convenience, certain industries were massed in isolated neighborhoods along highways outside town. These were few in kind, mainly large-scale production facilities for leather, glass, pottery, bricks, and tile.

We know of no smelting at Rome but another heavy industry, cremation of the dead, flourished by sheer virtue of population. Cremation for extraurban burials took place at the cemeteries themselves – not because religious scruple required it, but because crematoria in the urban core presented the same kind of environmental hazards as potteries, glassworks, and tanneries. A rough estimate based on population models would suggest that somewhere around 55 bodies were burned daily in the cemeteries around Rome before the advent of inhumation in the second century.

All these industries seem to have been sequestered because of the dense smoke or fumes they produced. But they also benefited from clustering in remote locations where land was cheap and materials could be delivered or shipped out in bulk. Several such clusters are known around Rome. An enormous second- or third-century tannery was recently found at Casal Bertone in the eastern suburbs. A complex of late-first-century potteries is known in the vicinity of the Villa Sciarra on the Janiculum Hill. North of the developed part of the Vatican, along Via Triumphalis at the clay beds of Montemario, were brickworks. And the *Liber pontificalis*, the official biography of the early popes, refers to a huge "city of brickworks" outside the Aurelian Wall on Via Salaria. This is not to say that such industries were completely zoned out of the city; they were not. The main criterion for sequestration may have been the scale, not the type, of an industrial operation.

If any broad conclusion can be drawn from patterns of habitation and activity, it is that urban policy in Rome, though increasingly centralized under imperial control through time, largely tolerated pluralism and freedom of movement. It was an easier task within the top-down patronage system of the empire than in the freewheeling and fractious late republic. Yet the concentration of certain services and occupations was clearly encouraged. Evidently operators of large production facilities in particular were induced to form industrial parks, as it were, on the outskirts of town.

One last zone of concentration deserves attention. Rome's wharves stretched intermittently along miles of the river, from Pietra Papa far south of town to the northern Campus Martius. Around the 80s C.E., the Naumachia Augusti fell into disrepair and gradually yielded to redevelopment, as surviving fragments of the Severan marble plan may indicate (Fig. 88). The Nemus Caesarum mostly disappeared and its eastern, riverside zone developed into a waterfront and warehouse district. The catalyst for change seems to have been Trajan's expansion of Portus, the port complex near Ostia, which increased the volume of barge traffic along the river's right bank. A new bridge, later called Pons Traiani, seems to have run across the river southeast of the old *naumachia*. Its odd diagonal course may have been intended to soften a jog in the flow of Trajan's new aqueduct, the Aqua Traiana (dedicated in 109), which probably piggybacked on it.

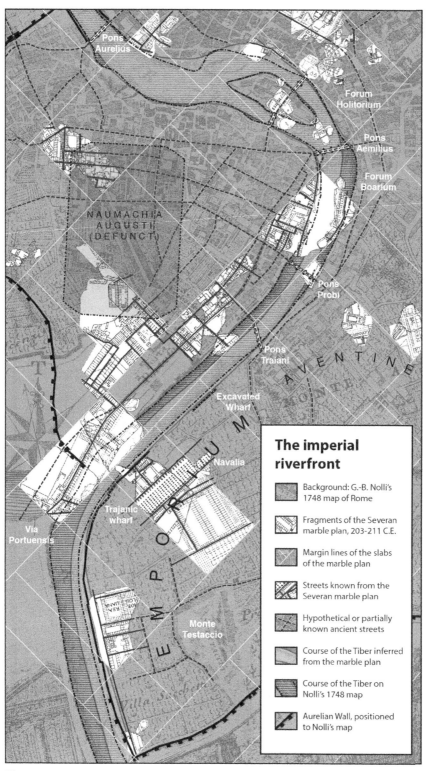

The imperial riverfront

Background: G.-B. Nolli's 1748 map of Rome

Fragments of the Severan marble plan, 203-211 C.E.

Margin lines of the slabs of the marble plan

Streets known from the Severan marble plan

Hypothetical or partially known ancient streets

Course of the Tiber inferred from the marble plan

Course of the Tiber on Nolli's 1748 map

Aurelian Wall, positioned to Nolli's map

88.

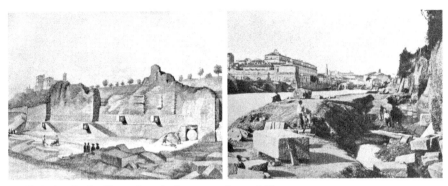

89. Trajanic wharf at Emporium during excavations, 1868.
Source: Photo: Ninci e Figlio; engraving: anonymous. G. Gatti, "L'arginatura del Tevere a Marmorata," *BullCom* 64 (1936), 55–82, tav. II & III.

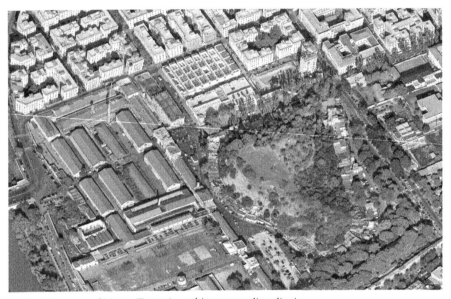

90. Satellite view of Monte Testaccio and its surrounding district.
Source: © 2014 Data SIO, NOAA, U.S. Navy, NGA, GEBCO, Landsat, Google.

Across the Tiber, Trajan expanded the wharves at the Emporium. Here massive warehouses already lined the river; but a tract of Trajanic wharf, still littered with stocks of offloaded marble, was excavated in the 1860s (Fig. 89). During Trajan's reign, the importation of oil amphoras peaked, greatly augmenting the Emporium district's famous artificial hill, Monte Testaccio, a solid heap of millions of discarded amphoras (Fig. 90).

The Severan marble plan is surprisingly accurate; with due caution it can be overlaid on modern maps. Although it seems not to represent the Tiber's shoreline or towpaths, it does render the various kinds of river frontage directly behind them, including the occasional sharp jog or sheltered berth. Our overlay

graphically demonstrates how the river has shifted over time, especially on the city's south side, where most of its merchandise arrived (see Fig. 88). That displacement must have happened before the construction of the Aurelian Wall in the 270s. South of the bend, the Aurelian river wall overlies what seems to have been water only seven decades earlier. The slightly angled western embankment, traced on the marble plan, funneled the current into a dangerously swift and narrow bend, which over time defeated it. Unspecified floods melted it away and the river burst its cincture, relaxing westward, crumbling the rigid riverfront architecture and forcing an emergency diversion of the great harbor road to Portus, Via Portuensis. With the broadening and slowing of the current here, all the left-bank wharves from the bend southward for several kilometers became choked in silt. Not a single ancient bridge survives south of the island except the forlorn fragments of the Pons Aemilius; all were washed out over the centuries, sometimes repeatedly. The river was forever in flux, then and thereafter, and its margins perforce were treated as temporary.

BIBLIOGRAPHY

Bruun 1991; Ciancio Rossetto 2006; Clauss 2000; Coarelli 1997b; Dey 2011; Dilke 1985; Eck 1997; Erdkamp 2013; Kardos 2001; Labrousse 1937; Laurence 2007; Lo Cascio 1997; *LTUR*, "Figlinae (in Figlinis)" (F. Astolfi); *LTUR Suburbium*, "Figlinae civitas" (D. De Francesco); "Tri(umphali) via (officina)" (L. Camilli); Maischberger 1997; McGinn 2006; Meneghini/Santangeli Valenzani 2006; Palmer 1980, 1981; Pavolini et al. 2003; Robinson 1992; Rodríguez Almeida 1981, 2002; *SDFUP;* Taylor forthcoming; Trimble 2007; Tucci 2004.

FOURTEEN

TETRARCHIC AND CONSTANTINIAN ROME

THE "ROMAN RECOVERY" OF DIOCLETIAN (284–305) AND THE TETRARCHY he established with his colleague Maximian (286–305) and two junior emperors, Galerius and Constantius Chlorus, are significant milestones in Roman history, changing the social structures of Roman life irreversibly. Their effects on the city are hard to read except in one sense: the imperial brick-works were reorganized and the mighty machine of the *cura operum publicorum*, the public works commission, sprang back into action – only now the artisan-ate operated under compulsion. For a while the imperial granite and porphyry quarries in Egypt again filled orders from Rome for large columns, statues, and sarcophagi. The material benefits of this minor renaissance accrued mostly to the monumental center. In 283 Rome experienced another damaging fire, this one at the Forum's northwest end. Diocletian and Maximian restored the Curia and parts of the adjacent Forum of Caesar, the Temple of Saturn, the Basilica Julia, and the Rostra, eventually augmenting the latter in 304 with five statue-crowned columns celebrating the current tetrarchs and, at the center, Diocletian, who retired that year after two decades as emperor. The opposing Rostra in front of the Temple of Divus Julius also acquired columns on a sim-ilar scale, and the southwestern flank of the Forum too (Figs. 91, 92).

This kind of attention to the city was only to be expected. But the crowning glory of Diocletian's building program was a monument of munificence: a vast bath-gymnasium complex on the Viminal plateau modeled on those of Trajan and Caracalla (Figs. 93, 94). Its water supply, an augmentation of the Aqua

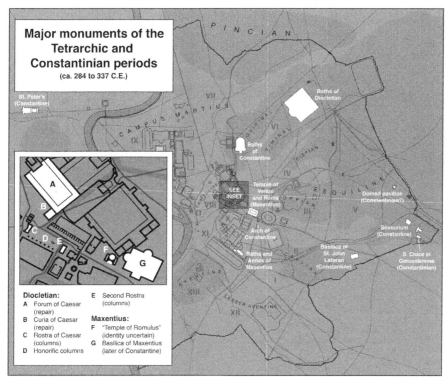

Major monuments of the Tetrarchic and Constantinian periods
(ca. 284 to 337 C.E.)

St. Peter's (Constantine)

Baths of Diocletian

Baths of Constantine

Temple of Venus and Roma (Maxentius)

SEE INSET

Domed pavilion (Constantinian?)

Arch of Constantine

Sessorium (Constantine)

Baths and Annex of Maxentius

Basilica of St. John Lateran (Constantine)

S. Croce in Gerusalemme (Constantinian)

Diocletian:
A Forum of Caesar (repair)
B Curia of Caesar (repair)
C Rostra of Caesar (columns)
D Honorific columns

E Second Rostra (columns)

Maxentius:
F "Temple of Romulus" (identity uncertain)
G Basilica of Maxentius (later of Constantine)

91.

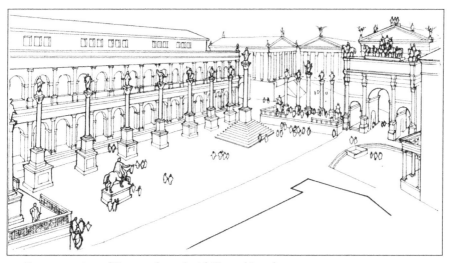

92. Reconstruction of Forum adorned with Tetrarchic columns.
Source: Claridge 1998. By permission of Oxford University Press.

Marcia, represented the first significant improvement to the aqueduct system in 80 years. The architecture's state of preservation is stunning; today the central bath block hosts the church of S. Maria degli Angeli and the Museo delle

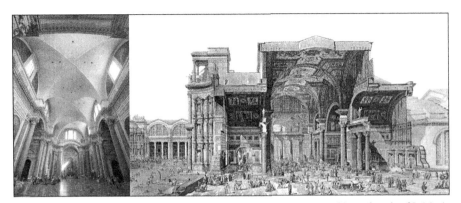

93. Cutaway reconstruction of Baths of Diocletian; *frigidarium* converted into church of S. Maria degli Angeli by Michelangelo.
Source: After E. Paulin. D'Espouy and Seure 1910–1912.

94. Aerial view of Baths of Diocletian and Piazza della Repubblica. Stazione Termini at far right.
Source: Photo: SF Photo/Shutterstock.

Terme. The colossal granite columns and most of the vaulting in the church's transept, formerly the central *frigidarium*, are original. Almost the entire footprint of the complex and many of its vaulted halls remain impressed in the modern city fabric. Piazza della Repubblica itself is defined by the huge semicircular exedra of the baths' southwest platform (Fig. 94).

This is all very fine; but the aggressive building program, authorized by absentee emperors and probably financed in part by Aurelian's wine revenue,

may have been little more than a smokescreen to obscure the systematic politi-
cal marginalization of Rome. Diocletian, whose anniversary jubilee marked
his only visit to Rome, reportedly departed in ignominious flight. When word
arrived in 306 that Galerius planned to eliminate Rome's traditional exemp-
tion from tax privileges and remove its resident Praetorian cohorts, the city
erupted. The tide of anger lifted Maximian's son Maxentius (306–312) into
power. His reign as self-proclaimed *Augustus* of the West was marked above
all by the sincere attention he gave to Rome, where he lived and held court,
even building a palatial villa with a full-scale circus on Via Appia. A small but
intense fire, perhaps around 306 or 307, damaged the lower Forum; it con-
sumed Hadrian's Temple of Venus and Roma and the Horrea Piperataria.
Maxentius' energetic response may have inspired his unique personal epi-
thet *conservator urbis suae*, "Custodian of his City" (see Fig. 91). The temple,
which had special symbolic value for Rome, was rebuilt on a new design,
its back-to-back chambers barrel-vaulted in concrete (see Fig. 64). A modest
rotunda, traditionally called the "Temple of Romulus" but of uncertain iden-
tity, went up along roughly the same frontage line as the Temple of Antoninus
and Faustina to its northwest, leaving a gap (corresponding to the prehistoric
Sepulcretum) between. Aligned with it to the southeast, there arose one of
the most formidable monuments of antiquity: a titanic "basilica" modeled on
the triple-cross-vaulted *frigidarium* design of the imperial baths (Fig. 95), but
its side bays connected, like aisles, by arches piercing the dividing piers. Any
function ascribed to this building, apart from sheer rhetoric, seems almost
immaterial; but it may have housed, rather too magnificently, the office of the
urban prefecture, which was steadily acquiring near-absolute control over city
administration. If so, then Rome could hardly have asked for a more flamboy-
ant "city hall" – a construct, incidentally, with no real meaning in antiquity, and
thus strangely suited to this outstandingly impractical building.

Such ostentation had a price. Owing to the Tetrarchic revival of the build-
ing industry, Maxentius could rely on an ample supply of bricks, mortar, and
concrete. But certain prestige stones could no longer be procured from abroad.
Rome's stocks of colored marble – green Carystian (*cipollino*), purple-streaked
Phrygian (*pavonazzetto*), yellow Numidian (*giallo antico*), brecciated Lucullan
(*africano*), and many others – were gradually becoming zero-sum commod-
ities. Egyptian porphyry and granite would soon follow suit. Henceforth,
if a project required large columns, they would have to be ransacked from
other buildings. Conceivably, Maxentius commissioned the eight colossal,
gray-streaked Proconnesian marble columns erected in his basilica, since their
quarries on the island of Proconnesus remained in operation. But such a req-
uisition would have taken years to fill at enormous expense. Maxentius was
on a wartime budget and in a hurry: the basilica's great vaulted roof could not
be built until the columns were in place. Since he resorted to *spolia* (despoiled

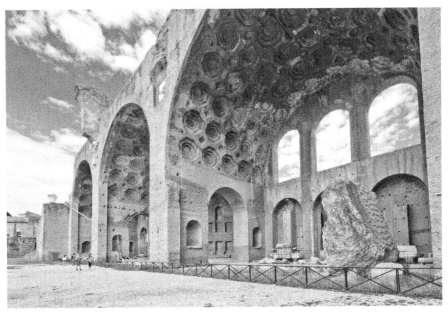

95. Ruins of Basilica of Maxentius.
Source: Photo: V. Lopatin/Shutterstock.

materials) even for his much smaller rotunda (the "Temple of Romulus") next door, the likely conclusion is that these 54-foot columns were secondhand – taken, we surmise, from Hadrian's hulking Serapeum on the Quirinal Hill (see Fig. 63), which had fallen on hard times. Perhaps another fire had damaged the Quirinal, for Maxentius seems to have cleared the area adjoining the Serapeum for a new bath complex later finished (and claimed) by Constantine. This may well have been the opening gambit in a centuries-long game of strip mining old buildings to adorn new ones.

Maxentius' reign came to a famous end at the Battle of the Milvian Bridge in 312 when Constantine's forces, inspired by their leader's vision of a heavenly christogram, routed his army by Via Flaminia on the right bank of the Tiber. The new master of Rome would prove just as attentive to the city as his predecessor, but in very different ways.

The great model of Rome in the age of Constantine, supervised by Italo Gismondi in the 1930s, is justly famous (Fig. 96). Yet in its exquisite perfection it is doubly deceptive, for it feigns both completeness and completion: completeness, in the sense that it patches enormous gaps in our knowledge of the city with a kind of artful photoshopping of plausible-looking urban fabric; completion, in that it strips away any symptoms of emergence and decay. This is a dream city that has reached perfect, ineffable fruition: as the Italians would say, *tutto a posto*. It intimates a teleology: the imperial city we are beholding, from our celestial perch, has reached its destiny. It is all downhill from here.

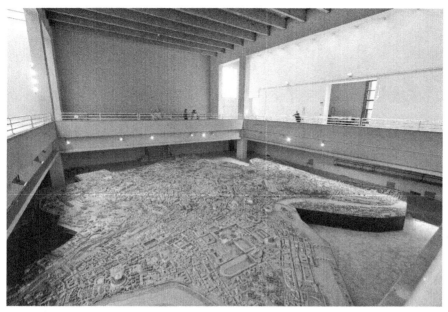

96. Model of ancient Rome.
Source: Museo della Civiltà Romana.

Occasionally the model has been updated, but its changes are inevitably just
perfection in a new guise. It presents a Rome utterly bereft of process – the
dying, birth, illness, injury, scarring, healing, and remaking to which all cit-
ies, districts, and neighborhoods are subject – at a moment in history (like
Gismondi's own, the Fascist era) when Rome experienced convulsions of
change. The truth is radically different. Work yards for the Christian basili-
cas soon to rise on Rome's edges abounded with the columns, entablatures,
and stacks of marble sheathing stripped from once-proud buildings. Where
are their morose carcasses on Gismondi's model, or the works in progress?
Even Constantine's triumphal arch (or was it originally Maxentius'?) on the
Sacra Via (Fig. 97) despoiled at least three imperial monuments, two of them
celebrating the most revered of Roman emperors, Trajan and Marcus Aurelius.
Were these reliefs ransacked locally, or farther afield? Rome was still a pagan
city at this time, and it was still looked after: apart from the Serapeum and
its vicinity, which must have suffered some unspecified disaster, temples and
their cults went on as they always had. Constantine had no legal recourse to
go after public or sacred buildings anyway; nor would he have wanted to. His
principal source of prestige stones must have been the villas and houses of the
diminished aristocracy, which he would have patiently purchased "for parts,"
as it were. This may be evident in the fact that the largest monolithic column
shafts at his disposal, the 24-footers in the nave of St. Peter's, were well under
half the height of Maxentius' megaliths.

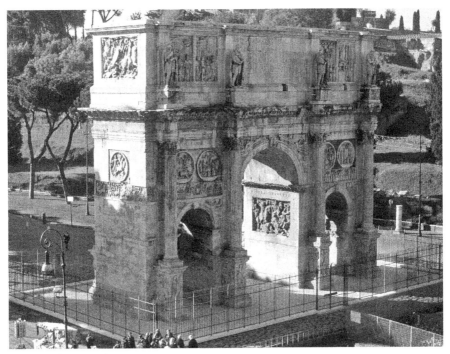

97. Arch of Constantine.

Rome had no teleology. Its landscape was perpetually textured by districts and buildings in decay, under construction or renovation, or in some indeterminate state. Like other cities, it wavered between decline and emergence, loss and renewal. This was the norm, punctuated at intervals by calamitous disasters. Sparkling new forms always coexisted with others in disrepair or dereliction. But by Constantine's age, contrary to Gismondi's sterilized fantasyland, something had changed fundamentally. Now dismemberment had become systematic, targeted, and amply scaled to clothe new monuments in fitting grandeur. Over time this tendency accelerated as an undiminished appetite for antique marbles to encrust new churches, palaces, and aristocratic mansions contended with the reality of a decimated supply network. The imperative of reuse – *translatio* – encouraged a new aesthetic in which the repurposed elements, their lively heterogeneity repudiating the accustomed uniformity of the orders, took on new metaphorical potential in their ecclesiastical contexts.

In the mid-third century Christians formed a prominent community in Rome, but at some 30,000–40,000 strong, hardly a dominating presence in a city that even in the depths of crisis was home to perhaps 20 times that number. But the era of exponential growth for Christianity empirewide had begun; one plausible estimate counts Rome's Christian population at 200,000

by the time Constantine had his celestial vision half a century later. It was still a minority, though – perhaps one in four. Despite the overheated narratives of martyrologies, the empirewide Great Persecution of Christians from 303 to 311 leaves a surprisingly small footprint at Rome, and virtually none at all after Maxentius took power in 306 with a proclamation of tolerance. In fact, the shortage of local martyrdoms was so keenly felt by later Christians that they purloined stories from other regions; thus the *Passio sanctorum quattuor coronatorum*, celebrating the stonemason-saints still venerated in Rome as the church of SS. Quattro Coronati, somehow manages to transpose their story from Egyptian Mons Porphyrites, where the four men were condemned to hew colossal columns for Diocletian's building projects, to Rome, where they were purportedly martyred and buried at the catacombs of SS. Marcellino e Pietro on Via Labicana.

The renewal of the city's core in the early fourth century was largely Maxentius' achievement. Constantine left his predecessor's projects alone, doing only what was necessary to complete them, consolidate them, and take credit for them. He registered no resentment against the city or its pagan core; after all, these projects beautified Rome, employed its people, and reasserted its self-respect by boosting the importance of the urban prefecture and the *cura operum publicorum*. And he needed this stability and continuity to undertake his own grand building scheme, which was largely self-funded and suburban. We refer to the great martyrs' basilicas he established along the highways radiating from the city. Constantine's strategy was to reassert Rome's status as the *caput mundi* by encircling it, in effect, with a crown of thorns.

Located at the tombs of Rome's most revered martyrs, great basilicas became attractions along a pilgrimage circuit. The route started at Ostia, where as a kind of spiritual appetizer for pilgrims, Constantine founded churches of Peter, Paul, and John the Baptist – the dedicatees of the three greatest churches he founded at Rome. Upriver, the circuit included St. Peter's northwest of the urban core; S. Paolo fuori le Mura to the south; S. Lorenzo fuori le Mura and SS. Marcellino e Pietro to the east. Two others, S. Sebastiano to the southeast and S. Agnese fuori le Mura to the northeast, may have been founded shortly after Constantine's death. (Another basilica, just northwest of S. Sebastiano, may be dedicated to Pope Mark [336], who died a year before Constantine.) Only two Constantinian basilicas were intramural but they too avoided the urban core. St. John Lateran, Constantine's first church project, was designated Rome's cathedral. Built directly over the headquarters of Maxentius' Praetorian cavalry, it occupied imperial property on the outer Caelian and thus posed no legal obstacle. Nor did S. Croce in Gerusalemme, founded in the 320s by the emperor's mother, Helena, at her palatial *horti* (the Sessorium) nestled in the easternmost reentrant of the Aurelian Wall (see Fig. 80). We do not know by what legal recourse Constantine appropriated land for the others, or destroyed an entire

98. Plan of St. Peter's and known extent of its underlying cemetery with hypothetical plan
of Circus of Gaius and Nero. Actual disposition of the circus is disputed.
Source: Hesberg 1987. By permission of Bayerische Akademie der Wissenschaften.

cemetery sector to undergird St. Peter's. Founding this church was an exorcism
of sorts – a negotiation of space simultaneously hallowed and accursed.

The early veneration of the apostles Peter and Paul at Rome was compli-
cated by competing claims to their material presence. By the third century
each saint had an established shrine on the site of his later basilica – Paul on Via
Ostiensis and Peter on Via Cornelia in the Vatican – and simultaneously at the
S. Sebastiano catacomb along Via Appia. But only the former shrines, called
"trophies," endured past the fourth century, by which time they were encased
in enormous basilicas. A trophy (*tropaeum*) is a victory monument; indeed, the
traditional triumphal route culminated near a famous trophy site – the Temple
of Jupiter Feretrius on the Capitoline, where Romulus had reportedly dedi-
cated Rome's first *tropaeum* in its initial triumph. The processional route to
St. Peter's was a path for the new *triumphator* – the pope, Peter's heir, solemnly
ratifying Constantine's vision on the eve of battle: *"In hoc signo vinces."* Yet even
in this district the triumph of Christus was incomplete until at least the 390s,
when a neighboring pagan sanctuary, the Phrygianum, was finally closed. The
spring festival of its cult of Cybele and Attis, marked by a notoriously bloody
sacrifice just around Easter week, was a particular affront to Christians.

Peter's trophy, a simple columnar shrine of the mid-second century, occu-
pied a small courtyard within a traditional street of mixed pagan and Christian
tombs that were overrunning Nero's abandoned circus along Via Cornelia.
Burying the tombs in earthworks but leaving the shrine free, Constantine's
builders raised a tremendous five-aisled basilica atop them (Fig. 98). The shrine
fronted the apse under a canopy supported by magnificent imported twisted
columns. The hundreds of other columnar elements of the basilica were sec-
ondhand. Out in front was a rectangular colonnaded atrium; in its center, at

some indefinite time, there appeared another canopy. This enclosed a second trophy: a huge bronze pinecone adapted into a fountain (see Figs. 133, 185). The pinecone's origins are unknown, but the best conjecture is that it was a symbol of the god Attis snatched from the neighboring Phrygianum after its demise in the waning of the fourth century. With its pagan symbolism so brazenly reappropriated, it contended meaningfully with its pendent enshrined in the sanctuary: every pilgrim would behold this neutered emblem of a vanquished cult before entering to pay tribute to the victor.

BIBLIOGRAPHY

Bowersock 2005; Brenk 1996; Castagnoli 1992; Coarelli 1986, 1999; Cullhed 1994; Curran 2000; Daguet-Gagey 1997; Drijvers 2007; Dumser 2005; Dyson 2010; Ensoli/La Rocca 2001; Giavarini/Amici 2005; Hansen 2003; Holloway 2004; Hopkins 1998; Kalas 2015; Kinney 2005, 2010; Krautheimer 1983, 1993; Marlowe 2006, 2010; Monaco 2000; Moss 2013; Pensabene 1993; Rubin 2004; Spera 2003; Steinby 1986; Taylor 2004; Toynbee/Ward-Perkins 1956, 1984; van den Hoek/Herrmann 2013.

FIFTEEN

TROPHIES AND *TITULI*: CHRISTIAN INFRASTRUCTURE BEFORE CONSTANTINE

BEFORE CONSTANTINE ARRIVED IN ROME, THE WORSHIP OF CHRIST HAD already found some favor among the Roman elite. There may also have been a loose confederation of small *domus ecclesiae* ("houses of the church," or house-churches) within the city and extramural cemeteries sponsored by prosperous Christians. But a cohesive Christian institution with an administrative infrastructure – what we call the Church, with a capital C – may only have developed after Constantine. In fact, Rome's *domus ecclesiae*, extrapolated from later literary sources, have eluded archaeological corroboration. Yet they must have existed, even if their importance, especially among elite worshippers, has been exaggerated. Shops and other venues suited to lower-status Romans, who constituted the great majority of Rome's Christians, would also have hosted informal congregations. Above- and belowground cemeteries proliferated outside the Aurelian Wall and "trophies," *memoriae*, were set over the newly built tombs of notable martyrs in them; these became sites for ritual enactment and important processional destinations. Burial places, known as *areae*, were dispersed along major consular roads. Some were extensive underground catacombs; others held freestanding sarcophagi, mausolea, or rows of simple graves presumably topped by movable funeral tables (*mensae*).

Over time the Church, needing to confer administrative uniformity on the observances of the faith and a clear environmental order among the separate loci, took issue with these extemporaneous and diffuse practices. Although it may eventually have acquired sites already marked by Christian use through

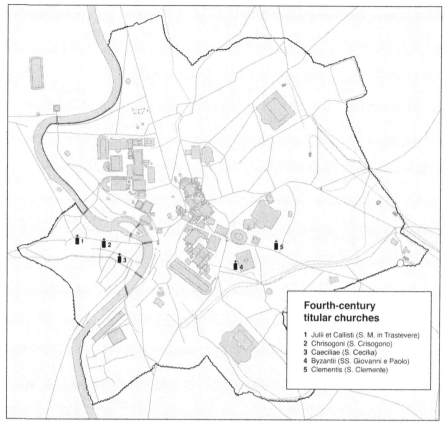

**Fourth-century
titular churches**

1 Julii et Callisti (S. M. in Trastevere)
2 Chrisogoni (S. Crisogono)
3 Caeciliae (S. Cecilia)
4 Byzantii (SS. Giovanni e Paolo)
5 Clementis (S. Clemente)

99.

bequests or purchase, this does not imply a physical master plan for Rome at this time. Rather, as more private property passed to the church, its authority over rituals, burials, and the spaces accommodating them gradually centralized so that, for example, specific churches became allied with specific cemeteries, often establishing physical proximity and sharing officiating clergy with them.

A list generated at the synod (church council) of 499 mentions 25 administrative parish churches in Rome. Known as *tituli*, from the Latin meaning "legal title" or simply "inscription," each reputedly had its own clergy and cardinal. It was long believed that some *tituli* were pre-Constantinian, their primordial remains underlying the later basilicas; but as with the claim for *domus ecclesiae*, archaeological confirmation eludes us and literary testimony is untrustworthy. Many of these churches may have developed independently and haphazardly, acquiring their "titles" only later, when an ecclesiastical infrastructure had developed to systematize them.

Three fourth-century churches later called *tituli* – *Crisogoni, Callisti*, and *Caeciliae*, all in the Transtiberim – stood in relative proximity along important highways (Fig. 99). The Transtiberim was a crowded quarter, a hotbed of

populism and exotic religions where Christianity found an early home. A constant flux of outsiders poured into the area. Artisans, sailors, potters, tanners, the millers of the Janiculum who ground the grains of Africa in mills turned by the waters of the Aqua Traiana – these were its primary residents. The sailors of Ravenna had their barracks here and the tanners' guild its headquarters. Temples to Syrian gods such as Jupiter Heliopolitanus were established on the slopes of the Janiculum. This was also the Jewish quarter and may have contained several of Rome's 11 attested synagogues.

Via Aurelia ran immediately north of the church of S. Crisogono as it approached the Pons Aemilius. Founded by Pope Sylvester (314–335), the church (apparently built into a dye works rather than a house) stood across from the barracks of the seventh cohort of the fire department (see Fig. 34). Also on Via Aurelia but farther west, the Titulus Julii et Callisti stood under what is now the Basilica of S. Maria in Trastevere. Built as early as the second quarter of the fourth century, it adjoined a *domus ecclesiae* – or so tradition has it. Sources attribute the church to Pope Julius I (337–351); the report of an earlier sale of the land by Pope Callixtus (217–222) may be a fabrication. The third of these, the Titulus Caeciliae, stood east of S. Crisogono, set in a superblock defined by Roman streets on all four sides including Via Portuensis to the east. The present ninth-century church rose over a fourth-century *titulus* inserted into a second-century apartment block where reputedly Pope Urban I (222–230) built a church to St. Cecilia in 230. The physical histories of the *tituli* have been churned into the city fabric even as the busy trowel of fable has obscured their institutional origins.

The Titulus Byzantii (or Pammachii), the present church of SS. Giovanni e Paolo, stood on the Caelian – a hill that acquired great significance during the medieval period. Founded in the early fifth century, it was built over two Roman houses, one an *insula* with shops, the other a *domus* with a bath. Situated on the westernmost brow of the hill, it fronted upon the Clivus Scauri, an important third-century street ascending sharply from the valley between the Palatine and the Caelian and down again toward Porta Metrovia at the Aurelian Wall. Many important houses as well as military and police barracks, a big market, and brothels fronted upon this street; it was not exactly an exclusive district. Probably shortly before 250, the *insula* was merged (at least in the upper stories) with the small *domus*. A large hall on the upper floor may have been used by the mid-third century as a meeting place for Christians – though this identification, like so many others regarding early-Christian Rome, has been vigorously challenged.

At the opposite end of the hill, the Titulus Clementis stood in the middle of a block. The fourth-century church sits on a first-century public building remodeled in the third century and a *mithraeum* (a gathering place for followers of the god Mithras), which lies under the apse. A large open hall in the middle

of the third-century structure may have been remodeled as a meeting place for Christians. The present Via di S. Giovanni in Laterano, which passes alongside the church and was certainly located there in the Middle Ages, may have existed in antiquity as well. Even if these were pre-Constantinian *tituli*, which is unlikely, then Christians of that period obviously lived in areas of considerable social and ethnic diversity. Except for the fact that they stood along major roads, these early *tituli* (and those that soon followed) never constituted any kind of system, either in the framework of the 14 Augustan regions, or in the pattern of heavily populated areas. The teeming Subura counted no known *tituli*, for example, whereas Transtiberim had three.

Outside the city, cemeteries and the martyrs' tombs set within them developed into places of ritual – but gradually. Early Christians accepted Roman attitudes toward burial: it was a private family affair, independent of municipal planning and free of state interference. One could be buried in an *area* or in the occasional catacomb according to one's family affiliation. Family groups included slaves and freedmen, regardless of differences of faith; so Christian burials were interspersed among others. According to the dominant tradition, Peter and Paul, the early Christian heroes, were both buried in mixed *areae*.

As with the *domus ecclesiae* and the *tituli*, recent scholarship has demythologized the catacombs. No longer are any of them regarded as exclusive enclaves of Christian burial; nor does Christianity speak to their origins. And while certain catacombs were once thought to have had close connections to certain *tituli* and their neighborhoods, the associations no longer seem so clear. Moreover, the already universal practice of inhuming rather than cremating the dead did not emerge from Christian rite. The expansion so famously exemplified by the catacombs met *everyone*'s needs. As Rome Christianized, so did the catacombs; but both did so incrementally. Catacombs often took advantage of abandoned *pozzolana* quarries, in part because the ground was easy to work. Unlike open-air cemeteries – where the land was soon used up and property values or ownership patterns may have deterred expansion – they were readily extendible, both laterally and vertically. The catacomb of Domitilla alone has a total of about 12 kilometers of underground galleries (see Fig. 85).

The desire to preserve family identity and mitigate the cost of private burial led to the development of catacombs in the high imperial era. The catacomb with the earliest documented Christian connections was that of St. Callixtus, a public cemetery built for the community (Fig. 100). According to later sources, it was sponsored by Pope Zephyrinus (198–217) and administered by Callixtus before his papacy. Callixtus himself is not buried there, but this catacomb in time enshrined several deceased popes, as did others like that of Priscilla. Although most catacombs appear to have been privately administered, and many may have originated on imperial property, the

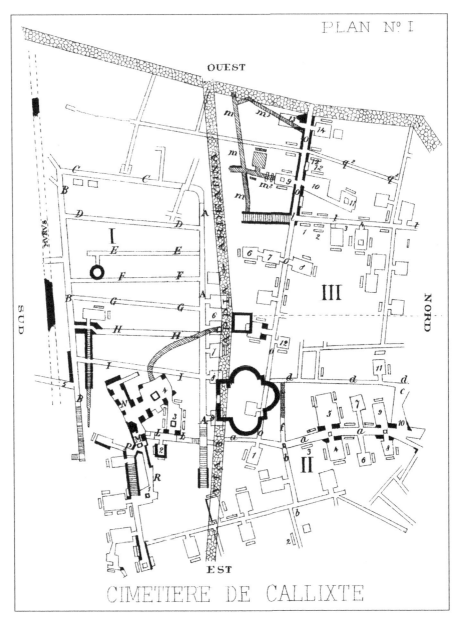

100. S. Callisto cemetery.
Source: Nortet 1900.

post-Constantinian Church began to consolidate sections of underground galleries, and perhaps small *areae*, into more general systems of burial environment that reflect the early attempts of the Church as a corporate entity to own and control property for its own uses (Fig. 101).

The physical development of the pre-Constantinian catacombs of Rome is fairly clear. The underground galleries, while somewhat erratic, formed a

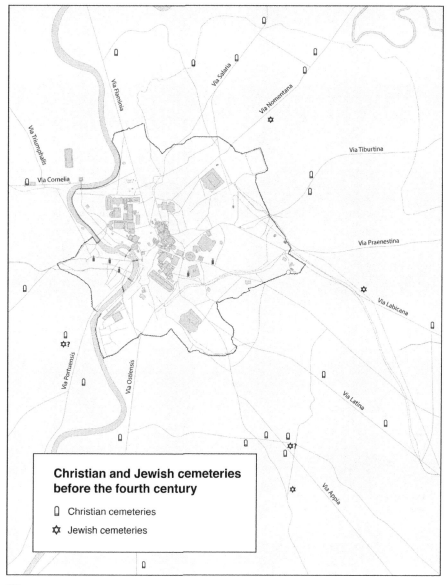

101.

system of streets and cross-streets that could be extended when necessary (see Fig. 85). Over time several stories were connected with narrow ramps or stairs so that increasing demand for space by the fourth century led to the complex maze of corridors that we see today. The most common burial plot was the *loculus*, a shelflike niche cut into the walls of the galleries (Fig. 102). Square or polygonal rooms (*cubicula*) branched out from the galleries for the more well-to-do (perhaps for the sponsor's family), whose burials were set in larger arched niches called *arcosolia* (Fig. 103).

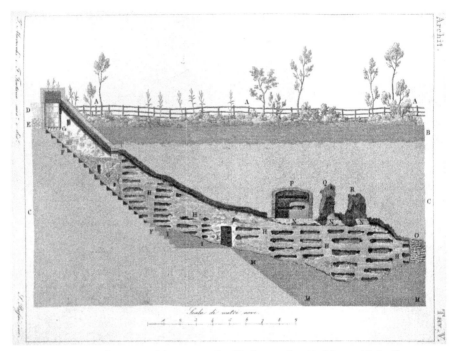

102. Section view of a sector of the catacomb of S. Agnese fuori le Mura with *loculi*.
Source: Marchi 1844.

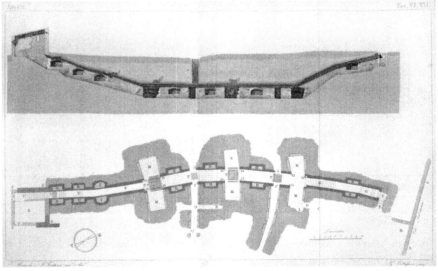

103. Section and plan of an entrance to the catacomb at SS. Marcellino e Pietro.
Source: Marchi 1844.

Catacombs were meant for burial, not regular services; but on occasion, such as an important martyr's or saint's day, Christians held large cemeterial meetings at these sites, probably in the affiliated churches aboveground. The

main function of cemeteries beyond burial itself was to create an environment for ritual visits to the tombs and for the funeral meals associated with them, which were mostly private family events. Some tombs had *mensae* for this purpose, with a hole to pour libations into the grave; others had a more elaborate setting, such as a tomb chamber with mourners' benches.

Martyrs were everybody's dead. Their tombs were well known to the community and they received special treatment. Their shrines were more or less elaborate, with some space around them and a monument to mark the site. The most famous were the trophies of Paul on Via Ostiensis and Peter at the Vatican. The church of S. Paolo fuori le Mura occupies an area rich in *columbaria;* purportedly Paul was originally buried here after his martyrdom. His sarcophagus was found in 2006 beneath the main altar embedded in restorations completed by the emperor Theodosius I in 390 and then covered over after an earthquake in 443. At this time a marble plaque with the inscription PAVLO APOSTOLO MART ("To Paul, Apostle and Martyr") was placed over the sarcophagus. The plaque contains a round hole that seems to preserve the pagan practice of pouring libations into graves.

The trophy ascribed to St. Peter at the Vatican appears to date to 160–170, about a century after the apostle's presumed martyrdom (see Fig. 98). The Christian burials here were potent symbols that neutralized the memory of Nero's notorious games and his martyrdom of Christians. Originally the site was used for simple inhumation burials in a manner contrasting sharply with the elaborate family tombs of the rest of the Vatican cemetery. Some of the earlier tombs were cut into the slope of the hill, while later, more elaborate ones, like those at the Santa Rosa cemetery recently discovered under a Vatican parking lot, stood at a higher level due to the terracing of the slope. Peter's shrine was carefully maintained through the third century. Graffiti recording simple prayers of pilgrims for the well-being of their relatives and friends suggest the continuity of a pre-Constantinian martyr cult, but apart from one disputed partial graffito there is no mention of Peter himself.

A *memoria* to Sts. Peter and Paul, located beneath the church of S. Sebastiano on Via Appia, dates from 258. According to early tradition (and early Christian graffiti at the site) their bodies were buried here temporarily after their martyrdom. By the fourth century, the site was hosting a celebration of Peter on the joint feast day for both martyrs (29 June), while Paul's feast was held at his tomb on Via Ostiensis. The Via Appia catacomb's origins go back to the first century C.E., when a subterranean *pozzolana* quarry was cut into the steeply sloping sides of a valley. Later a series of three tombs was built, partly aboveground and partly into the hillside, their lower chambers reached by stairs that accommodated earlier tombs in this area. Over time the ground level rose and buried the three tombs. The north side of the complex is bounded by the *columbaria*; the west, by an enigmatic building that was probably a place of

reunion for visitors. At the northeast corner of the enclosure was a large room, the Triclia, a funeral banquet hall that overlooked a paved courtyard and steps that led down to a water tank cut into the rock.

This then is the built environment of Christianity in 312, the year of Constantine's vision and his subsequent victory at the Milvian Bridge: some dwellings or commercial spaces adapted for congregations, perhaps a few *tituli*, and some public cemeteries specifically dedicated to Christian burials with *memoriae* above- or belowground, maintained and venerated with special rituals. Not an elaborate or ambitious architectural arrangement, certainly nothing monumental for a city with a population of some 800,000, to be sure; but it had enough ritual authority to condition the development of the Christian city in the coming centuries.

BIBLIOGRAPHY

Adams 2013; Bosio 1632; Bowes 2008; Brandenburg 2005; Camerlenghi 2007; Colini/Gismondi 1944; Curran 2000; Duchesne 1886–1892; Ferrua 1975, 1990; Filippi 2004; Fiocchi Nicolai 2009; Fiocchi Nicolai/Pergola 1986; Gregorovius 1894–1902; Hillner 2007; Johnson 1997; Krautheimer 1969, 1975, 2000; Lampe 2003; Leon 1960; Liverani 2010; Mazzoleni 1975; Mulryan 2014; Pani Ermini 1972; Pergola 1998; Rebillard 2009; Snyder 1985; Sordi 1965; Spera 2003; Sperandio/Zander 1999; Testini 1970; Thacker 2007; Tolotti 1970; Toynbee/Ward-Perkins 1956; Valentini/Zucchetti 1940–1953; Vielliard 1959; Vismara 1986; White 1990.

SIXTEEN

WALLS MAKE CHRISTIANS: FROM FOURTH TO FIFTH CENTURY

C ONSTANTINE'S LEGALIZATION OF CHRISTIAN WORSHIP USHERED IN A FRESH environmental order that would soon support a new political and social era – one that gave the empire a historic challenge, and for the constructive energies of the imperial machinery, a program of vast scope and diversity. Forging a theater for the new state religion was both open-ended and restricted by Christian precedent, creating architectural and urban innovation that was simultaneously tradition breaking and conservative. The shape this willed ambience of devotion would take was not prescribed. Constantine's actions would shake the world; and the official Christianization of Rome's built fabric, for all its logic, has something of the revolutionary and astounding about it.

Consider this. The generation born in Rome at the turn of the fourth century would have witnessed, within its lifetime, the new monumentality of the Roman countryside, where, by midcentury, new, expansive cemeterial basilicas, visible from afar, protected the martyrs' graves and loomed along the consular roads a mile or two beyond the Aurelian Wall. The Lateran quarter became a busy administrative and ritual nucleus that contrasted sharply with its sedentary, heretofore almost rural existence. Unfamiliar traffic patterns within and without the city directed people toward these very magnets of urban life. The great military garrisons such as the Castra Praetoria had been closed and some others demolished, and the Palatine's bureaucratic bustle quieted. St. Peter's modest tomb forced the unlikely and difficult transformation of the Vatican

district from a quiet suburb to a center of international pilgrimage. Rome was still a familiar city, of course, but in retrospect it seems propelled on an irreversible path of transmutation.

This first crucial period for the medievalizing of Rome – the fourth century – witnessed major building activity. On the secular side there were Constantine's baths, his remodeling of the Basilica of Maxentius, the Basilica of Junius Bassus, new triumphal arches, renovated urban bridges, and a new colonnaded street that traversed the Campus Martius heading toward the Vatican, the so-called Porticus Maximae (see Figs. 91, 104). This impressive colonnaded avenue built between 379 and 383 probably began at the Theater of Balbus and reached the Pons Aelius at Hadrian's mausoleum, giving access to the complex of St. Peter's. And for the Christians, there were the imperial foundations of Constantine and his immediate successors: the Lateran basilica, St. Peter's, and a more modest S. Paolo fuori le Mura (rebuilt entirely on a grander scale by the end of the fourth century), S. Agnese fuori le Mura, SS. Marcellino e Pietro, the Basilica Apostolorum (later S. Sebastiano), and a complex near Via Praenestina annexed to the mausoleum called Tor de' Schiavi. Small-scale urban *tituli* were updated and many new ones created. New architectural forms also appeared: the T-shaped basilicas of St. Peter's and S. Paolo, the standard three-aisled church with apse, the extraordinary conception of the *basilica subteglata* (to be discussed shortly) with its U-shaped plan and special ritual use, and the interesting transformation of older buildings such as the Sessorium Hall into the church of S. Croce in Gerusalemme, and a nymphaeum courtyard complex into the church of S. Pudenziana (Fig. 104).

Spurred by enthusiastic patronage and the resources of the court, Christian imperial programs rivaled the grand building enterprises of pagan emperors. This was not the natural outcome of the early experiments in making ritual places, but a quantum leap, and in a completely different mode. The *tituli* and the cemeteries were, if you will, community design. They started in an improvised way, out of a limited sense of program and a modest vision. The fourth century introduced design by fiat and new structures of enormous size were laid out with unfaltering confidence. The cemeterial basilicas were between 250 and 350 feet long, not counting the huge atria fronting some of them. Building St. Peter's into the slope of the Vatican Hill and creating a platform for S. Lorenzo fuori le Mura meant moving vast amounts of earth. These were programs worthy of their imperial patronage: ambitious in size, broad visioned, well crafted, marble clad, magnificently furnished, and endowed fully for their upkeep and economic security.

Despite a general dependence on non-Christian formulas and conventions, there was a conscious attempt to design new building types easily distinguishable from the familiar landscape of existing architectural forms. This is especially noteworthy because the precise functional requirements had not

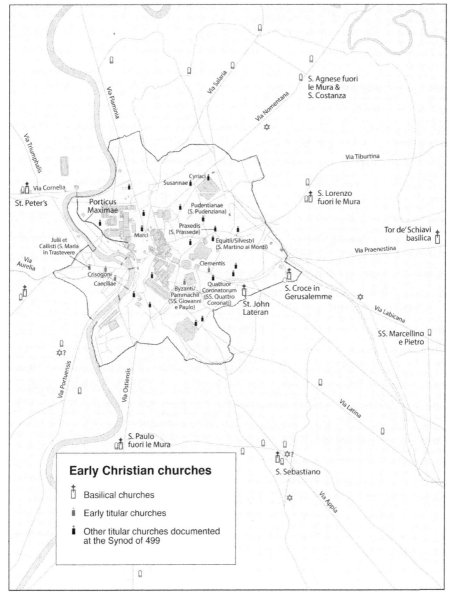

S. Agnese fuori
le Mura &
S. Costanza

Via Salaria

Via Flaminia

Via Nomentana

Via Triumphalis

Via Tiburtina

Cyriaci

Via Cornelia

Susannae

St. Peter's

Porticus
Maximae

Pudentianae
(S. Pudenziana)

S. Lorenzo
fuori le Mura

Praxedis
(S. Prassede)

Marci

Equitii/Silvestri
(S. Martino ai Monti)

Julii et
Callisti (S. Maria
in Trastevere)

Tor de' Schiavi
basilica

Via Praenestina

Via
Aurelia

Crisogoni
Caeciliae

Clementis

Byzanti/
Pammachii
(SS. Giovanni
e Paulo)

Quattuor
Coronatorum
(SS. Quattro
Coronati)

St. John
Lateran

S. Croce in
Gerusalemme

Via Labicana

SS. Marcellino
e Pietro

Via Portuensis

Via Ostiensis

Via Latina

S. Paulo
fuori le Mura

Early Christian churches

Basilical churches

Early titular churches

Other titular churches documented
at the Synod of 499

S. Sebastiano

Via Appia

104.

yet been formulated. Throughout the fourth century, as the Church slowly
tightened control over ritual, this first generation of monuments did not just
respond to clearly prescribed programs and practices; their patterns of use were
influenced by them. For example, the atrium – a colonnaded forecourt resem-
bling those already existing at the Pantheon and imperial fora – often preceded
a basilical church's main entrance. It may have been suggested by the rules of
formal composition first and only later assigned specific liturgical or other
functions (see Fig. 133).

The projects stood along major roads well away from the urban core, all but the Lateran basilica outside the city walls. In one sense, it profited Constantine and his successors enormously that the *loci venerationis* of their adopted religion were in the extramural cemeteries, where they could establish suitably grand cult buildings to the great martyrs without giving obvious offense to the pagan presence at the core. Along with St. Peter's tomb the only other architectural erasure of an earlier regime was the bishop's (that is, the pope's) church and residence at the Lateran, which stood above the new rubble of the Praetorian barracks on a remote hill barely within the walls, far away from the center stage of the pagan city. This remoteness would prove extremely inconvenient in later centuries. There was little doubt about Constantine's claim to the property of the imperial guard: they were the emperor's to dispose of as he wished. S. Agnese fuori le Mura too may have been on imperial lands, and therefore presented no problems of occupation. In short, Constantine acted boldly but also prudently by founding his churches within the domain of a long-established imperial patrimony.

St. Peter's was the only Constantinian foundation requiring forceful interdiction of an active and large cemetery – a *locus religiosus*, in principle considered inviolable and inalienable by law. *Violatio sepulchri* was a serious crime. But as Pontifex Maximus, Rome's supreme priest, the emperor had direct jurisdiction of the cemeteries. He alone could authorize the removal or translation of bodies or the suppression of the cemetery for the public good. Thus Constantine could grant himself permission to acquire the Vatican cemetery. Also, the circus over which the tombs were built had once been imperial property. Even if Nero or a successor had conveyed it to the public, Constantine may have successfully reclaimed the land by the civil procedure of *vindicatio*. Either way, the stakes were probably highest here in the Vatican and this action undoubtedly troubled the non-Christian powers of the city.

A priority was to increase the number of parish churches and improve their strategic distribution within the urban fabric (see Fig. 104). These early structures are traced to the post-Constantinian era, reflecting a systematization that is more in keeping with the later fourth or early fifth century: the tightening liturgical prescriptions of a fast-developing Church (the apse was now a mandatory feature, for example); the suppression of other popular religions such as Mithraism, Christianity's great rival for the Roman soul in the second and third centuries, and whose temples were sometimes co-opted for Christian use; the heightened decorum and prestige of the newly legalized religion; and larger parish populations. The Titulus Callisti (S. Maria in Trastevere) was overlaid by a basilica; the Titulus Clementis (S. Clemente) was rebuilt; and the Titulus Byzantii (SS. Giovanni e Paolo) was handsomely redone. Many new *tituli* of this period seem more evenly distributed than before, with three in the lower Campus Martius, two near the Baths of Caracalla, one flanking

Chiesa di SS Nereo ed Achilleo
1 Terme di Antonino Caracalla . 2 Chiesa di S Balbina, 3 Chiesa de detti SS, 4 Vigna de Padri Gesuiti, 5 Chiesa di S Sisto Papa, 6 Via Nuova .

105. SS. Nereo ed Achilleo.
Source: Vasi 1747–1761, III, 58. Courtesy of American Academy in Rome.

the Palatine Hill, and two on the Esquiline. In some cases there is a coupling of *tituli* – S. Susanna and S. Ciriaco on the Quirinal, S. Clemente and SS. Quattro Coronati on the Caelian, and S. Sisto and SS. Nereo ed Achilleo, both near Caracalla's baths but opposite each other on the street (Fig. 105). This may be more a matter of later coincidence than intentional fourth-century planning, though the presence of baths – ever popular with pilgrims in late antiquity – may have played a role in the convergence. For others including S. Crisogono and S. Maria in Trastevere – and perhaps S. Martino ai Monti and S. Prassede on the Esquiline – the pairing may reflect increased concentrations of Christians in the area. *Tituli*, whatever their number and location, whether new or old, were centers of urban organization, their presence quickening some urban corners and their façades enhancing street architecture. For several decades beginning around 380, for example, the main façades of *tituli* at S. Clemente, SS. Giovanni e Paolo, and S. Pietro in Vincoli featured open colonnades communicating with an atrium or directly with the street (Fig. 106).

Through design, new urban patterns acknowledged the environmental changes brought about by Christianity. The clearest example of this is the recognition of the monumental significance of St. Peter's. In antiquity, the Pons Aelius and the short-lived Pons Neronianus had connected the city to the Vatican playgrounds and cemeteries, but no attempt had been made to cut an artery across the Campus Martius directly to them. Now strapped to the Campus, St. Peter's needed not just an easy passage between the Vatican and

106. SS. Giovanni e Paolo, portico.

the city, but also a triumphal approach worthy of its fame and splendor. This is
what the Porticus Maximae achieved. From its start at or near the Theater of
Balbus, it skirted the Theater of Pompey and continued along the present Via
dei Giubonnari, Via del Pellegrino, and Via dei Banchi Vecchi until the Piazza
Sforza Cesarini, where it forked. The main branch then headed north to the
Pons Aelius. This path would become part of the ceremonial Via Papalis, the
Pope's Road. Stretching from the Vatican to the Lateran, it would remain the
most important processional route through the eighteenth century.

St. Peter's, S. Agnese fuori le Mura, S. Lorenzo fuori le Mura, the anonymous
basilica and catacomb at Tor de' Schiavi (which may not even be Christian),
SS. Marcellino e Pietro, and the Basilica Apostolorum, now dedicated to S.
Sebastiano, were cemeterial foundations outside the walls, but only St. Peter's
was well placed in relation to the city. Facing east, it invites formal approach
from the city by way of the Pons Aelius and down Via Cornelia, which may
have been on axis with it at the time of Constantine. The Porticus Maximae
was a monumentalized western extension of this route across the river.

Knowing the intended uses of these extramural cemeterial basilicas informs
us about the frequency and density of traffic that poured toward them, as well
as the environmental order around the buildings occasioned by their purpose.

107. Remains of *basilica subteglata* of S. Agnese fuori le Mura.
Source: © Google 2014.

At the beginning, they were built at the actual tomb, aboveground if it was in an open-air cemetery, or starting at the level of the catacomb if it was underground. Constantine's own installations should be seen in this context, and be understood to have addressed one principal concern – the orderly provision for funeral banquets at these major *memoriae*.

Overpopulation and the sometimes-raucous nature of the funeral banquets in honor of the martyrs and the common dead that surrounded them eventually urged corrective action. The Church responded with new galleries at the older catacombs, adding to their capacity, and wholly new cemeteries to alleviate the crowding of the extant ones. Also, it undertook to identify and rank the martyrs in an attempt to elevate a small number of officially honored saints over others with popular followings.

Generally these imperial foundations had two separate and distinct foci, the martyrium and an adjoining place of congregation. The latter, taking the form of U-shaped *basilicae subteglatae*, were built for the most part as a kind of crowd control at times of maximum use, such as the saint's feast day, when thousands would converge at the small martyrium to eat and drink in honor of the dead. Over time, the martyria had been surrounded with the graves of the faithful who sought eternal rest in the martyr's presence. The basilicas imposed some order on the chaotic and feverish invasions of favored burial areas, themselves accommodating many burials but also channeling the movement of crowds through them in an orderly manner (Fig. 107).

These covered cemetery basilicas almost certainly did not contain an altar at first, their chief ritual furniture being the *mensa*, or offering table. But since

the funeral feasts culminated in a mass, the distinction was a fine one. Probably by the end of the fourth century they functioned as churches to complement their more specialized use, and as such served the suburban populations living nearby. The *mensa*, in short, doubled as altar. This point is important because as centers of general pilgrimage and as churches for suburban parishes, the basilicas gave rise to an extended environment that transformed the Roman countryside. With pilgrims came people who catered to their needs: guides, vendors, innkeepers, and the like. Pilgrimage centers must have had staff to tend them – guards, caretakers, and gravediggers. They and their families needed housing. The officiating clergy, led by the bishop, needed overnight quarters on the eve of important services. Except on major occasions such as Easter, when the pope administered the rite of baptism at the Lateran basilica, nearby resident farmers used the basilicas for regular services instead of travel-ing into town. Over time activity around the saints' tombs and basilicas created settlements that included baths, hostels, porticoes, and even palaces.

The economic basis of the countryside may not have changed much. The emperor and the landed aristocracy had originally shared the immediate extra-mural countryside, the Roman Campagna. Structurally speaking, the basic economy of late antiquity – the cultivation of large estates called *latifundia* – had not changed appreciably, and the Roman drainage and irrigation systems continued to be in use. Since the emperor owned vast territories, the land was often his to give, although the Roman aristocracy also donated land to the embryonic Church and the basilicas were endowed with property, much of it extending around them. Thus by the fifth century the bishop of Rome had become a powerful landowner. But now the land, known as *domus cultae*, was tilled and cultivated not for absentee imperial landlords but for the bishop's administrative apparatus. Endowments included everything upon the land – fields, vineyards, water, and houses as well as movable goods and, by necessity, the tenants who farmed the property. The Campagna was being Christianized as rapidly as the city in the fourth century, perhaps more so, and the Church was beginning to amass territorial wealth that would, in time, become the mainstay of its power and the means for its charitable administration.

Sooner or later, any ruling party will come to see the political advantage of architecture and planning. The Church is no exception. There is a story told of Marius Victorinus, a fourth-century orator who in his old age con-verted to Christianity. His friend and adviser the priest Simplicianus told him one day, "I will not count you among the Christians until I see you in the church of Christ." Marius replied with a wry question: "It is walls, then, that make Christians?" There was a time, long ago, when *ecclesia*, "Church," had meant the community of Christians who had no need of special buildings to proclaim their faith and reaffirm their bonds. The Church was where the Christians were. Christ was the Good Shepherd, with the errant sheep draped

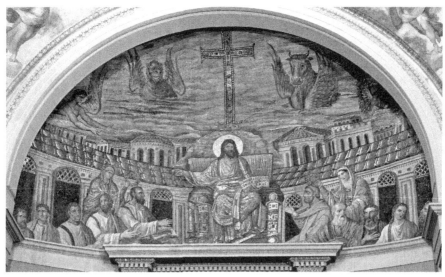

108. Apse mosaic of S. Pudenziana.
Source: Photo: Welleschik. Title: "Apsis Mosaic of Santa Pudenziana, Rome." Wikimedia Commons CCBY-SA 3.0 (http://creativecommons.org/licenses/by-sa/3.0/deed.en). Converted to B&W.

across his shoulders. That time was over. Christ, as he appeared in the 390s in the apsidal mosaic at S. Pudenziana, was now enthroned as a divinity, presiding simultaneously over a splendid heavenly city behind and the gleaming earthly assembly hall before him (Fig. 108). The answer to Marius' rhetorical question was now a definite yes. Walls indeed made Christians!

BIBLIOGRAPHY

Adams 2013; Alexander 1971; Arena et al. 2001; Armellini 1891; Barker 1913; Bosio 1632; Bovini 1948; Brandt 2014; Brandenburg 2005; Castagnoli 1969; Colini/Gismondi 1944; Costambeys 2001; Curran 2000; Duchense 1886–1892; Ferrua 1975; Gregorovius 1894–1902; Harris 1999; Hertling/Kirschbaum 1956; Hoogewerff 1947; Hülsen 2000; Krautheimer 1937–1976, 1969, 2000; Lampe 2003; Lanciani 1892; Lehmann 2003; Liverani 1998; Magnuson 2004; Marazzi 2000; Mulryan 2014; Partner 1972; Rebillard 2009; Redig de Campos 1967; Royo 2001; Sordi 1965; Thacker 2007; Tomassetti 1979–1980; Valentini/Zucchetti 1940–1953; Vielliard 1959; Ward-Perkins 1984, 2005; Webb 2001.

SEVENTEEN

A TALE OF TWO ROMES

W E BEGIN OUR PROCESS OF UNTANGLING THE MEDIEVALIZING OF ROME
with two urban pendants, a pair of images: Rome as it was two or
three generations after the Milvian battle, in the late fourth century, and Rome
in the twelfth century – a long time in the life of any organism, not least
a great city. The point is to show the general structure of late-antique and
late-medieval Rome, and to ask the question, How did we get from A to B?
With what process, speed, and purpose did the city progress, over eight cen-
turies, to a point where untidy and exuberant urban scrub had penetrated and
overgrown the grand order of the imperial capital, without however being able
to obscure it entirely (Fig. 109)?

There are two ways of studying this contrast between late-antique and
late-medieval images of Rome. One is common, and the humanist poet
and scholar Francesco Petrarca (1304–1374), known as Petrarch, was the first
Renaissance writer to encourage it: to view the late-medieval city unfavorably
against the ancient substance of the Constantinian city. His aim was political
and propagandistic – to resurrect the notion of a resplendent classical Rome,
which had been abused and belittled during the Middle Ages. He and later
Renaissance writers assigned themselves the task of giving birth anew to
this classical splendor. Medieval Romans themselves were not taken up with
laments. It was their city and they lived in it, adjusting and reshaping, add-
ing and curtailing, fitting it to their own lives. And that is the second way of
looking at the contrast, to study the vital processes that led from the mighty

109. View of Vatican and Trastevere.
Source: Schedel 1493.

metropolis of the Mediterranean to the different and equally viable city, the
Seat of Peter. We must avoid the mistake of seeing the thousand years of medi-
eval Rome as an unchecked slide from Trajanic or Hadrianic summits toward
physical degradation and collapse. Our goal is to understand medieval Rome,
not to condemn it.

How can we account for a city that during the fourth century was essen-
tially whole but became disjointed, environmentally and socially – an assembly
of more or less independent parts fortified and pitted against each other in the
twelfth century? The flamboyant contrast exists of course only in the imag-
ination. No Roman would have experienced it. Unless autocratically willed,
urban process is slow and insidious. Change and decay come about organically,
in cities as in other living things; their long-term effect is more readily appar-
ent than the vital forces that bring it about. In this way Rome's experience
was similar to the broad pattern of urban behavior in the centuries following
the collapse of imperial order. Depopulation and the concomitant shrinkage
of urban form; disregard for once-extant orthogonal relationships and the cor-
rosion of regular street layouts; the reuse of pagan buildings for contemporary
needs, both as building material for new structures and as ready envelopes for
new purposes – these phenomena can be observed in varying degree in all the
major urban centers of the Roman Empire in the West.

Yet Rome's case is special, in intensity at least if not in essence. It was the
largest and most prestigious of the empire's cities, effectively exporting noth-
ing except power; it was a city of consumers provisioned by the world; and in
its Constantinian transformation, it remained the only city in the West where
imperial patterns were retained and made the basis of the new Christian order.
It was the only city that could count on others to protect its memory and
whose physical and social deterioration was counterbalanced by a continu-
ing preeminence of moral prestige. It remained, despite its own worst efforts,

indestructible. As Pope John XXII (1316–1334) reportedly said, "Whether we wish it or not, Rome will be the capital of the world."

From the fourth century two parallel tendencies had been at work to medievalize Rome: the creation of a new administrative structure, namely, that of the Church, which would counteract the power vacuum created when Constantine moved the imperial court to his new capital, Constantinople, in 330; and the preservation of the prestige of imperial Rome, as an idea if not a practicality. It is these concomitant aims that would determine the reordering and revision of the imperial fabric of the city. However obvious, it ought to be stressed anew that imperial Rome did not submit to the program of the new faith overnight; nor did it regress and decay quickly after 330.

Partisan Church Fathers freely exaggerated the speed and efficiency with which the pagan fabric was exorcised. St. Jerome (ca. 347–420) assures us that "all Roman temples are covered with soot and cobwebs" and that the "gilded Capitoline temple remains squalid and desolate," its rites defunct. The facts are different. Though there had been numerous official injunctions against pagan rites beginning with the reign of Constantine, neither were cults themselves effectively suppressed in Rome, nor did the edicts give license for the neglect or despoliation of their holy places. Bloody sacrifices to Cybele and Attis continued until the very end of the fourth century right beside St. Peter's. The Atrium Vestae in the heart of the Forum (see Fig. 68) discharged its sacred role until the death of the last Virgin in 394. Constantius II, who ordered all temples closed in 356, could visit Jupiter's temple on the Capitoline and praise it without hypocrisy. At any rate, the Christian emperors ordered that temple altars be destroyed, not the temples themselves – and that pagan sacrifices be prohibited but that the temples be "conserved as ornaments of the city." As late as 439, imperial edicts were calling for pagan temples, full of incalculable treasures, to live on as state museums.

Statues were often moved from sanctuaries to adorn public places, but the temples' contents remained largely intact, as did severe sanctions against looting for reusable building materials. Constantine or his successors abolished the office of *curator aedium sacrarum* and placed the temples under the care of the *curator operum maximorum*, as befitted their new role of public monument. At the end of the century, laws forbidding the erection of private structures against sacred buildings were revived; and although temples had been assigned to other public uses and subsidiary buildings once owned by temples were now given to the guilds to use and maintain, no pagan public building was co-opted for Christian use until 526.

Ancient and modern writers alike have overdramatized Rome's physical deterioration. One hears of Alaric, king of the Visigoths, sacking Rome in 410, as the beginning of the end, and the narrative hits bottom as Totila the Ostrogoth takes the city in 546, starts dismantling its walls, and moves the

110. Tenth- to eleventh-century interventions in ruins of Theater of Balbus.
Source: Courtesy of Ministero dei Beni e delle Attività Culturali e del Turismo – Soprintendenza Speciale per i Beni Archeologici di Roma.

senators and their families to the countryside. But the responsibility of these sieges for Rome's physical decay has been exaggerated. The city actually suffered more from earthquakes and fires than from the notorious sacks of Alaric, the Vandals in 455, Ricimer's troops in 472, Odoacer's in 476, and later Totila. Earthquake damage in 408 is easily confused with the effects of Alaric's 410 sack. Fires might have been caused by earthquakes or set accidentally. Pillaging troops are interested in acquiring loot, such as bronze temple fixtures, not laboriously destroying monumental buildings. Churches on the whole were off limits by Alaric's orders; St. Peter's and S. Paolo fuori le Mura were specifically spared, as indeed they may have been again by the Vandals in 455. The truth is that despite earthquakes and three sacks between 408 and the Gothic Wars of 537–538, the emperor, the still-functioning urban prefecture, the Church, and private citizens were able to repair much of the city.

But in the fifth and sixth centuries, as the imperial presence retired altogether from Rome and the urban prefecture declined, repairs became more difficult and the deterioration of the public monuments began in earnest. Earthquakes, floods, and fires continued. Taking advantage of inefficient policing, the local populace stripped public buildings of marbles, statues, and cut stone. To make mortar, they tossed them into limekilns conveniently set within large ruins like the Basilica Julia and the Atrium Vestae in the Forum, and the area called Calcarario within the old Theater of Balbus (Fig. 110).

Finally, when the Ostrogothic commander Vitiges cut the aqueducts in his siege of 537, the prodigious flow of water into the city was reduced to a trickle. The public baths closed and many people abandoned the hills and drew closer to the major source of water, the Tiber. Progressive depopulation of the city, a process linked to political instability, famines, disease, and other urban plights, accompanied these displacements. Some parts of the abandoned periphery were turned into stretches of farmland. Even so, Procopius, a historian who accompanied the general Belisarius when he defended Rome against Vitiges' siege, wrote that he knew of no other city "which takes pains to conserve its ancient splendor. Even though having suffered so much from the barbarians, she has managed to preserve and keep her buildings in use. She can show many such monuments, built so solidly that neither the passage of centuries nor lack of care could weaken them."

Nonetheless, between the later sixth and the ninth century, Rome's topography would change drastically, becoming a ghost of its former self, rundown and overgrown. But this obsession with classical Rome limits our curiosity about medieval Rome – a vital and spirited community that if viewed on its own merits emerges as a city of tremendous importance and originality. Like medieval art, its urban morphology is not a debasement of classical precedent but a new expressive language with its own rules and preferences, its own time-spirit. To appreciate this is a welcome antidote to the steady diet of elegy that began with the city's demise in the fifth century and was deliciously sustained for the next thousand years.

One of the most sensible attitudes of medieval Rome was to use its illustrious imperial frame – its walls, road system, and aqueducts – as long as possible. Its greatest imperial legacy was perhaps the Aurelian Wall, a superb buffer that throughout the long, turbulent Middle Ages was more often breached through treachery than by successful assault. The wall had been built at a time when the empire could still command the best construction performance and a ready arsenal of building resources – imperial brickyards, an organized labor force, technical know-how, and long-tested regimentation. The one major disadvantage of the wall was that its circuit was too big for the shrinking city; and so over time some posterns and gates were closed.

Ironically, as medieval Rome shrank within the walls, it extended outside them. Thus many important extraurban complexes such as St. Peter's, S. Paolo fuori le Mura, and S. Lorenzo fuori le Mura – repositories of major wealth and centers of suburban communities – were outside its circuit (Fig. 111). These sites were relatively safe when the aggressors were themselves Christian (as were the East Germanic Ostrogoth and Visigoth tribes who eventually settled in Rome), but the problem became serious when a non-Christian power, the Muslims, whom the Romans called Saracens, appeared in earnest in the ninth century, overpowered the Roman army, and stormed St. Peter's. The

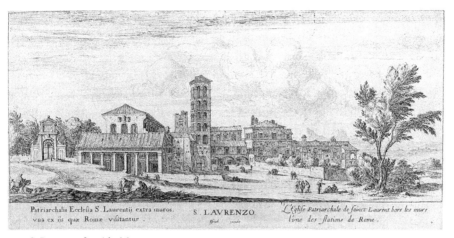

111. S. Lorenzo fuori le Mura.
Source: I. Silvestre, *Les églises des stations de Rome* (1640). Courtesy of Vincent J. Buonanno.

construction of walls around the church and its environs (848–853) and the slightly later fortification of S. Paolo resulted from this disaster.

And so the Aurelian Wall was kept and tended to, and continued to serve admirably until the nineteenth century. Major repairs and augmentations were few and early. Between 401 and 403, with the threat of Alaric looming on the horizon, the emperor Honorius reinforced the towers and gates and raised the curtain walls between them (see Fig. 73). In the sixth century, Theodoric, king of the Ostrogoths (498–526), sponsored some minor work. When Belisarius took charge of the city in 536 he introduced some modern features, including a "deep and noteworthy ditch" with a wide berm that gave ample room for fighting and kept siege engines well away from the wall.

Rome's imperial highways also continued in use, but changing ritual and political conditions affected their hierarchical and functional order. The communities that developed around the cemeterial basilica churches in the immediate periphery needed to connect not only with Rome's center but also with each other. The cult of martyrs brought about a cross-country traffic, from one basilica to the next, as people now undertook general pilgrimages. To accommodate this traffic, a kind of irregular ring road developed, linking the radial consular roads. Sigeric, for example, an English pilgrim who visited Rome in 990, progressed clockwise around the city beginning with St. Peter's and going on to S. Valentino at the Milvian Bridge, S. Agnese fuori le Mura, S. Lorenzo fuori le Mura, S. Sebastiano, S. Anastasio, and S. Paolo fuori le Mura. To do this, there must have been a pattern of connecting roads like Via delle Sette Chiese, which now links S. Paolo with S. Sebastiano.

At the same time, these major pilgrimage centers animated some previously secondary roads, the best example being the approaches to St. Peter's. Some miles north of the Milvian Bridge, as Via Flaminia made its final southward

approach to Rome, a road branched off to the right. This insignificant append-
age now became a principal thoroughfare because it gave the pilgrims a short-
cut directly to St. Peter's and the Vatican.

Political fortunes also affected consular highways. The busy imperial thor-
oughfare Via Ostiensis, for example, continued to be important over several
centuries of Christian rule for two reasons: grain from the papal estates in
Sicily was transported by sea to Ostia's port and thence to the city; and north-
ern pilgrims sometimes chose the sea route from Marseilles to Ostia. But with
Saracen peril on the high seas this southern route lost all strategic importance.
Papal estates reorganized into large farms closer to Rome, the Tiber continued
to silt up the ancient harbors, and new small river wharves were built within
Rome's walls.

The third major determinant of medieval Rome, alongside the wall and
the roads, was the ancient aqueduct system. There had been 11 aqueducts in
all. The last ancient line, the Aqua Alexandrina, was built in 226. By 398/399,
when major repairs were undertaken, the urban prefecture had absorbed this
city department, which continued to oversee the maintenance of aqueducts
and hundreds of public fountains. Some baths too continued in use; those of
Constantine on the Quirinal, for example, were repaired just prior to 443.

The aqueducts had obvious strategic importance. Procopius narrates,
and archaeology confirms, that once Vitiges had cut the aqueducts in 537,
Belisarius thwarted an attempt by the Ostrogoths to enter Rome through the
channels by blocking them with masonry. The fountains ran dry; the baths
became inoperative; and the mills that ground the city's grain on the Janiculum
were incapacitated. This last inconvenience Belisarius set straight by mounting
mills upon rafts and mooring them in the Tiber where the current turned the
wheels. His invention fed Rome for another 1,300 years (Fig. 112). Ironically,
the one aqueduct we know Belisarius later repaired, the Aqua Traiana, is the
very one that archaeology confirms to have remained permanently blocked
where its conduit joined the mills on the Janiculum. The aqueduct had another
artery branching off to the Vatican, however, and this may have been the object
of the restoration.

Pope Gregory I (590–604), known as Gregory the Great, worried at the end
of the sixth century that without care the aqueducts would fall into complete
ruin. Some repairs were undertaken, but the entire system could not be saved.
After the sixth century there was no clear urban administrative jurisdiction,
and the large workforce necessary to clean and maintain the sources and chan-
nels did not exist. As the imperial baths fell into disuse and Agrippa's vener-
able fountains vanished from the streets, Rome grew dependent on intramural
springs, cisterns, wells, and of course, the Tiber (Fig. 113).

Pope Hadrian I (772–795; not to be confused with the eponymous emperor
of the second century) repaired the Virgo, Claudia, Marcia, and Traiana

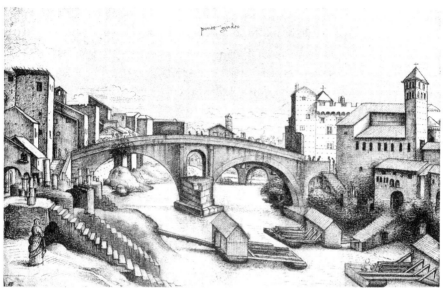

112. Tiber Island mills. Workshop of D. Ghirlandaio.
Source: *Codex Escurialensis.* Egger/Hülsen/Michaelis 1906.

113. View of Ponte Fabricio and Tiber Island.
Source: H. Cock, 1550. British Museum 1922, 0410.263AN428341. © The Trustees of the British Museum.

aqueducts in the eighth century by commandeering a huge labor force from *domus cultae* in the surrounding countryside. These aqueducts continued to function more or less regularly for another two centuries, and their activity conditioned new residential patterns. The Traiana, flowing from the area around Lake Bracciano in the north, served the fountains and pilgrim baths in the populous Vatican community. The Claudia and the Marcia, derived from springs in the Alban hills to the southeast, entered the city at Porta Maggiore (see Fig. 38), providing water to the churches, the monasteries, and the Lateran complex on the Caelian and Esquiline Hills. The Virgo, because it ran underground for most of its path until it entered the city from the north, was spared during military campaigns; in fact, it flows into Rome to this day. Its presence was undoubtedly responsible in large measure for the residential takeover of the Campus Martius and the choice of the lower Via Lata for the houses of noble families in the later Middle Ages.

The ancient Romans had leveled hilltops and filled valleys to create suitable platforms for monumental building projects; the lay of the land changed less willfully in the Middle Ages. But slow change was exacerbated after the sixth century by unregimented and poorly administered urban life. Floods were a constant threat in the low-lying areas and they left behind alluvial deposits that contributed to the rising soil levels. Refuse, including material from demolished buildings, despite many prohibitions, was dumped in the nearest convenient location. The riverbanks also deteriorated and faulty and untended drainage in low-lying areas encouraged marshy spots to form in the subsoil. The city by degrees became a wetter, less healthy place, and over time fever and malaria became endemic.

Fires and earthquakes contributed to the general disorder. Their ruins were left in situ and new construction simply started over them, as at the Lateran basilica, using the ruins as foundations. In general what was unused or unclaimed collapsed in time and slowly disintegrated under the rain and sun. Natural decay, combined with the sudden detritus of fires and earthquakes, formed piles all over the cityscape. Over time they turned into small hills like Montecitorio, where the Parliament building now stands; and major Roman monuments were slowly buried, sometimes completely.

One final observation is critical to our understanding of medieval Rome: its residents accepted that public structures should accommodate lesser uses. Humble spaces for recluses and pilgrims, such as little chapels and memorial structures, gathered in the sustaining frame of a great basilica because they belonged there. At St. Peter's, for example, *cubicula*, little rooms designated for the poor or devout pilgrims, may have run along the aisles (see Fig. 133). As the centuries wore on, small churches grew in this frame, like baby kangaroos in their mother's pouch, and the north side of the unfinished atrium was used for the front wing of the episcopal palace. Tolerance toward these humble

carbuncles on monumental forms accords with the fundamental concept of public charity – that the rich and the Church must care for the poor and the lowly. This meant that charitable functions were accommodated either within the precincts of churches or palaces or in new purpose-built structures. Thus much of medieval Rome's rundown look may be due, at least in part, to a mentality that responded to need with decisions that felt easy and natural instead of legislating propriety of design.

That mentality may explain the peculiar transformation of the ancient scheme by which, for example, cutting diagonally through the massive geometrical structure of an imperial bath to move quickly from one point of contemporary interest to another seemed more vital than preserving the integrity of the design and going around it or along its prescribed axes. And so it happened that the preponderantly orthogonal scheme of the ancient Campus Martius was slowly fractured, made small, intimate, and intricate. The monuments were cut down to size, as it were, so that only traces of them would survive. This has been called the destruction of ancient Rome, but we might also consider calling it the creation of medieval Rome – an astounding urban transformation of the ancient city that sprang from impulses for this alternative kind of order.

BIBLIOGRAPHY

Arena et al. 2001; Bertolini 1947; Brandenburg 2005; Bruun 2007; Buzzetti 1968; Cassiodorus 1886; Castagnoli 1969; Chastagnol 1960; Coates-Stephens 1997, 1998, 2004; Colini/Gismondi 1944; Curran 2000; De Rossi 1864; Dey 2011; Duchesne 1886–1892; Egger et al. 1906; Evans 1994; Gatti 1979; Gregorovius 1894–1902; Harris 1999; Homo 1934; Krautheimer 1986, 2000; Lanciani 1880, 1892; Lavedan/Hugueney 1974; Liverani 1998; Llewellyn 1993; Marazzi 2000; Meneghini 1999, 2000; Meneghini/Santangeli Valenzani 1995, 2004; Monciatti 2005; Ortenberg 1990; Reekmans 1964; Richmond 1930; Royo 2001; Santangeli Valenzani 1994, 1996–1997, 2007; Smith 2000; Sordi 1965; Valentini/Zucchetti 1940–1953; Vielliard 1959.

EIGHTEEN

THE ROME OF GOTHS AND BYZANTINES

B Y AROUND 400, ROME ALREADY HAD THE BEGINNINGS OF AN AMBIVA-LENT environmental order, part classical and part medieval. There was a splendid urban frame accompanied by history, legends, and administrative apparatus. The Lateran now headed a system, distinct from the older one but symbiotic with it, comprising a network of parish churches each with its own clergy, and beyond the walls, cemeteries with their own important pilgrimage centers and suburban organisms. Much of this structure was in place by the fifth century.

Rome's imperial religious infrastructure had been largely neutralized. temples were decommissioned; cults suppressed; cult statues moved to public spaces to be regarded simply as art; and treasure, in part at least, removed. A marginal group, the Goths, had settled in Rome on the rundown edges of the Esquiline and Caelian Hills establishing their ecclesiastical tradition, Arianism, a fringe Christian sect considered heretical and often persecuted. The Jews may have been similarly concentrated, probably in the Transtiberim. Meanwhile Mithraism had closed shop and its places of worship had been abandoned or reappropriated for Christian use. The seeds of religious absolut-ism in a once-tolerant multifaith city were evidenced by the institution of an administrative structure as early as the mid-third century that divided Rome into seven ecclesiastical regions, whereby the Church was now organizing the entire city for its own purposes as if its assumption of civil jurisdiction were only a matter of time.

If Christianity was neutralizing or superseding polytheistic Rome's religious architecture, the same could not be said for the remaining pagan structures, including the imperial centers of government, which still functioned more or less as before. These were the Palatine; the Curia on the Forum and its dependencies, which had been the base of the Senate for a thousand years; and the offices of the urban prefecture, perhaps now in the Basilica of Maxentius, which had absorbed all the once-independent city services including the police, grain and oil distribution centers, and the water and public works commissions. Christian Rome needed this still-functioning administrative network as much as imperial Rome had. The Senate was now more concerned with the city's daily operation than with foreign policy. And since the imperial bureaucracy had left, a skeleton staff oversaw the once-bustling Palatine.

New additions in the Christian city structure of the fifth century were few. First, several *tituli* were added, raising the total of parish churches to 25 (see Fig. 104). One was built between the Baths of Diocletian and the Campus Martius in an area devoid of churches; another on the remote eastern edge of the Esquiline between the Servian and Aurelian Walls; another off the Clivus Suburanus on the Esquiline; and two near the Baths of Caracalla. Also, for the first time baptisteries were installed in some parish churches and administered by cardinals rather than the pope at the Lateran.

Rebuilding some *tituli* into more elegant parish churches continued: SS. Giovanni e Paolo, S. Pietro in Vincoli (destroyed by fire or earthquake and rebuilt around 450), and perhaps S. Marcello. Some architecturally primitive *tituli* such as S. Lorenzo in Lucina in the Campus Martius and, most notably, S. Sabina on the Aventine Hill were monumentalized for the first time (Fig. 114). The rebuilt parish churches thus became more pronounced urban foci; it is at this time that the stational liturgy began to be formalized. They were now destinations of official visits by the bishop – stations in papal processions at certain times during the year, favored with much pomp and pageantry. Except the Porticus Maximae, the streets used for these processions were the old ones of pre-Christian Rome, now with elevated purpose.

Several churches, some quite large and each with its own officiating clergy, were built ex novo within the walls but outside the titular system. The Basilica of S. Maria Maggiore, founded on the Esquiline by Pope Sixtus III (432–440), represents the coming of age of the papacy as a powerful and independent patron. Perched on the Cispian spur of the Esquiline, it formed a Christian focal point in the grand urban vista extending between the Baths of Constantine and Trajan (Fig. 115). Another important basilica, the martyrium of S. Stefano Rotondo on the Caelian, consecrated by Pope Simplicius (468–483), evoked the rotunda of the Holy Sepulcher in Jerusalem. These two large churches, positioned on visually prominent sites and built under papal initiative to special purpose and dimensions, must have been meant

114. S. Sabina apse.

as extensions of the Lateran – stations between the cathedral and the urban center that would share some of the liturgical functions of the bishop's own church. Having no fixed local congregations, they were meant to accommodate big crowds, not just a parish. They were stations for the major Church feasts that the bishop celebrated in front of his Christian flock: Good Friday at S. Croce in Gerusalemme, with its presumed relic of the True Cross and the apse of the martyrium built there under Constantine; Christmas Eve at S. Maria Maggiore, the first church to be dedicated to the Virgin in Rome; Christmas Day at St. Peter's and S. Stefano; and Easter at the Lateran (Fig. 116). The churches delimited an area of particular papal influence within the city and would later serve as defensive bulwarks of the Lateran quarter. Their urban presence crowning the Caelian and Esquiline Hills may be the most impressive aspect of the fifth-century Christian city structure.

The collapse of the Western Roman Empire is closely tied to the Germanic Visigoth and Ostrogoth tribes. Their involvement began with the sack of Rome by the Visigoth Alaric in 410. By the end of the fifth century the Goths had de facto control of Italy; their Ostrogoth leader, Theodoric the Great (498–526), who ruled from his court in Ravenna, was grudgingly recognized by Rome as the sovereign representative of the Byzantine emperor in the West. In the early sixth century the Ostrogoths and Visigoths vied for control of Rome, a factor contributing to Vitiges' siege of the city in 537–538. This political instability did not support the clear vision, long-term planning, and unambiguous authority needed for decisive urban readjustment. Imperial patronage was now

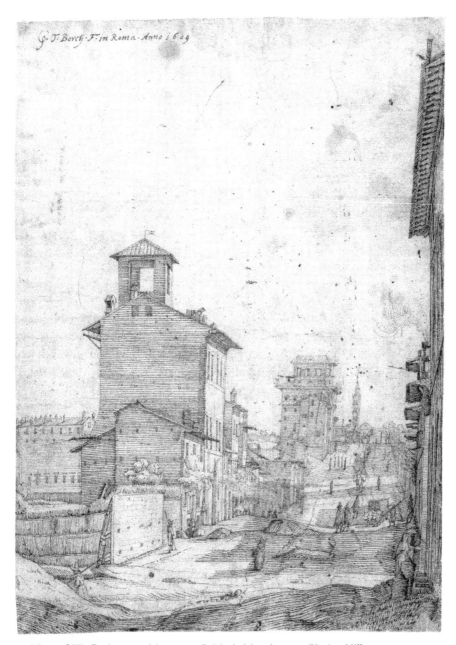

115. View of Via Panisperna rising up to S. Maria Maggiore on Cispian Hill.
Source: G. ter Borch the Elder, 1609. Courtesy of Rijksmuseum. RP-T-1887-A-870. Purchased
with the support of the Vereniging Rembrandt.

focused on other cities, and the Church, though rich, was only now beginning
to draw up the ledger of its responsibilities, among which city planning was
not very high. Finally, it was not yet clear where urban administrative authority
lay and the urban process reflected this indeterminate civic state.

116. Churches on Caelian and Esquiline. 27: S. Giovanni in Laterano; 28: S. Maria Maggiore;
29: S. Croce in Gerusalemme; 39: S. Stefano Rotondo.
Source: Dosio 1561. Courtesy of American Academy in Rome.

The permanent contingent of Goths further complicated the ambiguous
relationship of the ancient city structure to the new one. In Rome, this Arian
enclave brought about an urban arrangement, tentative and peripheral. Their
first immigrants to Rome were undoubtedly members of the military. Settling
at the edge of the city, on parts of the Esquiline and Caelian Hills, was no
accident. The area had been militarized for centuries, with its barracks, parade
grounds, and military graveyards beyond the Aurelian Wall.

There were a few Arian churches in Rome (Fig. 117). The main one,
S. Agata dei Goti – whose dedicatee the Goths held in special reverence – in
the Subura, was a small basilica built or rededicated by a private patron in
the 460s. S. Andrea in Catabarbara was initially a secular hall built by Junius
Bassus around 358 and converted into a church by Pope Simplicius. At least
one more church has disappeared. S. Severino stood near the *domus Merulana*,
an imperial property near the Lateran palace, perhaps in the declivity between
the Caelian and the Esquiline. Finally, there was S. Agata in Esquilino, which
might have been Arian. It appears in the late-eighth-century pilgrim's guide
called the *Einsiedeln Itinerary* (Chapter 22), but has never been positively
identified.

Foreign rulers felt great pride in being agents of Rome even though they
were not often resident there. To Theodoric, being the king of Italy carried a
special responsibility toward Rome's administration and physical well-being,
a responsibility he discharged admirably. Upkeep and rehabilitation were his
main concerns. The great buildings and systems were to be kept in order, but
to the extent possible the modern needs of the city were to be accommodated
within the venerable frame. He saw to repairs of the aqueducts, the walls, the
Curia, the Theater of Pompey, and the Colosseum; likewise he gave priority

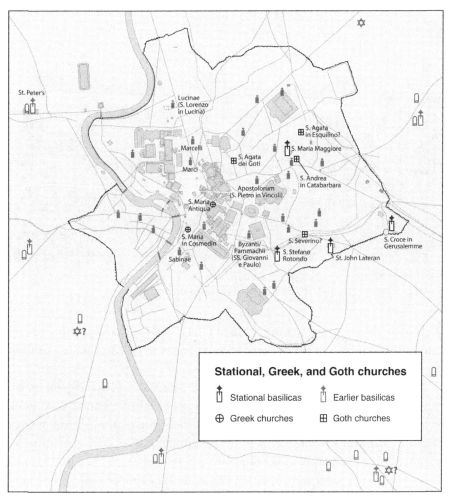

117. Map with stational, Greek, and Goth churches.

to staffing the maintenance offices for the city's monuments. A body of pro-
fessional men under the direction of an *architectus publicorum*, responsible to the
city prefect, oversaw repairs. The office of *comes formarum* was revived to super-
vise the water system, and a separate official was entrusted with the drains. Two
directors oversaw port facilities: a *comes portus* and a *vicarius portus*. Specific
allocations of materials and moneys were made to ensure the success of these
measures. From the wine tax alone, 200 gold pounds annually was allotted to
maintain the Palatine structures and Rome's walls.

Theodoric's concern for rehabilitation, urban renewal, and alternate use of
monuments had an immediate impact on urban process. In 526, the year of his
death, Pope Felix IV (526–530) converted the so-called Temple of Romulus
on the Forum (given him by Queen Amalasuntha, Theodoric's daughter) and
part of Vespasian's Templum Pacis into the church of SS. Cosma e Damiano

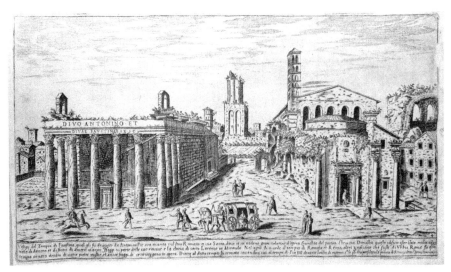

118. View of SS. Cosma e Damiano in Forum.
Source: Dupérac 1575. Courtesy of American Academy in Rome.

(Fig. 118). Although this was not the first public building to be put to an alternate use, it was the first major imperial monument to be consecrated – and in the very heart of pagan Rome, the Forum.

Theodoric demanded that his architects respect and emulate ancient architecture in contemporary construction. They were instructed that new work should harmonize well with the old: Rome sprang eternal, and as the heir of emperors, the king saw himself as more than its curator. Two tangent attitudes attended the reuse and rehabilitation of the imperial fabric that he championed. First, the nascent romanticizing of selected ancient monuments or built systems raised them above purpose and time. From this attitude sprang the codification of what came to be called the Seven Marvels of Rome – the Janiculum Hill (for its chains of mills?), the drains, the aqueducts, the Forum of Trajan, the Colosseum, the Odeum of Domitian, and the Baths of Caracalla – first attested in the fifth century by Polemius Silvius.

The second attitude fuses imperial and Christian Rome in metaphorical and mythical ways. "How wonderful must be the heavenly Jerusalem, if this earthly city can shine so greatly," Fulgentius, a visiting African monk, exclaimed at the time of Theodoric's triumphal entry into the city in the year 500. This literary fusion addressed Rome's religious rehabilitation as a whole, while the identification of specific spots in the urban core with Christian events (excluding the places of martyrdom and extramural burial) began in earnest at about this time. Once again the Forum was an environment of special symbolic importance. By the early sixth century at the latest, the corner toward the Temple of Vesta and the atrium of the Vestal Virgins was associated with Christian virgins. About 565 a shrine to the Virgin Mary, later called S. Maria Antiqua, was

set up in a massive imperial vestibule to the Palatine complex. Acting as a gate for the imperial palace, it was under the care of the Byzantine administration. Pope Gregory the Great even prayed in the Forum of Trajan for the salvation of that emperor, neither friend nor enemy to Christians in his lifetime, whose built programs Gregory thought earned him a place in the Christian afterlife.

These literary exorcisms are important in softening the environmental schizophrenia of Rome, a frame with two contents – one of them grand and famous but culturally tending toward obsolescence, the other new and ascending but as yet unable to create its own urban image. As the popular mind peopled the theaters of pagan splendor with Christian spirits, official practice brought about a similar rapprochement. In the year 500 Theodoric, the preserver of the ancient imperial city, made a solemn stop at St. Peter's upon entering Rome before proceeding to the Forum to meet the Senate. By the same token, he arbitrated the most crucial Church assembly, the synod of bishops, patriarchs, and other top-ranking ecclesiastics during the Laurentian Schism – a result of two claimants to the papal throne – which began in 502. They met at St. Peter's, at S. Croce in Gerusalemme, and once in the ancient Basilica Julia in the Forum.

The urban situation began to change with the arrival in 537 of the Greek general Belisarius, who commanded the Ostrogothic army for the Byzantine emperor Justinian against Vitiges' rival Gothic army. Besieged in the city, he set up headquarters in one of the imperial *horti* within the Aurelian Wall on the Pincian, strategically proximate to Porta Flaminia, the main Visigothic approach from the north. In the process, he modernized city defenses and ensured the safety of the grain supply. As we have seen, when the aqueducts were cut, he fostered a technological innovation, floating grain mills in the Tiber – thus adding an element to the visual image of the city that would endure until the late nineteenth century (see Fig. 112).

The Byzantine influx had lasting consequences in Rome from the time of the Gothic Wars in the 530s and 540s until the fall of the Western Roman Empire under the Exarchate, in 752. From an environmental viewpoint, the Greek-speaking Byzantine colony that practiced a branch of Catholicism known as Eastern Orthodox was more integrated into the urban fabric than the Gothic one had been (see Fig. 117). It began on the Capitoline and Palatine slopes with a population of military and civil dignitaries, while the ordinary immigrants settled in the Velabrum, between the slopes of the hills and the river, where they founded their church, S. Maria in Cosmedin (Fig. 119).

Beyond the walls, around Constantine's great basilicas, rural communities were organizing themselves into Christian suburbs, tilling the land and taking advantage of the trade spurred by the flourishing cult of relics. Around them the earliest official monasteries began to appear in the fifth century. First Sixtus III built one beside S. Sebastiano on Via Appia, and then Leo the Great

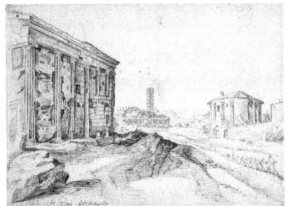
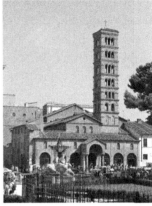

119. View with S. Maria in Cosmedin, round temple, and Temple of Portunus. View of the church today.
Source: J. Brueghel the Elder (attributed), 1594. British Museum Oo,9.10AN187184. © The Trustees of the British Museum. Present-day view of S. Maria in Cosmedin.

(440–461) added another behind St. Peter's apse. Many intramural monasteries began as ad hoc installations founded by wealthy or pious people in their houses or in property they owned, or by special-interest groups to cater to their own beliefs. This randomness created an unpredictable and undisciplined environment, which the Church sought to regulate.

One way to place the monasteries under closer Church supervision was to cluster them around basilical churches and even some titular churches – S. Crisogono, for example – with their members providing specific services such as devotions. Some clustered around sites like St. Peter's and the Lateran basilica, at the sanctuary end, thereby expressing their dependence on the church and the services they performed for it. By the mid-tenth century there were 93 monasteries in Rome or just outside the Aurelian Wall (Fig. 120). And as we shall see, the Greek presence animated the expansion and urbanization of another great Christian institution: *hospitium*, charity to strangers, the sick, and the poor.

BIBLIOGRAPHY

Arnaldi 1986; Brandenburg 2005; Burgarella 2002; Chastagnol 1960; Costambeys 2001; Cross/Livingstone 2005; Dey 2008; Duchesne 1886–1892; Economou 2007; Ferrari 1957; Gregorovius 1894–1902; Hülsen 1924, 2000; Lanciani 1892; Lavedan/Hugueney 1974; Magnuson 2004; Marchetti-Longhi 1938; Michel 1952; Mulryan 2014; Niederer 1952; Testini 1970; Zeiller 1904.

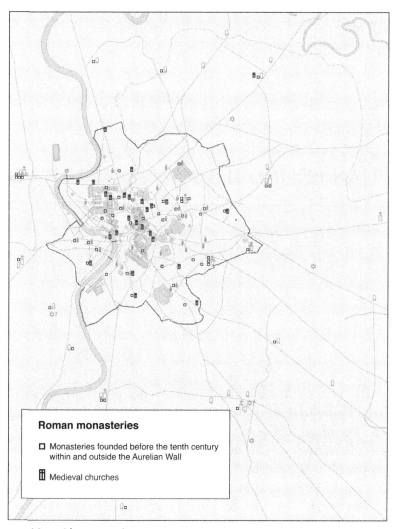

Roman monasteries

☐ Monasteries founded before the tenth century within and outside the Aurelian Wall

⊞ Medieval churches

120. Map with monasteries.

NINETEEN

CHRISTIAN FOUNDATIONS

I N 609, THE BYZANTINE EMPEROR PHOCAS, WHO CONTROLLED ROME through the Exarchate, gave the Pantheon to Pope Boniface IV (608–615) at his request. The pagan temple dedicated to all the gods was immediately rededicated to St. Mary and to all the martyred saints. S. Maria *ad martyres*, which we now call S. Maria della Rotonda, was named a stational church, meaning that the faithful joined to celebrate a particular day in the saints' calendar – in this case, 1 November, All Saints Day, followed by All Souls Day. Thus the church became an important destination; indeed it is listed 5th of 26 churches in a seventh-century itinerary, *De locis sanctis martyrum* (Fig. 121).

The Pantheon, as S. Maria, was now under the protection of the Church, which took responsibility for its maintenance. Thus when the Byzantine emperor Constans II stripped off its bronze roof tiles in 663 to take back to Constantinople, Pope Gregory III (731–741) had them replaced with sheets of lead for protection. His restoration set a precedent of pastoral care that lasts to this day. S. Maria continued to use the colonnaded forecourt adjoining it to the north as a place to assemble before entering the sanctuary. Even through centuries of flooding and silting, it was cleaned and maintained until the tenth century.

The Pantheon was not the only ancient monument to gain new purpose during the medieval period. A charitable institution providing food, shelter, and bathing facilities for the poor, the *diaconia*, probably arrived with the Greek colony. It and related urban services including *xenodochia* (charitable

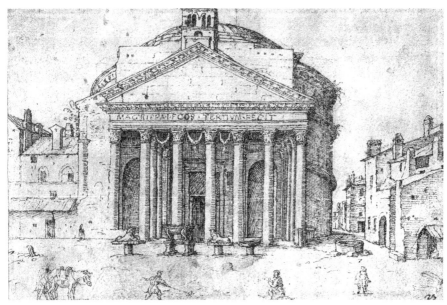

121. Pantheon.
Source: M. van Heemskerck, 1530s. Hülsen/Egger 1913–1916.

institutions providing food and shelter), *gerocomia* (old-age homes), and *ptochia* (poorhouses) often took advantage at one time or another of modest ancient structures that had few ambitious formal functions of their own. As monasteries and churches did, the *diaconia* played a vital role providing social services to the poor and to pilgrims.

Diaconiae often served more than one purpose, and their programs changed over time. For example, some of them administered hospitals, so at some point in its history an individual *diaconia* might assume the care of the sick within its own walls rather than run a separate organization under its supervision. Or else part of the original program might be accommodated in a neighboring structure with the necessary facilities in place. For example, the Roman tradition of bathing persisted, but only in small facilities that responded to the new requirements of the Church. Thus the hygiene of "Christ's poor," and most especially bathing, was considered an attendant responsibility by the *diaconia* authorities. A weekly bath called *lousma* was standard. Now unless the individual *diaconia* was set up for this bath, the poor would be marched to a nearby thermal establishment in a neat procession, led by the staff and singing hymns. Feeding, healing, and bathing were component aspects of this all-embracing charitable program. Archaeological ruins standing between the ancient temples of Bellona and Apollo, near the Theater of Marcellus, reveal this exact functional pairing: the remains of the late-eighth- or early-ninth-century *diaconia* at S. Angelo in Pescheria communicated along a short public path to a nearby *lousma* (Fig. 122).

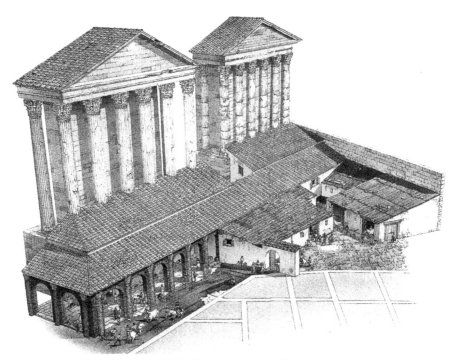

122. *Diaconia* of Sant'Angelo in Pescheria with *lousma*. Inklink.
Source: Courtesy of Ministero dei Beni e delle Attività Culturali e del Turismo – Soprintendenza Speciale per i Beni Archeologici di Roma.

With few exceptions, the 18 urban *diaconiae* were set within remodeled Roman buildings, most of them of a utilitarian rather than monumental nature: public porticoes, warehouses, market buildings, and, in the case of S. Maria in Cosmedin, centers of the old imperial food program, the *annona*. The general preference for such structures is explained by the fact that, since the *diaconia* functioned economically on behalf of its beneficiaries, pilgrims and the city's poor, easily acquired humble structures were clearly more desirable than a public monument with its attendant legal and financial burdens.

By the golden age of *diaconiae* – the pontificates of Hadrian I and Leo III – there were 18 of them in the city and 5 outside the Wall. These latter were arranged around St. Peter's, 3 of them in front, where the colonnaded portico met the atrium stairs at a court called Cortina, and 1 along the north flank of the basilica, just behind the pope's palace. The fifth was away from the basilica at the beginning of the porticoed approach. All date from the mid-eighth century.

We can learn a great deal by noting the locations of intramural *diaconiae* (Fig. 123). Concentrated in the Velabrum, the Forum, and the neighborhood of the Theater of Marcellus, with three in the Campus Martius and a sprinkling along the eastern hills, all stood on major thoroughfares or within easy access of the river. We encounter nine heading west along the Vicus Tuscus,

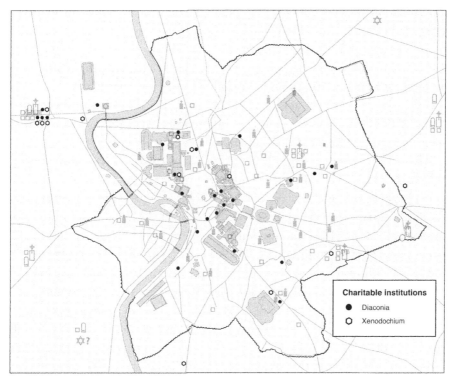

123. Map with charitable institutions.

the Argiletum, and the Clivus Suburanus. This makes eminent sense; the *dia-coniae* were distribution centers. Foodstuffs arrived by the main roads as did the people who traveled to these centers for their rations.

What is more, their frequency reveals a shift in the urban population by this time, the seventh to ninth centuries, as common folk began to abandon the hills in favor of the flatlands and the population exploded with refugees from Syria, Palestine, Egypt, Spain, and other Mediterranean countries conquered by the Saracens. It seems that a central cluster of them existed in the urban core within easy reach from the periphery, and another cluster for the area of the Campus Martius to the west of Via Flaminia; isolated *diaconiae* served the sparsely inhabited hills. But the location of *diaconiae* is not strictly guided by a concentration of people; we know of none in the Transtiberim, teeming with refugees.

The pattern bears little relation to the 14 Augustan regions or the 7 eccle-siastical regions, an arrangement devised by the Church for its own purposes, which, in the sixth century, was adopted increasingly for civil purposes as well. *Diaconiae* were originally private initiatives, separate from the organizational system of the Church. By the same token, the distribution pattern had little connection to the Byzantine division of the city into 12 military districts called *scholae militiae*. In a few cases a *diaconia* is adjoined to a monastery,

but the monastery is always considerably later, as at S. Maria in Via Lata. First mentioned in the time of Leo III, its *diaconia* was only connected with the monastery of S. Ciriaco in the mid-tenth century. Personnel from regular monasteries staffed some *diaconiae*, but prominent lay figures might also serve as administrators. Starting in the seventh century, the *diaconiae* were slowly absorbed by the Church and in time fell under the direction of the regular ranks of the clergy. Only in the eleventh century were they converted into parish churches with their own individual clergy.

There is much to be said for linking the *diaconiae* with the Byzantine rule of the city or at the very least a general Eastern impetus. Their area of maximum concentration was precisely the area we designated in the previous chapter as the Greek quarter of the city, and they flourished during the pontificates of several Eastern popes, beginning with Theodore I (642–649), and then more or less continuously from John V (685–686) through Zachary (741–752). The institution originated in the East and first appeared in the West in Italian cities with close Eastern contacts such as Naples, Ravenna, and Pesaro. Significantly one of the earliest *diaconiae* was at S. Maria in Cosmedin – the Greek church par excellence and the closest the Byzantine congregation came to having its own cathedral (Fig. 124; see Fig. 119).

Interestingly, the insertion of that *diaconia* into a distribution center led some early scholars to think that the *diaconia* was the Church's conscious replacement of the imperial *annona* after it had stopped functioning, but this is unlikely. By the end of the fifth century Pope Gelasius (492–496) is said to have saved the Romans from famine, and from that time the pope's charity began to be expected, independent of the state. This was despite the more or less continuous, though perhaps not entirely dependable, operation of the imperial *annona* until the end of the sixth century. Indeed, the *praefectus annonae* continued to be appointed, and in 554 the emperor Justinian reaffirmed the right of the city of Rome to state support, and every September or October a certain amount of wheat was sent from Sicily to Rome for the public granaries. But the Church had long maintained its own granaries. Imperial boats were put at its disposal for the transfer of this grain. The cargo arrived at Portus by Ostia and then went upriver to the *horrea Agrippiana* in the Velabrum, which remained in use until the ninth century. Ordinarily, Rome's wheat was imported from North Africa, Sicily, and Sardinia, but the Saracen invasion of North Africa beginning in 641 upset this program. As the empire's resources dwindled, the popes leaned heavily on the Church's own agricultural colonies, or *domus cultae,* near Rome. The wheat was now carried in carts along Via Cassia, Via Tiburtina, and Via Appia, rather than by ship from overseas.

It is in this period, when the imperial machinery had stopped delivering from abroad, that scholars have wanted to see the beginnings of the *diaconia* in Rome. But the *diaconia* was a very special semiprivate charitable initiative,

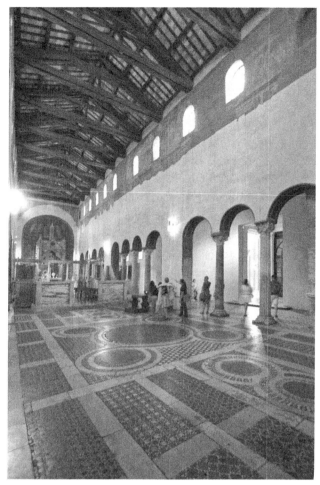

124. S. Maria in Cosmedin, interior.

cooperating both with the imperial *annona* and with the Church's formal wel-
fare plan but independent of both. Various sources attest that similar privately
endowed institutions called *xenodochia* had existed in Rome from the fifth
century, and from the fourth century at Portus, where pilgrims disembarked
for their final leg of pilgrimage to the city. These privately endowed hospices
seem to have emphasized medical care above other services, and thus comple-
mented the mission of the *diaconiae*. Sometimes historical continuity between
the two institutions can be inferred in one place; at S. Maria in Via Lata, for
example, the *diaconia* had been preceded by a *xenodochium* founded by the
Byzantine general Belisarius himself, presumably around 538.

More than any other medieval Roman building type, the *diaconia* was bound
up with urban process. Evidently the Church recognized the importance of
this institution in reorganizing the city and consequently it tightened its hold
and undertook to create *diaconiae* as time went on, rather than let them operate

where they pleased. This had been the pattern of the Church since the late fourth century – to take advantage of private initiative and step in at the right moment to regulate it and draw it into the Christian city structure.

There are the other charitable organizations to consider. Fifteen *xenodochia* have been documented at Rome, and most can be located (see Fig. 123). *Hospitalia* too were present – a term that reminds us of our own hospital and is used in that sense in the later Middle Ages, probably representing the emergence of specialized buildings devoted to the care of the sick, such as Santo Spirito in Sassia or the Lateran hospital. But originally the *hospitale* seems to have provided food and shelter, but not medical care, for pilgrims. There were also *ptochia*, literally poorhouses; *gerecomia*, or old folks' homes; and charitable lodgings like the rows of *cubicula* for the poor, which Pope Symmachus (498–514) provided near St. Peter's, S. Paolo fuori le Mura, and S. Lorenzo fuori le Mura. As the old Roman aristocracy waned, along with their foreign landholdings supporting their charitable foundations, the Church stepped in to carry on the tradition. From the sixth century onward the pope and his growing administrative apparatus provided these institutions' endowments, support, and maintenance.

The urban issue involved here was one of administration. The imperial system of the 14 Augustan regions had survived, in memory at least, well into the medieval period. The 7 ecclesiastical regions, responding to the reduced population and density of the city, replaced it; but they neither recognized nor anticipated the peculiar distribution of this population, away from the hills and into the Tiber floodplain and Transtiberim. The Byzantine administration introduced a third system based on the recruitment of an urban militia. It divided the population into 12 *scholae*, each with its own chief after the ninth century. Whatever its exact boundary scheme, it conformed more closely to the medieval pattern of urban density. And this is where the *diaconia* comes in. Since it served as a vital neighborhood gathering place, the *diaconia* was potentially an organizing unit, but with a charitable emphasis rather than a military one. A semiofficial grouping of the population by *diaconiae* seems to have been introduced by the eighth century, the Church's own answer to the Byzantine scheme of urban militia.

The seventh century witnessed the dissolution of the early Christian environmental order. The ability of the titular churches to determine the social and political structure was weakened by the proliferation of special churches and the spread of the *diaconiae*, whose function as food distribution centers created a new system of urban organization that was more in tune with the actual distribution of the populace than the abstract scheme of 7 ecclesiastical regions. Theoretically, you could belong now to three different and not always overlapping jurisdictions: your parish within one

of the seven regions, your militia within one of the 12 *scholae*, and your *diaconia*.

Notably, *diaconiae* played a part in a new twelfth-century administrative scheme of the *rioni*, which has lasted in one or another form until the present. This is reflected in small but important ways. Two of the *rioni*, for example, are named after *diaconiae*: *Regio Sancti Eustacchi*, after the *diaconia* of S. Eustachio and *Regio Sancti Angeli*, from Sant'Angelo in Pescheria. Until the thirteenth century there was no *rione* in the Transtiberim, just as there were no *diaconiae* there, a curious anomaly given its dense population. Although the district's three *tituli* ensured a strong Christian presence, it also harbored many Jews and other non-Christians and its exclusion from the Christian charity system may initially have reflected that fact.

Finally, contrary to late antique burial laws repealed only under Pope Leo VI (886–912), burials began to appear within the city walls by the mid-sixth century in abandoned imperial buildings such as the Baths of Caracalla; in houses on the Caelian Hill; under the pavement around the Colosseum; and in the Porticus Liviae on the Oppian Hill. They are also found around intramural churches such as those located on land that had been part of imperial *horti*. This migration has been seen as a way to protect the dead after the chaos of the Gothic Wars. Yet some graves predate the wars; moreover, the migration of saints' bodies from extramural to intramural burial sites would not begin in earnest until the mid-ninth century. Marios Costambeys sees urban burial as another example of "how the Church came to dominate the management of the dead." We can also see how the intramural burials are clear evidence of the migration, in part, of the shrinking urban population to lower areas near the river, and the concomitant availability of once-imperial land that, as we shall see, quickly became part of the patrimony of monasteries and churches.

BIBLIOGRAPHY

Antonetti 2005; Augenti 1996; Bertolini 1947; Birch 1998; Cecchelli 1951; Coates-Stephens 1997; Colini/Gismondi 1944; Costambeys 2001; Dey 2008; Duchesne 1886–1892; Falesiedi 1995; Gregorovius 1894–1902; Homo 1934; Hoogewerff 1947; Hülsen 2000; Krautheimer 2000; Krautheimer et al. 1952; Lestocquoy 1928–1930; Magnuson 2004; Meneghini 1999; Niederer 1952; Santangeli Valenzani 1996–1997; Stasolla 1998; White 1997; Wisch 1992.

TWENTY

FROM *DOMUS LATERANI* TO *ROMANUM PALATIUM*

I F MEDIEVAL ROME, IN ITS LONG HISTORY, HAD ANYTHING LIKE A MORAL and administrative focus, it was the Lateran palace and the *basilica Constantiniana*, now called S. Giovanni in Laterano, St. John Lateran, which Constantine, freshly victorious at the Milvian Bridge, built to serve the pope, bishop of Rome. From that moment the fate of medieval Rome was bound to this remote corner of the city, which grew steadily in girth and importance even as the inhabited core contracted away from it. By the ninth century the Lateran complex had become to papal Rome what the Palatine had been to imperial Rome, the supreme seat of administration and political power. Despite ravaging invasions and other adverse conditions, despite the search for alternative seats of papal rule, the Lateran remained inarguably preeminent until the official move to the Vatican in 1420 following the return of the papacy to Rome.

Our investigation into the Lateran's first 1,100 years must be brief, and sadly there is little left to see of this once-magnificent theater of autocratic rule. Other than the baptistery, some adjacent structures, the rebuilt and relocated Triclinio Leonino, and the largely thirteenth-century Sancta Sanctorum, new construction between the sixteenth and nineteenth centuries devoured or covered over nearly the entire medieval scheme. Still, the Lateran was relatively lucky. In an exhaustive study of the physical and literary documents that Rohault de Fleury published in 1877, we have a compelling plan and reconstruction drawing of the complex at the end of the Middle Ages, as it stood in

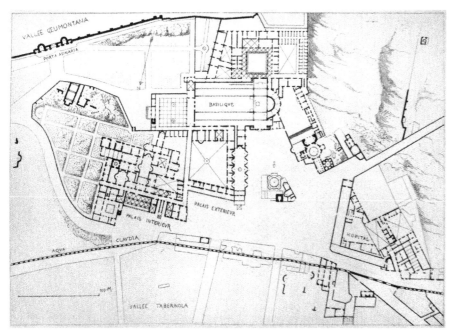

125. Hypothetical plan of Lateran Borgo in 1300. North is toward bottom.
Source: Rohault de Fleury 1877.

126. Hypothetical reconstruction of Lateran Borgo in 1300.
Source: Rohault de Fleury 1877.

1300 – the first jubilee year, which drew Giotto and Dante to Rome – pristine and isolated from its environment (Figs. 125, 126).

But because our environmental approach privileges process over the culminating product, our task is to peel back the layers of time so that we can see the matrix of streets, the Aurelian Wall, aqueduct arcades, and other elements that spawned a whole urban quarter we call, by the common Italian term for such

127. Lateran Borgo showing ancient, medieval, and Renaissance remains.
Source: FUR.

a compound, the Lateran Borgo. To aid our reconstructive surgery, Rodolfo Lanciani's *Forma Urbis Romae* (1893–1901), which shows the modern streets and buildings over the medieval and ancient Lateran neighborhood, is essential (Fig. 127).

Until the Aurelian Wall encircled the Lateran region in the 270s, it lay outside the classical limits of the city. An almost rural hilltop, some distance from the city core, it linked to the center along Via Tusculana, which later took the name Via Maior; the modern Via SS. Quattro Coronati more or less follows it. The road from the Colosseum penetrates the Servian Walls at Porta Querquetulana, crosses Via Caelimontana (which follows Nero's branch of the Aqua Claudia toward the Temple of Claudius to the west), and continues across the Lateran area toward Frascati and Tusculum in a southeasterly direction. Via Maior lays the strongest claim as Rome's main traffic artery; it was the last stretch of the processional route of popes, kings, and pilgrims that began at St. Peter's and extended to the Lateran as Via Papalis. It entered the restricted L-shaped space of the Campus Lateranensis – the plaza preceding the Lateran basilica – at an oblique angle. This is quite unlike the approach to the Vatican, where the bridge created a monumental axis to Hadrian's mausoleum, whereupon a left turn onto Via Cornelia produced another axial prospect westward to St. Peter's.

There was no religious compulsion to build the Lateran complex here, no special holy site to honor as with the great extramural basilicas. Rather, this large parcel of imperial property was Constantine's to give away without formal Senate approval or painful expropriation, and it stood a reasonable distance from the core of the imperial city, a location that must have recommended the site but would prove inconvenient from the very start. Also, the choice might have been political; the disgraced military unit that had been housed here and led by Constantine's enemy Maxentius was wiped away with a Christian cloth. Whatever the rationale, a splendid basilica supplanted the barracks between 312 and 328, the nave smothering its body and the apse overlapping the former officers' quarters. In the lavish *domus* next door, a round room became the baptistery and the rest was turned into the temporary residence of the bishop of Rome. Nearby in the palace called Sessorium, where Constantine's mother, Helena, had lived from 317 to 322, a hall was being converted to a church of the Holy Cross (S. Croce in Gerusalemme), remnants of which she had miraculously found, it was said, in Jerusalem at the place of the Crucifixion.

The Christianization of the hill was sparse and slow after Constantine. Elegant residences and the military zone vanished in early Christian times, submerged under the cathedral or allowed to vegetate. By the sixth century most of the aristocratic estates undoubtedly belonged to the Church or at least to Christians, but many were abandoned (some to cemeteries) as water supplies dwindled, slave labor became unobtainable, and the Christian ethic abjuring unseemly wealth took hold. The elite divestiture of property, much of it in villas or cultivatable land, for the sake of Christian charity had begun just before the sack of Alaric in 410.

The most important building projects at the Lateran during its first period, ca. 350 to 750, included the Scala Sancta, the Sacred Staircase, said to be from the Palace of Pontius Pilate in Jerusalem. Left of these stairs were other functional spaces including the *schola cantorum* to teach young boys the Roman chant, with an attached dormitory; the private apartments of the pontiff; and the chapel of S. Lorenzo. This first palace was built beside the basilica's atrium, establishing the pattern for the Vatican palace later. There, both church and palace faced the city, from which most of the faithful approached. But the Lateran basilica looked eastward away from the city while the palace, which was not just a papal residence but also an administrative center, faced north toward other monumental basilical outposts, including S. Maria Maggiore, rather than the logical approach from the city along Via Tusculana to the west-northwest.

The *domus* adjoining the baptistery did not long satisfy the requirements of a bishop's residence and administrative headquarters. By the mid-fourth century, the round baptistery room was converted into an octagon and became isolated in the *domus*, its focus now toward the newly built cathedral (Fig. 128). By the fifth century, some administrative buildings already stood at the north end of

128. Lateran Baths with baptistery in background.

the area. Later two monasteries occupied the western corner of Via Tusculana toward the wall; one of them perhaps blocked the road by the time of Pope Gregory the Great, thwarting its function as a public thoroughfare. The only ancient building left standing through the Middle Ages was the Lateran Baths, whose ruins can still be seen today. These may have operated as before until the aqueducts were cut in 537.

Beginning about 750, the palace spread westward; no longer a simple *patriarchium*, or bishop's residence, it grew into the *sacrum palatium*, the successor of the Palatine, the seat of *imperium* or temporal rule. The older, eastern half became more residential in character and now included a peaceful private retreat where the pontiff with his priests could escape the bustle of the administrative palace. The new wing, the Council Hall, linked directly to the basilica and hence to Church administration.

As the faithful donated property to the Church its relationship to its land-holdings changed; the bishop of Rome was now a powerful landlord. The popes tried to build up their estates into more efficient units, not only of production but also now of defense; this was their major initiative in the eighth century. Those who lived and worked on the papal *domus cultae*, the *familia sancti Petri*, were slowly shaping up as a rural militia and labor force at his disposal.

The nature of the Lateran complex also changed significantly at this point. It had been of course the setting for solemn religious observances when the bishop met his people en masse, at Easter most notably, in full pomp. It had also been the main stage for ceremonial and administrative pageantry, the obvious highlight here being the papal election when the assembly of clergy, army, and laypersons would gather at the cathedral or its square for the event. Most importantly, the Lateran was the administrative headquarters of Peter's patrimony; it held valuable archives, records, and altar furnishings. All these functions gave the Lateran a strategic and even military role, and as the focus of papal power, it became the target of political and social unrest. Since papal elections were often major factional battles, the Lateran figured prominently in these skirmishes. Possessing it legitimized the election; therefore, both popes and the antipopes who sometimes opposed them contended for it.

The Lateran complex was significantly enlarged between 900 and 1350, when the authority of the Church was under continual threat from some Roman nobles and foreign rulers such as the Holy Roman Emperor. Now fortified towers loomed over an uneasy prospect. One, probably built by Pietro Annibaldi, brother-in-law of Innocent III (1198–1212), stood at a strategic crossroads, where Sixtus V Peretti (1585–1590) would raise an obelisk in 1588. Another stood in the quarter of the Lateran hospital, and a third fortified a bit of the Neronian aqueduct. These last two stood in opposition: the Ghibelline faction, headed in Rome by the Colonna family, which supported the Holy Roman Emperor, sponsored one; the Guelph party under the patronage of the Orsini family, who supported the pope, built the other. Marking their encampments on the battlefield of the papacy, these were the sullen insignia of outright urban warfare in the twelfth and thirteenth centuries.

The birth and growth of the Lateran complex and its immediate periphery had an undeniable, centuries-long impact on the urban development on the Caelian Hill. This *suburbium*, as it was called, extended naturally from the Lateran complex to the Colosseum, beginning at the north entrance of the cathedral and stretching to the church of S. Nicola in Formis and the Aurelian Wall. The Church or its agencies owned houses and shops that lined the Campus Lateranensis to the north and extended on two sides of Via Maior all the way to the Colosseum. Some 200 of them belonged to the chapter of the Augustinian monks, while the Colonna-sponsored Compagnia dei Raccomandati al S. Salvatore "*ad sanctum sanctorum*," who ran the hospital, firmly controlled the entire region between the Lateran and the Colosseum beginning in the early fourteenth century.

After years of turmoil involving the papacy, the nobility, the Comune (the city government at this time), and interfering secular powers, most notably the king of France, Pope Clement V (1305–1314) transferred the papacy to Avignon in 1309, where it remained until 1376, when Gregory XI (1370–1378) returned

it to Rome at the urging of St. Catherine of Siena. Like Clement, all the popes elected during that time were French. With the power vacuum created by the papal court's absence, the Lateran complex lost its primacy. Without its bishop the cathedral had lost its raison d'être; and associations such as the Compagnia took on greater control of the area, which now saw fewer and fewer pilgrims. Even with Gregory's return, the Lateran's hold continued to weaken as the legitimacy of the elected popes was challenged during the Western Schism, when many popes refused to live in Rome. The schism lasted until 1417.

The Aurelian Wall defined the south and east quarter of the Lateran complex; Via Labicana, running in the valley between the Caelian and the Esquiline, was its northern boundary, although the basilica of S. Maria Maggiore on the Esquiline, built in the fifth century, may have helped to leap the boundary and lay claim to an area well to the north (see Fig. 116). Via Appia bounded the quarter on the southwest. Two churches, S. Sisto and SS. Nereo ed Achilleo, flanked this lower stretch of the road; S. Stefano Rotondo higher up on the Caelian overlooked it. The western line was the valley between the Caelian and the Palatine. The late medieval Caelian ridge had two formidable monuments, SS. Giovanni e Paolo looking inward toward the Lateran, and S. Gregorio Magno beside its ancient monastery. S. Gregorio claimed control of Via Appia with its own fortified compound on one side of the road, and on the other, the Septizodium and a fort at the eastern end of the Circus Maximus. In 1145 the Church legally yielded its control of this strategic area to the powerful Frangipane family in return for guarantees to defend papal interests.

Though Constantine had established the Roman bishop in this inconvenient corner of the city, there had been many reasons to stay: nearby property to inherit, imperial land endowments, and the prestige of accommodating the great Christian emperor's basilica. A forged eighth-century document known as the *Donation of Constantine* purportedly from him to his contemporary, Pope Sylvester, transferred papal authority over Rome and the Western Roman Empire to the Church. A depiction of the "donation" soon appeared in the old portico at the Lateran; it showed the church as the setting for the transfer, explicitly granting primacy to this basilica over St. Peter's. The image was even invoked to argue for retaining the Lateran as the papal court.

Yet by 1145 Rome's hills were in steep decline. After a sack of the city in 1084 by Robert Guiscard, a mercenary soldier and de facto protector of Pope Gregory VII (1073–1085), malaria and other disasters slowly brought about the abandonment and deterioration of the high ground. A curtailed Lateran enclave would remain on guard, but now it languished amid fields and ruins, tethered to the city's fugitive core only by a few lonely streets (Fig. 129). Ghosts of the past haunted empty lanes lined with tall blank walls and cypresses. Greatly damaged by fires in 1306 and 1361, the palace was finally abandoned after the Western Schism when Martin V Colonna (1417–1431) restored the papal court

129. Panorama of Lateran Borgo with statue of Marcus Aurelius between palace and cathedral. *Source*: M. van Heemskerck, 1530s. Egger/Hülsen 1913–1916.

to Rome in 1420. Thenceforth the headquarters of the Roman Church would occupy the Vatican.

BIBLIOGRAPHY

Alexander 1971; Birch 1998; Brandenburg 2005; Brandt 1997–1998; Brentano 1991; Colini/Gismondi 1944; Delogu 2000; Duchesne 1886–1892; Frugoni 1999; Gregorovius 1894–1902; Harris 1999; Hülsen 2000; Krautheimer 2000; Lanciani 1880; Lauer 1911; Liverani 1998; Llewellyn 1993; Marazzi 2000; Partner 1972; Pietrangeli 1990; Rohault de Fleury 1877; Scrinari 1991; Valentini/Zucchetti 1940–1953; Vielliard 1959.

TWENTY ONE

THE LEONINE CITY: ST. PETER'S AND THE BORGO

T HE BUILT ENVIRONMENT AND NATURAL TOPOGRAPHY OF ST. PETER'S HAVE changed dramatically since the medieval period. There is little left of the grand and ragged splendor of Constantine's basilica, though it survived the vicissitudes of a millennium and more. Nor is much left of the great pilgrimage quarter with the hostels, monasteries, national *scholae*, the old papal palace, small churches, and *diaconiae* that crowded the medieval Vatican quarter, known as the Borgo, around St. Peter's basilica. Relics of its physical form are sprinkled in unlikely places: the giant pinecone and peacocks that adorned the central fountain of the atrium now ornament Bramante's Belvedere in the palace grounds. The obelisk, a surviving fixture of Nero's circus, long remained in situ on the south flank of the basilica transept; now it centers Bernini's oval Piazza S. Pietro. Of the other familiar medieval landmarks, only the indestructible Mausoleum of Hadrian is still there (see Fig. 65), demilitarized into a museum and pleasure gardens, and connected to the Borgo by fragments of the Leonine Wall, like some defanged but noble beast on a leash (Fig. 130). Yet despite all the changes, a pilgrim transported from the Middle Ages would have no problem recognizing the pervasive cult of St. Peter and his shrine, the foremost, if not the only, reason for the long, involved development and life of an entire urban region. Few manmade places in the world have more obsessively clung to the sustaining principles of a place of veneration in perpetuity.

To envision the medieval city at the Vatican, the Burgus Sancti Petri, or the Civitas Leonina of the documents, we must do several things: situate

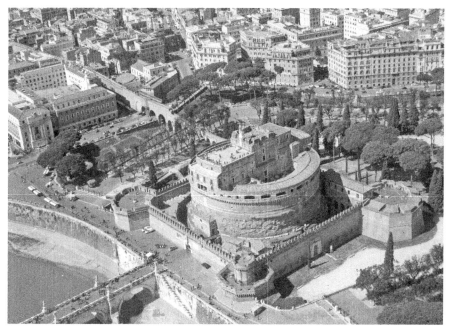

130. Passetto di Borgo connecting Vatican Palace and Mausoleum of Hadrian.
Source: Photo: SF Photo/Shutterstock.

Constantine's church in the context of the built and natural environment of
antiquity and its subsequent crowning with a string of dependent buildings;
examine the development of the Vatican Palace before it was submerged under
Renaissance forms; and unearth the urban history of the Borgo itself.

The Vatican and the Lateran were medievalized in distinct ways. For one
thing, even if parts of the Vatican were developed under Caligula and Nero
and were included in the regionary catalogs, the district retained a suburban
character. The emperor Aurelian felt no need to enclose any part of it when
he speedily threw up his wall around the city. For another, unlike the Lateran
basilica, which Constantine built on unhallowed ground over condemned
property that was conveniently available to him, St. Peter's, at great material and
moral cost, required demolishing existing pagan and Christian tombs to isolate
the shrine Christians had revered since long before Constantine's conversion.
And, paradoxically perhaps, the simultaneous isolation from and proximity to
the medieval urban core, as well as the association with a specific saint – the
father of the papacy, no less – engaged the Borgo in the urban process of later
medieval and Renaissance Rome to a degree the Lateran never saw.

To establish the precise lines of the classical topography is not easy. We do
know that the obelisk, before it was moved to its present location, had never
been uprooted from its Roman foundations along the spine of the circus
where Nero drove chariots and persecuted Christians. Of the circus and the
necropolis built over it, we have said enough already (see Chapters 14–16).

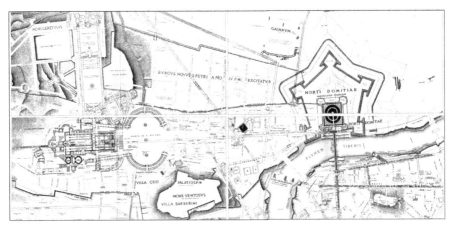

131. Vatican Borgo showing ancient, medieval, and Renaissance remains. Naumachia of Trajan ("Gaianum") is misaligned.
Source: FUR.

Vestiges of Nero's postconflagration street grid appear north and east of the circus, most prominently in the identically oriented Naumachia of Trajan and Mausoleum of Hadrian (see Fig. 44). Constantine's basilica was aligned almost exactly with the south side of the mausoleum, so we can reasonably suppose, as Lanciani did, that the most important avenue between the two monuments, Via Cornelia, ran true to the grid under the modern Via della Conciliazione (Fig. 131). The *Nuremberg Chronicle* of 1493 seems to show the street as an arrow-straight promenade running from the mausoleum straight up to St. Peter's doorstep (Fig. 132).

This then constituted Constantine's site in the northern sector of the 14th Augustan region: cemeteries and sports grounds in the valley; an urbanized neighborhood of unknown dimensions on the sprawling Prata Neronis, the "Plains of Nero"; imperial pleasure gardens and vineyards on the slopes of the Vatican and Janiculum hills to the west and south. St. Peter's, at the eastern foot of the Vatican Hill, was anchored on massive foundations of concrete masonry. Its form was that of a giant T and it served a double program as both memorial and basilica. For its first century, there is no reason to view St. Peter's any differently than Constantine's other great cemeterial basilicas in the urban periphery. It was not meant as a regular congregational church, although it may soon have assumed this function to serve the permanent community that began to develop around it. Only when Gregory the Great had the presbytery raised and a crypt created below it around the year 600 was the main altar finally placed over Peter's tomb. By this time, the nave's initial purpose – to serve as a covered cemetery and the setting of the funeral feast on the saint's day – no longer predominated (Fig. 133).

For centuries, the neighborhood of St. Peter's was a work in progress. Since the mid-fifth century a large gleaming mosaic had adorned its façade, but

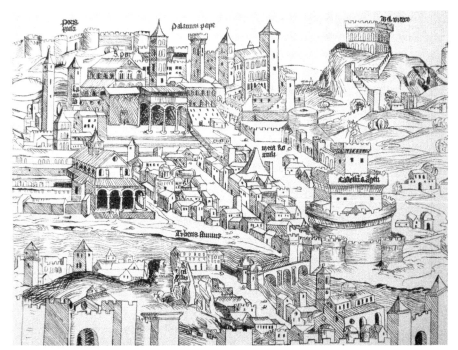

132. View of Vatican Borgo, detail.
Source: Schedel 1493.

the north and south porticoes of the atrium that fronted the church were
probably never completed. The famous Porticus Maximae, which linked
this atrium to the Tiber crossing – that too may have never been fully real-
ized. The earlier Vatican pontifical residence was not even mentioned until
Pope Symmachus added two wings of an episcopal residence; at this time he
also repaired and adorned the church. Whatever temporary lodgings there
were before, Symmachus had neither pretensions of grandeur nor adequate
meeting rooms.

Originally slow and tentative, the Borgo's growth followed the usual pat-
tern for extramural cemeterial basilicas: functional buildings, such as lodg-
ings for clergy and maintenance staff, monasteries, and cells for guests and the
devout, arose. By the seventh century, development was quickening largely
because of the special veneration of St. Peter. Pilgrimage, particularly from the
north, had swelled, necessitating hostels and subsidiary churches for pilgrims or
visitors unaffiliated with a national group. Then when the mid-ninth-century
Leonine Wall was built, the quarter emerged as an independent entity hosting
a crowded and bustling community of foreigners and papal dependents.

Between about 500 and the construction of the Leonine Wall, development
occurred around several distinct foci. The immediate periphery of St. Peter's
continued to receive monasteries, *diaconiae*, *xenodochia*, and palace additions.
The monasteries wrapped themselves around the sanctuary end of the basilica

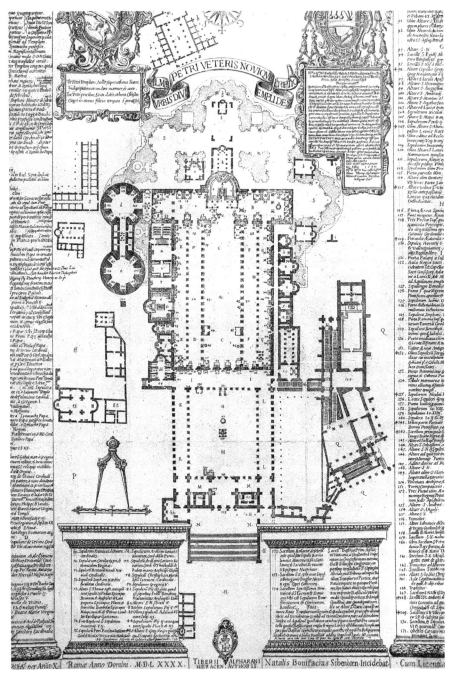

133. Old St. Peter's with new St. Peter's overlay, 1590.
Source: Alfarani 1914.

and the *diaconiae* clustered at the east end, each location thereby expressing
a distinct functional relationship to the basilica. The monasteries served the
inner, confessional dimension of the church while the *diaconiae* fulfilled the

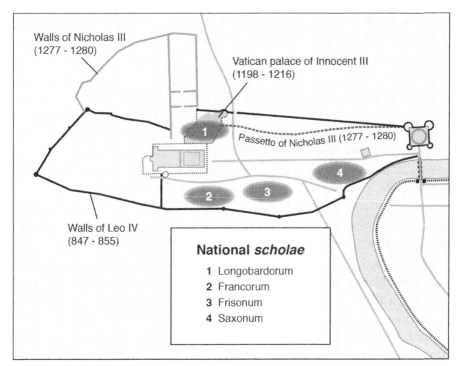

134. Map with *schola* locations and Leonine Walls.

monastic mission of charity to the pilgrims. At the same time, the proces-
sional approaches to the basilica became spines for building activity. There,
two paths met at right angles in front of the church at a small piazza, known
as the Cortina. One was Via Cornelia, which led from the city by way of the
Pons Aelius. Pilgrims arriving from the north followed a different ancient road
known as the Rua Francigena, which may have constituted a length of the
old Via Triumphalis, the consular road approaching the Vatican from the north
(see Fig. 44).

Two terminal foci, St. Peter's and Hadrian's Mausoleum, framed the city
route. The mausoleum had been used as a fort since the siege of 537/538, when
it was connected at its square lower story with the Pons Aelius, forming a nar-
row fortified bridgehead. The mausoleum's defenses were augmented with six
towers in 552. Near it the church of S. Maria in Hadriano was built as a *diaconia*
at the time of Pope Hadrian I. Westward along the porticoed Via Cornelia,
toward the basilica, were a string of chapels and churches.

A new institution, a sort of fraternal order called a *schola*, also arose along
the pilgrimage routes (Fig. 134). Originally there were four major *scholae*,
Saxonum, Frisonum, Francorum, and Longobardorum, each serving national
communities: Saxons, Frisians, Franks, and Lombards. Their origin is unclear,
but all four certainly existed in 799 when their members joined a vast proces-
sion of clergy and laymen to greet the returning pope at the Milvian Bridge

on 29 November. The national groups created their own nuclei along the two generating axes, the Porticus Maximae and the Rua Francigena. Each *schola* consisted of a church and lodgings for the visiting nationals, but the lodging system was probably not a single building. Rather, we are dealing with whole neighborhoods, a parish almost, with a group of houses clustered around a church or along a street or two. The disastrous Borgo fire of 847 began at the *schola Saxonum*, which was composed at that time of a group of timber houses, rather like a Saxon hamlet. It was built south of Via Cornelia, where the Santo Spirito in Sassia hospital, built by Innocent III within the ruins of an English hospice, stands today.

All four *scholae* were on higher ground; this siting was healthier than the damp plain and it also gave them a physical cohesion consonant with the medieval principle of clustering. The church today called SS. Michele e Magno belonged in the Middle Ages to the *schola Frisonum*; it stood on a small hill called Palatiolum. One reaches it today by climbing a stairway from Borgo Santo Spirito. The *schola Francorum* seems to have centered on S. Salvatore in Terrione, which survives in modified form beside Porta Cavalleggeri. The *schola Longobardorum* was west of the Rua Francigena on the eminence of the Mons Saccorum. It and its church, S. Giustino, were eventually swallowed up by the Vatican Palace in the later Middle Ages, possibly under Boniface IX (1389–1404), who suppressed the Rua Francigena to create, perhaps for strategic reasons, an open piazza in front of the papal palace.

The presence of the foreign *scholae* in the Vatican – a totally undefended suburb until 850 – is interesting. Do we credit them to a special zeal among northerners for the cult of Peter, or to the possibility that the Romans did not want them in the city's core? We might infer the latter – that the foreigners lived in the Borgo not by preference, but by coercion. The pattern of isolating alien contingents in peripheral areas had been established early: the Goths in their quarter on the semiabandoned edges of the Esquiline and Caelian; the *schola Graecorum* around the church of S. Maria in Cosmedin; the Jews in the Transtiberim.

But ascribing such concentrations to policy or even prejudice entails caution; birds of a feather flock together, and their habitats may be more justly premised upon a history of chance opportunities and national identity than of forced segregation. The *scholae* may have begun with a few houses for pilgrims who intended to settle near St. Peter's to end their days in the shadow of the apostle's shrine. At its height the Saxon *schola* was a pilgrim's community with considerable attached property living under a centralized organization of a quasi-monastic character. By 846, when the Saracen fleet appeared at Portus, the *scholae* were populous enough to warrant inclusion in the Roman system of *scholae militia*. On one day in August the Saxons, Frisians, and Franks were sent out to fight the Muslims. A relieving Roman party arrived later that day, but withdrew

because they were outnumbered, leaving the soldiers from the Vatican *scholae* to be massacred! The chilling incident proves that the *scholae* were permanent – not a group of transient pilgrims – but also that they were expendable.

Reaching St. Peter's on 27 August 846, the Saracens sacked and looted it indiscriminately. Promptly the German emperor Lothar, technically the defender of the Church, set out with Pope Leo IV (847–855) to prevent a recurrence of the Saracen disaster by building "a stout wall ... around St Peter's." Subsidies were levied throughout the Holy Roman Empire to finance the work, begun in 848. Workers were recruited from monasteries and the Church's *domus cultae*. The resulting Leonine Wall, having little in common with the mighty Aurelian Wall, was a thin curtain of which little survives, but its extent around St. Peter's and the Borgo is relatively clear. For our purposes it defines the precise extent of the Vatican quarter deemed worthy of defense. It would determine, by and large, the subsequent development of the Borgo for several centuries.

Monasteries had from a very early date begun to cluster around the basilica. Pope Leo the Great had added one (later dedicated to SS. Giovanni e Paolo) behind the apse of the basilica. A convent, "Hierusalem," probably stood by the north transept; the neighboring S. Stefano Maggiore, perhaps started as a convent, was converted to a basilical monastery. S. Martino, probably from the first half of the seventh century, and S. Stefano Minore, from the mid-eighth century, stood near the obelisk. The environmental impact of these basilical monasteries extends beyond their physical association with St. Peter's. Each of them started acquiring property as the Borgo began to develop in earnest by the seventh century. By the eleventh and twelfth centuries the monasteries owned much of this quarter, now within the Leonine Walls. S. Martino, for example, held most of the area south of Via Cornelia, including the property and churches of the scholae Saxonum, Frisonum, and Franconum. Each monastery had its own endowments, including real estate outside the Borgo, which implies an organizational network of great intricacy. It seems that the Borgo was first organized around the property pattern of the northerners and that, as the *scholae* weakened, the monasteries stepped in to assume ownership.

The palace, such as it was, stood in the flat ground immediately north of the atrium of St. Peter's. To Leo III belongs the *triclinium* (dining hall), which may have been occasioned by the crowning of Charlemagne as emperor here at St. Peter's on Christmas Day of 800. By 900 there was a presentation balcony of some kind. The crucial turning point probably occurred during the pontificate of Innocent III, who took up residency here as a result of political unrest. He added some administrative offices and rooms for the clergy, thus preparing it for its destiny as the new headquarters of papal administration. He also further fortified the palace. Shunning the Lateran as his residence,

Nicholas III (1277–1280) began to build a second Vatican palace complex that actually overleapt the confining Leonine Wall to occupy a plateau on the Mons Saccorum that later became the Belvedere.

One more aspect of the Vatican complex bears on our theme of process. Nowhere was the impact of the northern pilgrimage more evident than at St. Peter's, where permanent settlements began early. As St. Peter's fame spread, immigrants swelled the Vatican quarter and this Transtiberine nucleus began to counterbalance the Lateran's pull as the administrative headquarters of the papal regime. The Vatican's presence brought about the creation of a processional axis, Via Papalis, cutting directly across the tangle of the city and joining the far-flung poles of the *sacrum palatium* of the Lateran and the shrine of the apostle at St. Peter's. As we shall see, ritual would forge urban paths where reason and convenience might not otherwise have walked.

BIBLIOGRAPHY

Alexander 1971; Alfarani 1914; Antonetti 2005; Bertolini 1947; Birch 1998; Buzzetti 1968; Dey 2008; Duchesne 1886–1892; Ferrari 1957; Finch 1991; Gasparri 2001; Gregorovius 1894–1902; Harris 1999; Homo 1934; Hoogewerff 1947; Hülsen 2000; Johrendt 2012; Kessler/Zacharias 2000; Krautheimer 1937–1976, 2000; Lanciani 1890; Liverani 2010; Magnuson 2004; Monciatti 2005; Noble 1984; Redig de Campos 1967; Romanini 1983; Sordi 1965; Toynbee/Ward-Perkins 1956; Valentini/Zucchetti 1940–1953; Vielliard 1959; Yawn 2013.

TWENTY TWO

VIA PAPALIS, THE CHRISTIAN *DECUMANUS*

A S THE CROW FLIES, ABOUT FIVE KILOMETERS SEPARATE THE VATICAN AND the Lateran – a long walk and a considerable distance on horseback. The spiritual energy flowing between them created an unlikely Christian *decumanus*, a major east–west street that now rivaled the ancient north–south *cardo* defined by Via Flaminia/Appia. To the medieval Roman and the foreign pilgrim this was the ultimate ceremonial path, Christian Rome's triumphal way. It conjured images of dazzling processions led by pontiffs and crowned heads of state, eventfully traversing the city with meaningful stops and attendant ritual. Processions such as the papal *possesso*, a ritual walk to the Lateran taken by the newly crowned pope, began at St. Peter's (Fig. 135). From there one moved down the length of the porticoed Via Cornelia toward the Tiber with the somber bulk of Hadrian's Mausoleum as the first beacon; across Pons Aelius, and through the Campus Martius, with pagan landmarks and Christian stations to the right and left, to the foot of the Capitoline; then skirting it along the north and east to enter the Roman Forum; passing through it to the crest of the Velia at the southeast end, where the Arch of Titus stood and opened the way down the slope to the Colosseum; and up again, to the top of the Caelian and the sprawling and spirited complex of the Lateran.

This was Via Lateranensis, Via Papalis, Via Maior: as close to an organizing central axis as medieval Rome ever had. But it was no triumphal route in the formal sense. Were it not for the power of processions to fashion continuity

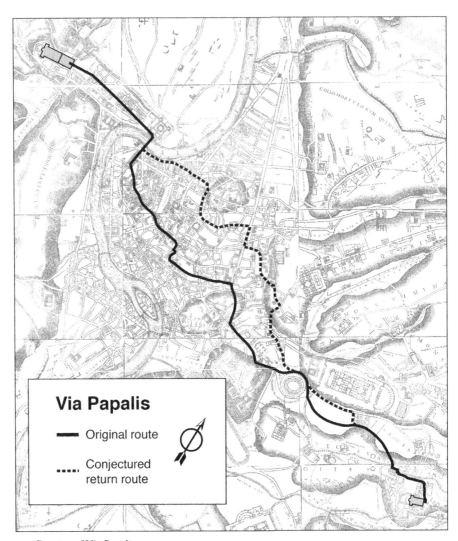

135. Routes of Via Papalis.

and cohesiveness through ceremonial movement, it would be seen for what it really was, a string of neighborhoods and a patchwork of streets of different width and indifferent rectitude, going uphill and down, and flanked by everything from rows of unassuming houses or yard walls to the still-proud marble frames of ancient theaters, monumental monasteries, and parish churches. It was no *cardo* or *decumanus* in the Roman sense. Via Papalis was not, in other words, the initial organizing determinant of the course of urban order, but the unanticipated and improvised reaction to the pull of two far-flung ceremonial centers.

That St. Peter's and the Lateran basilica had generated urban traffic from the start is evident, but there was probably no continuous flow from one end

to the other. No clear route lay between them and each had its own distinc-
tive character: St. Peter's, a memorial shrine and a point of pilgrimage; the
Lateran basilica, the administrative center of the bishopric of Rome. About
halfway between them stood the millennium-old centerpiece of Rome and
the Roman world, the Forum, where stood the *umbilicus mundi*, the navel of the
world, from which all Roman roads sprang and all distances were measured.

The north–south Via Flaminia, which bent at the foot of the Capitoline
ultimately to join Via Appia, had been the de facto *cardo* of ancient Rome. But
by the seventh or eighth century, the Vatican and Lateran magnets had forced
the shaping of a Christian *decumanus* that was now the dominant chord of the
urban scheme. To be sure, the Flaminia–Appia *cardo* remained functional and
prominent. Porta Flaminia remained Rome's major entrance from the north
for those who crossed the Milvian Bridge and traveled down along the left
bank; Via Flaminia was the main artery into the urban core. Even so, many
northern travelers preferred to veer off the Via Flaminia before the Milvian
Bridge and enter the Borgo along the right bank and the city via the Pons
Aelius.

Within the walls several important churches and *diaconiae* lay alongside
or near Via Flaminia, by now called Via Lata, beginning with S. Lorenzo in
Lucina, a fifth-century basilica raised over an earlier *titulus* and remodeled in
the eighth century (see Fig. 117). A late-antique triumphal arch, the so-called
Arco di Portogallo, spanned Via Lata at this point (Fig. 136). Across the way
was S. Silvestro in Capite, an important eighth-century monastery and church.
Farther down, also on the east side, stood the titular church of S. Marcello,
and more or less across the way the *diaconia* of S. Maria in Via Lata ensconced
within a Roman *horrea*. At the foot of the Capitoline Hill stood the basilica of
S. Marco, a fourth-century titular church remodeled in the Byzantine manner
during the sixth century. This lower, downtown stretch of Via Lata just north
of the Capitoline had become the preferred location for rich houses in part
because of the ample water carried there by the still-functioning Aqua Virgo.
But for all this activity, the Flaminia/Lata was not what it used to be. The first
stretch inside Porta Flaminia until S. Lorenzo in Lucina began, in time, to look
like a country road.

The new east–west crosstown passage may not have emerged until 800.
In that year Charlemagne was crowned as the first Holy Roman emperor.
Significantly, his coronation took place at St. Peter's and he chose to stay
nearby, rather than at the Lateran palace; only after the ceremony did he pro-
ceed with his cortege to the Lateran for the attendant festivities. From this
time onward, the *diaconia* of SS. Sergio e Bacco just to the east of St. Peter's
north transept served as imperial headquarters whenever the emperor was in
Rome. By choosing to reside *apud beatum Petrum* the emperor was putting
Rome on notice: it was the papacy as an institution, the legacy of Peter, that

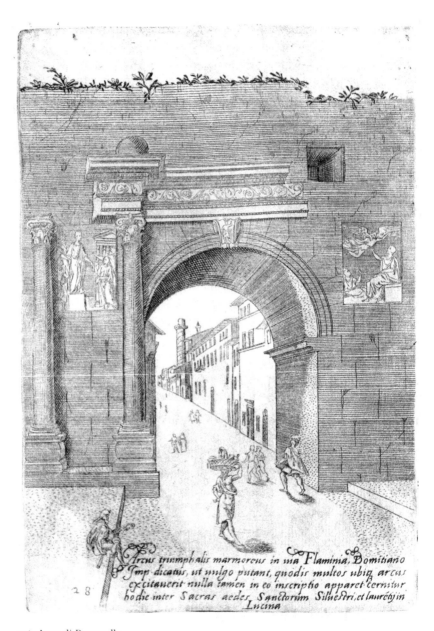

136. Arco di Portogallo.
Source: G. A. Dosio, *Urbis Romae aedificiorum illustrium quae supersunt* (1569). Courtesy of American Academy in Rome.

he was obligated to defend, not the individual pope of the moment ruling at the Lateran.

Solemn religious processions characterized Christian Rome from the start. Traditionally the pope led his clergy from the Lateran to the principle stational churches within the city, first probably in the fifth century, when the important feasts of Christmas Eve, the day after Christmas, and Good Friday took

the papal cortege to S. Maria Maggiore, S. Stefano Rotondo, and S. Croce in Gerusalemme, respectively, and to St. Peter's on Christmas Day. St. Peter's would have been involved directly again on 29 June, during the feast of Sts. Peter and Paul, and a procession between the two apostles' churches probably became part of this anniversary celebration.

For such ceremonial reasons and for the pilgrims' own processions among Rome's churches, specific routes were formalized within the urban fabric. They initially made no significant deviations from the network of ancient streets, but did revise their hierarchy and functional sequences. The so-called *Einsiedeln Itinerary* provides our first glimpse of these routes passing through the *abitato* (the inhabited parts of the city) out to the various monuments. Dating from the late eighth century, but surviving only in a thirteenth-century copy, it consists of 13 itineraries that are nothing more than spare lists of buildings and sights arranged in columns left and right of the major routes. It cannot be taken entirely at face value since it makes occasional errors. The lists are probably abridgments of a longer commentary to a now-missing map. Four salient points deserve notice: they indicate pagan monuments as well as Christian; these monuments are still called by their ancient names even though the identification is not entirely accurate; many of these monuments survived and were known in the late eighth century; and east-west routes, such as Via Papalis, predominate.

Because no copies of an accompanying map exist, scholars have made remarkable attempts to reconstruct it – the most important being those of Lanciani in 1890 and Hülsen in 1907 (Fig. 137). For example, Lanciani's is a normal map of Rome on which he plots the 13 routes specified by the *Itinerary* in black lines. Over these he traces in red the routes indicated by a second itinerary from the twelfth century, the *Ordo Romanus Benedicti*, also called the *Liber politicus*, of Benedetto Canonico, canon of St. Peter's basilica. Lanciani's thesis is that while the streets that the late-eighth-century pilgrim traversed were all ancient Roman roads with the pagan monuments significantly preserved, by the twelfth century a new street network had infiltrated and broken up the ancient street structure into a medieval maze, destroying many of the pagan monuments in the process and confounding the memory and identification of others.

Both the purpose and the path of Via Papalis had changed since the days of the *Einsiedeln Itinerary.* For twelfth-century pilgrims, Benedetto's *Ordo* was a primary text for the rituals, processions, litanies, and indulgences of the Church. By now both the ceremonies of the coronation of the Holy Roman Emperor and the consecration of a newly elected pope were held at the Vatican and resolved at the Lateran after a solemn procession along Via Papalis. Popes and emperors made their way along the route in a cortege that observed a strict hierarchical order of clergy, nobles, and choirs. Over time the route became

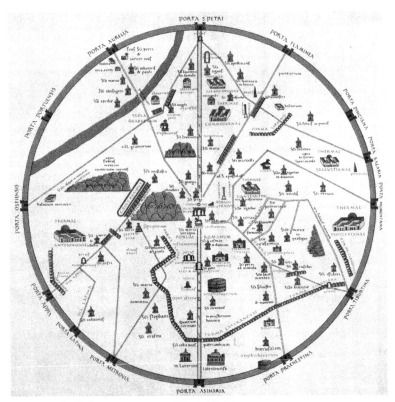

137. Hypothetical reconstruction of *Einsiedeln Itinerary* map.
Source: C. Hülsen, *La pianta di Roma dell'anonimo einsidlense* (Rome 1907).

richly decorated with triumphal symbolism (Fig. 138). Along the way bells tolled, people cheered, and the clergy and dignitaries of individual parishes and representatives of the *scholae* would move forward to pay homage. At five points along the way – including in front of St. Peter's and S. Adriano in the Forum, the former Curia consecrated in 630 – largesse was distributed at the head and rear of the procession.

Comparing the Einsiedeln and Benedetto itineraries reveals significant divergences along Via Papalis. There are now two separate routes – one proceeding from the Vatican to the Lateran and another for the reverse trip (see Fig. 135). In the first, the path has shifted northward at the start of the Campus Martius (where it will stay for several centuries) and moves along today's Via del Banco di Santo Spirito, Via dei Banchi Nuovi, Via del Governo Vecchio, and so down toward Largo Argentina. No ancient pavement has been found along much of this new path, so we may be dealing, in part, with a medieval creation. The return route is interesting also (see Fig. 135). After touching the apse of SS. Quattro Coronati, it left Via Maior to cut across to Via Labicana, which it followed until the Colosseum. This route may have bypassed the Forum altogether, following instead (to use the modern names) Via del Colosseo/Via Tor

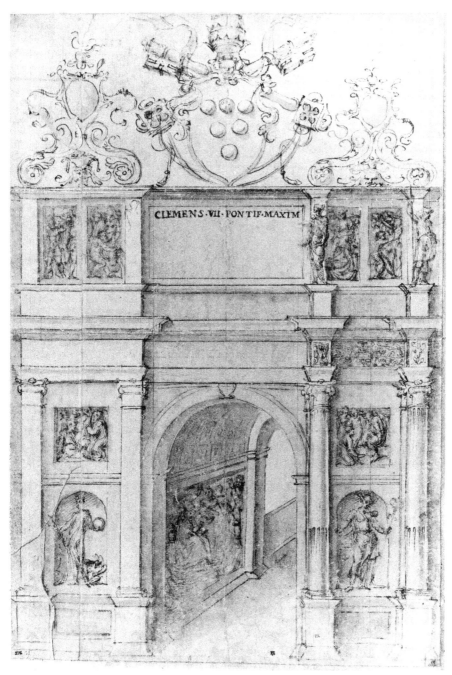

138. Drawing of triumphal arch for papal procession of Clement VII.
Source: B. Bandinelli (attributed), ca. 1523. Victoria and Albert Museum 2257-2006AC5582.
© The Victoria and Albert Museum.

dei Conti up to the Torre del Grillo directly behind the Forum of Augustus (see Fig. 30, where both towers are visible), past SS. Apostoli to Via Lata, and up this artery to S. Marcello, where the procession would turn left and enter Via di Pietra, regaining the Pons Aelius along the river by means of Via Tor di Nona and Via dell' Orso.

These deviations must have been the result of practical or administrative considerations. Stretches such as the Via del Governo Vecchio/Banchi Nuovi detour take advantage of the path of least resistance through the fractured urban fabric between two points. Given the special nature of these Church and state processions, the return trip along the north edge of the Campus Martius provides an opportunity to touch upon as much of the city as possible. This also recognizes the northward shift of population by the twelfth century and the many important churches along the way such as S. Marcello, S. Maria in Aquiro, S. Maria in Campo Marzio (i.e., the Campus Martius), and S. Apollinare. Finally, and perhaps most importantly, there is the military situation. The safety of the city hung in the balance of feudal strife. The eleventh and twelfth centuries particularly are a three-cornered contest among papal power, the rising voice of the Comune representing petty nobility and the new middle class, and the major noble families that sided either with the legitimate papal party or against it. All three worked to enlist outside support: of the Holy Roman emperor, the French king, or the Norman Crown of Sicily. The city was an armed camp with rival forts holding sway over strategic points of the urban pattern. The right of a procession to pass, whether imperial, papal, or civic, was not automatic but had to be secured through negotiation or confrontation. The path above the Forum along a string of forts (Torre delle Milizie, Torre dei Conti, Torre del Grillo, etc.) was not accidental (see Fig. 150).

One final comparison between the *Einsiedeln Itinerary* and that of Benedetto bears making – the manner in which they refer to ancient monuments and sites. At the time of the Einsiedeln pilgrim, not only were more ancient landmarks still standing, but also, people on the whole knew what they were. The locations of Christian monuments, the main interest of the pilgrims who used the guide, were often keyed to pagan buildings. Rome was one city and along the way one encountered old buildings and new, often one inside the other. By Benedetto's time the reverse held: fewer pagan monuments still stood but they were now keyed to nearby churches; and their original identification was often forgotten. Benedetto's *Ordo* references the same pagan sites by the same names as another mid-twelfth-century guide to ancient Rome, the *Mirabilia*, which was most likely also written by Benedetto. Often revised, it was considered a kind of semiofficial document. It presented a grand tour of ancient ruins and narrated fantastic stories about them, and these stories have often been taken as proof of the abysmal ignorance of late-medieval Romans.

What is surprising, therefore, is that such a view exists – the need, that is, to distinguish a historical Rome, separate from and parent to the new Rome. For all the confusion about names and identifications, great effort is made to point out the number and locations of many building types, and to note long-ruined ancient buildings. Even the fantastic stories had a serious aim: to prefigure the age of grace by attributing to ancient monuments events that were in the nature of Christian revelation. Rather than fuse the two Romes – the Pantheon could have served as a model of their coexistence – the itineraries project two distinct images, a Rome of the Caesars and a Rome of Christ, interwoven by a continuous thread of destiny to rule the world. The ancient *caput mundi* prefigured the seat of Peter, as the Old Testament anticipated the New. Thus it was presumed worthwhile to learn about the ancient monuments, point them out, and give them names. Far from demonstrating ignorance, therefore, Benedetto's *Ordo*, the *Mirabilia*, and other literary efforts of the mid-twelfth century are the signposts of a serious resurgence. Like their ancient forebears, Rome's citizens once again understood their city in historical terms and partook of the resurgent energies to reclaim its former glory. It was a fateful reincarnation. Alongside Via Papalis, there was now another processional way, stretching in time, a line of destiny that extended from the beginning of the city's history to the present. Medieval Rome, which had learned to live with an overwhelming past, was now deciding that it deserved it.

BIBLIOGRAPHY

Anonymous, *Mirabilia urbis Romae;* Arena et al. 2001; Barker 1913; Birch 1998; Brentano 1991; Cecchelli 1951; Delogu 2000; Finch 1991; Frugoni 1999; Gregorovius 1894–1902; Hibbert 1985; Hülsen 1907, 2000; Katermaa-Ottela 1981; Krautheimer 2000; Lanciani 1880; Magnuson 2004; Noble 2001; Ortenberg 1990; Romanini 1983; Santangeli Valenzani 2007; Valentini/ Zucchetti 1940–1953; Wisch 1992.

TWENTY THREE

THE URBAN THEATERS OF *IMPERIUM* AND SPQR

I N NO OTHER CITY OF THE EMPIRE DID THE IDEA OF ROMAN GOVERNMENT
survive as tenaciously as in Rome itself. Two symbolic aspects sustained
this idea: the concept of *imperium*, the privilege of continuing Roman impe-
rial rule; and the counterpoint of populism, the trappings of a people's gov-
ernment, the Roman Comune, as contained in the rubric *Senatus Populusque
Romanus*, or SPQR, stamped to this day on every length of pipe and sewer
tube laid by the municipality. The Palatine was the physical location for the
institutionalization of the concept of *imperium* during the Christian Middle
Ages, and the Capitoline became the new home of the Roman Senate in the
eighth century.

Of all the features that characterized Rome as the quintessential imperial
city of classical antiquity, the Palatine was preeminent; it served as residence of
the court and headquarters of the large and mighty imperial bureaucracy. If
the imperial domain was readily transferable to the Church (as we have seen
with large land grants), this was not the case for the Palatine, which as offi-
cial residence of the emperor was managed by the Senate, as were the other
major monuments of the ancient city. The Palatine was the symbol of imperial
authority, the *memoria* of *imperium*, as it were, and was certainly not conveyable
without admitting that the West was lost to the Byzantine Crown. Whether or
not the Roman emperor, resident in Constantinople, ever saw the Palatine, it
remained his premier palace up to the collapse of the Byzantine Exarchate in
752, when all pretense of holding the West ended.

Under the emperor Justin I (518–527), an office was created of three *curatores* carrying the highest title of *illustris*, who took charge of all imperial residences, including the Palatine. Later the office was decentralized and the number of *curatores* increased so that every palace had its own maintenance endowment and probably its own *curator*. A letter of Gregory the Great attests to the existence of "diverse Palatine officials in Rome." The palace was functional at least until the early eighth century. The emperor Constans II stayed at the palace in 663 and it remained functional until at least 712, when the *dux* Christophorus resided there.

The post-Constantinian occupation of the palace was intermittent into the eighth century, and there are intriguing signs that the popes may have attempted a takeover at some time; they definitely allied themselves with this formal seat of *imperium* during John VII's pontificate (705–707). According to the *Liber pontificalis*, John built an *episcopium* (papal residence) on the Palatine, perhaps where the so-called Domus Tiberiana lies, immediately above a new Byzantine entrance to the palace beside S. Maria Antiqua. This move was extraordinary because the pope had no legal title to it. His decision was conscious and political, the Palatine having been the scene of major confrontations in recent decades between imperial agents and popes. John's appearance at the imperial palace at this juncture in the relations between Byzantine administration and the papacy was surely no small matter.

We know little of the papal palace, except that it was used by John's successor Constantine I (708–715). There is in fact no reason to suppose that this *episcopium* lasted much beyond that, and if it did, certainly it was not a viable alternative to the Lateran. It seems clear, on the contrary, that the short-lived flirtation with the idea of transferring the papal court to the Palatine, and thus assuming imperial prerogatives for the seat of Peter, was superseded by the policy of making the Lateran the new Palatine, as we discussed in Chapter 20. By the year 750 the episcopal residence at the Lateran was called *Romanum palatium*.

Amid this palatial setting the Church's presence on the Palatine was modest. On the hill proper, as opposed to the slopes and the foot, there were only two churches in the Middle Ages, and both were quite late; S. Maria in Pallara stood at the northeast corner of the Palatine overlooking the temple of Venus and Roma and the Colosseum, and S. Cesario, clearly an important church, was on the palace grounds by 603. Sometime before 825 it became associated with a Greek monastery known later as S. Cesario Graecorum and ranked as first among Roman monasteries, possibly because of its mythic status as the original Palatine chapel.

By 750 all attempts to occupy the imperial palace were forsaken, as was the attempt to maintain the new papal *episcopium* above S. Maria Antiqua. That church was abandoned after the earthquake of 847, and its privileges and

possessions were moved to S. Maria Nova, built that year by Leo IV on the western edge of the platform of the temple of Venus and Roma. The papacy's interest in the Palatine and the Forum now shifted to this corner, where the Sacra Via, running from the Forum, met an extension of Via Appia – the main southern approach into the city – also linked to the Lateran along Via Papalis. No longer strictly trying to occupy the Palatine symbolically, the papacy now sought to occupy it strategically by way of surrogates and allies. Meanwhile an antipapal, proimperial contingent began to occupy the Aventine in the ninth century. By the tenth century the powerful Tuscolani family was firmly established there.

The papacy's hold over the valley between the Palatine and the Caelian meant that it controlled the southern approach into the city and the western flank of the papal quarter (see Fig. 116). The Aurelian Wall effectively shielded the southern and eastern flanks. By the early tenth century the area around the Arch of Titus and all the way up the Palatine to the S. Cesario monastery was a rather populous residential quarter. The Clivus Palatinus was lined with houses. At the top, the path forked, one branch leading to the monastery of S. Maria in Pallara, the other to the ruins of the imperial palace, by then covered by fields and vineyards. At the other end of this east side of the Palatine stood the Septizodium and the *diaconia* of S. Lucia *ad septem vias*, mentioned prominently in the *Einsiedeln Itinerary* and built into the abandoned palace. Across the way, on the side of the valley toward the Caelian, stood SS. Giovanni e Paolo and the monastery of S. Gregorio.

At a time when the feudal struggle for control of Rome began in earnest, sometime in the later tenth century, baronial families – the Frangipane, the Ildebrandi de Imiza, the de Papa, and the Astaldi – appeared on the scene. They started to fortify the Palatine on the north side, presumably with the initial blessing of the Church, which had to seek strong local patrons to defend its property and power. All were of the Guelph or propapal faction, and so by 1000 the Palatine was a stronghold of the papal cause. In 150 years, the Frangipane would dominate the entire Palatine, displace the other families, and build impressive fortifications at every corner. One was in the Septizodium, which had already been fortified by at least the tenth century; commanding a long view down the Appia, it protected the hill behind. The Frangipane also, over time, strategically occupied the temple of Venus and Roma, the Colosseum, the Circus Maximus, the northwest corner of the Palatine above the Velabrum, and the Janus Quadrifrons, a late-antique freestanding arch also in the Velabrum (Fig. 139). Their link to the temple of Venus and Roma was via the fortified Arches of Titus and Constantine (see Fig. 37), which in turn provided the link to the Colosseum (Fig. 140). Many of the properties were ceded to them in exchange for an oath of papal support. This formidable *rocca dei Frangipane* became the chief redoubt and a refuge for popes against imperialists during the

139. So-called Arch of Janus in Velabrum.
Source: Dupérac 1575. Courtesy of Vincent J. Buonanno.

140. Fortified Arch of Constantine.
Source: G. ter Borch the Elder, 1609. Courtesy of Rijksmuseum. RP-T-1887-A-866. Purchased with the support of the Vereniging Rembrandt.

ascendancy of the short-lived Roman Comune, which began in 1143 with a popular uprising. The Frangipane were so closely allied with the papacy that they were, in fact, listed in 1149 as among the Comune's worst enemies.

By the twelfth century there was not much left of the grand concept of *imperium* in the fractured fabric of the Palatine. With the Lateran in physical decline, the Palatine in the hands of barons, the Aventine controlled by antipapal forces,

and the Vatican not yet fitted for its leading part in the perpetuation of the imperial idea, one other hill gained sudden prominence and laid claim for some decades to the memory of Rome's universal dominion. One day in late 1143 a group of dissatisfied Romans "wishing to restore the ancient dignity of the city" rebelled against papal authority and their baronial supporters. They stormed and seized the Capitoline for themselves, declared themselves free of papal interference, and reclaimed what they saw as their ancient right to control the Senate and claim the moniker SPQR, "which had lapsed for a long space of time." It was the latest in a series of popular uprisings that had been galvanizing the social and political order of Italian cities against the dominant system. Leading families of the new movement organized themselves to unravel the power of the Crown with its perquisites, the great feudal nobility, and the Church.

The import of this popular uprising, in Rome of all places, was not lost on the Church. Alone among the cities of its region, Rome was ruled by the bishop and his priests. The pope held the regalia, appointed the prefect, and controlled all aspects of municipal administration. Foreign policy was conducted from the Lateran, with reference not only to the lands of Peter and the Church's role in the political construct of Europe but also to Rome's relations with its own neighbors. The pope was the largest landowner in Italy, and the Church and its dependencies held most of the territory within the Aurelian Wall. Directing its animus against this priestly order, the *populus* was acting *contra domum Dei*, against the house of God. The she-wolf, now the emblem of the Roman Comune, was challenging St. Peter.

Church revenues were confiscated and the houses of cardinals and of nobles hostile to the revolution were looted, their towers demolished. Innocent II (1130–1143), as he lay dying in 1143, was coerced (some say) by the Comune to reinstate the Roman Senate. It is not surprising, therefore, that Pope Lucius II (1144–1145) tried to suppress this republican challenge before it got out of hand. He dissolved the Senate and imported troops into the city to attack the Capitoline, but was wounded in the fray. On the day that he died, 15 February 1145, the papal conclave sequestered itself in the monastery of S. Cesario in the Frangipane fortress on the Palatine.

The next step was for the Comune to create its own ritual environment. The newly reconstituted Senate first met in the Corsi palace, which occupied the strong frame of the ancient Tabularium (see Figs. 19, 143). These new surroundings, as Arnaldo da Brescia told the senators, were beneath the newly found dignity of the SPQR. He counseled them to rebuild the Capitoline, and they did so quickly. By 1151, a new headquarters of the civic government emerged on the site of the future Palazzo dei Senatori, which now commands the axis of Michelangelo's architectural reimagining of the Capitoline (see Fig. 181). This place remains, nearly nine centuries later, seat of the people's government and symbol of occasional popular defiance of more potent orders.

141. Arch of Septimus Severus and the church of S. Adriano.
Source: Dupérac 1575. Courtesy of American Academy in Rome.

All too romantically, we regard the Roman Senate as the center of pagan resistance to the Christian takeover of the city and its traditions. Yet the Senate had not been a powerful decision-making agent for Roman government for centuries. Yes, early Christian rulers paid deference to it, but only for selfish reasons or for pomp. The duality of Church and Senate simply was not genuine, at least after 400, when the noble families produced both the senators and high clerics, and when at times a single person would serve in both bodies. Pope Gregory the Great, for example, was urban prefect before entering the clergy. Also the Senate and Church jointly worked to solve the city's problems, especially threats from the outside, during the vacuum created by the departure of Constantine's imperial court in the 330s. The senatorial tradition may have continued from the seventh to the early twelfth century, but the august deliberative body would have been an instrument of the Church.

The Senate, conceptually at least, was accepted in the public mind as the interpreter of the sentiments of the people. In its annals and its oratory, talk of *libertas* and *aequitas* was frequent, and it seems not surprising that in searching for a voice for themselves with the authority of the past, the people would turn to the Senate's memory. Thus the Curia was duly repaired after Alaric's sack of 410 and continued in use even after Pope Honorius I converted it into the church of S. Adriano in the early seventh century. The only Christian addition was an apse, and, notably, the new church was neither a *titulus* nor a major papal basilica. Some kind of double function for the building is therefore not out of the question, at least until its conversion to a *diaconia* in the late eighth century (Fig. 141).

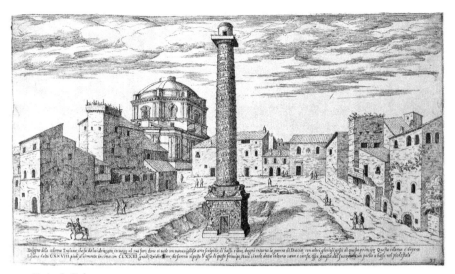

142. Trajan's Column.
Source: Dupérac 1575. Courtesy of Vincent J. Buonanno.

The Senate then moved up to the Capitoline and held its meetings, continuing an ancient tradition according to which the body had met there for solemn occasions. The hill had always been a public space, with no palaces or residential fabric except on the slopes. S. Maria in Aracoeli was the only Christian presence on this most sacred hill of pagan Rome. The present church dates to the second half of the thirteenth century, but some kind of religious community had occupied the hill by the eighth century.

The young Comune busily set out to claim its own landmarks in the city, including the she-wolf sculpture and the venerable Column of Trajan, which it voted to preserve in 1162; to subdue the baronial families and cardinals; and to define and fortify its own environment on the Capitoline (Fig. 142). A palace stood on the left side of the Palazzo dei Senatori extending along the flank toward the monastery of S. Maria in Aracoeli. Here was the main council hall, a two-level structure opening out toward the north and the Campus Martius, and turning its back on the fora (Fig. 143). An open market, which had for centuries operated on the hilltop, was now displaced to the foot of the hill. Merchants' guilds, dormant for most of the Middle Ages, found fresh strength and built their own jurisdictional tower, the Torre del Mercato or Torre del Cancelliere, overlooking the market.

But little more than half a century after the fever of 1143, the Comune had lost some of its authority. Innocent III claimed the right to appoint a single senator of Rome through an intermediary, and in another hundred years the Comune hardly existed, its power absorbed by the papacy. To combat its power, popes gave aid and comfort to the small communes of the Campagna, which found in the papacy a bulwark against the expansionism

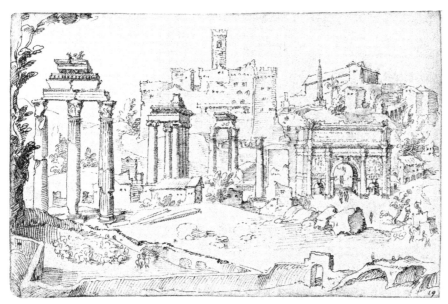

143. View of Roman Forum toward Tabularium and church of S. Maria in Aracoeli.
Source: M. van Heemskerck, 1530s. Egger/Hülsen 1913–1916.

of the republic of Rome. At this stage, military defenses were built inside and outside Rome: fortified towers in the city, fortified churches outside the walls. The issue was no longer Rome against the Goths or the Lombards or the Arabs, but Rome against itself.

BIBLIOGRAPHY

Augenti 1996; Bartoli 1911, 1929; Brancia di Apricena 2000; Brandizzi Vittucci 1991; Brentano 1991; Cecchelli 1951; Duchesne 1886–1892; Ehrle 1890; Gregorovius 1894–1902; Homo 1934; Hubert 1990; Krautheimer 2000; Lenzi 1999; Llewellyn 1993; Magnuson 2004; Meneghini 1999; Meneghini/ Santangeli Valenzani 1995, 2004; Moscati 1980; Re 1880; Steinby 1986; Tomassetti 1979–1980; Verzone 1976; Vigueur 2001.

TWENTY FOUR

HOUSING DAILY LIFE

A CITY IS A RESTLESS ORGANISM THAT SHIFTS, ADJUSTS, DECAYS; A THOUSAND small interventions affect its corporate body every day as bits of it shrink and crumble imperceptibly. But this cumulative agitation over several centuries is not necessarily negative. It is simply inevitable change. Thus far we have regarded these changes as they affect medieval Rome's important building complexes and loci of power – the Lateran, the Vatican, the Capitoline, and those institutions and rituals that characterized the Christian center – the titular churches, the *diaconiae*, the *xenodochia*, and Via Papalis. But what about the small-scale, fine-grained fabric of the city made up of houses, gardens, industries, and markets? Until recently, medieval everyday life was of little importance to archaeologists, who habitually ignored or discarded its material evidence as they dug down to the ancient city. Fortunately attitudes have changed to such a degree that Rome's medieval archaeology is a growth industry today. Since the 1970s, excavations have revealed the complex reorganization of streets and the transformation of public buildings for residential and industrial uses, especially between the eighth and eleventh centuries.

At the end of antiquity, as the regionary catalogs make clear, there were more than 40,000 apartment units in Rome, some of them five or six stories high. These filled in the cracks of the monumental downtown, pushed up the slopes of the eastern hills, and occupied the southern sector of the fourteenth Augustan region, the Transtiberim. By contrast, most noble estates stood in

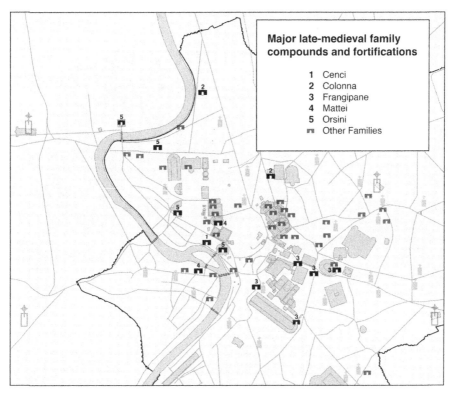

Major late-medieval family compounds and fortifications

1 Cenci
2 Colonna
3 Frangipane
4 Mattei
5 Orsini
🏰 Other Families

144. Map with major late-medieval family compounds and fortifications.

greenspace, at the crests of the hills, especially the Caelian and Aventine, and we have already noted their physical takeover by Christian institutions.

The transfiguration of the teeming tenement blocks was less sensational than the dissolution of titled property, and thus harder to record. With population decline beginning in the fourth century one must envisage a slow process of partial occupation and then total abandonment, the stripping of usable material, the inevitable collapse and disintegration, and the final burial under rising soil. New structures took over as need and convenience dictated; the urban fabric found its own logic. Once the machinery of public services ground to a slow halt, no attempt was made to control the development of this urban pattern until the thirteenth century, when the office of the *magister aedificiorum urbis* was revived under the name *magister stratarum*, superintendent of streets.

The street pattern, or as much of it as was useful, remained mostly unchanged for centuries. The population slowly moved toward the new axis, Via Papalis, thinly stretched between the Lateran and the Colosseum, and then progressively denser toward the area of the fora and between that area and the river (Fig. 144). Over time, important Roman families including the Alberini and Cesarini built residences along or very near Via Papalis, increasing its prestige.

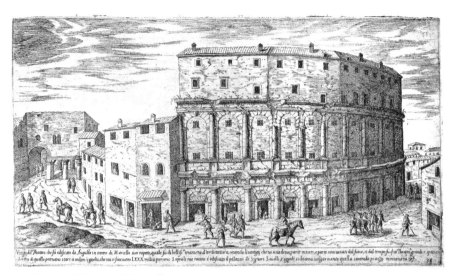

145. Ruins of Theater of Marcellus.
Source: Dupérac 1575. Courtesy of Vincent J. Buonanno.

The abandoned estates at the edges of the residential core just within the wall were being converted to agricultural land, providing for the needs of the city. The distinction between city and country, in fact, was less sharp than it had been. While the eastern hills and the northern intramural sector of Via Flaminia were effectively rural, bits of city had developed in the countryside around the basilicas of S. Paolo fuori le Mura, S. Lorenzo fuori le Mura, and especially St. Peter's. Rome, in a curious urban paradox, was shrinking and expanding at the same time.

As early as the mid-fifth century some large exclusive *domus* had already been abandoned and then partially reinhabited. One striking example was a fourth-century imperial house on the Quirinal Hill. It was vacated, probably within 150 years after its construction, and then a much smaller residence with an internal courtyard was inserted into a portion of the original. By the fifth and sixth centuries we see this kind of intensive fracturing of the imperial environment increase, as a glass factory, bakeries, and new institutions such as *xenodochia* burrowed into theater vaults and public porticoes; as new graves were dug beneath once-marbled floors; and as new paths that would ultimately become new roads were beaten through formal public spaces. A recently discovered Hadrianic auditorium west of the Column of Trajan had a second life in the sixth century when it was transformed into a metal forge, perhaps the Byzantine mint for bronze coins.

By 500, the theaters may have started falling vacant, their vaulted innards giving shelter to a population of squatters, their exterior ground arcades to vendors and street merchants (Fig. 145). A century later, vineyards occupied abandoned areas, especially on the hills. By the eighth century, the city still

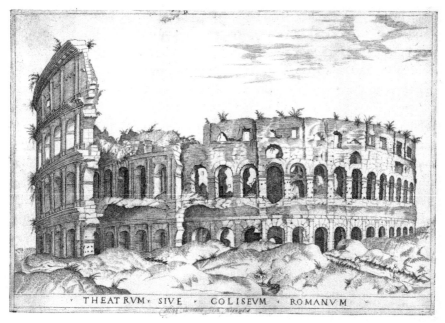

· THEATRVM · SIVE · COLISEVM · ROMANVM ·

146. Colosseum.
Source: Anonymous, *Speculum Romanae magnificentiae*, 1542–1570. British Museum 1920, 0420.51
AN495592001. © The Trustees of the British Museum.

relied on grain from the Campagna, but as Rome's continuing contraction demanded more self-reliance, working gardens with vegetables, fruit trees, and herbs proliferated in the center.

The Colosseum had already lost its main attraction when Honorius suppressed gladiatorial combats in 404; animal shows, the *venationes*, ceased in 523. After the 410 sack of Alaric, and a series of damaging earthquakes, its neighborhood, later called *regio Coliseo*, became somewhat more rural. Even as scavengers began to whittle away at this handy stone quarry, the spaces beneath some arches were converted to animal shelters with haylofts above; at least one served as a bakery. The arena became a cemetery, despite half-hearted ordinances prohibiting intramural burial. Much of the south wall collapsed in the mid-ninth century, probably as a result of subsiding soils directly under the building, where two distinct geological formations meet.

Even in this collapsed state the brutish mass of the Colosseum was yet a potent symbol of the myth (for which there is no evidence) of Christian suffering there. Like St. Peter's, it represented the fateful and ironic convergence of Christian saints and pagan spectacle. It also had become a symbol of Rome's own imperishability. An oft-recited homily had originally evoked the Colossus of Nero, but was soon deflected to the Colosseum itself as a symbol of the Eternal City: "As long as the Colossus stands, so shall Rome; when the Colossus falls, Rome shall fall; when Rome falls, so falls the world" (Fig. 146).

By the twelfth century the Frangipane family inhabited and had begun to fortify their *palatium* within the northeast quadrant of the Colosseum. S. Maria Nova on the Palatine now owned many of the *crypta* (vaulted corridors) and would soon inscribe seven of their framing arches with talismanic crosses. The arena was now an *area ortiva*, cultivated in common. After the papacy decamped to Avignon, the Colosseum became a public arena hosting, for a while, bull-fights, even as it continued to be ransacked for building materials. By the end of the fourteenth century the Compagnia del Santissimo Salvatore *ad sanctum sanctorum* controlled the building; Via Papalis now transected the arena like a string through a bead.

After the ninth century the broader lines of the fora and the Campus Martius were fractured and burrowed into as spurts of ad hoc activity carved out new paths of communication. And, of course, the public spaces associated with the people's communal life shifted and changed. In imperial times the regime invested public spaces like the Forum Romanum, and those for com-mercial life like the Forum Boarium and the Forum Holitorium, with the grandeur of marble. But marble was hardly an option for the medieval city. As they decayed, the imperial fora and other porticoed public spaces lost their attraction. Already by the time of Theodoric (498–536), and with his blessing, the Forum of Trajan was being converted to housing. As the king wrote in granting the request of one Albinus to build housing over the south exedra, it was better to occupy public buildings and so forestall their ruination (Fig. 147).

The truth is that the fora were no longer downtown. Rather, the city had realigned its diminished center in the Campus Martius along and between the main routes to the populous Borgo across the river. Here some new public spaces were staked out, principally the Campo de' Fiori and Piazza Navona. Their form was unpremeditated from the start. The Campo was a natural openness in the urban fabric, overseen at one corner by the Cancelleria, and at the other by the fortress of the Orsini set in the ruins of the Theater of Pompey. When the Comune took control of the Capitoline in the mid-twelfth century, the general market moved downhill, where it remained until the fifteenth century; then it migrated to Piazza Navona. This second "forum" was a well-defined open space that effortlessly transformed from a backyard dump into a public square within the looming exoskeleton of the Stadium of Domitian's crumbling grandstand.

The decisive abandonment of the ancient Forum did not come about until the ninth century and was not complete until the eleventh when, after the 1084 sack of Guiscard, the site was so ruined that the documents declared it inaccessible. But we must caution against taking such testimony at face value. Comparing the image of the ancient Forum to the medieval cow pasture it had become makes a poignant contrast of *vanitas*. Manmade glory is evanes-cent; cows grazed now where once-resplendent fanes stood. There was really

147. Reconstruction of Fora of Trajan, Augustus, and Nerva in the tenth century.
Source: Courtesy of R. Meneghini – R. Santangeli Valenzani/Inklink.

no reason in the world to petrify and preserve a public space, even had one
the means to do so, when its rituals were no longer valid and its resident spirit
had departed.

As the monumental city gave way, stone by stone, to the realities of medieval
life in Rome, we begin to see a new strategic pattern of inhabitation in the
ninth and tenth centuries (Fig. 148; see Fig. 144). At the same time, new fami-
lies with impressive wealth from landholdings in the Campagna and from trade
with North Africa and the Middle East rose to prominence. They amassed
property in formerly public areas and created compounds, called *curtes*, set
within both ancient and new walls made of *spolia*. These compounds shared
the physical characteristics of monastic foundations, sometimes including a

148. Reconstruction of Forum of Nerva in tenth century.
Source: Courtesy of R. Meneghini – R. Santangeli Valenzani/Inklink.

private chapel and bath. Many churches from this time were called *in curte*, or *de curte*, such as S. Maria *in curte domnea Micinae*, indicating that they were likely within an aristocratic compound. The choice of the word *curtes*, previously used only for extramural properties, reflects the ruralization of the inner city by the ninth century. In light of our goal to understand urban process, specifically the fracturing of the medieval city, these compounds offer invaluable insights into Rome's least understood period, the ninth and tenth centuries.

Thus far, archaeology reveals two distinct house types, the two-story *domus solarata* for the aristocracy (the residential heart of the *curtes*) and the single-story *domus terrina* for the lower classes. The *domus solarata* typically had two stories, each with multiple uses: the ground floor of beaten earth was for animals, workspace, and storage and housed a terra-cotta hearth. The second floor, connected by an exterior wooden staircase, was for family use. The *domus terrina* typically included one or two small rooms with a terra-cotta hearth set directly on the beaten-earth floor and had an adjoining small garden. The two house types were never far from each other, as one depended upon the other.

There were also large working gardens located in formerly public areas. One occupied an area in the Forum of Caesar where an imperial pavement had been ransacked for building materials in the early ninth century. An area of about 1,000 square meters has been uncovered, and recent paleobotanical analysis has documented plum, cherry, fig, and nut trees; a vineyard with vegetables planted within the rows; lettuces; and many different herbs including mustard, mint, and coriander. This land was clearly intended for intensive

cultivation as the ground was raised and improved later in the century, and small irrigation channels, a larger drainage channel, and protective barriers were built around the trees. This garden probably was owned by an aristocratic family, and perhaps worked by *domus terrina* residents. It seems likely that this residential pattern spread to other parts of the city by the tenth century.

Several stunning aristocratic *curtes* have come to light, particularly in the Fora of Nerva and of Trajan (see Fig. 147). They provide us with a laboratory to study urban process from the ninth through the eleventh century. In Nerva's Forum, a *curtes* built of reused ancient stone blocks also took advantage of standing monumental walls for its enclosure (Fig. 148). To the east was a private garden with trees and a well; to the west, an area for animals, a work yard, and a cesspit. Accessory structures were set into the ancient ruins.

Perhaps the most dramatic *curtes* was the so-called Campus Kaloleonis, later called Campo Carlèo, which insinuated itself into the protective walls of Trajan's Forum in the mid-tenth century (see Fig. 147). In addition to the *domus solarate*, 10 small *domus terrine* with gardens covering about 200 square meters have been identified thus far. Additionally, more than 1,000 cubic meters of imported topsoil overlay the compacted earth of the forum to create about 5,500 square meters under intensive cultivation with vegetables, vines, and fruit trees. The scale of work to import the soil alone indicates that Caloleus, its owner, commanded an exceptional labor force and great wealth.

The lower Campus Martius was also home to urban *curtes*. This zone stretched from the Area Sacra di Largo Argentina in the west to S. Marco in the east; then to the foot of the Capitoline Hill; to S. Angelo in Pescheria, where the Jewish Ghetto was built in the sixteenth century; and back to the area where the modern Via Arenula now cuts through the ancient quarter. As early as the fifth century this zone, slightly larger than one square kilometer, enclosed grand formal spaces such as the Porticus Minucia, the Area Sacra di Largo Argentina, and the theater and "*crypta*" of Balbus. The entire area buzzed with activity as the aristocracy and the peasants went about daily life. By the tenth and eleventh centuries 4 important churches occupied this zone, S. Marco the most significant, along with 19 smaller churches, including one, S. Lorenzo in Pallacinis, which was listed in the eighth itinerary of Einsiedeln. Between these and along the newly beaten paths, monasteries with their orchards, vineyards, and wells were interspersed with small houses, stables, and industrial sites (Fig. 149).

In Largo Argentina a *curtes* held the corner at an important juncture along Via Papalis and the portico of the Crypta Balbi. It included an independent church built into an ancient temple. Fully fortified with both new and old walls, it may have been the earliest example in Rome of *incastellamento urbano*, the fortification of the city into private enclaves. Its strategic location along

149. Reconstruction of medieval Crypta Balbi workshops.
Source: Inklink. Courtesy of Ministero dei Beni e delle Attività Culturali e del Turismo. Soprintendenza Speciale per i Beni Archeologici di Roma.

Via Papalis is probably not coincidental, but rather expresses that its owners may have controlled this particular stretch of the road. Another important *curtes* stood in the nearby Porticus Minucia, where remains of medieval houses, gardens, stables, limekilns, a glass factory, baths, cemeteries, and lost monasteries and churches, including S. Lorenzo in Pallacinis, have come to light.

With increasing political and economic instability, private enclaves, ever more fortified, would cluster mostly in the fora, along Via Papalis, and in the lower Campus Martius. In the eleventh and especially the twelfth century, the aristocratic *curtes* enclaves began to give way to a new pattern of urban residential defense that reflected growing internecine hostility among powerful baronial families. Small fortified mansions, or groups of houses placed together under one extended family, most of them with one tower, were packed into the urban fabric. Rome's residents were preparing for all-out urban warfare.

BIBLIOGRAPHY

Ajello Mahler 2012; Arena et al. 2001; Baiani/Ghilardi 2000; Brancia di Apricena 2000; Brentano 1991; Cecchelli 1951; Coates-Stephens 1996, 1997; Delogu 2000; Egger et al. 1906; Egidi 2010; Esposito et al. 2005; Gatti 1979; Gregorovius 1894–1902; Homo 1934; Hubert 1990; Hubert/Carbonetti

Vendittelli 1993; Katermaa-Ottela 1981; Kessler/Zacharias 2000; Kinney 2006; Krautheimer 2000; Lavedan/Hugueney 1974; Magnuson 2004; Manacorda 2000, 2001; Martini 1965; Meneghini 1999, 2000, 2001; Meneghini/Santangeli Valenzani 2004; *Roma nell'alto medioevo;* Romanini 1983; Sanfilippo 2001; Santangeli Valenzani 1994, 1999; Vauchez 2001; Verdi 1997; Wickham 2015.

CHAOS IN THE FORTIFIED CITY

WHEN THE BYZANTINE EMPIRE CEDED CONTROL OVER THE PAPACY IN 752, the Church, now protected by the Franks, became a vassal of the Carolingian dynasty. Charlemagne, first as king (768–814) and then as Holy Roman Emperor (800–814), and Popes Hadrian I and Leo III joined in a relatively stable alliance. Meanwhile, ties between the Church and the Byzantine rulers unraveled in the mid-ninth century as threats from outside invaders such as the Lombards and Saracens increased. The Church and the Holy Roman Empire coexisted uneasily for more than five centuries, with the emperor most often dominating. The growing Roman noble class, itself divided into ruthless factions, sometimes supported the pope and at other times the emperor.

This led to several important changes. The continued Saracen peril on the seas spelled the end of the port facilities at Ostia and Portus, and their abandonment resulted in some new, smaller river ports to augment those already within the city. The exposed countryside contained treasures, both material and spiritual, that had to be moved within the wall for safekeeping or given their own local protection. Relics of martyrs and other Christians, hitherto inviolable where they lay, were now dug up and taken into the city, where they were distributed among the churches. At the same time, the great shrines were fortified. The fort of Johannipolis around the complex of S. Paolo and the Leonine Walls of the Borgo were the work of the ninth century. In the Roman countryside both the castle and the fortified village (both called *castellum*) had become common. The population shifted markedly to new defensible centers

and the *domus cultae* broke up. The once tightly administered papal domain, a vast landholding operation strapped to the Lateran, splintered into fragments ruled by individual churches, monasteries, and increasingly the rising noble families. The same pattern of breaking up large units into smaller governable – that is, defensible – elements transformed the urban landscape as these families, for protection, engaged their own private gangs for open warfare in the streets.

But by the early tenth century one powerful family – the Tuscolani from ancient Tusculum southeast of Rome – effectively seized Rome and took control of the Church. We first hear of them in the person of Theophylact I (d. 924/5), count of Tusculum. In Rome commanding soldiers of Emperor Louis III in 901, he entrenched his retinue within the strategic ruins of the Serapeum on the Quirinal (see Fig. 63), where his family continued to reside for many generations. He and his son-in-law Alberic I of Spoleto appointed the next pope, Sergius III (904–911). After Theophylact's death, Alberic assumed control of Rome, followed by his son, Alberic II of Spoleto (905–954). The younger Alberic installed his brother as Pope John XI (931–935), thereby controlling both the papacy and by extension temporal management of Rome. His control was so absolute that he handpicked the next six popes. At his death he even arranged for his son Octavianus to be elected Pope John XII (955–964). Not satisfied controlling the city and the Holy See, Alberic also set out to control the monasteries. To do this he summoned Odo of Cluny to Rome in 936 and made him the general supervisor of all Roman monasteries and convents with the goal of placing them all under Benedictine rule. His efforts at reform had mixed results.

The eleventh century was cataclysmic and the fracturing of the city fabric continued apace. Churches now were individually fortified. Within the Leonine city, the basilica of St. Peter's had its own set of defenses; Henry IV, the Holy Roman Emperor, built and garrisoned his own fort, called Palatiolum, between the church and the river, demolishing a section of the Borgo for the purpose. Siege engines monitored the Tiber's crucial bridges at Hadrian's Mausoleum and at the island. The Borgo, fortified to forestall another Saracen sack, was now protecting the papal party from its own citizenry, or from noble challengers. The conflict of 1084 between Henry IV's German troops and the Normans who were defending Pope Gregory VII ended in a hideously destructive battle and the subsequent sack by Robert Guiscard, which ravaged the Via Lata quarter and the Caelian Hill. The ancient *tituli* of S. Clemente, SS. Quattro Coronati, and the Lateran palace were all damaged.

Urban warfare was at its height and the city now bristled with feudal towers attached to large baronial houses, mansions, or groups of houses united under a single ownership (Fig. 150). Anything could be fortified – bridges, aqueducts, triumphal arches, theaters, the Palatine, the Colosseum, major arteries into the city where tolls were collected, and signal towers used to warn of

150. View of Torre delle Milizie from Aventine.
Source: Codex Escurialensis. Egger/Hülsen/Michaelis 1906.

impending dangers. In addition to single towers, areas of considerable size could be defended, including the *rocca Frangipane* at the Palatine. As we have seen, over a century and a half the Frangipane were able to give shelter to the papal cause when it suited their interests by means of a sprawling defense system to guard against attacks from the southern routes, Via Ostiensis and Via Appia, just as the Leonine Walls and Castel Sant'Angelo guarded the northern routes.

For centuries, medieval Romans had been converting the buildings of pagan Rome to new purposes, animating ancient streets with Christian pageantry, and availing themselves of building material from the carcasses of abandoned structures. Now, many ancient monuments left standing – triumphal arches, theaters, the Colosseum – became the fortified power bases of noble families who capitalized on a longstanding legal impasse over their status. The Carolingian emperors had no right to them, since their *imperium* derived from the popes. The noble *baroni*, themselves often claiming imperial lineage, openly challenged the popes' right to control the city. And so the Mausoleum of Augustus, the Theater of Marcellus, the Theater of Pompey, the Colosseum, and bits of the Roman Forum, Circus Maximus, Stadium of Domitian, Septizodium, and Palatine were absorbed into the redoubts of the Colonna, Millini, Frangipane, Pierleoni, and Orsini families, among others (see Fig. 144).

Physically, these giant bones of a bygone age stood out by their mass and the strength of their construction. By colonizing them, the families were inhabiting a state of mind. To live in and fight from the Mausoleum of Augustus or the Forum of Trajan was to absorb some of the fabled energy of the men who subdued the world for Rome. Now Rome itself would bow before the nobility

for its survival. Generally speaking, the northeastern half of the city was in the hands of proimperial families, with the Colonna claiming the Mausoleum of Augustus as their major stronghold by the twelfth century. The propapal party dominated the southwestern part, from the Capitoline and Palatine to the Vatican bridgehead. The Orsini held three major strongholds – Hadrian's Mausoleum (answering the Colonna across the Tiber), Monte Giordano, and the Theater of Pompey; the originally Jewish Pierleoni family held the Theater of Marcellus; and the Frangipane, the Palatine. Compared to the earlier towered mansions these strongholds were gargantuan. Even in its dilapidated state, the Colosseum alone – built to hold 50,000 spectators – could still have housed hundreds if not thousands. What is distinctive about these newly fortified monuments is that they were self-contained – true urban castles.

There is something incredible, almost fictional about Rome's shape-shifting topography during the eleventh and twelfth centuries, when the built fabric was divided among contending parties in such a fluid manner that allegiances seemed to realign by the day. Nothing about papal politics and alliances with the nobility remained stable, and the built environment could hardly keep up with the rapid political changes. Even a single noble family could switch their political allegiance – propapal Guelphs or proimperial Ghibellines – within one generation. For example, in 1084, the propapal Corsi fought for Gregory VII on the Capitoline; 20 years later, Paschal II (1099–1118) forcefully evicted the now-proimperial family from their stronghold.

Not only was the Church threatened by the fluctuating strength of the Comune and the rising power of the noble class, particularly the *baroni*, it was also threatened from within. From the last third of the eighth century until the late tenth century, 33 of the 39 popes were Romans or from towns immediately outside Rome. The others were from the Papal States. Their allegiance lay close at hand. Roman cardinals continued to be elected pope, but increasingly the German, Portuguese, Spanish, English, Bavarian, and especially French candidates, with their allegiances far away, were elected as well. The waning of domination by Roman and Papal States candidates coincided with the continuing claims of antipopes: there were 15 of these for the 16 legally elected popes between 1058 and 1159. Also, the Church had to deal with the powerful Neapolitan and French monarchies, which took turns holding the papacy as a political chess-piece. In the thirteenth century especially the French kings adroitly seated their own cardinals on the papal throne.

In the tumultuous years of his papacy Pope Boniface VIII (1294–1303), an Italian from the powerful Gaetani clan, sought to wrest the rights and privileges of Peter from imperial control and restore them to the papacy. But he seems to have been hopelessly inept in political matters, and his pontificate was characterized more by blatant nepotism than diplomacy. The one bright moment of his papacy, at least from the perspective of our environmental

151. Pilgrims traveling to Rome, Frieze, Fidenza Cathedral, late twelfth century.
Source: Photo: Clop/Wikimedia Commons/PD-Self.

approach, happened in 1300. More pilgrims than usual visited Rome that year
and this inspired Boniface to declare it the first Holy Year, later called a Jubilee
Year, in which any pilgrim who traveled to Rome would be granted forgive-
ness for all sins (Fig. 151). An eyewitness, Giovanni Villani, said (doubtless with
some exaggeration) the city was inundated with as many as 200,000 eager pil-
grims on any given day. The influx was meaningful in several ways. First there
was little time to prepare, and so the Church's physical resources to provide for
the pilgrims were severely taxed. Private individuals stepped in both to support
and to profit from the visitors with food, beds, and other essentials. Also the
Church grew immensely wealthy from donations by the faithful. Most impor-
tant, Rome was once again the center of the Christian experience.

The Holy Year succeeded beyond all expectations. Unfortunately it had
little lasting effect in physical terms because with the election of Clement V
in 1305, the French took full control of the papacy. In 1309 Clement aban-
doned Rome completely, moving the entire papal court to Avignon, where
it would remain until 1376 under the next six popes, all French. Without
the pope, his entourage, and the multitude of hangers-on, not only did the
Lateran complex become redundant, but also far fewer pilgrims flowed into
Rome. Another consequence was that few Italians, and even fewer Romans,
were created cardinals and resided in Rome. Of the 220 cardinals appointed
by legitimate popes during the fourteenth century, only 10 were Italian, and
of the 5 Romans, 3 were Orsini and 1 was a Colonna. Even so, most of them
resided in Avignon at least part of the time. Finally, the papal absence gave
the baronial families and the Comune an opportunity to regain control of
Rome. The Colonna (who had taken over from the Tuscolani) and Orsini
families, among others, continued to exercise influence: the Colonna over
most of the sparsely populated northeastern Campo Marzio from the Forum
of Trajan to the Milvian Bridge; and the Orsini at the Theater of Marcellus,
the Theater of Pompey, and Monte Giordano, all three strategic locations in
the southwest.

The population had been moving over the centuries closer to Via Papalis,
especially between the fora and the river. Over time, important Roman fami-
lies built residences along or very near the street. As the baronial families were

152. Aracoeli steps and church of S. Maria in Aracoeli above them.

locking down entire neighborhoods, especially in the fourteenth century, the merchant class was also growing stronger – both in wealth and in political prestige as they assumed leadership of the city government. Some, such as the Cenci and Papazzurri families, even began to build towers as the barons did, but less for defense than for proclaiming their wealth. Meanwhile zealots such as Cola di Rienzo, son of a washerwoman and a tavern keeper, led a popular revolt in 1347 to claim leadership of the city, which the Senate then granted him, and to seize any power held by the noble families. It was he who inaugurated the grand Aracoeli staircase that same year (Fig. 152). Even so, within months the nobles had ousted Cola, but over the next eight years his influence fluctuated until he was finally murdered by a mob on the steps of the Capitoline and his body burned at the Mausoleum of Augustus.

In spite of the chaos, between the twelfth and fourteenth centuries new hospitals were founded and churches built or ornamented with brilliant pavements and bell towers (Fig. 153; see Fig. 106). Both the hospital and church of Santo Spirito in Sassia were enlarged under Innocent III; the small chapel just inside Porta del Popolo was transformed into the magnificent church of S. Maria del Popolo under Gregory IX (1227–1241) and given to the Augustinians; Rome's only Gothic church, S. Maria sopra Minerva, was begun in 1280 at the Dominican monastery; and smaller churches and hospitals including S. Maria delle Anime, which originated as a hospice for pilgrims from the Holy Roman Empire, began in 1350. A new hospital was founded near S. Giovanni in Laterano in 1338 and another at S. Giacomo in Augusta, near the Ripetta, the

153. S. Benedetto in Piscinula, cosmatesque paving.

following year. Intricately patterned geometric floors, their marble despoiled from ancient monuments, were installed in many important churches such as S. Cosimato and S. Maria in Trastevere, while many churches, including S. Maria in Cosmedin (1123) and S. Sisto Vecchio (ca. 1216), received tall bell towers to call the faithful to services (see Fig. 119). By the early 1300s huge glistening façade mosaics ornamented S. Maria in Aracoeli, S. Maria Maggiore, S. Maria in Trastevere, S. Giovanni in Laterano, and S. Paolo fuori le Mura; like beacons they shone from afar.

Pope Gregory XI (1331–1378) made a triumphant entry into Rome on 17 January 1377. His intent was to reestablish the Seat of Peter, bristling with towers and battlements, in its rightful home (Fig. 154). Continuous rioting forced him out of Rome in May. He returned in November, but his death the following year sent cardinals scurrying back to Avignon. During this period, known

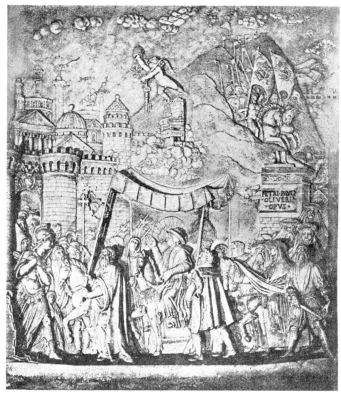

154. Pope Gregory XI entering Rome.
Source: Relief by P. P. Olivieri in S. Maria Nova, 1584. Lanciani 1906.

as the Western Schism, competing claims to the papacy between 1378 and 1417 plunged the city even deeper into chaos. The constant threat of violence, the lack of public amenities, and the congested streets, dilapidated riverbanks, and ruinous state of buildings made the city treacherous (Fig. 155). Little new construction was initiated; many tottering ancient buildings were pulled down, while others were appropriated for churches and fortified palace compounds. Yet throughout this period of disorder, the need persisted to reappropriate ancient Rome symbolically and physically as a means to confirm the city's continuing status as a world power.

Petrarch visited Rome in 1337 and saw a "broken city." Yet he was struck by the physical presence of the ancient ruins and was convinced that they held the power to ignite in Rome a thirst to rediscover its past, to begin "to know herself," to regain its importance in the world, and once again to rise to glory. When the popes finally returned from Avignon, reestablishing the Seat of Peter as the center of Christendom in 1420, his cri de cœur found a receptive audience among humanists, cardinals, and popes eager to embrace the renaissance of ideas, arts, and scholarship.

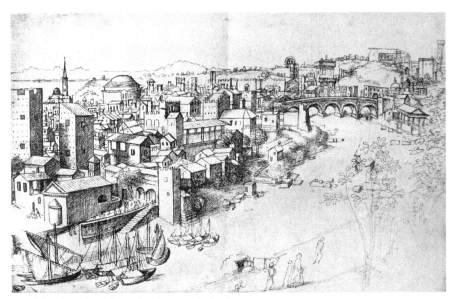

155. Ripa Grande with medieval towers in landscape.
Source: Codex Escurialensis. Egger/Hülsen/Michaelis 1906.

BIBLIOGRAPHY

Ajello Mahler 2012; Amadei 1932; Brancia di Apricena 2000; Brentano
1991; Camerlenghi 2007; Cecchelli 1951; Coates-Stephens 1996, 1997, 1998;
Colini/Gismondi 1944; Duchense 1886–1892; Egger et al. 1906; Ehrle 1890;
Frugoni 1957; Gasparri 2001; Gatti 1979; Gregorovius 1894–1902; Hamilton
1961; Homo 1934; Hopkins/Beard 2005; Hubert 1990; Hubert/Carbonetti
Vendittelli 1993; Hülsen 2000; Katermaa-Ottela 1981; Kessler/Zacharias 2000;
Kinney 2006; Krautheimer 2000; Lenzi 1999; Llewellyn 1993; Magnuson 2004;
Manacorda 2000, 2001; Martinori 1933–1934; Meneghini 1999, 2000, 2001;
Meneghini/Santangeli Valenzani 2004; Panvinio 1561; Priester 1993; Romanini
1983; Sanfilippo 2001; Santangeli Valenzani 1994, 1999; Tomassetti 1979–1980;
Ventriglia 1971; Verri 1915; Waley 1961; Wickham 2015; Yawn 2013.

THE TIBER RIVER

ODAY IT IS HARD TO IMAGINE WHAT THE TIBER RIVER (FIG. 156) WAS LIKE in the fourteenth and fifteenth centuries when it was still the heart of Rome's small but bustling industrial zone. Brickmakers and potters worked on the right bank; tanners and candlemakers on the left; millers, stevedores, and laundresses along both sides, with ferrymen navigating between them. The *acquaeroli* – water merchants who sold Tiber water for drinking now that the aqueducts were essentially dry – usually claimed the upper stretches, where there was less pollution. The millers worked where the current was strongest, from the bend of the Tiber at the Hospital of Santo Spirito in the Borgo to below Pons Aemilius (called Ponte S. Maria since the early eleventh century) and especially near the Tiber Island, where they had congregated ever since Belisarius had the millwheels moved there from the Janiculum Hill after the Gothic War (Fig. 157). Polluting industries, such as tanning and ceramics, were restricted to less salubrious parts of the river. The ceramicists worked along Via dei Vascellari (Pottery Row) in Trastevere, where their kilns and smoke posed less threat to the city, and the tanners, whose work was perhaps the filthiest of all, were restricted to an area just above the Tiber Island on the left bank.

The Tiber was still congested with vessels bearing goods and people to Rome as they had for 2,000 years, and stretches of the river were still zoned for port activities. But Rome had long gone without amphoras filled with Spanish olive oil offloaded at Testaccio, or majestic blocks of Greek marble hoisted off imperial barges at the Emporium below the Aventine. Since at least the

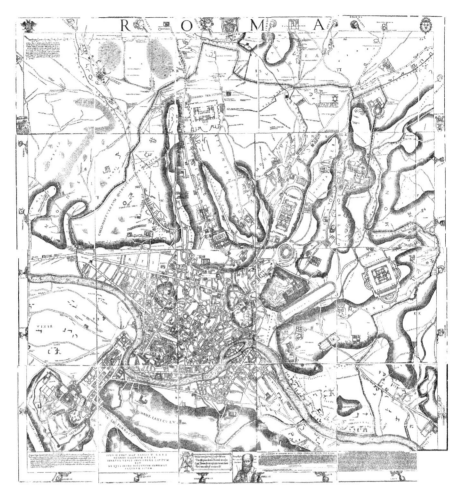

156. Map of Rome. 1551. North is angled leftward.
Source: Bufalini 1911.

ninth century, when Saracen pirates had imperiled Ostia, Rome's few docks lay within the walls. To supplement the Leonine Walls, Pope Leo IV also built two towers near Porta Portuensis anchoring a chain suspended across the Tiber to prevent attacks from downstream.

Testaccio, now far outside the inhabited area, became both farmland and a seasonal playground for bullfights and other sports (Fig. 158; see Fig. 178), while the ancient imperial port known as Pietra Papa farther south on the right bank was now stranded 50 meters from the shore as the Tiber shifted its course. Abandoned perhaps since the ninth century, the Emporium acquired the new name Marmorata when it was found to be a treasure trove for scavenging ancient marble blocks (Fig. 159; see Fig. 89). The major southern port probably moved to Trastevere in the area later known as Ripa Romea, and still later as the Ripa Grande. The smaller Ripetta Port in the Campo Marzio

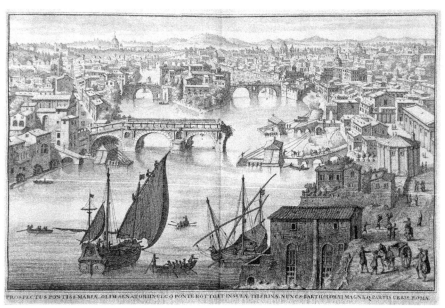

157. View of Tiber.
Source: L. Cruyl. In Deseine 1704. Courtesy of Vincent J. Buonanno.

158. Testaccio district with Tiber, detail.
Source: Dupérac 1577.

above Ponte Sant'Angelo continued to receive lumber from the north and limestone, the primary building material for new construction, from the area around Tivoli.

159. View of Marmorata.
Source: Dupérac 1575. Courtesy of Vincent J. Buonanno.

While Romulus and Remus might not have recognized the late-medieval Tiber shore, they would have found the devastating inundations all too familiar. Rome's low alluvial plain still fell victim to flooding just as in antiquity. It had become more densely inhabited during the medieval period as nobles occupied ancient monuments and common folk squeezed into leftover ruins and the interstices between them. This was especially true in the areas closest to the Tiber, as in Trastevere, where rich and poor alike settled in a thin riparian strip that ran approximately from S. Maria in Trastevere along Via Aurelia, now known as Via della Lungaretta, east toward S. Crisogono, then to a cluster of fortified buildings at Pons Cestius, now called Ponte Cestio, and another at Ponte S. Maria, and finally turning south toward S. Cecilia.

By the sixteenth century Tiber floods were truly ferocious, due in part to deforestation upstream. Those of 1530, 1557, and again in 1598 remain the highest ever recorded. Parts of the city – most notably around the Pantheon – were submerged beneath as much as seven meters of water. It was not uncommon for a cardinal or noble to place a commemorative inscription on a palace or church façade to indicate the flood level and to signify a "witness" to the event. These inscriptions, dating from 1277 to 1937, can still be seen throughout the Campo Marzio, the Borgo, and Trastevere.

Amelioration efforts began with Julius Caesar's unfulfilled plan to divert the river's course from the Milvian Bridge along the foot of the Vatican and Janiculum Hills (see Chapter 4). Popes also commissioned proposals to control the Tiber, all of them shelved. Most notably, after the 1598 flood, Pope Clement VIII Aldobrandini (1592–1605) enlisted the most renowned architects of the day, including Giacomo della Porta, Domenico Fontana, Giovanni Fontana,

and Carlo Maderno, to propose solutions. Responding to the 1742 flood and hoping to facilitate trade, Benedict XIV Lambertini (1740–1758) ordered a survey of the Tiber's banks and bed from its juncture with the river Nera to its mouth below Ostia to eliminate obstructions (Fig. 160).

Floods repeatedly swept away the grain mills, endangering or killing their operators and destroying their supplies. Tiber Island was especially vulnerable. Its church, S. Bartolomeo all'Isola, which included the chapel of the millers, whose confraternity was located there, was often damaged. The 1557 flood was so violent that it cut a new course to the sea near Fiumicino, where Rome's Leonardo da Vinci airport is now located. Receding floodwater left cellars filled with muck, a riverbed clogged with sediment and debris, polluted wells and cisterns, and buildings reduced to rubble. All this was followed by rampant disease and, without grain, often famine as well.

With recurring floods it is easy to imagine the deplorable state of the Tiber in the late medieval period. Reeds and rushes grew wildly among the pungent, garbage-lined banks. City collectors of human and animal waste had chucked their gleanings into the river for centuries. This tradition was allowed to continue well into the eighteenth century as a means to ensure that waste and refuse from fishmongers, butchers, and the like was not left in the public streets and piazzas. Over time dump sites were individuated – the tanners, for example, were explicitly forbidden to dump their waste near the places where water sellers collected drinking water. Short piers were even built out into the river to enable residents to walk to the end and more easily throw rubbish into the river current. All the debris severely compromised boat traffic and the millers' paddlewheels were frequently damaged.

It would not be amiss to consider the Tiber a veritable purgatory flowing through the heart of the city since all the drains debouched there, just as they had in antiquity. Its bed was so clogged with trash, debris, dead bodies, construction materials, and antiquities that some objects lay submerged for a millennium. In 1878, near Ponte Sisto, an entire triumphal arch associated with the bridge's ancient analog, the Pons Aurelius/Antoninus, was found in the river's muck during dredging for the long-awaited flood embankment walls. It may have collapsed in a flood as early as 791.

As in the past, the floods left behind alluvial deposits that raised ground levels. Without continual maintenance the riverbanks, drains, and sewers deteriorated to the point that the subsoil in many areas became seasonally susceptible to standing water. Near the river, the most vulnerable areas were the Ortaccio at the Mausoleum of Augustus and the Ghetto; farther inland, the Roman Forum around the Temple of Vesta often stagnated, as did two connected seasonally marshy areas – the Pantano Spoglia Christi around the Column of Trajan and the Pantano di San Basilio, stretching from the Forum of Augustus to the Basilica Julia. Levels also rose in Trastevere and the Borgo.

160. Map of Tiber from Malpasso to its mouth.
Source: Chiesa and Gambarini 1746. Courtesy of Vincent J. Buonanno.

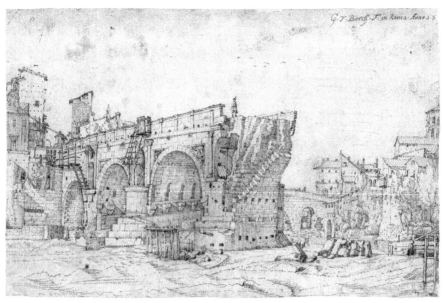

161. Ponte Rotto.
Source: G. ter Borch the Elder, 1609. Rijksmuseum RP-T-1887-A-871. Purchased with the support of the Vereniging Rembrandt.

Rome's Tiber was still spanned by four ancient bridges at the beginning of the fifteenth century: the Pons Aelius, the Pons Fabricius and Pons Cestius at the island, and the Pons Aemilius – by then called Ponte Sant'Angelo, Ponte Fabricio, Ponte Cestio, and Ponte S. Maria, respectively. By at least the eleventh century, if not earlier, rising noble and merchant families had fortified the bridges and claimed them for strategic reasons and for the right to control and tax the goods and people crossing them. The bridges, like everything else along the river, were vulnerable to flood damage and were sometimes rendered impassable. Ponte Sant'Angelo was seriously damaged in the 791/2 flood. Ponte S. Maria "fell" during the 1230 flood and again in 1557 and 1598. Since then it has been known by its nickname, Ponte Rotto, the "Broken Bridge" (Fig. 161). Ferries, which had carried goods and passengers across the river throughout the medieval period, continued to take up the slack. It was not until the mid-nineteenth century, under Pope Pius IX Mastai-Ferretti (1846–1878), that any new bridges would cross the Tiber within the intramural city. Today there are 16, including a railroad bridge.

The perpetual bedlam of the Tiber must have seemed an insurmountable barrier to effective urban planning; even the best-intentioned projects almost inevitably faltered. Piecemeal solutions, no matter how well intentioned, were generally ineffective because they failed to consider the entire city and its waterfront in a comprehensive manner. Individuals fortified riverfront building façades, but this practice often left others downstream more vulnerable. Ports

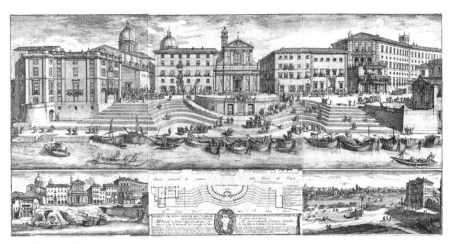

162. View of Ripetta.
Source: A. Specchi, 1704. Courtesy of Vincent J. Buonanno.

received the most attention, most notably the spectacular Porto di Ripetta
(1704), which transformed a decrepit, eroding shoreline into an urban show-
piece, if only temporarily (Fig. 162).

This band-aid approach persisted until embankment walls, corseting the
river and towering 13 meters above the water, were built after a disastrous
flood in 1870 (Fig. 163). They completely transformed the river's topography.
Hundreds of buildings and gardens were destroyed to accommodate them; the
Porto di Ripetta was sacrificed; street patterns were rearranged; the ground
level along the banks was raised as much as 11 meters to eliminate declivities
toward the river; and new trunk lines for a comprehensive urban sanitary sys-
tem were laid behind them.

While most of Rome except the island is now protected from flooding,
the city is effectively alienated from its river. The uniformly bland embank-
ment walls have effectively erased the palimpsest of Rome's fluvial history and
have destroyed nearly all references to the idiosyncratic characteristics of each
neighborhood that fronted it – the seductive Porto di Ripetta, the palaces,
houses, gardens, stables, mills, industries, riparian vegetation, sewer mouths,
beaches, fishing platforms, laundry sites, and the steaming stench that swaddled
its shores. In spite of their deficiencies, the Tiber banks remained recreational
destinations – most commonly for swimming, especially on the right-bank
strands south of the Hospital of Santo Spirito and south of Ponte Sisto. The
river also hosted processions and civic celebrations related to fluvial life. On
24 August, the Festa di S. Bartolomeo, patron saint of the millers, culminated
with boat races and swimming events. Commoners clustered on the bridges
and stretches of open riverbank, while nobles and cardinals such as the Farnese
could watch from viewing platforms located in their riverside gardens.

163. Tiber embankment in late nineteenth century.
Source: Photo: A. Vasari, late nineteenth century. Rome, Istituto Nazionale della Grafica, Fondo Vasari inv. 1183. Courtesy of Ministero dei Beni e delle Attività Culturali e del Turismo.

But Rome had already begun to turn its back on the Tiber when the railroads arrived in the 1850s, rendering river transport irrelevant almost overnight. Henceforth the Tiber ceased to have a fundamental economic role in the city's life; its principal urban function today is recreational. Yet even in this respect it remains decidedly unsatisfactory. Although the embankment wall is now lined by majestic plane trees at street level, little has been done to clean up the river's filthy waters, or to create a tempting environment for a stroll down along the concrete-and-stone riverbanks. In the early twentieth century the northern intramural stretch became a popular recreational area with swimming and canoe clubs and floating dance halls colonizing its shore. Some canoe clubs still survive, but in the 1960s the dance halls and swimming clubs slowly shuttered or moved to new locations farther north and south beyond the walls. Their carcasses soon became sites for less savory and often illicit entertainments. The twenty-first century has seen a growing interest in reviving the river for sport and entertainment; dining and dancing barges have returned and a new bike path links Rome to Ostia. But these are largely cosmetic efforts. The river-level paths are generally bleak and untended from mid-October to May, the river is rarely dredged, and its banks rarely cleaned after ever more common high-water events. Overlapping agencies – there are more than a dozen – have rendered it a no-man's land. Separate authorities oversee water quality, sanitation, flooding, tree trimming, cleaning, and

commercial uses, among others. Although the river is a centerpiece in the regional ecological and historical protection strategy of the 2008 *piano regolatore*, there is still little concern for it as an organism.

The Tiber's heartbeat has slowed since its economic and mercantile heyday before the Industrial Revolution; now it is nearly dormant for eight months of the year. But during the summer, along the newly named "Fiume di Cultura," the River of Culture, the cash register's ka-ching almost drowns out the cries of the seagulls scavenging along the now seasonally privatized riverbank. From June to September entrepreneurs colonize sparkling white party tents on the right bank, where they offer "cultural activities." These are little more than food, drink, and souvenir stalls catering to suburban Romans and tourists. At the same time large parts of the island, once used almost as an urban beach, are closed to accommodate an outdoor movie theater that is public only in name. Clean and inviting, the island and the right bank have found a ready clientele. Meanwhile, the left bank lies derelict and unkempt. Saplings sprout from the embankment walls, stinging nettles and wild roses have taken hold everywhere, and the tattered tents of homeless Romans grimly confront their shining counterparts across the divide.

BIBLIOGRAPHY

Adinolfi 1881; Bacci 1558; Benocci/Guidoni 1993; Brocchi 1820; Carbonetti Vendittelli 1990; Cassio 1756–1757; Chiesa/Gambarini 1746; Cohen 1998; Courtenay 2003; Delumeau 1957–1959; Di Martino/Belati 1980; D'Onofrio 1978, 1980; Egger et al. 1906; Fea 1832; Frosini 1977; Funiciello et al. 2008; Gigli 1958; Hubert 1990; Hubert/Carbonetti Vendittelli 1993; Jones 2009; Katermaa-Ottela 1981; Krautheimer 2000; Lanciani 1906, 1988, 1989–2002; Lee 1985; Long 2008; Magnuson 2004; Maier 2006, 2007; Martini 1965; Meijer 1685; Narducci 1889; Nibby 1838–1841; Orbaan 1911; Partner 1976; Re 1880; Re 1920; Rinne 2001–2002, 2010, 2012; Robbins 1994; Rodocanachi 1894; Salerno et al. 1973; Sanfilippo 2001; San Juan 2001; Segarra Lagunes 2004; Smith 1877; Stow 2001.

TWENTY SEVEN

HUMANIST ROME, ABSOLUTIST ROME
(1420–1527)

A WHOLLY NEW CHAPTER IN ROME'S HISTORY BEGAN WHEN THE ROMAN cardinal Oddo Colonna ascended to the pontificate in November 1417 at the Council of Constance, Switzerland. Taking the name Martin V, he chose to return the Church to its rightful home – an act that concluded the Western Schism. Negotiating safe passage through central Italy and reaching an accord with Queen Joanna of Naples to evacuate her troops from Rome delayed his entry until September 1420. When he arrived at Petrarch's "broken city," he found Rome's 17,000 inhabitants famished and living among abandoned and teetering houses, collapsed churches and monuments, and streets buried under trash. Martin found a city desperate for rehabilitation.

Cardinals and curial officers, hangers-on, eager opportunists, merchants, and prostitutes followed in his wake, swelling the population to nearly 30,000 within a few years. Although Martin left little personal stamp on Rome, he prepared the city for a Jubilee in 1423. He made strategic repairs to Ponte Sant'Angelo, to the church and palace at SS. Apostoli (the old Basilica Apostolorum, a Colonna property), and to the Lateran basilica – the last a bid to reestablish papal control over the derelict Caelian Hill. Most significantly, Martin placed the office of the *maestri delle strade*, citizens appointed by the Senate and charged with maintaining urban order, under direct papal authority in 1425.

If we may speak of a single moment in Rome's urban history when the Middle Ages decidedly gave way to the Renaissance, it would be the ascension of Nicholas V Parentucelli (1447–1455) from Liguria in northwest Italy.

He used urban restoration as a political tool to repair the image of papal primacy and to wrest control from the Comune, which had thrived during the Avignon papacy. Nicholas ushered in a nearly 90-year run of non-Roman popes who brought with them foreign cardinals and foreign bankers. Unlike pontiffs and nobles of the previous 800 years, who had adapted existing buildings and streets to meet changing conditions, these men were unburdened by sentimental ties to the city. They laid down new streets, ransacked neighborhoods, and imposed their own urban logic on what they saw as the chaotic medieval city, particularly in anticipation of Jubilee years.

To prepare Rome for the 1450 Jubilee, Nicholas restored the pontifical palace at S. Maria Maggiore, the city walls and gates, and the major bridges approaching the city from the north and east to varying degrees. He moved the papal residence from the Lateran to the Vatican – an act that decisively annexed papal power to its most legitimate symbol, St. Peter's tomb. The Vatican, already considerably safer than the Lateran, now required further protection. Nicholas fortified its enclosing walls, built by Nicholas III Gaetani Orsini in 1278–1279, and laid out what may have been Rome's first Renaissance villa garden.

With the popes of the mid-fifteenth century, an orbit of elite humanists intent on fulfilling Petrarch's vision of Rome reborn circled around the papacy and curial court. They studied ancient texts and reinterpreted them for contemporary use. And for the first time, they examined ancient buildings firsthand, treating them as objects of scientific inquiry. Leon Battista Alberti (1404–1472), adviser to Nicholas V, prepared a strategy for urban restoration based on architectural and urban design rules that respected ancient norms. In his treatise *On the Art of Building in Ten Books*, Alberti associates Rome's physical fabric directly with its reputation. Restoring the first would repair the latter, and the Church would thereby inherit the classical tradition.

Antique monuments were subject to increasing scrutiny. Rome's best-preserved ancient building, the Pantheon, enjoyed particular attention, not only as a textbook for understanding ancient architecture but also as a site worthy of restoration. While its forecourt had been an antiquities sculpture gallery since the twelfth century, its portico had long been cluttered with market stalls slotted between the columns. Even Eugenius IV Condulmaro (1431–1447), who showed little interest in Rome's physical well-being, had repaired the Pantheon's dome, removed the tradesmen's booths, and paved its piazza, which then stood well above its ancient level (see Fig. 121).

The greatest artists of the Renaissance, including Brunelleschi, Raphael, and Bramante, parsed and documented the ruins to understand ancient architectural principles and to test the veracity of Vitruvius. In a famous 1519 letter to Leo X de'Medici (1513–1521) Raphael argued that the most important ancient buildings be listed; measured; drawn in plan, section, and elevation; and repaired. Humanist popes actively protected ancient monuments while

164. Pilgrims crossing Ponte Sant'Angelo with ruins of Pons Neronianus in foreground.
Source: *Codex Escurialensis*. Egger/Hülsen/Michaelis 1906.

obliterating buildings of lesser pedigree to feed their visions of a rational, ennobled Rome. They wanted it both ways, even to the point of occasional schizophrenia: Pius II Piccolomini (1458–1464), himself a poet and human- ist scholar, in a papal bull of 1462 insisted on vigilant protection of Rome's ruins; yet his workers scavenged the Colosseum's fallen travertine blocks for St. Peter's (see Fig. 146).

The wildly successful 1450 Jubilee made Rome's physical limitations and lack of planning all the more apparent to Nicholas and his successors. They focused on imposing clarity on Rome's streets, both to improve circulation and to facilitate defensive maneuvers. The most critical node stood at Piazza di Ponte, where Via Recta, Via Papalis (Via Papale in Italian), and Via Mercatoria, all east/west streets, converged at the head of Ponte Sant'Angelo. The ensemble of streets, piazza, and bridge, a perpetual bustle of people, animals, and carts, was the physical nexus between the papacy and the city (Fig. 164). It had symbolic importance for processional and pilgrimage routes and it empha- sized the economic and political importance of Rome's richest immigrants, the Florentines, who lived and conducted business in Rione Ponte. It was here that many people died in a crush of traffic during the 1450 Jubilee when part of the bridge collapsed. The catastrophe led to a series of plans to alleviate con- gestion at Piazza di Ponte; implementation took more than 50 years.

Widening and regularizing Piazza di Ponte was not enough. One had to engage the entire area around the piazza – the Borgo and a large swath of the *abitato* between the Tiber and Piazza Navona – and this took time. For the 1475 Jubilee, the northern Italian Sixtus IV della Rovere (1471–1484) eased the

pilgrims' path by regularizing several portions of Via Papale. He sliced a new boulevard, Via Sistina, straight through the urban clutter to connect Piazza Ponte to Piazza Nicosia; and he erected Ponte Sisto on the ruins of the ancient Pons Aurelius/Antoninus, setting the stage for aggressive and innovative urban interventions in the Campo Marzio. Sixtus instituted a vigorous policy of eminent domain whereby private property could be expropriated for the "public good." The targets of eviction were often Roman baronial families, some controlling entire neighborhoods, and rising members of the merchant class. The beneficiaries were rich foreign cardinals, such as Sixtus' kinsmen, who desired prime urban venues for grand new palaces. This "ennobling" of Sistine Rome was code for preemptive elevation and installation of the new nobility at the expense of Rome's own.

As part of a defensive strategy to reinforce Castel Sant'Angelo, the Spaniard Alexander VI Borgia (1492–1503) carved a new street, Via Alessandrina (now Via Borgo Nuovo), through the Borgo to make a direct link between its entry gate and the Vatican. While its opening coincided with the 1500 Jubilee, it was intended not as a pilgrimage street to St. Peter's but as a processional route for dignitaries arriving at the Vatican. To attract new development befitting Church aristocracy, Alexander ordered several property owners to build imposing palaces where his street met Piazza Scossacavalli (Fig. 165).

Another northerner, Julius II Della Rovere (1503–1513), implemented his elegant and efficient plan to connect the Borgo and Rione Ponte across the Tiber River through aggressive appropriation. He began by widening Via de' Banchi at Piazza Ponte and installing the papal mint at its head to face Castel Sant'Angelo. His plan included rebuilding the long-derelict Pons Neronianus and linking it to a new street, Via Giulia (see Fig. 183). This would shoot straight south through the medieval maze of the Campo Marzio along the Tiber to connect to Ponte Sisto. Across the river a new straight avenue almost paralleling Via Giulia, Via della Lungara, would double back northward to connect the Trastevere plain to the Borgo and the Hospital of Santo Spirito (see Figs. 165, 168). Julius aimed to create noble streets that would consolidate papal administrative offices along their length, facilitate traffic, and rationalize the visual and spatial experience of Rome. But Via Giulia did not develop as envisioned. The rebuilt Pons Neronianus remained unrealized; Julius' Palazzo dei Tribunali, a papal ministry building, remained incomplete for 50 years; and the two grandest palaces alongside it, the Farnese and the Spada, turned their backs on it. Even more disastrous was Julius' disregard for the existing urban fabric and property ownership, which precipitated a revolt by the nobles whose properties were ruthlessly hacked asunder. Like twentieth-century freeways cutting through historic neighborhoods, the street severed traditional patterns of movement and forged new spatial relationships and resentments.

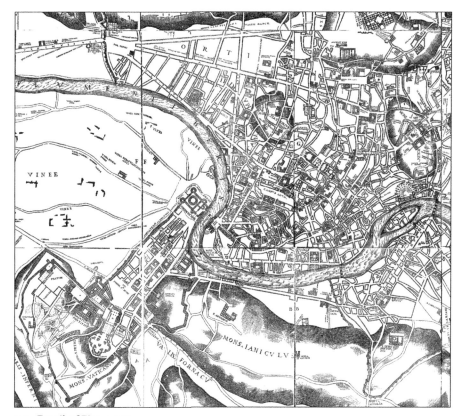

165. Detail of Figure 156.

Leo X, from Tuscany, continued in this vein. He laid out Via Leonina to connect Piazza del Popolo directly to the Ripetta port; from there it continued toward Via Sistina, the church of S. Luigi dei Francesi, and his family palace in the heart of the *abitato*. His successor, Paul III Farnese (1534–1549), the first Roman pope in nearly 90 years, had clearly caught the rationalization bug and deployed it around the city. First, he built Via Paolina (now Babuino) east of the Via del Corso to balance Via Leonina. His ensemble of streets radiating south from Piazza del Popolo was the first formal *trivium*, a trident of streets designed to facilitate movement (see Figs. 165, 168, 197). This new urban strategy, invented in Rome, made its way into villa and city plans from Versailles to Washington, D.C.

This *trivium* provided a framework for the future development of its piazza and for the straight streets and regular blocks that characterize the northern Campo Marzio. Paul completed a second *trivium* by bracketing Via Papale as it entered Piazza di Ponte with two new streets that cut through a dense neighborhood (see Fig. 168). Via Paola led to Via Giulia and the newly built church of S. Giovanni dei Fiorentini, thus emphasizing the importance of the Florentines who dominated banking in the city and who clustered at the north end of Via Giulia.

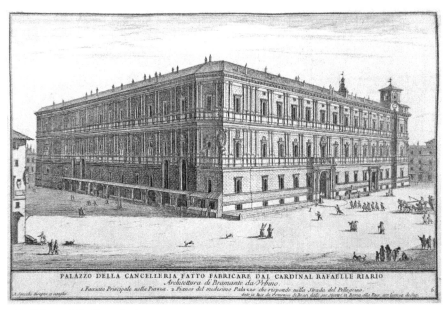

166. Palazzo della Cancelleria.
Source: Specchi 1699. Courtesy of Vincent J. Buonanno.

The new clerical palaces were luxurious, with sumptuous rooms, commodious libraries, display spaces for recently excavated antiquities, and vast warrens of rooms for their "families," which included not only relatives both rich and poor, but also their many attendants and servants. Significantly, their palaces established a different urban scale and created new urban centers, separate from the Borgo and the Vatican, controlled by cardinals and operating like miniature fiefdoms. The Venetian cardinal Pietro Barbo began expanding his fortified medieval residence into Palazzo Venezia in the 1450s. The modest building, a hybrid of medieval and Renaissance architectural styles, grew to occupy an entire city block and even harnessed the church of S. Marco to its façade. As Pope Paul II (1464–1471), Barbo continued to occupy the palace and to enrich and enlarge it, adding a private cloistered garden.

About the same time, Cardinal Domenico Capranica began his palace, which because of his influence was allowed to interrupt the straight run of Via dei Coronari just before it reached the Corso. His palace was modest compared with those built only a few years later, such as Palazzo Cancelleria, begun in 1485 for Cardinal Raffaele Riario. This behemoth exhibited the latest in Renaissance design, and it too yoked a church within its façade, S. Lorenzo in Damaso. Its extensive façade, nearly 90 meters long including the church, dominated a huge public square near Via Papale, shifting circulation patterns and stimulating building activity in the area (Fig. 166).

Cardinal Alessandro Farnese began his palace in 1515, but the 1527 sack interrupted the work. Once he was named Pope Paul III in 1534, work

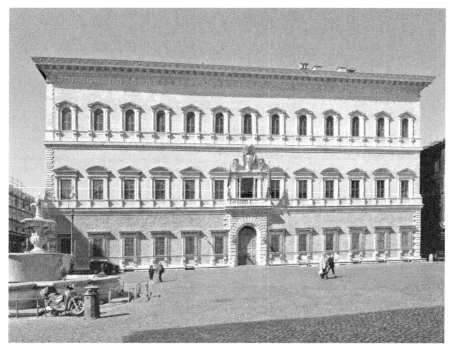

167. Palazzo Farnese.
Source: Photo: Mirabella. Title: "Palais Farnese." Wikimedia Commons/CC BY-SA 3.0 (creative-commons.org/licenses/by-sa/3.0/deed.en). Converted to B&W.

resumed in earnest. Although Palazzo Farnese stood on Via Giulia, its façade connected visually and symbolically to Via Papale to the northeast. To ensure visibility from that street to the palace's main entry, he cut a new street, Via de' Baulari, straight across the Campo de' Fiori between the papal route and the palace façade. What the palace lacked in street frontage (75 compared to the 90 meters at the Cancelleria), it made up for with an entirely new piazza created through eminent domain and the imposition of building restrictions on competing structures (Fig. 167). In back, a bridge spanned Via Giulia to provide access to a private garden on the Tiber, which in turn gave a view of the Villa Farnesina (formerly Chigi) on the opposite bank. Michelangelo even proposed a bridge across the Tiber here, but the Farnese had to make do with a private ferry. Like Palazzo Venezia, which became the focus for Rome's Venetian population, Palazzo Farnese formed the hub around which the French presence in the city revolved – a role it maintains today as the venue of the French embassy.

Nobles from ancient families, including Francesco Orsini, built new palaces in the fifteenth century – his was on Piazza Navona – as did less famous residents such as Lorenzo de' Manili, a Roman of distinguished pedigree and an avid antiquarian. In 1467/68 he assembled several contiguous houses that he owned in Piazza del Pianto and ornamented them with a single inscription

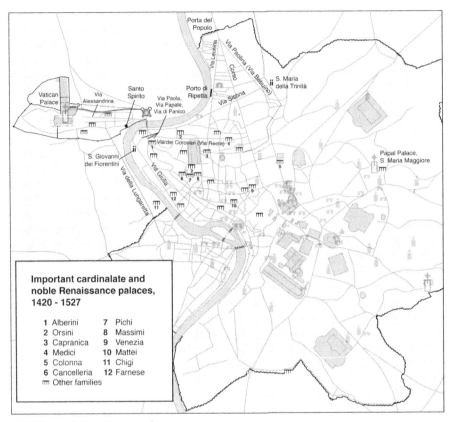

168. Map with Renaissance palaces.

carved in Roman letters onto the façade: URBE ROMA IN PRISTINAM
FORMAM RENASCENTE ("[Built] when Rome was reborn in its pre-
vious form"). The notion of Rome's rebirth, or restoration, was an insistent
theme of that optimistic age.

Newly minted noble families arising from the merchant class, such as the
Alberini, Massimo, and Pichi, also built new palaces during the early sixteenth
century (Fig. 168). The arrivistes in particular wanted to establish a strong
urban presence and stake out as much street frontage as possible, ideally along
Via Papale. They strapped smaller buildings together and hired famous archi-
tects to adorn these architectural agglomerations with continuous Renaissance
façades that could compete, if not in size, at least in beauty with those of the
cardinals. The Alberini claimed a site at the head of Via Papale just south of
Piazza Ponte where their palace was visible to anyone crossing from Ponte
Sant'Angelo. Palazzo Massimo alle Colonne united three smaller buildings
behind one façade at a critical point along Via Papale, near the Cancelleria
and across the street from Palazzo, Pichi built about 20 years earlier (Fig. 169).
These palaces differed from the Cancelleria, Farnese, and Venezia palaces in

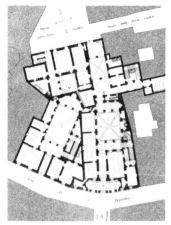

169. Palazzo Massimo alle Colonne. Ground floor plan and view.
Source: P. Letarouilly, *Édifices de Rome moderne* (Paris 1840–1857).

that their ground floors were for the most part rented out for mercantile and manufacturing activities. In this way the palaces united into one building the owner's business interests and lust for status.

Rome was in tumult after 1517 when Martin Luther posted his Ninety-five Theses charging the Church with complete spiritual and moral decay, thus setting the Reformation in motion. Clement VII de' Medici (1523–1534) responded with astonishing incompetence; as his political allegiances with the French, Spanish, and English wavered, tensions only mounted. Antipapal factions arose, even within the Curia; Cardinal Pompeo Colonna actually attacked and seized the Vatican with his private militia in 1526. The next year Colonna joined forces with the duke of Bourbon on behalf of Charles V, the Holy Roman emperor, to attack Clement. Troops entered the Borgo and crossed the Tiber into the city, killing and injuring civilians and destroying property. Clement fled, and Rome's population (counted in an official census shortly before the sack) swiftly plummeted from 55,000 to perhaps 35,000.

In 1530 a devastating flood reached the highest level ever recorded – the water was more than six meters deep inside the Pantheon – leaving a ruined city that many compared to conditions after the 1527 sack. Crop failures followed, and the city fell again into decline. Many Renaissance achievements were lost; once again streets became impassable, drains remained clogged, and houses crumbled. Urban disorder reflected that of the Church itself. To some contemporary observers Rome was given up for lost.

BIBLIOGRAPHY

Alberti 1988; Burroughs 1990; Cafà 2010; Capgrave 1911; Ceen 1986; Chastel 1983; Choay 2001; Coffin 1979; Dandelet 2001; Esch 2000; Fragnito 1993;

Frommel 1973; Fulvio 1527; Guicciardini 1993; Guidoni 2007; Howe 1992; Infessura 1890; Ingersoll 1985, 1994a; Lanciani 1906; Lee 1958; Magnuson 1958; Müntz 1878; Partner 1976; Pastor 1968–1969; Pecchiai 1958; Richardson 2009; Rodocanachi 1912; Romano 1939; Salerno et al. 1973; Simoncini 2004; Stinger 1998; Tafuri 2006; Temple 2011; Triff 2000; Valtieri 1984; Verdi 1997; Weil-Garris/D'Amico 1980; Westfall 1974.

TWENTY EIGHT

PLANNING COUNTER REFORMATION ROME

 E ARLY-SIXTEENTH-CENTURY PROTESTANT REFORMERS VIEWED THE CATHOLIC Church as a morally depraved body in which popes operated like kings, cardinals lived like princes, and monks were dissolute fornicators. In response to allegations of corruption, Paul III convened the Council of Trent (1545–1563), an assembly of bishops and theologians, to clarify Church doctrine. The council met for 25 extended sessions over the next 18 years. Pius IV de' Medici (1559–1565) ratified its decrees in January 1564, ushering in the period known as the Counter Reformation, and promulgated strict rules to reaffirm the primacy and legitimacy of Catholicism.

Because Rome, the head of the Church, was also in disarray, Pius and his immediate successors set about restoring its buildings and streets. The cleansed and renewed city would mirror the new moral order of the Church and its clergy. Over the next half-century they initiated grand urban infrastructure projects: restoring ancient aqueducts; regularizing, widening, and paving streets and piazzas; cutting new straight avenues through the medieval maze; building new drains and sewers; and legislating the disposal of rubbish.

Restoring the Aqua Virgo, now called the Acqua Vergine, was the first priority. It had supplied the Campo Marzio modestly throughout the medieval period and Nicholas V had partially restored it in the 1450s, but still its delivery was sporadic and inadequate. By 1570, Pius V Ghisleri (1566–1572) had restored it back to its abundant and pure source springs. With an assured water supply, he proposed 17 new public fountains in important locations including

170. Proposed Acqua Vergine Fountains, 1571.
Source: Rinne 2010.

Piazza Colonna, Piazza Navona, Piazza del Popolo, and Piazza della Rotonda. This hydraulic scheme, on a scale not seen in Rome since antiquity, provided drinking water for people and animals; in some cases, it also spurred urban development (Fig. 170).

Streets were torn up to accommodate the distribution conduits and new drains to carry off any water that could not be reused, such as that from laundries and wool factories. When possible, the drains were linked to newly discovered and restored ancient drains and sewers. The whole project provided

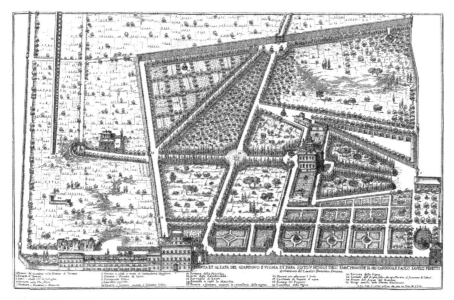

171. Villa Montalto.
Source: Falda 1670. Courtesy of Vincent J. Buonanno.

a perfect opportunity to improve living conditions in the Campo Marzio – with the added bonus of newly paved streets once the work was completed.

Water also flowed to palaces and monasteries. Work proceeded west and south in stages, so public fountains and private water subscribers living nearest the main distribution points in the sparsely populated northern Campo Marzio were the first to benefit. A construction boom followed in the water's path. New houses rose near the fountains and along the streets where pipe was laid. But the Vergine's waters were constrained by low pressure; Rome's hills remained dry. Gregory XIII Boncompagni (1572–1585) sparked interest in building a second aqueduct to terminate on the Quirinal, but the project was not implemented until Sixtus V pushed through the restoration of another ancient aqueduct, the high-level Aqua Marcia, naming it Acqua Felice. Terminating near the Baths of Diocletian, it soon served the Quirinal, Esquiline, Pincian, Caelian, Viminal, Capitoline, and Palatine hills.

Sixtus aimed to restore Rome's hills to their antique splendor with sumptuous irrigated villas and gardens. While a cardinal, he had amalgamated several vineyards and orchards near his church, S. Maria Maggiore; later he exploited the Acqua Felice to transform them into a luxuriant, fountain-studded garden estate, Villa Montalto (Fig. 171). Subsequent popes, cardinals, and important curial officers also acquired vineyards and orchards on Rome's eastern hills and the Palatine and converted them into gardens with gushing fountains, flowering plants, pebbled walks, ancient inscriptions, and sculptures. Intensely cultivated with plants, these environments were intended also for the cultivation

of humanist ideas. With the secularization of cultural life in general the villas gradually replaced monasteries as centers of contemplative life.

Sixtus had a three-pronged urban-renewal agenda. The Felice was one part; the others were economic development and a rationalized street system. His most aggressive proposal, only partially realized, exploited the new water supply to develop the Baths of Diocletian area into an industrial site with a (short-lived) silk factory, an animal market, a huge granary, a vast public laundry, and new shops and houses. The entire area was identified at Borgo Felice and persons who bought property nearby received special tax breaks.

A rational street system was crucial to his larger goal, to recreate Rome as a city of devotion in which pilgrims marked out their commitment to the restored and reformed Church by moving between stational churches. In a 1586 papal bull, he called on all Romans, especially the curial officers, to undertake annual pilgrimages and to visit certain churches during Holy Week. Specific churches were identified, all located outside the *abitato*, and long, straight avenues were built to connect them (Fig. 172). This entailed leveling hills and filling valleys to smooth out Rome's topography. The Quirinal offers striking evidence of this monumental task; it was lowered four meters to accommodate the new streets and the water conduits beneath them.

Some of Sixtus' proposed streets, like one notionally connecting S. Paolo fuori le Mura to S. Lorenzo fuori le Mura, were never built. Others remained incomplete, as Via Felice did. Meant to transect extensive tracts of vineyards and vegetable plots to link S. Maria Maggiore with Piazza del Popolo, it fell short of its destination. To do this would have entailed negotiating the steep Pincian slope; so the road terminated at Piazza Trinità dei Monti until the eighteenth century, when the Spanish Steps connected it to the Campo Marzio (see Fig. 176). But overall the plan was clear and functional, creating more direct connections from Rome's center to its far-flung outposts such as the Lateran. It became the benchmark for the nineteenth-century organization of streets on the Esquiline and Quirinal Hills. Sixtus relocated recently excavated ancient Egyptian obelisks to provide focal points for distant views and organize circulation at major road intersections. This was a phenomenal engineering feat, particularly at St. Peter's, where the huge obelisk of Nero's circus was moved to the piazza to stand in front of the church. Symbolically, the other obelisks then referred back to St. Peter's as they also linked far-flung neighborhoods to Rome's historic center.

Paul V Borghese (1605–1622) restored a third aqueduct, the ancient Aqua Traiana, calling it Acqua Paola. Its high source springs delivered water to the Vatican, the Borgo, Trastevere, and the top of the Janiculum. The Paola, completed in 1612, served a number of new public fountains, most notably one that Paul installed in front of St. Peter's and the spectacular "Il Fontanone" – literally, "the Colossal Fountain" – terminating the aqueduct on the Janiculum.

172. Conceptual diagram of Sixtus V's new road system.
Source: Bordini 1588. Courtesy of American Academy in Rome.

Besides serving public fountains, the Paola, like the Felice, irrigated private vil-
las on Rome's hills, particularly at the Vatican, as well as smaller urban gardens.
By the end of Paul's pontificate the three new aqueducts served 35 ornamental
fountains; more than 70 public fountains for drinking, watering animals, and
laundry; and hundreds of private subscribers at palaces, villas, and monasteries.
The arrival of fresh water changed Rome in significant ways: it boosted pop-
ulation, improved public health, and stoked property speculation. But it also

CHIESA DE SANTI VINCENZO, ET ANASTASIO ALLA FONTANA DI TREVI, DE PADRI RELIGIOSI DI S·GIROLAMO, ARCHITETTVRA
di Martino Lunghi il giouine 245
1 Fontana di Trevi· 2 Palazzo dell' Em·Card· Carpegna· 5 Loggia et Horologio del Palazzo di Mte Cauallo·

173. Bernini's unfinished Trevi Fountain and church of SS. Vincenzo ed Anastasio.
Source: Falda 1669. Courtesy of Vincent J. Buonanno.

had significant small-scale effects, such as easing women's work – laundresses
no longer had to trudge to the Tiber – and creating foci for neighborhood
socialization.

Paul's successors, most notably Urban VIII Barberini (1622–1643), expanded
Rome's water network and conducted a major restoration project on the
now-50-year-old Vergine. Urban also increased the number of public foun-
tains, turning many of them into vehicles of urban propaganda for his policies.
Pietro and Gian Lorenzo Bernini's Barcaccia ("little boat") Fountain in Piazza
di Spagna, for example, was Rome's first public fountain to be ornamented
with the papal coat of arms and to refer, through other symbols, to the Church
and to a specific historic event, the 1598 flood. Meanwhile, more effectively
than any billboard, Bernini's Triton Fountain used a spectacular water display
to stake out and mark Barberini territory at the foot of their family palace on
the Quirinal Hill.

Urban's boldest hydraulic gesture was to have Bernini reorient the Trevi
Fountain, which had for centuries faced west toward the Campo Marzio. Now
planned on a monumental scale, it would face south to be visible from the
top of the Quirinal Palace, an official papal residence (Fig. 173). Only the
foundation for Bernini's fountain was complete at Urban's death in 1643, and
so it remained for nearly 120 years, operating as a laundry fountain and horse
trough with a woollen mill tucked behind. The reorientation altered circula-
tion patterns in the area, and it sparked an interest in creating a new type of
piazza – one focused on the dramatic potential of water.

With its internal power dispersed to the Spanish and French and its exter-
nal influence diminished in the face of Protestantism, the Church of the

174. Plan of Rome, 1676.
Source: Falda 1676. Courtesy of Vincent J. Buonanno.

mid-seventeenth century turned eagerly to cultural tourism. This was the dawn-
ing age of the European Grand Tour, a phenomenon that would exert a power-
ful influence on urban form and process. Alexander VII Chigi (1655–1667) saw
the dramatic potential inherent in many of Rome's piazzas. He understood that
by creating immersive theatrical spaces that conjoined Rome's glorious ancient
past and its compelling present he could create an artistic tableau for tourists'
consumption (Fig. 174). Piazza del Popolo and Piazza Colonna are key exam-
ples. Each contained a major ancient monument, an obelisk and the Column of
Marcus Aurelius, respectively, around which wrapped an orchestrated environ-
ment of contemporary churches, palaces, and fountains. At Piazza Colonna, he
built a palace for his family, thereby installing them in a studied scenography of
imperial power and public ritual (see Fig. 66).

 In other instances, the exhilarating baroque play of volumes that had first
appeared in Rome's churches was applied to public spaces, lending them a new

175. Panoramic view of Piazza S. Pietro, ca. 1909.
Source: Library of Congress Prints and Photographs Division, Moffitt Studios ©1909, LC-
USZ62-131703.

sensuality and drama. Under Alexander VII, Rome became a more theatrical
city, where extravagant court and religious rituals were enacted in articulated
outdoor rooms that reinforced notions of power and representation. Piazzas
were permanent stage sets! At S. Maria della Pace the tiny forecourt formed
a continuous, peripheral, articulated façade of extravagant geometries. Most
notably, around Piazza S. Pietro, now centered on the ancient obelisk Sixtus V
had installed there, Bernini created an enclosed arena with twin fountains sur-
rounded by a curved double colonnade. It remains the greatest public gather-
ing place in Rome, where huge audiences of the faithful still watch the drama
of religious rituals unfold (Fig. 175).

Alexander VII paid for these expensive projects with church, public, and
private funds, and with so-called improvement taxes levied on landowners –
even as their houses suffered amputations to widen streets. His justification
was that construction alleviated unemployment – a common refrain among
the city's great builders ever since. The newly regularized streets and piazzas
would be wide enough for passing and turning carriages, by this time the
preferred mode of transport for cardinals, nobles, and the multitudes of illus-
trious, cultivated, and wealthy foreigners flocking to Rome. Sixtus V may have
transformed Rome for the pilgrims' sake, but Alexander VII did it for the
free-spending tourists.

The theme of theatricality continued into the eighteenth century with four
important projects in the Campo Marzio: the Porto di Ripetta (1704), the
Spanish Steps (1717–1726), Piazza Sant'Ignazio (1726–1727), and the com-
pletion of the Trevi Fountain (1732–1762). The Ripetta occupied a strategic
sector of the Campo Marzio riverbank, providing excellent connections to
major piazzas, avenues, and markets. Clement XI Albani (1700–1721) hired
Alessandro Specchi to transform the old port, little more than an irregular
landing, into an expansive, dramatic, and scenographic space on the riverbank
(see Fig. 162). Specchi's design embodied baroque fluidity in section, with cas-
cading stone steps; in plan, its undulating curves contrasted pleasingly with the
shoreline's contrived rectitude. In elevation, its elegant backdrop for commer-
cial life was best viewed from the shore and opposite bank. But the Ripetta

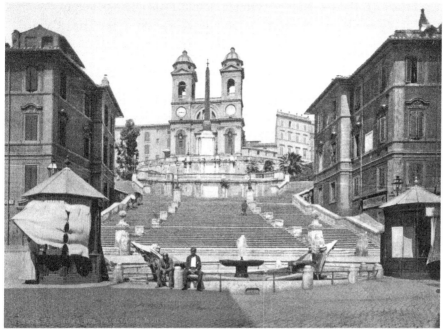

176. Spanish Steps, 1890–1900.
Source: Library of Congress Prints and Photographs Division. Detroit Publishing Company,
1890–1900. LOT 13434, no. 194.

was more than an urban beautification project; it solved pressing circulation
problems by greatly expanding the wharf's capacity, and it stabilized the river-
bank at a vulnerable point.

Like the Ripetta, the Spanish Steps – a project designed by Francesco de
Sanctis and completed under Innocent XIII dei Conti (1721–1724) – was
much more than an urban beautification effort (Fig. 176). It facilitated circula-
tion from the church of S. Maria della Trinità dei Monti down a steep, unstable
slope, through Piazza di Spagna 30 meters below, to Via dei Condotti, and on
toward Ponte Sant'Angelo and the Vatican (see Fig. 190). As we have seen, the
project indirectly completed Sixtus V's plan to connect Santa Maria Maggiore
to Piazza del Popolo with a long, straight street. While the Ripetta balanced
new design ideas with functional and economic goals, the Spanish Steps were
important politically because they symbolically united the Spanish Embassy at
the bottom of the Pincian Hill with the church and convent of the Trinità dei
Monti, under French patronage, on the top. Additionally, both projects com-
municated with Piazza del Popolo.

At Piazza Sant'Ignazio, as at S. Maria della Pace, baroque design principles
were aggressively applied to shape public space. Here, the façades of buildings
are united in a continuous, sculpted cloak of fragmented prisms and cylin-
ders to create one of Rome's most dramatic yet intimate public spaces. Piazza

Sant'Ignazio is the last gasp of baroque design principles applied to the creation of *al fresco* Rome. With the important exception of the Trevi Fountain, emotive baroque invention would give way to clear, logical, neoclassical design principles.

Rome's urban fabric was radically altered by Counter Reformation popes to register shifting values. Sixtus V used streets and obelisks to open the city to pilgrims in an effort to revive religious devotion. Alexander VII and others exploited new architectural concepts to maximize the personal drama of the urban experience. With few exceptions, the roads, aqueducts, and piazzas of Counter Reformation Rome provided the developmental framework for the next two centuries. Wholesale reconfiguration of entire neighborhoods would not resume in earnest until the late nineteenth century. But it was not only streets and piazzas that changed. Churches and palaces also took on increased urban prominence as they grew in scale to accommodate growing communities of fervent worshippers and the increasing size of cardinals' families.

BIBLIOGRAPHY

Andres 1976; Antinori 2008; Ashby 1935; Beneš 1989; Benocci/Guidoni 1993; Bevilacqua 1988; Bevilacqua/Fagiolo 2012; Burroughs 1994; Cancellieri 1811; Capogrossi Guarna 1873; Carbonetti Venditelli 1990; Ceen 1986; Cerasoli 1900; Coffin 1979, 1991; Connors 1989; Connors/Rice 1991; Crocco 2002; Curran et al. 2009; Dandelet 2001; Delumeau 1957–1959; D'Onofrio 1986; Ehrle 1956; Evans 2002; Fagiolo Dell'Arco 1997; Falda 1670, 1676; Foglietta 1878; Fontana 1590; Franzini 1657; Gamrath 1987; Guarini 2002; Guidoni 2007; Habel 2002, 2013; Heilmann 1970; Hibbert 1985; Howe 1992; Ingersoll 1985; Insolera 1993; Jacks 2008; Krautheimer 1982; Lanciani 1883, 1906; Lefevre 1960; Long 2008; Marder 1978, 1991; Marliani 1534; Martin 1969; Martinelli 1644; Montaigne 1903; Müntz 1878; Murray 1972; Narducci 1889; Nussdorfer 1992; Orbaan 1910, 1911, 1920; Partner 1976; Pastor 1968–1969; Pecchiai 1950; Re 1920; Rinne 2001–2002, 2005, 2007, 2010, 2012, forthcoming; Roca De Amicis 1984; Romano 1939; Salerno et al. 1973; Sanfilippo 2001; San Juan 2001; Simoncini 1990; Spezzaferro/Tittoni 1991; Stow 2001; Valone 1994; Varagnoli 1996; Waddy 1990; Wasserman 1963; Westfall 1974.

TWENTY NINE

PROCESSIONS AND POPULATIONS

M EDIEVAL AND RENAISSANCE POPES ORCHESTRATED PROCESSIONS AND urban theatricals to serve their political goals just as Rome's imperial rulers had staged public spectacles to manifest their civic power and responsibility. Translating icons and holy remains, receiving foreign dignitaries, staging funerals, and holding public games were all carefully choreographed and codified ceremonies which, like the ritual performance of the mass, reinforced the Church's spiritual authority and buttressed its temporal rule over the city. Moreover, by engaging important churches and palaces along the way, the Church manifested control over particular sites of contention.

The most important procession was the papal *possesso*, the route of which, weaving through the Campo Marzio along Via Papale, had developed over the centuries into the most important east–west passage in Rome. Occasionally, in times of political tension, the established route was modified to avoid specific locations or to reflect new alliances between the Church and barons; yet the ceremony continued in reduced form, even while the popes were in Avignon (see Chapter 22; Fig. 135).

With renewed papal commitment to Rome in the mid-fifteenth century, the *possesso* became a vigorous political symbol of the intertwined rebirth of city and Church. But now that the popes resided at the Vatican rather than the Lateran palace, its route was reversed. After being crowned at St. Peter's, the pope, mounted on a white horse and surrounded by his entourage, headed to the Lateran to take possession of his bishopric. Elaborate and ephemeral

271

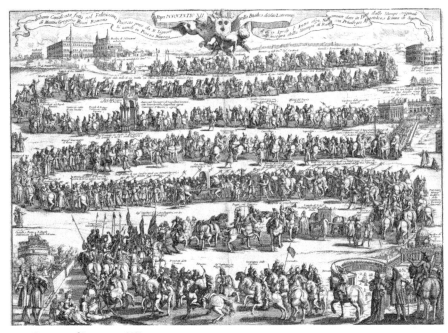

177. *Possesso* of Innocent XII.
Source: G. Frezza, 1692. British Museum 1979, U.669. AN265315. © The Trustees of the British Museum.

triumphal arches, decorated with papal insignia, were deployed at key loca-
tions along the route (see Fig. 135). Over time the *possesso* became more
splendid – the papal cortege grew larger, the vestments more sumptuous, and
the pageantry more elaborate – all in an effort to confirm papal sovereignty
over the Christian world, the city government, and the nobility, and to delin-
eate the specific relationships of each body with the pope. Rituals articulat-
ing papal control occurred at designated sites along a well-defined route; at
Monte Giordano, for example, the pope met with Jewish leaders, while at
Piazza S. Marco he tossed coins into the crowd (Fig. 177).

Equally, as the route changed – ascending the Capitoline Hill by the
mid-sixteenth century rather than skirting its base as it had earlier – the
possesso mirrored the increasing spatial and temporal power of the papacy
over secular interests. When the newly enthroned Sixtus V made his *possesso*
in 1585, the lines were clearly drawn. The nobles and the Senate had been
put in their places – deeply subservient to the pope – where they would
remain for centuries. The pope's "possession" of the Capitoline, once the
stronghold of anticlerical sentiment, could hardly have sent a stronger signal
of his dominance.

Ritual celebrations were deeply ingrained in Roman life. Easter Week and
other occasions were observed with services and solemn processions. None
were as extensive as the *possesso*, but even as early as the eleventh century they

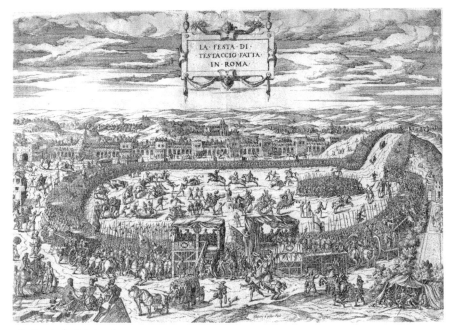

178. Festival at Testaccio.
Source: E. Dupérac, 1554. British Museum 1869,0410.696. AN147782. © The Trustees of the British Museum.

could engage large sectors of the city. The processions to honor the Virgin's Assumption, for example, began at the Lateran on the night of 14 August and moved to S. Adriano on the Forum and then to S. Maria Maggiore, where the pope celebrated mass. More recently invented annual processions also held symbolic importance. The procession of Le Zitelle dal Monastero di S. Caterina dei Funari reinforced the status of its sponsoring monastery and its role in providing charity to impoverished girls; but conceived as a parade to exhibit "worthy" girls, it was in effect a matchmaking pageant advertising the participants' marriageability. Dressed entirely in white, the girls walked from their convent at S. Caterina dei Funari to the church of Il Gesù, then to S. Maria sopra Minerva to attend mass and back to the convent. Throngs of spectators lined their route – some, we may surmise, to nobler purpose than others.

Pre-Lenten Carnival lasted for eight days, culminating with Mardi Gras. During the medieval period, Carnival had been celebrated with bullfights, horse races, and other games in Piazza Navona and later in the Testaccio district, now far from the *abitato* (Fig. 178). Paul II moved the games to Piazza Venezia and Via Lata in 1466, and from then until the late nineteenth century, various races, some featuring riderless horses, dwarfs, and Jews, took place on the now-renamed Via del Corso ("Avenue of the Racetrack"). This avenue, the ancient Via Flaminia, ran directly from Porta del Popolo to Paul's own Palazzo

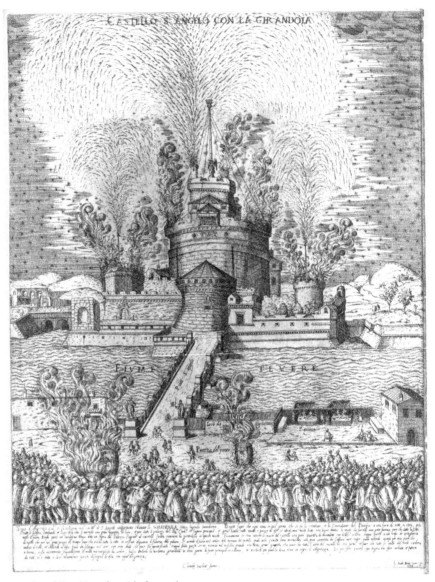

179. Castel Sant'Angelo with fireworks.
Source: A. Brambilla, 1579. British Museum 1862,1011.588. AN347377. © The Trustees of the British Museum.

Venezia; thus his impulse to resurrect its central role was only natural. Not coincidentally, it also presented ripe opportunities for real estate investment.

The urban calendar also included other public festivals. Rome's birthday, 21 April, was celebrated with a special mass followed by evening fireworks, music, food, and street parties (Fig. 179). The Chinea, a festival in which, since the eleventh century, the Roman ambassador of the Kingdom of Naples, who typically lived in Palazzo Farnese, paid homage to the pope, occurred on 28 June.

180. Fireworks preparation in Piazza Navona celebrating birth of the Dauphin in 1729.
Source: C. N. Cochin, ca. 1735. Courtesy of Getty Museum Open Content Program. 2644-067.
GRI Digital Collections.

Usually beginning from an extravagantly decorated Piazza Farnese, a *chinea* (white horse) was led through the streets to the Vatican. Everyone of rank participated. At the conclusion of this privately financed exercise in political stagecraft, the ambassador hosted a fireworks celebration in the piazza. Noble weddings and births also called for public celebrations, often lasting several days and commandeering an entire piazza with floats, stages, and fireworks (Fig. 180).

Holy Roman Emperor Charles V visited Rome in 1536. He arrived at S. Paolo fuori le Mura, where papal delegates met and escorted him to Porta S. Sebastiano, the gate of Via Appia. There, Roman barons, urban magistrates, and other dignitaries met him and followed his cortege along a route featuring as many ancient monuments as possible, newly relieved of medieval accretions to stand in heroic isolation. (This same strategy of isolating ancient monuments for political purposes would return with a vengeance under Benito Mussolini.) Passing the Baths of Caracalla, they proceeded through the Arch of Constantine to the Colosseum, under the Arch of Titus, and through the Roman Forum along the Sacra Via – 200 houses had been demolished to make way – and under the Arch of Septimius Severus. The entourage skirted the east flank of the Capitoline, passed Trajan's Column and S. Marco, then continued along Via del Pellegrino – pointedly *not* along Via Papale – to Ponte Sant'Angelo and St. Peter's, where the pope greeted Charles at the steps. The route, proceeding between the shrines of Christendom's two foremost apostles, was enlivened by ephemeral triumphal arches, richly decorated streets, tapestry-draped palaces, and throngs of cheering spectators.

Charles's entry left a stamp on Rome's urban complexion that survives to this day. His visit propelled Paul to reorganize the cluttered Capitoline Hill in 1538 according to Michelangelo's brilliant design (Fig. 181). This recalibrated

181. View of Michelangelo's piazza on the Capitoline.
Source: E. Dupérac, 1569. British Museum 1871, 0812.796AN495117. © The Trustees of the British Museum.

Rome's urban order by reversing the piazza's orientation. Formerly opening southward toward the Forum, the hilltop piazza now looked toward the Campo Marzio and the Vatican to the northwest. A triumphal ramp called the Cordonata, amenable to horses and carriages, provided a grand axial ascent (see Fig. 201). Renaissance façades masked the existing buildings facing the piazza and a new palace was added on one side to balance the composition. At the center of the trapezoidal piazza stood the focal point of the entire ensemble, an ancient equestrian statue of Marcus Aurelius removed from the Lateran (see Fig. 129). The plan also connected the Capitoline to the church of the Gesù with a new straight street, Via Capitolina (now Via d'Aracoeli), creating a diversion along Via Papale that allowed the *possesso* to ascend the Cordonata and descend into the Forum.

One of the most splendid nonpapal processions Rome witnessed was the triumph awarded to Marcantonio Colonna on 4 December 1571 to celebrate his defeat of the Turkish army at the Battle of Lepanto. The procession began at the port of Marino on the coast. Colonna was followed by 200 Turkish captives dressed in red and yellow, then by noblemen and the *maestri delle strade*. The participants followed the Tiber to Rome, where, like Charles V, they entered at Porta S. Sebastiano. The principal urban magistrates greeted and joined Colonna there and together they headed up Via Appia, turning right at the ruins of the Septizodium. There followed the Arch of Constantine, the

Colosseum, and the Arch of Titus, where the urban militia joined the entourage to continue across the Forum through the half-buried Arch of Septimius Severus, to the Capitoline's summit. The symbolism of this course was obvious to all (see Fig. 36); but Jupiter's Capitolium, once the culmination of the triumph, was now just a way station. Northward lay the Campo Marzio, and across it Colonna's ultimate destination, the Vatican palace and St. Peter's.

As public spaces assumed greater ceremonial importance, laws were increasingly enacted to control personal deportment within them. Printed *editti* (public declarations of law) were posted in streets and piazzas to remind people, including nobles and clergy, of their responsibility to maintain decorum; to limit activities like playing music and speech making; and to abstain from gambling, throwing trash, soliciting, or fortune-telling. Already marginalized populations like prostitutes and Jews were the chief targets of more sinister laws that increasingly prescribed where they lived and how they moved and conducted business in the city.

During the medieval period most Jews had lived among the Christians in Trastevere or near to the Theater of Marcellus. Sometimes a pope might protect them from violence, but as a rule they were barely tolerated. When at the end of the fifteenth century Jews were expelled from Spain, Portugal, and elsewhere, some of them emigrated to Rome, with predictable results. The influx discomfited the Church and exposed the entire Jewish community to severe reprisals. In 1554, decreeing that no Jews should henceforth live among Christians, Paul IV Caraffa (1555–1559) forced the Jews to sell their property and relocate to a *seraglio*, a newly walled and gated quarter of about two and a half acres along the Tiber in the neighborhood now called the Ghetto (Fig. 182). Apartment buildings were divided, streets sealed, and two gates built to lock its nearly 3,000 residents in at night. This was the most vile and malodorous part of the city. Tanners plied their trade on the riverbank immediately north of the *seraglio;* the urine and dung they used to treat animal hides rendered the entire area offensive and unhygienic, especially during the summer. By his actions, Paul IV bolstered a widespread prejudice that the Jewish people were unclean. It followed, then, according to the logic of demagoguery, that segregating them from gentiles was a public service. They were known even by their specially prescribed yellow hats, lest anyone should consort with them unwittingly.

The Jews' freedom to move about the city during the day fluctuated under different popes. Typically they were restricted to practicing only a few trades – most importantly, the rag trade. Immediately outside the Ghetto's major gate, in the bustling Piazza Giudea, Jewish dealers sold rags and old clothes to papermakers. Rome was a major publishing center, particularly of papal briefs and *editti*, but also of books and prints, all printed on rag paper.

The situation inside the Ghetto quickly deteriorated from uncomfortable and humiliating to severely overcrowded and unhealthy. Living conditions

182. Detail of Figure 174. Jewish Ghetto is shown alongside Tiber Island on left bank.

grew increasingly cramped as the Jews added new floors to accommodate new families and generations, inevitably diminishing everyone's access to light and air. Sixtus V (1585–1590) enlarged the Ghetto in 1587 with a new street along the Tiber, two new gates, and new houses that encroached over the riverbank. A small amount of aqueduct water was sold to the Jewish temples and used for ablutions, but the first public fountain only arrived in 1614; before that fresh water was fetched from Piazza Giudea during the day.

Prostitutes, whose haunts were Ponte Sisto and the Velabrum, also roamed the streets more or less at large, as did beggars and thieves. Having tried unsuccessfully to evict them entirely from the city, Pius V sequestered them in their own ghetto in 1566 at the Ortaccio, a damp and pestilential area near the Porto di Ripetta. Even if the motives behind the Ortaccio ghetto differed little from those used to justify the Jews' confinement, this experiment was futile and short-lived. The prostitutes were soon released, but on the condition that they would strictly avoid certain areas, including churches and monasteries. Since a church or monastery stood on nearly every street, the goal was to restrict them to trawling for trade in marginal districts.

Other groups formed identifiable neighborhoods by choice. Just as the Saxons and Frisians had clustered near the Vatican in the early medieval period, non-Romans of later times tended to congregate. After their

countryman Cardinal Rodrigo Borgia became Pope Alexander VI, Catalan merchants arrived in droves, congregating in the Trastevere. Venetians flocked to the S. Marco area, and the French to the Palazzo Farnese district, to be near their national cardinals. Some neighborhoods were elite: rich Florentines established their palaces and banks around Piazza Ponte and the church of S. Giovanni dei Fiorentini. Humbler neighborhoods bore the stamp of particular trades, not nations – like the army of newly arrived masons who lived around the Mausoleum of Augustus, where travertine blocks were offloaded at the Porto di Ripetta. Once they had amassed enough money and status in the city, they, like national groups, would build their own church.

All populations, regardless of station, needed to be controlled during epidemics. Until the eighteenth century, many infectious diseases were thought to spread by *miasma* or *mal aria*, literally "bad air," as punishment from God. It was also thought that contact with filth of all kinds, not least notionally unclean people like prostitutes, Jews, and many foreigners, transmitted diseases like the plague. Several strategies were employed to control disease: cleaning the sewers, especially in the summer months, when *miasma* was thought to be more insidious; cleaning the streets and dumping rubbish into the Tiber River; forbidding infected people, such as lepers and syphilitics, to enter the city; and confining the Jews, decade after decade, within the walls of the Ghetto.

Plague epidemics restricted movement even further. Public gatherings were essentially forbidden and infected individuals already in Rome were quarantined in their own homes, each bearing a sign of contagion on the door. If anyone within those houses died, the house was disinfected and its contents often burned; burials were restricted to common graves in extramural cemeteries. Movement into and out of entire neighborhoods was restricted, although special plague doctors, who wore identifying clothing, moved more freely. City gates were closed; guards inspected people, food, and goods entering the city; and the Tiber was closed to incoming vessels. Pilgrims and tradesmen were often forced to remain outside the walls for several days while health officials determined whether they carried disease. Special "pest houses" were set up to quarantine suspected plague carriers. One stood on Tiber Island, which could be easily isolated from the general population. The primary plague hospital, now known as the Hospital of St. John Calibita on the Island, was founded in 1584, not far from the ancient healing sanctuary of Aesculapius.

Such measures, when not obviously founded on superstitious bigotry, had their logic – but the truth is that they offered no real advantage over health policies of earlier ages, let alone the Roman imperial era, when the city's population exceeded that of the Renaissance tenfold. Only in the nineteenth century, when statistically grounded public health policy was born, could the leaders of cities like Rome hope to forestall and contain pestilence in a targeted and systematic way.

With its multitudes threading through new crosstown streets and teeming in its refashioned piazzas, Rome must have seemed open and inviting. Yet it was still, like its medieval ghost, constrained by largely invisible physical boundaries enveloping small neighborhoods of people related by trade, religion, and national allegiances. Even so, while economic and social differences became more pronounced through dress, architecture, and education, neighborhoods remained mixed, with cobblers residing cheek-by-jowl with cardinals and nobles. This would remain the case until the late nineteenth century.

BIBLIOGRAPHY

Ackerman 1961; Adinolfi 1881; Benocci/Guidoni 1993; Bevilacqua/Fagiolo 2012; Bonnemaison/Macy 2008; Brentano 1991; Burroughs 1990; Cafà 2010; Cancellieri 1802; Ceen 1986; Cohen 1998; Dandelet 2001; Delumeau 1957–1959; D'Onofrio 1986; Fagiolo Dell'Arco 1997; Forcella 1885; Fosi 2002; Fragnito 1993; Gamrath 1987; Gentilcore 2012; Gigli 1958; Ingersoll 1985, 1994a; Insolera 1993; Karmon 2011; Koslofsky 2011; Lanciani 1906; Maier 2006; Moore 1995; Partner 1976; Pastor 1968–1969; Podestà 1878; Rollo-Koster/Hollstein 2010; San Juan 2001; Savio 1972; Simoncini 2004; Sonnino/Traina 1982; Stinger 1998; Stow 2001, 2012; Tarquini 2005; Twyman 2004.

THIRTY

MAGNIFICENT PALACES AND RHETORICAL CHURCHES

N ICHOLAS V'S DECISION TO MOVE THE PAPAL RESIDENCE TO THE VATICAN altered the city's political and cultural landscape. To reflect the new status of the Vatican palace, he enlarged and improved it to serve as his residence, an administrative center for papal business, and a reception space for visiting dignitaries. For defensive reasons he linked it to Castel Sant'Angelo with a wall called the Torrione. His successors further expanded the grounds to include the heights of the Vatican Hill, where Innocent VIII Cibò (1484–1492) later built a small villa, the Belvedere. Julius II linked the palace to the villa with two long wings around a central courtyard designed by Bramante, called the Cortile del Belvedere. Sixtus V divided this in half to house the Sistine Chapel and the Salone Sistina (Fig. 183).

Nicholas V's ministrations to Rome ensured that a citywide surge in palace and church construction would ensue. In fact, the boom lasted 200 years, until the mid-seventeenth century. Colossal palaces such as the Cancelleria and the Palazzo Farnese went up with remarkable speed in the *abitato*. In the Borgo, too, more important prelates, nobles, and cardinals erected palaces of varying grandeur to be near the center of papal power. For example, Via Alessandrina built by Alexander VI passed alongside one flank of Piazza Scossacavalli, where, with financial inducements to develop the area, two cardinals and a papal chamberlain had all built impressive palaces by about 1520 (Fig. 184). Additionally, Rome's elite undertook to acquire large vineyards and orchards on the intramural hills – but not for their agricultural assets. From the

183. Borgo, Ponte Sant'Angelo, and Piazza Ponte.
Source: Dupérac 1577, detail.

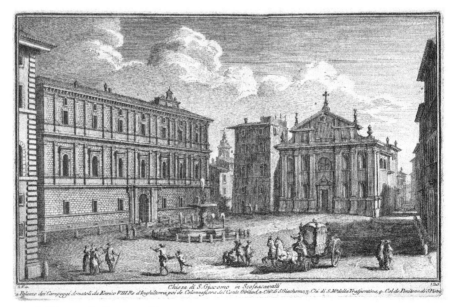

184. S. Giacomo in Scossacavalli.
Source: Vasi 1747–1761, VI.120. Courtesy of Vincent J. Buonanno and Brown University.

late sixteenth century these productive slopes, favored at last with aqueduct water, were repurposed into luscious villa gardens. The *horti* of antiquity had returned with a vengeance.

Christendom's most important church was now more than 1,100 years old and probably in physical distress; Nicholas V proposed to demolish it and to build an entirely new basilica. But only in 1505 did Julius II authorize a design competition for a new St. Peter's, which would gradually, after many fits and starts, grow up around its Constantinian ancestor and then, inevitably, consume it. Today we might be forgiven for regarding St. Peter's church and piazza as products of a single cohesive design, but we could hardly be more mistaken; for more than 170 years the area was a perpetual construction zone, and its *parti* a battlefield of ideologies (Fig. 185). Donato Bramante, the competition winner, proposed a central dome over an enormous Greek cross plan. But after his death Michelangelo redesigned the dome, which Giacomo Della Porta completed in 1590 (see Fig. 175). Paul V extended the nave and commissioned a new façade, which included the famous central loggia for papal announcements. The basilica was essentially complete in 1626, although tinkering continued until the nineteenth century. Throughout it all, amid the dust, bustle, and clatter, throngs of pilgrims passed through the Borgo as before. But the piazza still lacked a dignified entry sequence for worshippers at mass and special celebrations.

Urbanistically the most important element of new St. Peter's is its gently sloping piazza, with its grand flight of stairs, central obelisk, matching lateral fountains, and embracing colonnade. In 1587 Sixtus V, we recall, had relocated the obelisk here, where it established the focal point for Gian Lorenzo Bernini's oval colonnade of 1667 (see Fig. 175). Some have seen the extension of the nave as a grave aesthetic blunder, a rude prismatic snout strapped to a noble jaw; but Bernini's elegant scheme not only bestowed on new St. Peter's the grand portal it deserved, it wrapped the prosaic façade about with poetry, quickening the approach with the rhythms of anticipation.

Bernini's genius was to create a central, symmetrical public space from an irregularly shaped area surrounded by both motley and grand buildings. He did this by creating a cross axis and enclosing the piazza in the embrace of grand Tuscan-style triple colonnades that were wide enough for carriages to pass down the center and pedestrians to move along the sides – all under a protective roof. He also moved Paul V's earlier fountain from 1612 to one side and matched it with one of his own to give a more human scale to an otherwise colossal outdoor room. The magnitude of the piazza's all-embracing arms comports with that of the church; symbolically, it accommodates all Christians. To this day, the pope can address audiences of many thousands from the entry balcony.

St. Peter's and its piazza clearly constituted the most important construction project in Rome for the entire sixteenth and much of the seventeenth

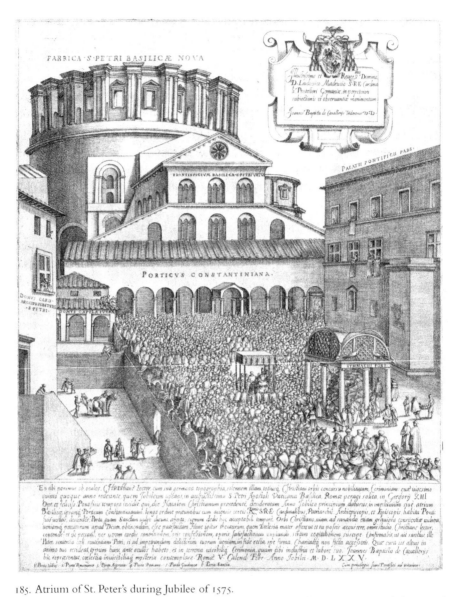

185. Atrium of St. Peter's during Jubilee of 1575.
Source: G.-B. Cavalieri, 1575. British Museum 1874,0613.613. © The Trustees of the British Museum.

century. Building materials intended for other projects were even diverted to St. Peter's, thwarting secondary urban building initiatives. Nonetheless, church building in general was booming, and as the number of worshippers swelled, the churches often ballooned in size. This reflected the decision made at the conclusion of the Council of Trent to reform the clergy and restore the faithful to their devotions with a renewed emphasis on the mass and the sacraments. What is most striking about the new post-Tridentine churches, characterized as "preaching" churches rather than parochial ones, is their scale, equaling that

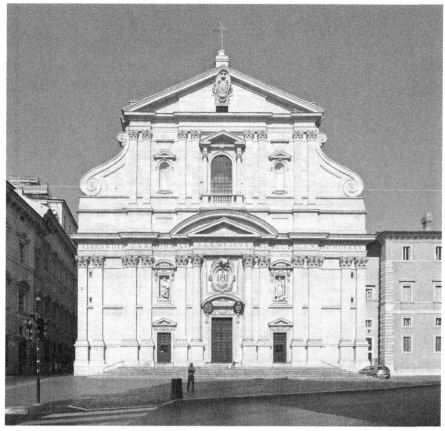

186. Il Gesù.
Source: Photo: Alessio Damato. Title: "Church of the Gesù, Rome." Wikimedia Commons/
CC-BY-SA-3.0 (creativecommons.org/licenses/by-sa/3.0/deed.en). Converted to B&W.

of the greatest medieval churches such as S. Sabina (see Fig. 114). Colossal pal-
aces and churches populated Counter Reformation Rome as powerful indi-
viduals and organizations employed the right of eminent domain to expand
into neighboring property to create impressive street frontages and consolidate
ownership. As a result, the larger palaces and massive new preaching churches
demanded wholesale neighborhood reconfiguration.

Among the preaching churches are Il Gesù, the mother church of the Jesuits,
begun in 1568 (Fig. 186); S. Giovanni dei Fiorentini, the national church of the
Florentines, begun in 1583 (although planned earlier); and S. Andrea della Valle,
the seat of the Theatine order, begun in 1590. Preaching churches continued to
be built well into the seventeenth century.

Their mammoth proportions, accommodating at times up to 2,000 wor-
shippers, meant that they cut extensive swaths through existing neighbor-
hoods, and like Renaissance palaces they occupied as much real estate and
street frontage as possible. Many of them had large associated monasteries

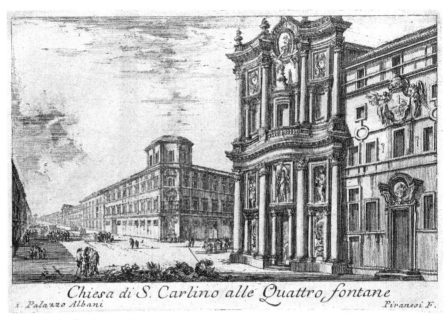

Chiesa di S. Carlino alle Quattro fontane
1 *Palazzo Albani* *Piranesi F.*

187. S. Carlo alle Quattro Fontane.
Source: G.-B. Piranesi, *Varie vedute di Roma*, 1748. Courtesy of Vincent J. Buonanno and Brown
University.

and also owned, through gift or purchase, scores of nearby properties that
they leased out for various uses or income. The Jesuits, for example, owned
and used many buildings in the heart of the *abitato*, including the Collegio
Romano, which became an important center for students of astronomy,
mathematics, and physics. Once the Collegio opened in 1584, its enrollment
grew rapidly to 2,000 students. The church of S. Ignazio next door was built
to accommodate this influx.

Some religious complexes were so large that they bumped up against their
rivals. The Jesuits at S. Ignazio found themselves across the street from a rival
preaching order, the Dominicans at S. Maria sopra Minerva. Farther south, the
Barnabites at S. Carlo ai Catinari and the Theatines at S. Andrea della Valle
engaged in a kind of turf war, grabbing street frontage and purchasing entire
blocks of outlying buildings for future expansion.

Equally important were Rome's smaller churches, many built in the first
half of the seventeenth century. Often commissioned by religious orders for
their own use, several of them represent the most architecturally innovative and
spatially complex buildings of the period. Among these are S. Ivo alla Sapienza
and S. Carlo alle Quattro Fontane (Fig. 187), both designed by Francesco
Borromini, and S. Andrea al Quirinale by Bernini. These buildings' complex
geometries of interlocking curved, triangular, and rectangular forms create
intensely dynamic and yet deeply contemplative spaces. Had their innovations

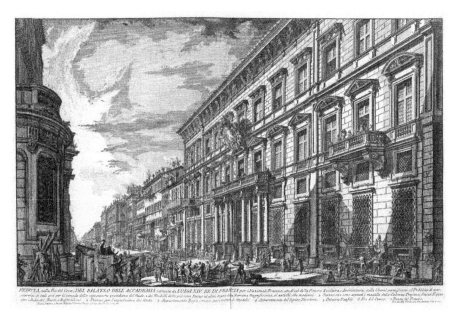

188. Via del Corso.
Source: Piranesi 1747–1778. Metropolitan Museum of Art/OASC; www.metmuseum.org.
Rogers Fund, transferred from the Library: 41.71.1.16.

been confined to interior spaces they might not have influenced Rome's urban form so profoundly. But their exteriors were equally exuberant, engaging and animating the street in new and exciting ways, most notably through undulating and embracing façades. In some cases, a single building could dominate and direct the design of an entire piazza, as at S. Maria della Pace (see Chapter 28).

Like monastic orders, palace owners of the late sixteenth and seventeenth centuries vied for prime locations as a means of asserting their urban importance. The Corso quickly evolved into a particularly favored location. It was Rome's major north–south street, the first to greet visitors from the north. But it was also a *destination* – an elegant boulevard where Romans made their promenade. Unlike the narrow, irregular Via Papale, the broad, straight Corso, lined with magnificent palace façades, encouraged the casual theatricality of showing off (Fig. 188).

Alexander VII intuitively understood the Corso's importance. To prove his point, he walked from Via Flaminia through Porta del Popolo and down the length of the Corso (see Fig. 190). On his way he encountered Palazzo Caetani (formerly Rucellai, today Ruspoli), the early Christian church of S. Lorenzo in Lucina, and the ancient Arco di Portogallo (see Fig. 136). Farther along, to the right, was Piazza Colonna, awkwardly shaped but by now a fashionable quarter housing several important palaces, to which he would add another (see Chapter 28). Irregular and in variable states of completion, these palaces

framed the Column of Marcus Aurelius and an Acqua Vergine fountain in the piazza. Installed along the southern Corso was a veritable gallery of imposing Renaissance palazzi: Sciarra, Doria Pamphilj, Salviati, and the venerable Venezia, among others.

Alexander VII's stroll was of no small consequence. Soon he had the inner face of Porta del Popolo remodeled, and across the piazza to the south he commissioned twin churches to be built at the head of Paul III's *trivium* of streets (see Fig. 203). Road obstructions like the Arco di Portogallo were removed; and the new Chigi family palace supplanted an older one on Piazza Colonna. Like Sixtus V, he provided financial incentives to speed redevelopment, particularly near S. Marco, even handing over publicly confiscated land to private citizens who promised to build palaces there.

To "build" a palace in Rome's *abitato* might mean several things; but by the seventeenth century, it did not necessarily translate to complete demolition and ground-up construction. Indeed, the medieval habit of building by annexation, whereby *baroni* accumulated neighboring houses into a single new megastructure, never died. Palazzo Cenci, just outside the area that would be designated the Jewish Ghetto, was pieced together over many decades, as was the nearby Palazzo Mattei. As they had gained wealth and status in the mid-sixteenth century, the various branches of the Mattei family had patiently bought up adjacent properties. By 1580 they controlled nearly an entire city block around the small house that their ancestor Giacomo Mattei had acquired in 1473.

With every election of a pope, new palaces were built or older ones enlarged to house his "family," who now had to live in a manner befitting their elevated status. The nobleman Gianbattista Altieri twice expanded his palace beside the Gesù – once when he was named a cardinal, and then again when his uncle ascended the papal throne as Clement X Altieri (1670–1676). Most impressively, on Piazza Navona Innocent X Pamphilj (1644–1655) expanded his sister's palace near the Four Rivers Fountain he commissioned from Bernini and erected an adjacent "family chapel," the church of S. Agnese, effectively commanding nearly a quarter of the piazza's real estate (Fig. 189).

Two palace expansions are especially compelling – Palazzo Quirinale and Palazzo Borghese. The site of what is now the Quirinal Palace enjoyed a commanding view of the city. It had been a vineyard with a small garden and simple residence owned by a series of notable families since at least 1467, when Oliviero Caraffa acquired the property. Over the next 120 years, Caraffa's nephews, followed by cardinals from the Farnese and d'Este families, sequentially embellished the property so lavishly that it achieved the status of palace and villa garden by 1575, when Cardinal Ippolito d'Este granted Gregory XIII Boncompagni (1572–1585) permanent access to the property as an urban retreat (Fig. 190). It became a critical component of Sixtus V's plan to dominate the ridge of the hill.

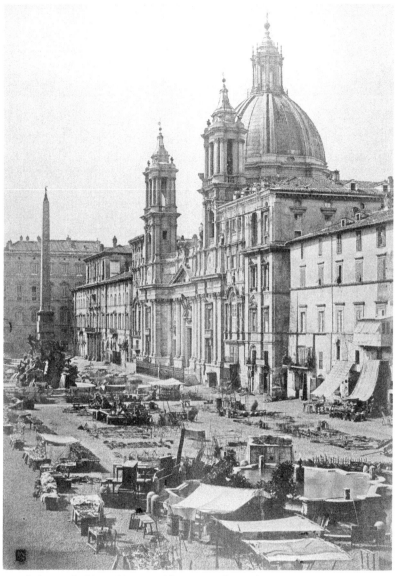

189. S. Agnese in Piazza Navona with open market in front.
Source: T. Cuccioni, 1858–1864. © Roma Capitale. Museo di Roma. Archivio Fotographico AF-6318.

As the name implies, the Borghese were not nobles, but bourgeoisie. Cardinal Camillo Borghese purchased a small palace and some surrounding properties near the Porto di Ripetta. After he was elected Pope Paul V in 1605 he gave the property to his nephew Scipione, whom he soon elevated to cardinal, to remodel into a suitable residence. Over 20 years the palace grew to be enormous and acquired many dependent buildings to house lower-ranked family members, servants, and stables. Accommodation was made for these and

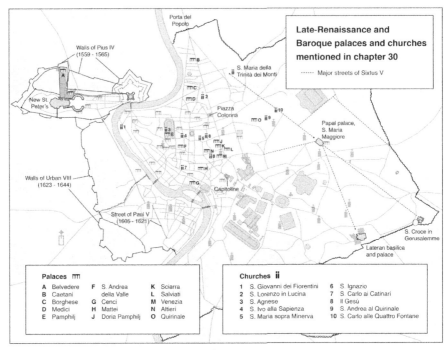

190. Map with Renaissance and Baroque palaces.

for a piazza by wiping out two residential blocks opposite the main entrance. To prevent unpleasant occlusions of the space and the view, a loop of bollards, still in place today, diverted street traffic away from the façade. The cardinal also desired a better view to the river: *presto*, the lumberyard at the Ripetta was moved northward and nearby market stalls disappeared. More was at stake than just egos, though; the Borghese arrivistes successfully thwarted the expansion plans of their neighbors, in this case, the de' Medici, whose urban palace lay just to the south.

Palazzo Spada, Borromini's jewel built in the shadow of Palazzo Farnese, also claimed its own private piazza – first by visually expanding its territory beyond its façade with a new fountain placed on axis with its entry, and then by securing the legal right to control how others used the space. Like the Borghese, the Spada effectively privatized a public space to gain some breathing room, even to the point of denying the owners of surrounding buildings the right to overlook the piazza.

Each new palace wedged into the dense *abitato* represented a successful claim by nobles and cardinals to imprint their own kind of local order onto the medieval urban fabric, but many also entailed the destruction of numerous smaller buildings, displacing families and businesses. As the seventeenth century drew to a close, this kind of disregard for the urban accommodation of ordinary people began to force a reevaluation of papal responsibility to

the poor. A brewing political and social revolution awaited Rome in the next century.

BIBLIOGRAPHY

Ackerman 1954; Andres 1976; Antinori 2008; Armellini 1891; Beneš 1989; Bevilacqua 1988; Burroughs 1990; Cancellieri 1802, 1811; Ceen 1986, 1991; Coffin 1979, 1991; Connors 1989; Connors/Rice 1992; Fagiolo et al. 1985; Fontana 1590; Frommel 1973; Gamrath 1987; Gigli 1958; Guidoni 2007; Habel 2002, 2013; Hibbert 1985; Insolera 2002; Krautheimer 1982; Lanciani 1883, 1906; Leone 2008; Marder 1978, 1991, 1998; Martinelli 1968; Nolli 1991; Nussdorfer 1997; Orbaan 1920; Pastor 1968–1969; Roca De Amicis 1984; Rinne forthcoming; Salerno et al. 1973; Signorotto/Visceglia 2002; Simoncini 1990; Spagnesi 1992; Specchi 1699; Valone 1994; Varagnoli 1996; Waddy 1990; Wasserman 1963; Weil-Garris/D'Amico 1980.

THIRTY ONE

NEOCLASSICAL ROME

R OME'S PERPETUAL BUILDING BOOM OBSCURED THE HARSH REALITY THAT the Church's political, economic, cultural, and theological influence had waned. While the rest of Europe celebrated the dawning Age of Enlightenment by embracing scientific inquiry, instrument making, and experimentation, the pope and his curial administration stubbornly resisted any intellectual challenges. The paranoid Roman Inquisition, seeing heresy everywhere, answered perceived subversion with either imprisonment or death.

When not absorbed in doctrinal matters, popes also considered urban issues, but for the most part, their focus now shifted to completing construction projects already in progress or initiating projects that addressed severe urban or social problems. Innocent XII Pignatelli (1691–1700), for example, formalized the Ripa Grande on the Trastevere riverfront. His monumental Ospizio Apostolico di San Michele, directly across the Tiber from the Aventine, encompassed a public hospital, orphanage, and reformatory. Though it answered an urgent social need, its immensity overwhelmed lower Trastevere and reinforced the district's associations with the underclass and outcasts for the next 300 years. Innocent's successors repaired consular roads to speed imports into Rome; enlarged Rome's granaries, now located in the ruins of the Baths of Diocletian; and, as we saw in Chapter 28, facilitated urban traffic and commerce at the Ripetta and the Spanish Steps.

This concern with social projects had its exceptions, most notably Clement XII Corsini's (1730–1740) decision to raise a new Trevi Fountain

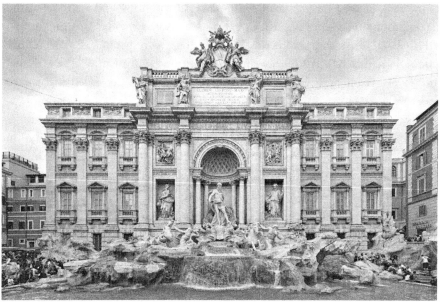

191. Trevi Fountain.
Source: Photo: David Iliff. Title: "Trevi Fountain, Rome, Italy 2 May 2007." Wikimedia Commons/CC-BY-SA 3.0 (creativecommons.org/licenses/by-sa/3.0/deed.en). Converted to B&W.

over Bernini's unfinished scheme, which still languished as a glorified washbasin and animal trough (see Fig. 173). In 1732 he launched a design competition, won by the architect Nicola Salvi. Construction plodded on over two more pontificates and 30 years, but when it was inaugurated in 1762 the Trevi quickly became the talk of Europe (Fig. 191). Now a properly dignified terminus for the venerable Acqua Vergine, it was the eighteenth century's answer to Paul V's colossal fountain on the Janiculum. Its ornate 50-meter span occupies almost the entire width of a constricted piazza where three streets converge. The Trevi, surely the world's favorite fountain, emblematizes Rome as certainly as the city's most famous building, the crosstown Colosseum. Like Hadrian's Venus, annexed dorsally to her sterner counterpart Roma, it represents Rome's gentler and more nourishing aspect.

During this flurry of public works building, it became progressively clearer that conserving ancient monuments and establishing museums to protect ancient sculpture were essential strategies for a city with such an intensely retrospective character. Clement XI Albani (1700–1721) understood that as the power of the Church waned, Rome's reputation in Europe and elsewhere relied on its inventory of ancient monuments that actively united past and present. The ancient Pantheon, long repurposed as a Christian church, was not only an iconic sacred building in need of preservation but also "a crucible of critical thinking" about broader issues of restoration. Clement XII restored

its interior, cleared its piazza of temporary obstructions, and remodeled the piazza's fountain, adding the small obelisk that adorns it today (see Fig. 60).

His Pantheon restoration was praised for its respectful approach, but when Benedict XIV ruthlessly and surreptitiously dismantled the original attic-level marble and porphyry interior revetments and replaced them with neoclassical-style stucco panels ("modern puffery," according to one infiltrator's bitter assessment), he and his architect were widely accused of sacrilege. Significantly, this controversy placed churches at the center of the restoration debate – whether to hew to original forms or allow some architectural invention to reflect current aesthetics.

Early Christian churches in particular were sometimes restored to reflect an idealized and often misunderstood formal purity. A conservation debate flared up in 1823 after a fire devastated the venerable church of S. Paolo fuori le Mura. From the smoldering ruins the opportunity arose to reconceive the building and its site completely. Instead, using a handful of rescued parts, *spolia*, and new materials, Church authorities resolved to rebuild the church as a simulacrum of itself. This decision set a precedent for the reconstruction of ancient ruins.

Despite Benedict XIV's scandalous "modernizing" in the Pantheon, his pontificate, and that of Clement XII, marked a brief and rather glorious period for Rome when learning flourished and the arts prospered through cultural and social building projects. Known as "the Enlightenment pope," he held a deep interest in mathematics, physics, medicine, and science in general; it was he who finally authorized the publication of the writings of Galileo, condemned of heresy more than a century before. Rather than initiate grand building schemes, he focused on urban administration. Two projects in particular are notable for their scientific rigor: a complete survey and mapping of the Tiber River from Malpasso in the north to its mouth, now situated well beyond the silted-up ancient port at Ostia, to combat flooding and increase its navigability; and the reorganization of the intramural *rioni* and clarification of their boundaries. He also authorized *La pianta grande di Roma* – the remarkable map surveyed, etched, and printed under the direction of the architect and cartographer Giovanni Battista Nolli. All three projects had lasting importance.

The Tiber flooded in January 1742, turning the attention of Benedict, the Roman Senate, and the general public to improving the river. Compared with the 1598 flood, which drowned the Pantheon in more than six meters of water, the incident barely registered. Nonetheless, it was the first significant inundation in more than 80 years – long enough for the collective memory to falter and history's lessons to fade. To say that Rome was unprepared grossly understates the case. As in the past, those areas closest to the river were hit hardest; shops and houses were ruined, supplies and food stores were lost, ports were destroyed, and grain mills were torn from their moorings and sank in the river.

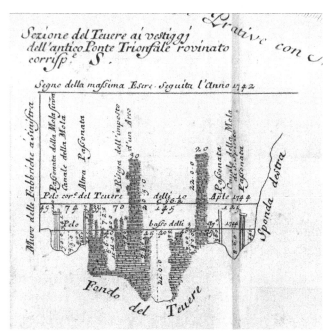

192. Schematic cross section of Tiber at ruined Pons Neronianus.
Detail of Figure 160.
Source: Courtesy of Vincent J. Buonanno.

Benedict summoned to Rome two specialists in engineering, surveying, and mapping of rivers, Andrea Chiesa and Bernardo Gambarini. They arrived in 1743 to study the causes of Tiber flooding and to propose improvements to prevent future catastrophes. Using the most precise instruments available, they surveyed the river and its banks within the city during spring 1744 and then surveyed up- and downstream during that summer (see Fig. 160). They identified the "precise location, size, and quality of all the principal impediments that exist in the bed of the Tiber," both visible and invisible, from Ponte Molle (the Milvian Bridge) to San Paolo fuori le Mura. Their section drawings revealed a submerged hidden landscape and clearly demonstrated the difficulty of finding a satisfactory course around the debris (Fig. 192). They published their findings in 1746, but their many recommendations to improve navigation and prevent floods went unheeded, in large part because of the cost and scale of the project.

Meanwhile, Benedict engaged Bernardino Bernardini to regularize the administrative boundaries of Rome's *rioni*. As Bernardini explained in the preface to his 1744 report to Benedict, the boundary lines were not clear and in fact were overseen by conflicting interests, which led to misunderstandings between property owners. The report contained lists of all the palaces, major piazzas, streets, churches, schools, hospitals, monasteries, and industrial sites and a map of *rione* boundaries created by Carlo Nolli and schematically based on the one published later by his father (Fig. 193). Bernardini had marble

193. Rione Parione (left) and Rione Pigna.
Source: B. Bernardini, *Descrizione del nuovo ripartimento de' rioni di Roma* (1744; reprint 1777).
Courtesy of Vincent J. Buonanno.

inscriptions posted with the name and hallmark of each *rione* to identify its newly surveyed boundaries so that anyone could with a "simple glance know the place in which he found himself, or where he desired to go." Typically two markers face each other at the boundary between *rioni*, except when the Tiber forms one of the edges.

This administrative document clarified and codified an urban agenda in a manner similar to Augustus' regionary city or the medieval military and parochial divisions. Simultaneously, Giovanni Battista Nolli and his team of assistants, including the young Giovanni Battista Piranesi, were nearing completion of a 13-year urban survey that culminated in the publication of *La pianta grande di Roma* in 1748 (Fig. 194). Still regarded as the finest map of Rome ever produced, the Nolli Plan, as it is usually called, abandons the bird's-eye approach of the previous two centuries and returns to the planimetric or ichnographic (perpendicular) view adopted in Bufalini's 1551 plan (see Fig. 156), but with a degree of accuracy that even GIS technology barely achieves. Its level of detail is still unmatched in the modern era and its sumptuous aesthetic has rarely been equaled in cartography.

Nolli's innovative mapping techniques – in particular the use of black and gray solids and white voids to differentiate private buildings from public streets, courtyards, churches, piazzas, and gardens – changed how we perceive urban space and "read" cities. He indicated slopes with textured S-shaped lines, rendered garden plants and cultivation patterns of vines and trees, and delineated the new *rione* boundaries with dotted lines. The life of the river is carefully depicted with floating mills, palisades, ferryboats, and cargo ships. Tempting as it is to imagine eighteenth-century tourists using the Nolli Plan to navigate Rome, it proved too comprehensive and costly for this purpose.

Benedict XIV had grasped the importance of city-scale analysis, but because of the political upheaval that soon engulfed Rome, his successors failed to initiate design projects encompassing this kind of citywide perspective. Rather,

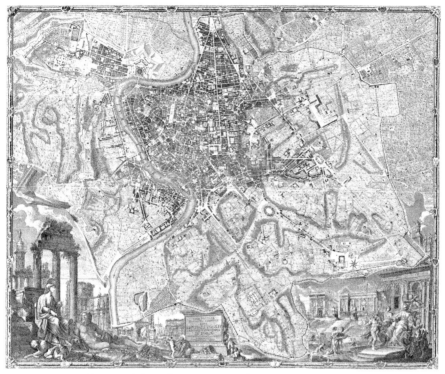

194. Large map of Rome. G.B. Nolli, *La pianta grande di Roma*, 1748.
Source: Courtesy of Vincent J. Buonanno.

popes such as Pius VI Braschi (1775–1799), whose reign coincided with
the revolutionary overthrow of monarchies then sweeping Europe and the
American colonies, responded to the threat of social unrest with broad social
programs and small-scale urban projects. Pius reopened moribund industries
and engaged in large-scale land reclamation by draining the Pontine Marshes
south of Rome.

His restrained urban vision for Rome was patterned on Sixtus V's reerec-
tion of Egyptian obelisks to focus distant views and mark important intersec-
tions. With revolutionaries snapping at his heels, Pius VI could only operate at
a smaller scale; he raised and consecrated three ancient obelisks. One, at Piazza
Quirinale, completes an ensemble that incorporates a fountain and two ancient
sculptures of Castor and Pollux wrestling with their rearing horses; the pair
probably had adorned the nearby Serapeum in antiquity. Sixtus had aligned
the statues to Michelangelo's Porta Pia more than a kilometer to the east. Pius
repositioned them so that the horses strain in different directions, with the
obelisk between them. The obelisk that he had placed in front of the church of
Trinità dei Monti is even more dramatic and intervenes even more directly in
Sixtus' plan, marking the intersection of the Spanish Steps and Strada Felice (see
Fig. 176). It also terminates the long view all the way down Via dei Condotti
to Piazza Nicosia. Standing today at the Quattro Fontane intersection, one can

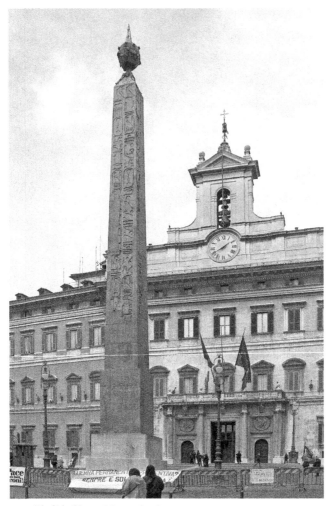

195. Obelisk, Piazza Montecitorio.
Source: Photo courtesy of Pamela O. Long.

descry three obelisks far down its streets: that of Sixtus V at S. Maria Maggiore to the southeast, and in the opposite direction the one Pius VI placed at Trinità dei Monti (see Fig. 190). Southwest lies the Piazza del Quirinale obelisk, pulled far off center in that irregular space, but aligned with sagittary precision to the view down Via del Quirinale. Pius VI's third obelisk – once the pointer for Augustus' giant sundial – was erected at Montecitorio, but because it sat within an enclosed piazza, its urban function differed from that of the others (Fig. 195).

Such tinkering could hardly have prepared Rome for the upheavals to come. In 1798 Napoleon's army invaded the city, exiled Pope Pius VI to France, created the Roman Republic out of the former Papal States, and established Rome's first planning commission, which because of the brevity of

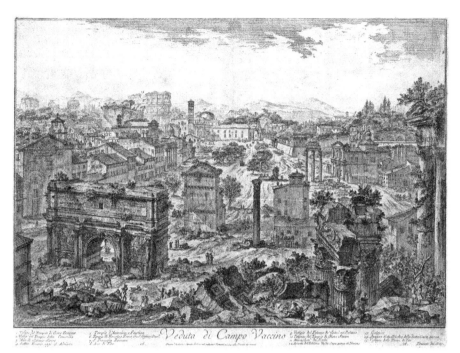

196. View of Campo Vaccino (the ancient Forum) from Capitoline.
Source: Piranesi 1747–1778. Library of Congress. Call Number: FP-XVIII-P667, no.3 (D size)
[P&P]. LC-DIG-ppmsca-23885.

Napoleonic rule failed to accomplish urban reform. Pius VI died in France in 1799, the same year that the Papal States were restored to the Church. The new pope, Pius VII Chiaramonti (1800–1823), also exiled in France, was allowed to return to Rome, but in 1809 Napoleon sent him back. Annexed again to the French Empire, this time Rome was declared a "free and imperial city" and the empire's second capital. The monasteries were confiscated and the religious orders of the entire Papal States – 130,000 monks and nuns – were turned out, causing great suffering among the poor, who relied heavily on the church's charity.

Napoleon's agents in Rome instituted the Napoleonic Code to regularize the city's legal system, arriving with money to support key urban projects. Napoleon himself never visited Rome, yet he commissioned public parks and markets, sponsored archaeological research, and instituted classical architectural and planning ideals, which together were perceived as the rational embodiment of republican virtues. The planning goal was to create a classicized, but *secularized*, city through utilitarian projects that would echo imperial Rome's grandeur. Excavations began throughout the city, and while the discoveries were held to an unprecedented level of scientific rigor, the city's magnificent patrimony of antique sculptures and artifacts, newly discovered or not, were

197. Bird's-eye view of Rome, detail with Piazza del Popolo and Pincian Hill.
Source: L.-J. Arnout, 1849. *Capitolium* 37.1 (1962 suppl).

packed off to France. (Many, but not all, have been returned.) The Forum
remained a cow pasture and an archaeological wilderness; even its ancient ori-
entation was uncertain at this time (Fig. 196). Napoleon's men, followed by
conscientious papal archaeologists, systematically excavated and cleared parts
of the Forum and restored many of Rome's major classical monuments – most
significantly the Arch of Titus and the Colosseum. Their architecturally ori-
ented, academic brand of archaeology may be the most lasting legacy of the
French occupation.

The highways between Paris and Rome were busy during these years, so
it is not surprising that Rome's "front door" should have attracted scrutiny.

197. (cont.)

Indeed Napoleon's urban agenda is most clearly articulated in Giuseppe
Valadier's 1811 design for Piazza del Popolo and the adjacent slope rising 30
meters to the crest of the Pincian Hill. Even after Alexander VII's interven-
tions, the piazza remained ill articulated, especially on its Pincian side, where
the slope presented a barrier between the Campo Marzio and the new hilltop
villas. Reorienting the piazza on an east–west axis with an oval plan echoing
St. Peter's, Valadier created a dramatic ramp for carriages and pedestrians to
ascend to the Pincian Gardens, Rome's first public park (Fig. 197). While the
piazza created a dramatic and effective portal into Rome, the gardens may be
Napoleon's most important urban legacy. Romans – *all* Romans – now could

walk or ride to a spacious park environment with public promenades, magnificent views, shade, and fresh air. Their design actively accommodated a rational structure for socialization – a critical principle of Napoleon's conception of social justice. Popes and cardinals had never imagined such a thing, let alone made it happen. It was well appreciated that churchless men like Julius Caesar and Agrippa had done both.

BIBLIOGRAPHY

Beltrani 1880; Benevolo 1971; Bernardini 1777; Bevilacqua/Fagiolo 2012; Camerlenghi 2007; Ceen 1991; Chiesa/Gambarini 1746; Choay 2001; Collins 2004; Crescimbeni 1719; Curran et al. 2009; D'Espouy/Seure 1910–1912; D'Onofrio 1992; Gross 1990; Guidoni 2007; Hibbert 1985; Hopkins/Beard 2005; Hyde-Minor 2011; Insolera 2002; Kirk 2005; La Padula 1969; Maier 2006, 2015; Minor 2006, 2011; Narducci 1889; Nibby 1838–1841; Nicassio 2005; Nolli 1991; Pinto 1986; Rea/Alföldi 2002; Ridley 1992; Tice/Harper 2010.

THIRTY TWO

PICTURING ROME

ARTISTS AND ARCHITECTS HAD FOLLOWED THEIR INSPIRATIONAL COMPASSES to Rome for centuries, but in the sixteenth century they began arriving in droves from all over Italy and Europe. With sketchbooks in hand, they came to study – and draw, paint, or etch seemingly every antiquity, palace, piazza, and bend in the Tiber River. The city was their subject – its buildings, ruins, topography, and people (Fig. 198).

After the Thirty Years War ended in 1648, when European travel became easier and safer, Italy enjoyed a more or less permanent surge of cultural tourism. For gentlemen of rank, particularly those from Great Britain, an extended period of European travel known as the Grand Tour, taking many months and sometimes years, was expected. The tour rapidly became a social and educational phenomenon – a kind of peripatetic finishing school in the gentleman's cultural education, culminating in Rome. King Louis XIV established the French Academy in 1666 so that artists and architects could measure and draw classical Rome as a foundation for their own contemporary practices. (Other nations followed only in the nineteenth century.) Although no longer a political force in Europe by the mid-seventeenth century, the city, with its fantastic mix of ancient relics and Renaissance buildings, still held allure and provided the excuse for educative travel – a new kind of pilgrimage, intellectual and aesthetic rather than religious, that Europe's burgeoning Protestant elites could embrace, and that could profit Romans catering to them.

198. Old St. Peter's and Vatican Palace.
Source: M. van Heemskerck, 1530s. Egger/Hülsen 1913–1916.

Now the need to feed, quarter, and entertain distinguished visitors in suitable style, and to accommodate the vast retinues of servants and horses they had with them, acquired even greater urgency. The area at the foot of the Spanish Steps quickly became identified with the foreigners who tended to settle or sojourn there, particularly the British. Also, the need arose to respond to the visitors' growing appetite to collect mementos, whether ancient sculpture or contemporary painted and printed views of the city and the Campagna (Fig. 199). Their lust for loot found a ready market, and the cultural tourists returned home with crate loads of antiquities and images of Rome's ancient and modern attractions.

Ancient sculpture, whether acquired legally or through clandestine dealers, was the most prestigious Roman souvenir. Illegal antiquities excavations had occurred for centuries, but the scale of looting swelled with the influx of "grand tourists," some of whom sponsored "personal explorations" among the ruins to collect and smuggle out their own keepsakes. This led Clement XII to purchase the largest privately held Roman collection of sculpture and painting and donate it to the Capitoline Museum in 1734 to stanch the flow of antiquities and Renaissance paintings leaving the city. Following suit, Clement XIV Ganganelli (1769–1777) founded the Vatican Museum. These museums were perhaps the most lasting legacy to Rome of the Grand Tour.

Paintings, too, were prestigious travel booty, and like sculpture they were difficult to export if they were considered part of Rome's Renaissance patrimony. Only paintings created by foreigners could be easily exported. Among the most fashionable and exportable subjects were scenes of momentous historic events that had taken place in ancient Rome or portraits of the distinguished traveler set within a classical landscape. Painted *vedute*, images of cityscapes and landscapes rather than individual buildings, became wildly popular, as did often

199. Imaginary gallery of painted *vedute*.
Source: G. P. Panini, *Modern Rome*, 1757. Metropolitan Museum of Art/OASC; www .metmuseum.org. Gwynne Andrews Fund, 1952,52.63.2.

idealized genre scenes of daily life set within Rome's most treasured public spaces and ruined landscapes.

Maarten van Heemskerck (1498–1574), a Dutch painter who worked in Rome in the 1530s, and other Low Countries artists introduced the *vedute* tradition to Rome. The *vedutisti* produced expansive and inclusive views that featured the complexity and irregularity of specific places within the city, often down to minute details (see Fig. 198). To do this they relied on surveying equipment or perhaps a camera obscura to create the deep perspective that made the *vedute* so different from the flattened or wholly symbolic views that had been popular in the late medieval period. This is one reason that *vedute* are such valuable historic documents. Ever more accurate and realistic, by the mid-seventeenth century they displayed almost photographic attention to detail, if sometimes with a mapmaker's perspective (Fig. 200). Giovanni Paolo Panini (1691–1765) famously cranked out scores of handsome paintings for wealthy tourists (see Fig. 199). He was a master of the large-scale topographic *veduta* and a type of picturesque view that inserted well-known monuments into entirely fanciful landscapes. Gaspar van Wittel, called Vanvitelli (1652/3–1736), another painter of *vedute*, was famous for his exceptionally realistic views, which were widely copied by other artists well into the nineteenth century.

200. Villa d'Este on Quirinal Hill.
Source: Falda 1670. Courtesy of Vincent J. Buonanno.

Maps too became increasingly accurate. Leonardo Bufalini's 1551 plan of Rome (see Fig. 156), a military plan of Rome, was the first scientifically surveyed map of the city since the Severan marble plan. Unlike bird's-eye-view or *veduta* maps, which showed façades and landscapes from an oblique angle, it was a perpendicular ichnographic plan of buildings and streets. Although incomplete and misaligned, and often exaggerating the scale of structures, it clearly differentiated between the short, crooked medieval streets and the long, straight Renaissance ones. It would never have been used for urban navigation; probably only a handful of knowledgeable people would have consulted it at all!

After Bufalini, mapmakers reverted to the oblique view, perhaps because their aims were aesthetic rather than utilitarian. Over time their maps became more pictorial, projecting an increasingly idealized image of Rome with sweeping panoramas that would be impossible to appreciate from the ground. Giovanni Maggi's 1625 plan with its tidy streets and houses, impressive ancient ruins, and elegant churches and palaces surrounded by walled vineyards and orchards is exceptional in this regard.

Giovanni Battista Falda's stunning 1676 *Pianta Grande di Roma* maintains this pictorial tradition but with a new twist (see Fig. 174). His is a plan projection – neither pure plan nor oblique view, but a hybrid of the two in which building façades are projected up in parallel lines at 45 degrees from the plan, similar to close-in urban views of Google Maps. Although the city at street level could never be read as a whole in Falda's plan, we do gain a greater sense

of how streets might have looked to the pedestrian, and we clearly register the increased accuracy of the street plan. He used a similar projection technique for his series of villa plans from 1970 (Fig. 200; see Fig. 171).

The ichnographic Nolli Plan of 1748, introduced in the previous chapter, returns to Bufalini's preference for presenting the urban fabric as a continuum. This frees us from thinking of buildings as individual objects of experience, as epitomized in the *Einsiedeln Itinerary* with its lists of monuments to the right or left. Now we see a flow of space from one piazza to the next and we shift our perspective from solely that of a viewer – standing back to admire a monument – to that of a participant in the urban drama. But even with its increased detail, tourists would not have used Nolli's map – or any of the others discussed previously – to navigate Rome's streets; they were far too cumbersome and expensive for that purpose. Map reading remained, on the whole, the province of professionals and connoisseurs.

Visitors such as Michel de Montaigne, who traveled to Rome in 1580, had hired *ciceroni* (guides) to help them make sense of the chaotic jumble of Rome's streets and ruins. But as travel became easier and less expensive, a more democratic, if still privileged, clientele began to take matters into their own hands – literally – by purchasing and following guidebooks. Like medieval itineraries, the new travel aids laid out specific routes – the must-see features, modern and ancient. By the late eighteenth century, they were filled with increasingly detailed information about the newly named streets and intersections, now identified by wall plaques. Often illustrated, they might include small fold-out maps and directions to important buildings and monuments or detailed plans of a specific neighborhood. Enterprising travelers made intricate sketches and took copious notes; some – Montaigne, Johann Wolfgang von Goethe, and others – later published them. These travel memoirs in turn fed the popularity of the Grand Tour.

Giuseppe Vasi's 1763 *Itinerario istruttivo di Roma* provides an eight-day, largely topographic approach to the city. It also includes a map – perhaps the first ever intended for tourists. On day one Vasi escorts the visitor across the Tiber via the Milvian Bridge and proceeds down Via Flaminia, straight through the Porta del Popolo. One passes slowly down the Corso, visiting notable palaces and churches, and by day's end reaches the Capitoline (Fig. 201). In other itineraries, Vasi guides the sightseer to more remote parts of the city; he saves St. Peter's, still the ultimate goal for most visitors, even non-Catholic tourists, for the final day.

More important than the guidebooks or painted *vedute* of Rome were printed images churned out by the thousands. Giovanni Battista Falda was not only an accomplished cartographer but also among the most prolific and talented *vedutisti* of the seventeenth century. His widely collected and circulated views of Rome's cityscape replaced the swaths of uneven ground, piles of ruins, and rubbish depicted in the sixteenth century with paved piazzas,

201. Cordonata of Capitoline.
Source: A. Specchi, *Il disegno e prospetto del romano Campidoglio moderno*, 1699. Courtesy of Vincent J. Buonanno.

bubbling fountains, and neatly dressed people strolling by elegant palaces and noble churches (see Fig. 173). If Rome had had its own travel bureau in the seventeenth century it could have done no better to promote the city's beauty and majesty than disseminate Falda's *veduta* prints around the major capitals of Europe. As it is, the collectors who carried home and displayed their *vedute* provided that service, giving tangible proof of Rome's past glories and broadcasting the architectural and urban achievements of the reborn city.

Falda's popular images, and those of other *vedutisti*, cemented certain iconic places in the imagination of tourists, molding their sensibilities, positively and negatively, in much the same way as a guidebook. Also like these, the *vedute* helped visitors match reality to the printed image as they traveled Rome's streets. As the Grand Tour grew more democratic, printed *vedute* gained popularity. Far less expensive and easier to transport than paintings or sculpture, they were also unambiguously legal to acquire. In the eighteenth century, the most prized *vedute* were those by Vasi and Giovanni Battista Piranesi (Figs. 202, 203) – Vasi for his meticulous record of the city, and Piranesi for his evocation of almost mythical, sometimes fanciful, but always exquisite and seductive views of Rome's monuments and landscapes. As Terry Kirk observes, Piranesi "inspired an entire generation to see Rome in a new sensibility of innovative inquiry."

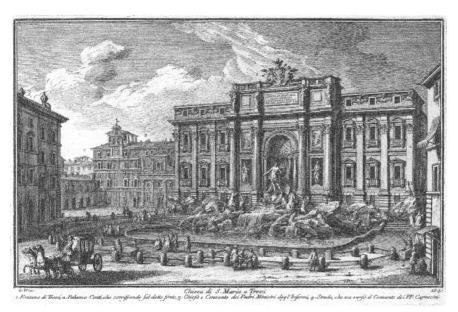

202. Church of S. Maria at Trevi and Trevi Fountain.
Source: Vasi 1747–1761, VI.104. Courtesy of Vincent J. Buonanno.

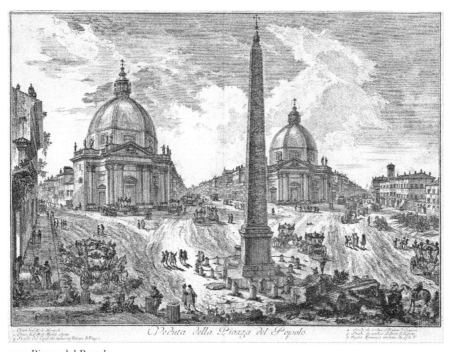

203. Piazza del Popolo.
Source: Piranesi 1747–1778. Metropolitan Museum of Art/OASC; www.metmuseum.org. Harris Brisbane Dick Fund 1937.37.45.3(49).

Bandi, printed legal prohibitions, provide a different view of Rome, revealing the increasingly regimented and constricted everyday and ceremonial lives of its residents. Posted in major streets, piazzas, and buildings, they reveal the constant surveillance of the Church and city administrators over public behavior. They provide insight into how Romans used public space – in the markets, at public festivals, at worksites, within the Jewish Ghetto – and often they show us the resulting social tensions that developed when different classes rubbed shoulders in unexpected or prohibited ways.

The ubiquitous *bandi* itemized categories of behavior that would not be tolerated in specific locations. The prohibitions ran the gamut from injunctions against gambling and urination in streets to precise instructions about where and when to dispose of trash, debris, and waste. Not surprisingly, the list of piazzas where it was forbidden to play games, solicit prostitutes, or wash laundry corresponds to those where important cardinals and nobles lived – that is, the ones popularized in *vedute*.

More ominously, a city ordinance of this period allowed neighbor to report neighbor for a violation. This clearly invited abuse, as the informer could collect anywhere from a quarter to a third of the fine. Thus we hear of people constantly watching their backs and of long-standing grudges exploding into violence against persons or property. By the eighteenth century permanent *bandi*, carved on stone plaques and affixed to building walls, began to appear. Far from proclaiming the deeds of a victorious emperor or the glories of Rome reborn, they characteristically warned against throwing dung or trash into a nearby drain. Like the new street signs and *rione* markers, the printed and carved notices carefully delineated a space, and one's place within it.

The *bandi* often were so extreme that in the absence of a free press, ordinary people were compelled to protest with their own pronouncements called *pasquinades*. Derived from "Pasquino," the nickname for a fragmentary ancient statue displayed near Piazza Navona, they often insulted the sitting pope. Pasquino was one of four so-called talking statues – Babuino on Via Babuino, Marforio in the forum (none other than the reclining river god representing the Tiber mentioned in the *Einsiedeln Itinerary*), and Madama Lucrezia in Piazza Venezia were the others – and in each case the *pasquinades* would be hung on a placard around the statue's neck. Overnight one or more of the other talking statues would respond with a wry comment, which in turn might incite further nocturnal badinage. Pasquino, ever the subversive, speaks his mind to this day.

Photography would prove particularly useful to document urban changes and conditions. Invented in the 1840s, the new technology coincided with the rise of an educated middle class, including Americans eager to visit Europe. Once cameras became cheaper and less bulky, a tourist could snap photos to record personal experiences of the city. Everything was fair game. Like the *vedute*, photographs exposed the fragility of Rome's ancient monuments, and

204. Tenements, via Marmorelle 19.
Source: Rodocanachi 1912.

as the lens of romanticism rendered the ruins ideal subjects to represent the historical past, their photographic documentation also increased the interest of non-Romans in protecting them.

Photography accompanied the spread of romanticism, a movement that was gradually supplanting the strict neoclassicism of the previous 150 years. One of the most revealing photographic subjects was Rome's abject state of decay. Idealizing, sentimental images of daily life among the poor and the picaresque had been the subject of paintings and prints for centuries; but photography, although capable of glossing over the misery of the underclass almost as flippantly as prints and paintings could – especially in its nascent documentary and journalistic applications – also revealed their unambiguous poverty, which was especially evident in the crumbling ruins and tenements they inhabited (Fig. 204). Thus, with their easy dissemination and

unvarnished sincerity, photographs achieved what Pasquino's barbed witti-
cisms never could: they became effective tools for social justice. It may be
no accident that the popular uprisings inflaming mid-nineteenth-century
Europe coincided with the birth of this powerful medium. At the same
time it should be remembered that by documenting actual conditions, pho-
tographs would be used to support the wholesale destruction of neighbor-
hoods, such as the Ghetto, fully two-thirds of which was leveled in 1885,
and the deportation of thousands of "urban poor and undesirables" under
Benito Mussolini's Fascist regime in the next century.

BIBLIOGRAPHY

Albertini 1510; Audebert 1981; Beltrani 1880; Benocci/Guidoni 1993;
Bevilacqua/Fagiolo 2012; Bufalini 1911; Ceen 1991, 2009; Choay 2001;
Cohen/Cohen 1993; Connors/Rice 1992; D'Onofrio 1986; Dupérac
1575, 1577; Egger/Hülsen 1913–1916; Egger et al. 1906; Ehrle 1935; Evelyn
1955; Falda 1669, 1670, 1676; Fauno 1548; Franzini 1643; Fulvio 1527, 1588;
Hibbert 1985; Hülsen 1907; Jacks 2008; Karmon 2007, 2011; Lanciani 1891;
Maggi 1915; Maier 2006, 2015; McPhee 2012; Montaigne 1903; Muffel
1999; Murray 1972; Nolli 1991; San Juan 2001; Spagnesi 1982; Specchi 1699;
Sturgis 2011; Tempesta 1915; Tice/Harper 2010; Vasi 1747–1761, 1763.

THIRTY THREE

REVOLUTION AND RISORGIMENTO

Aᴛᴛᴇʀ ɴᴀᴘᴏʟᴇᴏɴ's ᴄʀᴜsʜɪɴɢ ᴍɪʟɪᴛᴀʀʏ ᴅᴇᴘᴇᴀᴛ ᴀᴛ Wᴀᴛᴇʀʟᴏᴏ, ᴛʜᴇ ᴍᴀᴘ ᴏᴘ Europe was redrawn at the Congress of Vienna (1814–1815), repatriating most of the Papal States to the Church. As a result, Pius VII returned to Rome and the monasteries were restored. A few years of fragile stability ensued; but waves of violent protest ushered in Pius IX's pontificate and lasted through- out it. Forced to flee Rome during a popular uprising in November 1848, Pius left the city without a government. In February 1849 local revolutionar- ies held popular elections and declared a new Roman Republic. In exile, the reactionary pope sought military help from French and Spanish troops; these launched an assault on Rome in April. Under the charismatic leader Giuseppe Garibaldi, the Revolutionary Army and hundreds of citizen-soldiers resisted until the end of June, when the French finally gained entry and restored Pius to Rome and his papal seat.

Faced with growing anticlerical sentiment, Pius devised social programs to help stave off local uprisings and embraced urban innovations to modernize Rome. Under his direction a group of advisers and private investors initiated public works projects. These included Rome's first gasworks and gas-lit street illumination, telegraph lines, three Tiber bridges, railroads, and a new aque- duct (Fig. 205). He sponsored housing projects, public fountains and laundries, schools, a new tobacco factory, and an asylum. He also dismantled the Jewish Ghetto's gates.

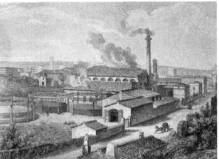

205. Public works projects under Pius IX; Trastevere asylum (left) and gasworks in Circus Maximus.
Source: Cacchiatelli 1863.

Nothing epitomized Machine Age modernity more than rail travel, which Pius embraced wholeheartedly. In the 1850s he initiated two passenger and freight lines connecting stations at Porta Maggiore and Porta Portese with a railroad suspension bridge across the Tiber linking via Ostiense to the left bank. The eastern station served both to receive incoming freight and to connect Romans to the countryside. The Porta Portese station emerged from a larger economic vision for Trastevere that included the tobacco factory, worker housing, and the restoration of Ponte Rotto with an iron suspension bridge.

During the 1860s Rome's urban development concentrated on the intramural eastern hills, home to vast estates of Pius IX's former military adviser, the wealthy prelate Francis De Mérode. He donated land in the ancient Castro Pretorio to Pius and then installed a new barracks, parade grounds, and exercise yards for the pope's 1,000 soldiers. At his expense, but ultimately to his immense profit, De Mérode platted his Viminal property in 1866 and cut a new street, the Strada Nuova, from the semicircular exedra of Diocletian's baths to Via Quattro Fontane. Meanwhile Pius decided to centralize rail operations with a new station, Stazione Termini, southeast of the baths. This required razing many elegant villas – including Sixtus V's Villa Montalto – and uprooting cultivated fields. Beginning in November 1870, the owner of Sixtus' villa sold it in parcels, beginning with those adjacent to the station, to a consortium of private speculators. When the station was inaugurated in 1872, they had already developed, without city approval, their own plan for a 330,000-square-meter area known as the Quartiere Esquilino, featuring large blocks and straight streets connecting to Sixtus V's original road system. In turn, the municipal government agreed to extend the Strada Nuova to connect the train station to downtown. De Mérode soon developed the Esedra into an elegant curved arcade; for those arriving by train, it displaced Piazza del Popolo as Rome's ceremonial gateway (see Fig. 94).

206. Piazza Vittorio Emanuele, view of public garden.
Source: Photo: A. Vasari, ca. 1900. Rome, Istituto Nazionale per la Grafica, Fondo Vasari inv.
1248. Courtesy of Ministero dei Beni e delle Attività Culturali e del Turismo.

To maximize profit, individual family lots were eschewed for elegant five-
and six-story apartments resembling Renaissance *palazzi* to entice upper-class
and bourgeois residents. Although remodeled and forlorn today, the neighbor-
hood focal point was, and still is, Piazza Vittorio Emanuele II, essentially an
English-style public garden providing verdant space and a healthful setting for
"genteel socializing" by its intended "ideal tenants" – government bureaucrats
(Fig. 206).

In 1868 Pius signed a contract with British investors to develop a mechan-
ically pumped aqueduct, the Acqua Marcia Pia Antica. Dedicated on 10
September 1870 at the pope's last civic appearance, it terminated in a public
park between the baths and the train station. Newly abundant water (and
the electricity it generated) served the residential Quartiere Esquilino and
transformed the area around the church of S. Lorenzo fuori le Mura into
an industrial sector; gradually, aqueduct water infiltrated the entire city. Pius'
aggressive initiatives, conjoined with De Mérode's self-serving but visionary
planning, inevitably aroused a frenzy of real-estate speculation that led to
modern Rome's eastward development.

The new Kingdom of Italy, which comprised most of the Italian penin-
sula except for the Papal States, was established in 1861 and its parliament
named Vittorio Emanuele II, ruler of Sardinia, its king. (He retained this title
to prevent confusion; Italy had had no King Vittorio Emanuele I.) Protected

by his French troops, Pius kept control of Rome until the outbreak of the Franco-Prussian War in July 1870, when his troops abruptly abandoned him. Perceiving his vulnerability, Nationalist forces bombarded and breached the Aurelian Wall 50 meters to the right of Porta Pia. On 20 September 1870, they occupied Rome, leaving Pius a "self-imposed prisoner" in the Vatican until his death. Italian unification occurred on 2 June 1871 and Rome was ultimately named the capital of the Kingdom of Italy.

The Nationalists, caught up in the political moment, hastened to construct a modern secular government. Expediency, not tolerance or pluralism, was the operating principle. Catholic orders were suppressed and their property seized; as before under Napoleon, monks and nuns were evicted. Government offices occupied some monasteries and most papal property was sold to speculators. Menacingly, the army occupied former papal offices at Montecitorio and Castel Sant'Angelo – the courthouse and prison, respectively – and beginning in 1871 it built a ring of 15 forts, with batteries, along major highways outside Rome's walls. Yet for the first time, Protestant churches were allowed within the city walls; St. Paul's within the Walls, the first, opened in 1880. And at long last, Jews could move freely through the city.

Probably no major European city was less prepared to become a national capital than Rome in 1871. Other than its superior water supply, nascent train service, gas streetlights, horse-drawn omnibus system, and hospitals, Rome's modern infrastructure was primitive. No comprehensive sewer system served its 220,000 residents. It lacked a secure remedy for Tiber floods, coherent traffic circulation, a housing policy, and, excepting De Mérode's projects, a master plan for urban expansion.

Within 10 days of the bombardment, the Italian government granted the new Roman Comune the right to prepare a *piano regolatore* (master plan). At first, grandiose intentions were bandied about to call in Baron Georges-Eugène von Haussmann, whose aggressive plan of imperial Paris, with its web of broad, regal boulevards spun over the medieval core, set that city apart aesthetically and technically from every other European capital. But Rome's planning director, Alessandro Viviani, settled on a more modest plan focused on traffic amelioration, flood prevention, a projected industrial zone in Testaccio, and a residential zone on the Esquiline. The municipal government ratified it in 1873, but corruption and rampant speculation stymied planning efforts from the beginning, as did constant shifts in the municipal administration and internal bickering among overlapping agencies. The Italian state initially failed to fund essential infrastructure, such as the Tiber embankment walls, because they saw this as a "civic (i.e., strictly municipal) responsibility." But Rome's municipal government, hampered by a meager revenue stream and a feeble industrial base, could barely maintain existing structures and services. The state finally relented in 1883, granting the plan legal status in revised form (Fig. 207). But

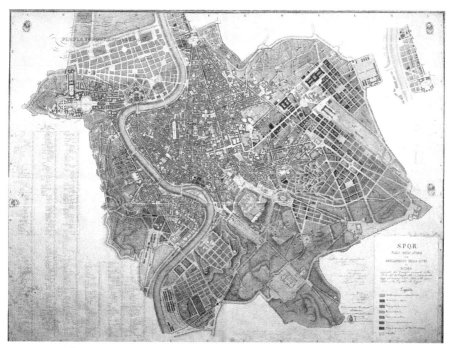

207. Master plan, Comune di Roma, 1883.
Source: Piano regolatore e di ampliamento della città di Roma (Rome 1886).

in the grip of "building fever," property speculators, sometimes complicit with self-serving civic administrators, were already laying out a new neighborhood on the Esquiline. Meanwhile, a government commission without municipal support had approved and commenced construction on the Quirinal.

The Nationalists aimed at nothing less than supplanting the Church, or at least isolating it physically. One strategy was to appropriate the hills overlooking the Campo Marzio, the Tiber, and the Vatican. The power shift was especially clear along the old Via Pia, now renamed Via XX Settembre. The Quirinal Palace, refashioned as the residence of Italy's president, anchored its western edge. Italy's new minister of finance, Quintino Sella, envisioned a *città alta* – a new government complex on the Quirinal separated entirely from the historic center. Despite opposition from the city government, his proposal to locate the most important government agencies there, including his own, gained traction. Construction began in 1871 (Fig. 208). The state planted its flag on the hill much as Sixtus V's Church had in the sixteenth century. But a new government, installed in 1877, shelved Sella's plan – only two more ministries located there, whereas the others were scattered around the city in new buildings or repurposed monasteries. Some sites were chosen for specifically symbolic reasons; the Supreme Court, for example, went up near the Vatican as a monumental secular rebuke to the councils of St. Peter, counterbalancing temporal justice against the spiritual.

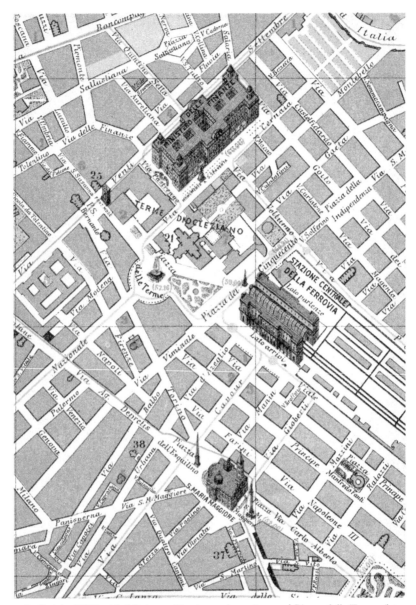

208. Quirinal Hill with Ministry of Justice, train station, and Piazza delle Terme (later called Piazza della Repubblica).
Source: J. de Barbari, *Pianta prospettiva di Roma* (Rome 1900), detail.

Chaotic and contentious as it was, Rome of the Risorgimento – the nationalist resurgence – witnessed urban transformations on an unprecedented scale. Within months after the calamitous flood of December 1870, Rome's municipal government approved a Tiber embankment plan, but this floated in administrative limbo for more than a decade before work began. Buildings and gardens along the riverbank were destroyed and street patterns reorganized

(see Fig. 163). The Ghetto was razed in 1885 partly to accommodate the new embankment and partly to serve sanitary purposes, leaving more than 3,000 people homeless with nowhere to go. Enormous sewer collector drains were installed behind the new embankment and ground levels raised – in large part with earth from the newly regraded Esquiline and Quirinal Hills, which had been lowered by as much as four meters in places. Twenty-meter-wide riverside boulevards, the Lungoteveri, were created along both banks and lined with "London" plane trees; four new bridges spanned the newly tamed river between 1886 and 1895.

The *piano regolatore* also addressed circulation through Rome's congested medieval core, where east–west movement had always been difficult. Increasing population and traffic lent greater urgency to the problem. A direct route between St. Peter's and Stazione Termini was the first priority. De Mérode's straight and wide Strada Nuova was extended down the Quirinal Hill to meet Piazza Venezia, carefully sidestepping, as much as possible, important buildings including the Markets of Trajan, Torre delle Milizie, Palazzo Colonna, and various churches as it negotiated the steep slope (Fig. 209). Named Via Nazionale and lined with new buildings and shady trees, this was Rome's first modern boulevard.

Connecting Piazza Venezia to the Borgo required greater delicacy because the entire route would pass through the historic Campo Marzio. Finding a path through this tangle of history required deft choreography. Viviani identified a gently sinuous course that slipped past the most important Renaissance and baroque buildings – Palazzo Venezia, Il Gesù, S. Andrea della Valle, Palazzo Massimo, the Cancelleria, and Chiesa Nuova – but scores of smaller buildings were demolished to accommodate his wide and flowing boulevard, named Corso Vittorio Emanuele II (Fig. 210). Together with Via Nazionale it supplanted Via Papale as Rome's most important cross-urban street – its *decumanus* to Via del Corso's *cardo*. Few residences fell victim to this project, at least when compared to later traffic schemes. Most unsettling were the leap in scale and the dislocation of long-resident families and businesses. Speculators, not small-scale stakeholders, were favored to develop the new street fronts; the result was an architectural gigantism to accord with the large preserved monuments. The anonymous victims of former displacements had simply relocated within the *abitato*; but now there began a new and enduring phenomenon, the exodus of nonelite Romans to the periphery.

Risorgimento Rome was a crucible of inequality. The 1873 master plan almost totally ignored housing, to disastrous effect. There was no strategy to improve substandard accommodations for the thousands of families already living there, or to house the legions of poor immigrants, primarily unskilled laborers who built the new Rome. Nobody gave relocation assistance to the victims of Corso Vittorio Emanuele II, let alone the Ghetto. Rome had nearly

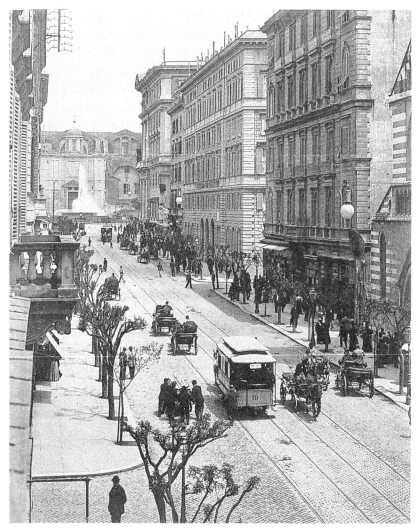

209. Via Nazionale.
Source: Photo: C. Tennerani, 1890. © Roma Capitale. Museo di Roma AF-3745.

300,000 residents by 1900, many of them without the prospect of stable residency. Some immigrants and displaced persons were absorbed into the city, but most had to make do with *baracche*, rough huts without sanitation services, running water, or paved streets. These spontaneous communities were randomly grouped primarily at the city's margins, nestled within ruins, against the Aurelian Wall and even inside its fabric, and strung out along the major highways (Fig. 211).

At first, only the industrial Testaccio neighborhood was allocated working-class housing, specifically for employees at the Cattle Market and slaughterhouse newly located there between 1888 and 1894 (see Fig. 90). Densely

210. Detail of Figure 207: Via del Corso Vittorio Emanuele II, running east–west from Piazza
Venezia (center right) to Ponte Sant'Angelo (upper left).

211. *Baracca* settlement adjoining Acqua Felice.
Source: Photo: Aldo V. Bonasia. Courtesy of *L'Unità*.

packed and poorly built, the speculative apartment blocks typically lacked gas, water, and paved streets. Because housing demand far exceeded the supply – only 40 percent of the Testaccio houses were built by 1906 – a large, unregulated, and very unhealthy *borgata* (slum) sprang up in the district. Testaccio registered about 10,000 legal residents in 1908, but its unregistered residents far outnumbered them; often, whole families rented a single room in another family's apartment.

Ernesto Nathan, Rome's first nonelite mayor (1907–1913), took full advantage of a newly authorized state housing agency, the Istituto Romano per le Case Popolare (ICP), to finance working-class housing by levying taxes on building lots. Though modest, the new apartments had private toilets and the housing blocks shared larger courtyards and gardens, ensuring that each unit had access to air and light. Over the next decade, hundreds of new apartments were built in Testaccio and other neighborhoods such as San Lorenzo. The ICP and other housing sponsors, including workers' cooperatives, created a viable affordable-housing model. The first cooperative housing, much of it concentrated in developments not far outside the walls, went mostly to public-service employees such as tram operators or government officials. Well into the twentieth century, theirs were the most fortunate working-class families in Rome.

Until the fifteenth century, wholesale destruction of Rome's urban fabric had been, for the most part, the result of fire, foreign invasions, or the constant conflict among noble families that characterized the late medieval period. But with the return of the papacy, the nature of urban erasure changed fundamentally. Individual popes, nearly all non-Romans with no sentimental attachment to the city, willfully expropriated and demolished private property to realize new urban strategies. Sixtus IV picked off a few buildings for Via Sistina; Alexander VI tore down several to create Via Alessandrina. Then Julius II leveled a few more to regularize Piazza di Ponte; but in no time he was sacrificing 100 private houses in a crescendo of destruction to create Via Giulia. At that time, papal prerogative sufficed as planning policy. Now, amid the bloodless optimism of the Machine Age, Rome's speculation booms and serial master plans rendered the popes' schemes for creative obliteration downright quaint by comparison. Only in 1962 would a *piano regolatore* finally prohibit such systematic changes to the historic center. Yet this decision too would create new urban predicaments that afflict the city to this day.

BIBLIOGRAPHY

Baxa 2004; Benevolo 1971; Cacchiatelli 1863; Cajano 2006; Caracciolo 1999; Coates-Stephens 2007; Cocchioni/De Grassi/Vittori 1984; Comune di Roma

1883; Courtenay 2003; Di Martino/Belati 1980; Frosini 1977; Girardi/Spagnesi/ Gorio 1974; "Un Inferno chiamato baracca" 1970; Insolera 1959, 2002, 2011; Kirk 2005, vol. 1; Kostof 1973, 1976; Lanciani 1988; Maroi 1937; Massimo 1836; Narducci 1889; Nibby 1838–1841; Piccinato 2006; Sanfilipo 1992; Segarra Lagunes 2004; Tafuri 1959.

THIRTY FOUR

ITALIAN NATIONALISM AND *ROMANITÀ*

P IUS IX AND KING VITTORIO EMANUELE II BOTH DIED IN 1878. QUIETLY
interred at St. Peter's, Pius was largely unmourned while the king received
a hero's burial at the Pantheon. Almost immediately, a national monument
embodying the aspirations and intentions of the new nation was proposed
in his honor. The still-unratified 1873 master plan had not anticipated such
a monument, so the contentious task to choose a site remained. After several
false starts, a design was selected to crown the symbolically potent Capitoline
Hill facing Palazzo Venezia. In the abstract, the monument, known as the
Altare della Patria, the Altar of the Fatherland, enjoyed wide popularity. Yet
once construction began in 1885 the shock of its gargantuan size, bright white
surfaces, inappropriate site, and disregard for the urban fabric stirred resent-
ment. Cultural critics delighted in vilifying it long before its inauguration on 4
June 1911, the 50th anniversary of Italian unification. Quite apart from its aes-
thetic extremes, it was jammed too tightly into the medieval and Renaissance
neighborhoods surrounding the hill, narrowing local streets and exacerbating
traffic just as motorized transit was beginning to burden the city's infrastruc-
ture (Fig. 212). And it set in motion actions and reactions with far-reaching
consequences. Traffic was diverted around it, and this entailed a complete
rearrangement of Piazza Venezia, which now functioned as a prologue to the
monument, and became, along with the Palazzo Venezia on its west side, the
"ritual nucleus" of modern Rome.

212. Aerial view of monument to Vittorio Emanuele II.
Source: Aerofototeca AM.0.150.Prosp. 0.27.4557.0.

During the liberal administration of Mayor Ernesto Nathan, a new *piano rego-latore* was ratified in 1909. Called the Sanjust Plan after its developer, Edmondo Sanjust di Teulada, it focused, as did earlier plans, on traffic intervention. But there were important innovations, too. Its new planning area, enclosed by a proposed urban expansion ring road, included the Roman Campagna immediately outside the walls; it displayed topographic contours for the first time; it expanded and defined new public transit lines; it described a rudimentary zoning plan with three types of housing, *fabricanti* (multifamily midrise), *villini* (low-rise), and *giardini* (luxury garden residences) linked to specific neighborhood development plans; and it identified specific locations for public parks and open space (Fig. 213).

This last point is particularly relevant. It has been convenient to complain that unregulated speculation destroyed half of Rome's greenspace by razing and paving over its famous Renaissance villas. This was certainly a tragic loss, but any city holding vast tracts of undeveloped land within its walls while con-fronting an influx of 100,000 new residents in 10 years would have encountered the same dilemma. What is lamentable is that Rome lacked any strategy to identify and protect those villas for public use. Because the 1883 *piano regolatore* neglected to correlate housing density with a need for public parks, speculators had continued to purchase Rome's hilltop gardens for upper-class and bour-geois apartments. So eager were the villa owners to sell and so voracious were

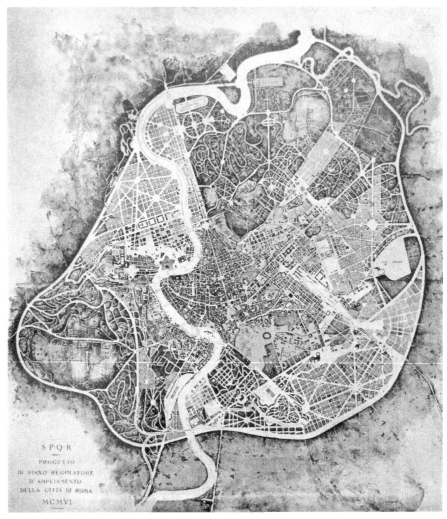

213. Sanjust master plan.
Source: Sanjust di Teulada 1908.

developers' appetites that the state was forced to purchase the 148-acre Villa Borghese on the Pincian in 1903 and donate it to Rome for a public park.

Aside from largely unrealized schemes proposed under the Napoleonic administration, the Sanjust Plan was the first to recommend public parks at a grand scale. It reserved a huge portion of the Villa Pamphilj on the Janiculum for public use and finally authorized the Parco Archeologico (first proposed in 1870 by Rome's new Archaeological Commission). Built between 1909 and 1917, the park stretches from the Circus Maximus east to the Aurelian Wall, encompassing the Baths of Caracalla (see Figs. 56, 71). Small houses, sheds, and gardens occupying the area were removed to visually isolate the ancient monuments in the parkland. Symbolically these monuments reinforced the growing nationalist sentiment of *romanità* ("Romanness.")

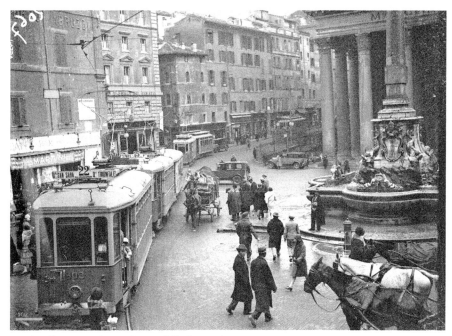

214. Traffic congestion in Piazza della Rotonda, 1929.
Source: Archivio Storico Fotografico ATAC 2067.

For all its virtues, Sanjust's plan could not anticipate the future any bet-
ter than its predecessors. Several projects and events – the 1911 Universal
Exposition, a wholesale industrial development in the Quartiere S. Paolo on
the Tiber south of Testaccio, the Garden City Planning Movement, World War
I, the phenomenal increase in motorized traffic (Fig. 214), and the rise of
Mussolini's Fascist regime (1922–1943) – would transform the city in ways yet
unimagined.

The 1911 exposition, celebrating 50 years of nationhood, occupied two
venues on opposite sides of the Tiber just north of the Aurelian Wall: Piazza
d'Armi on the right bank and the Valle Giulia on the left, with a new bridge,
Ponte Risorgimento, connecting them. It featured temporary and permanent
pavilions – one became the National Gallery of Modern Art – and addition-
ally some permanent "demonstration housing" projects. South of the city lay
a new industrial quarter in the alluvial zone between the Aurelian Wall and
S. Paolo fuori le Mura. Rome's new urban services were located here in the
1910s – principally the gasworks, the thermoelectrical plant (reborn today as
the stunning Centrale Montemartini museum), and the major depot for the
public market.

Construction costs skyrocketed after the First World War, and in 1920
the Istituto Romano per le Case Popolari initiated a new affordable hous-
ing scheme. Based on the British Garden City model, it featured low-rise

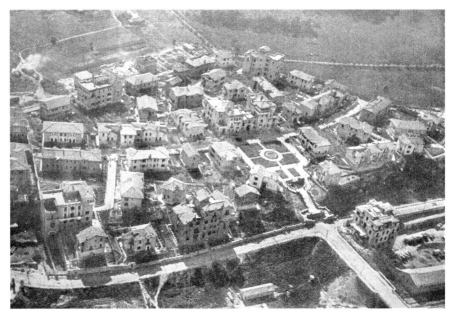

215. Aerial view of Garbatella, 1920s.
Source: "L'attività edilizia in Roma," *Capitolium* 1 (1925–1926), 44–49.

housing built at lower densities in extramural zones. The first of these, Garbatella (immediately to the south), Aniene (four kilometers northeast along Via Nomentana), and Lido di Ostia (begun a few year later on the coast) included small multifamily houses for the *piccolo borghese*, working- and middle-class families, grouped around gardens, parks, and a town center all in an effort to create a strong sense of place (Fig. 215). Adopting traditional indigenous building materials, forms, and techniques, each unit was generally self-contained, although some services were shared among families. The first phases of Garbatella and Aniene were completed in 1922 and were immediately absorbed into Mussolini's political rhetoric. Under him, the Garden City housing schemes were expanded with hundreds of new residences, generally smaller and denser than the original blocks. They included a new temporary housing type, the "suburban hotel," where families and single men and women displaced by Mussolini's slum clearance plans lived in multistory dormitories with communal facilities. Entire multigenerational families often occupied a single room in what was intended as temporary housing, but for many became permanent.

Italy's alliance with the Austro-Hungarian Empire and Germany in the First World War (1914–1918) brought devastation on the country and its citizens. More than a million wounded soldiers returned from the front without work and sometimes without housing. The ensuing political unrest, unemployment, and entrenched poverty offered Mussolini his opportunity to seize control of the country. When he marched into Rome in October 1922 with his army of

Blackshirt Fascists, King Vittorio Emanuele III (ruled 1900–1946) capitulated and allowed him to form a new government.

Mussolini arrived with a deep but misguided reverence for Rome's classical past. His urban policy aimed to reimagine this past in a modern Fascist metropolis. For Mussolini, "planning was pedagogy" – a curriculum of inflated *romanità* imposed on an infantilized citizenry. He saw himself as the new Augustus – a "spiritual father" to a revived Italian empire. As the first emperor had remade Rome, so too would Mussolini. In 1925 he proclaimed the scope of his ambitions: "In five years Rome must appear marvelous to all the peoples of the world; vast, orderly, powerful, as it was in the time of the first empire of Augustus." Italo Gismondi's famous model of the Constantinian city, built in the 1930s at Mussolini's request (see Fig. 96), presented an idealized Rome that in fact never existed – a city locked within an imagined moment, but one that the new regime hoped to unlock and reawaken.

Mussolini is a convenient scapegoat for the modern destruction of old Rome. But many of the projects that he forced on the city appeared in earlier master plans. Indeed, part of his agenda was to demonstrate his serious intention to fulfill the unrealized promises of unification, including the notion of a truly modern city, a "Third Rome," first articulated in the early days of the Risorgimento. Working with a planning committee, he articulated four primary goals for Rome in his new 1931 *piano regolatore*: to create a hygienic city with light and air by surgically removing those areas marred by "centuries of decadence"; to excavate archaeological sites, isolate the most important imperial monuments, and create vistas to them so that they would resonate with his political aspirations; to generate ceremonial space by reorganizing it around traffic flow; and to repopulate the Roman Campagna.

Mussolini's policies were essentially antiurban; his slum clearance plans for the historic center, known as *sventrimento*, literally disembowelment, effectively united these goals through forced eviction and wholesale excision. Perhaps inspired in part by the didactic power of the isolated monuments in the Parco Archeologico, he adopted a "liberation" policy suited to his Fascist regime. On the pretext of hygiene, working-class neighborhoods, which he saw as immoral, unhealthy, and dangerous for children, were demolished wherever they adjoined important ancient monuments or impeded his grandiose new boulevards. Wielding a ceremonial pickaxe dubbed "His Majesty the Pick," Mussolini would often strike the first blow that inexorably displaced thousands of families, destroying their homes and eradicating time's "unsightly accretions." The Forum and Markets of Trajan, the Forum of Augustus and Caesar, the "Arch of Janus" in the Velabrum, the temples in the Forum Boarium, the Theater of Marcellus, the Largo Argentina temples, and the slopes of the Capitoline Hill could now "loom in their required isolation" in scenic, ideological splendor. Visually,

this policy recalls Paul III plucking off the medieval barnacles that clung to ancient monuments along Charles V's processional route into Rome. Left behind was a sterile environment frozen in time – defoliated stumps stripped of habitat and hundreds of years of accumulated history, but perfect for enacting new rituals – principally the speeches, spectacles, and parades that were compulsory for building both *romanità* and Fascist nationalism.

Three projects perfectly characterize Mussolini's heavy hand: the Mausoleum of Augustus, Via dell'Impero, and Via della Concilazione. Around the mausoleum, the families whose homes and workshops clustered in an "unsanitary neighborhood" were "liberated" and relocated to hastily and poorly built new settlements outside the walls. Large-scale archaeological excavations followed the demolitions in a desperate attempt to recover any ancient ruins and artifacts that might nourish Mussolini's delusions of kinship between Fascist and imperial Rome. So rabid and rapacious was Mussolini's quest to unearth ancient Rome that he obliterated nearly all vestiges of the medieval or everyday Renaissance city standing in his way.

Fiddling with ancient archaeology even extended to moving ruins to establish a new "ideological scenography." When the Mausoleum of Augustus was finally unshackled from medieval accretions, it stood alone in a new piazza – so alone that Mussolini had Augustus' newly excavated Ara Pacis transported from its original site beneath a Renaissance palace on Via del Corso and rebuilt on a slight rise between the mausoleum and the Tiber to convey his neoimperial message more potently. A copy of the *Res gestae Divi Augusti*, the funerary inscription celebrating Augustus' accomplishments and life, was installed just beneath the altar. New government offices, tall enough to block out the remaining medieval fabric, pulled rank along the other three sides of his new piazza, clamping the mausoleum in a Fascist vise (Fig. 216).

Inaugurated in 1932, Via dell'Impero, the Street of the Empire (today called Via dei Fori Imperiali), ran directly over the ancient imperial fora. Its construction was a brutal enterprise, preceded by eviction of some 2,000 people to new extramural housing, removal of hundreds of "filthy and unsightly" medieval and Renaissance buildings, and excavation of the fora (Fig. 217). Via dell'Impero emphasized Rome's eternality by tethering Mussolini's regime, newly installed in offices at Palazzo Venezia, to one of the most powerful symbols of imperial Rome, the Colosseum. Excavations began at the Markets of Trajan and moved south, slicing through the Velian Hill. Paradoxically, after excavations, more than 80 percent of the site was reburied under the broad, straight avenue (Fig. 218). To mimic the Severan marble plan, which had stood nearby, he installed commemorative carved stone maps depicting the extent of the Roman Empire along his new street.

Via della Concilazione realized a centuries-old notion to connect Piazza S. Pietro and Castel Sant'Angelo for aesthetic and processional reasons. This

216. Mausoleum of Augustus before 1940.
Source: © Roma Capitale. Museo di Roma, Archivio Fotografico AF-5105.

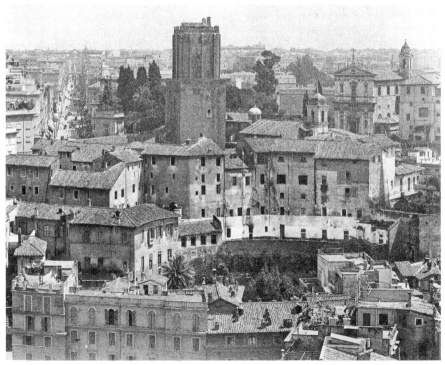

217. Markets of Trajan before intervention of 1911.
Source: Photographer unknown. © Roma Capitale. Museo di Roma, Archivio Fotografico AF-21477.

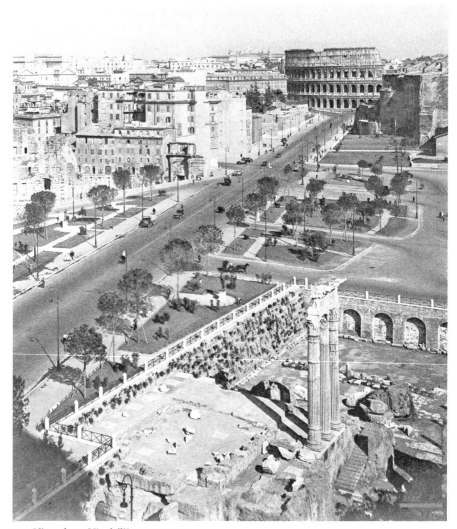

218. View down Via dell'Impero, 1930s.
Source: Archivio Storico Fotografico ATAC HDR.4568.

became possible in 1929 when the Lateran Pact clarified relations between the
Church and state. The pact acknowledged Roman Catholicism as the Fascist
state religion and identified the territory within Rome that it would govern.
Mussolini's "majestic" pick struck the first blow in October 1936. Soon the
so-called *spina*, a dense band of medieval and Renaissance buildings strung
between the two monuments and notionally overlying the central spine (*spina*)
of the infamous Circus of Nero, was reduced to rubble (Fig. 219). Essentially
complete in 1939, the new boulevard finally reunited the Vatican physically and
symbolically with Rome after the long banishment of the Risorgimento. St.
Peter's was now artificially isolated, like the imperial monuments, and given
equal representational weight.

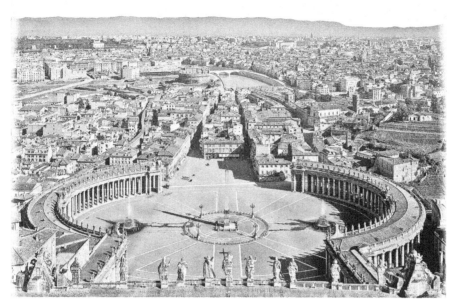

219. View eastward from St. Peter's dome before demolition of the *spina*.
Source: Photo: A. Vasari, ca. 1900. Rome, Istituto Nazionale per la Grafica, Fondo Vasari inv. 833.
Courtesy of the Ministero dei Beni e delle Attività Culturali e del Turismo.

Via della Conciliazione, the Street of Reconciliation, commemorated the
improved relations between Church and state; but its name held nothing but
irony for the nearly 5,000 displaced residents. Although roundly criticized and
generally disdained, the final design, unfinished until 1950, is remarkably effec-
tive; it provides a focus, processional route, and visual climax for pilgrims. Here,
as along Via dell'Impero, neighborhood shops and services were not replaced
because no residents were invited to return. Rather, the entire street is given
over to religious and cultural tourists.

Under Mussolini's urban vision for Rome, 12 large-scale suburban hous-
ing quarters known as *borgate* (semiurban settlements) were constructed out-
side Rome's walls to receive his urban deportees. These were *case rapidissime*,
hastily and poorly constructed by workers, most untrained, who themselves
were often homeless. Absurdly, some materials, such as doors and windows,
"nothing beautiful, but all good, sufficient, and valuable for those who have
nothing," were taken from demolished houses in the center. Built in 1924,
Acilia, intended for the families "liberated" from the Forum of Trajan, was
the first Fascist *borgata*. Located 15 kilometers outside Rome, it took no
account of the urban roots of its residents; rather, it aimed to control them
by isolation. Other extramural *borgate*, including Gordiani, Prenestina, and
Trullo, soon followed, all raised on the same presuppositions. Administrators
reasoned that surely the land, light, and air would mutate these slum-bred

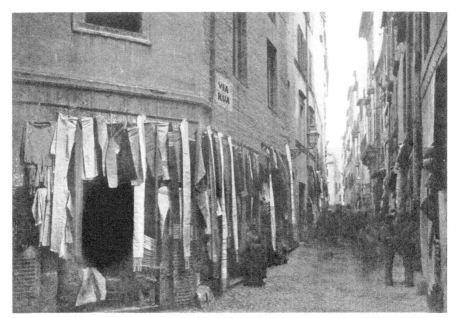

220. Via Rua in Jewish Ghetto before its demolition in 1880s.
Source: Capitolium.

unfortunates into happy agrarians and transform potential agitators into docile servants of the regime.

While many neighborhoods in the historic center had indeed been unhealthy and overcrowded, their intricate social environments had given work and support to the families living there (Fig. 220). Now, usually surrounded by flat, uncultivable, malarial land, and with no wealthier neighbors to require their skills and services – shoemaking, cabinetmaking, basketry – most families were shorn of the work that had sustained them for centuries. The result was a new social disequilibrium never before seen at Rome. On the one hand, the historic center accommodated wealthier Romans handsomely. On the other, poverty-stricken suburbs, ill served by transit, languished in isolation. In these marginal areas the *case rapidissime* became ad hoc permanent housing for increasing numbers of the displaced poor. Not surprisingly, the term *borgate* soon evolved to mean "slums," the very thing they were meant to supplant.

With immigrants constantly flowing into Rome since the 1870s, *baracche*, illegal settlements, had metastasized at the city's edges, especially after World War I. By 1920 an estimated 50,000 *baraccanti* lived in spontaneous encampments encrusting the consular roads to Rome. Resolving to reclaim the dignity of these ancient highways, Mussolini demolished the encampments, whence the displaced "voluntarily" repaired to his new communities. But no sooner did one *baracca* vanish than another popped up somewhere else (see Fig. 211). By the 1960s, two entire generations had grown up without decent housing,

and in the case of the *baraccanti* especially, without education or health services. "His Majesty the Pick," so adept at puncturing Rome's urban and social fabric and so inept at constructive social reform, had offered no remedy for the ills of the urban poor.

BIBLIOGRAPHY

Baxa 2004; Benevelo 1971; Caracciolo 1999; Cederna 1979; Cocchioni/De Grassi/Vittori 1984; Comune di Roma 1925–1976; Cuccia 1991; Etlin 1991; Governatorato di Roma 1931; Guidoni 2007; "Un Inferno chiamato baracca" 1970; Insolera 1959, 2002, 2011; Kallis 2012; Kirk 2005 (vol. 1), 2006; Kostof 1973, 1976, 1994; Marcello 2003; Maroi 1937; Muñoz 1935; Painter 2005; Piccinato 2006; Salvante 2012; Sanfilippo 1992; Sanjust di Teulada 1908; Seldes 1935; Singley 2007; Testa 1932.

THIRTY FIVE

A CITY TURNED INSIDE OUT

Mussolini's army invaded Ethiopia in 1935 and claimed it for the Fascist empire the following year. Envisioning a new Roman empire originating in Africa (Libya had been an Italian colony since 1911), he announced his intention to hold a universal exposition of art, science, and work at Rome – an "Olympics of Civilization." Disregarding his 1931 *piano regolatore*, he chose a site south of Rome for the Esposizione Universale di Roma, or EUR '42. This fairground, he vowed, would become the permanent nucleus of a new city, neither an extension of Rome nor its suburb. The Eternal City, it seems, was proving an eternal compromise. He wanted to build his ideal Fascist city from the ground up, and EUR '42 was his opportunity. Partitioned on a rectilinear grid and transected by a broad *cardo* and *decumanus*, its orthogonal plan evoked an ancient Roman colony more than Rome itself. Rome's recolonization of the Mediterranean would begin here (Fig. 221).

Workers broke ground in 1937, but when Italy joined forces with the Nazis in 1940, the exhibition was canceled. By July 1943, when Allied forces bombed the outskirts of Rome, EUR '42 had been abandoned. Two years on, Mussolini and Fascism had fallen. Construction recommenced in 1950, but far from being the monument that the posthumously dubbed "Sawdust Caesar" had envisioned, EUR (the name stuck, but not the date) became another Roman suburb, albeit one with grand aspirations.

Mussolini also oversaw three of Rome's largest urban propaganda projects in the 1930s – one each for sport, education, and entertainment. Confined

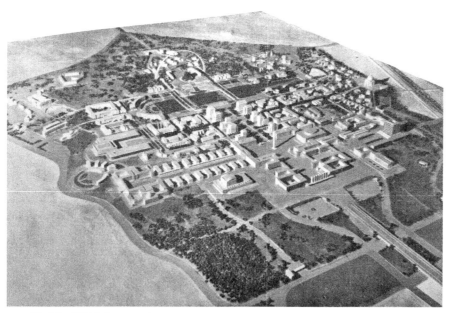

221. Model of EUR '42 complex.
Source: G. Florio, "La mostra dell'abitazione dell'E42," *Capitolium* 14 (1939), 371–96.

to Fascist Party members, these extravagant enclaves aimed to provide nearly self-sufficient, strictly controlled environments at varying distances outside the walls. Foro Mussolini, a "City of Sport," opened in 1933. It housed the flagship school of Opera Nazionale Balilla, a national organization that molded ideal Fascist youths through rigorous sports programs. It was also an arena for massive spectacles exalting the regime. Mussolini hoped to stage the 1944 Olympics there as a capstone to EUR '42. They too were canceled, but the dream came to oblique fruition when the venue, renamed Foro Italico, hosted the 1960 Olympics (Fig. 222).

Città Universitaria, the "City of Learning," now the main campus of Sapienza University of Rome, accepted its first students in 1935. Set on the Esquiline, it is a showcase of the austere Fascist style of architecture and planning. Marcello Piacentini's master plan intentionally echoed ancient Roman models – the forum, the piazza – but reinterpreted them through a modernist vocabulary. Intended as a crucible for molding "right-thinking" Fascist youth, it was a policed environment where student agitation could easily be quashed (Fig. 223).

The cameras started rolling at Cinecittà, "Cinema City," in 1937 and filmmakers churned out Fascist propaganda there until 1943. It then served as a displaced-persons camp for several years and was not fully revived until the 1950s. In the interim, Italian Neorealist directors turned to Rome itself as backdrop and subject. In now-iconic films such as Roberto Rossellini's *Roma città aperta* (1945), Vittorio di Sica's *Ladri di biciclette* (1950), and Federico Fellini's

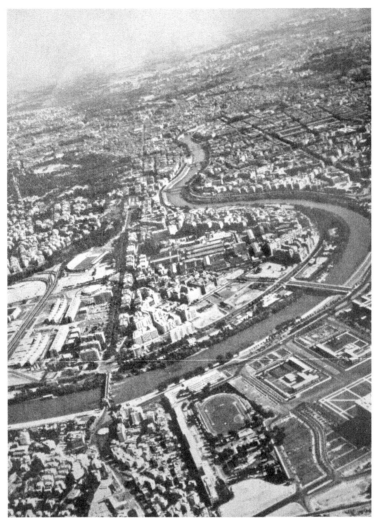

222 Olympic complex (left), Campo Flaminio (center), and Foro Mussolini
(lower right) in early 1960s.
Source: "Provvidenze per Roma," *Capitolium* 37.2 (Feb. 1962), 58–63.

La dolce vita (1960), they documented Rome's postwar physical and spiritual
desolation with wrenching images of a city that to them had lost its soul.
Meanwhile, in Hollywood, American directors paid tribute to Rome with
frothy romantic comedies, including William Wyler's *Roman Holiday* (1953) and
Jean Negulesco's *Three Coins in the Fountain* (1954), or historical extravaganzas
such as Wyler's *Ben-Hur* (1959) and Joseph Mankiewicz's *Cleopatra* (1963). It
was not long before Cinecittà was called "Hollywood on the Tiber." These
movies helped spur a new wave of tourism, by then Rome's principal industry.

Mussolini's dream of the ideal Fascist city and state was shattered in
1943 when Allied forces bombed Rome. They missed their target, the rail

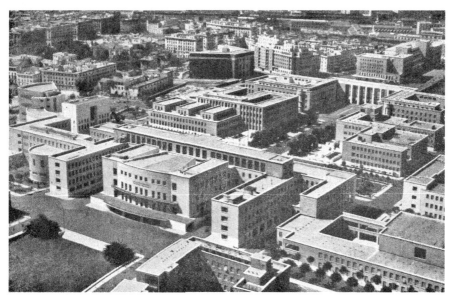

223. Città Universitaria, 1938.
Source: Wikimedia Commons/PD, Italy (it.wikipedia.org/wiki/File:Cittauniversitaria35.jpg).

yards, instead striking the venerable church of S. Lorenzo fuori le Mura, its working-class neighborhood, and parts of the Città Universitaria, killing about 3,000 and wounding more than 13,000. Almost immediately King Vittorio Emanuele III dismissed Mussolini from office and placed him under arrest. To protect Rome's citizens and architectural heritage, the king invoked an "open city" strategy, which allowed an invading army to enter without resistance. In September 1943, Italy and the Allies signed an armistice agreement.

In a final effort to hold Italy, the retreating Nazis occupied Rome. They entered like a triumphal Roman army, parading their Allied prisoners along Mussolini's Via dell'Impero. Rome was a prize they resolved to keep, but they held it only nine months. Desperate times approached – the Allied forces were advancing, and a potent Italian Resistance was forming – and desperate measures ensued. The Nazis cut the water supply and answered brave partisan attacks with indiscriminate massacres, most tragically at the Fosse Ardeatine, caves located in the suburbs, where 344 were executed. They rounded up and deported more than 1,000 Roman Jews to certain death; others they simply herded into the Campagna, leaving them where they were slain. The Allies liberated Rome on 4 June 1944 and occupied it until the war concluded in 1945.

Other than the tragic 1943 bombing, Rome's architecture and urban fabric remained essentially intact. But like the rest of Europe, Italy suffered postwar privation for several years. A black market in basic goods flourished through acute shortages of fuel, water, and food. Even the growing economic prosperity in Italy's North between 1950 and 1963 – the so-called Economic

Miracle – could not stem a growing sense of despair in Rome. Jobs and money were still scarce; the housing crisis reached emergency levels; thousands of families were homeless.

Rome's poor recovery can be blamed partly on its perpetually weak immune system. Repeatedly, its serial master plans had offered too little, too late. Housing policy was a disgrace. The state was ever loath to fund infrastructure and slow to approve master plans. Before the ink of the 1883 *piano regolatore* was dry, elaborate kickbacks and bribes, rampant speculation, relentless immigration, and unregulated growth had rendered the document practically useless. A dense and ubiquitous tangle of officials, developers, and banks, seemingly in perpetual collusion, has characterized Roman and Italian politics ever since. In the 1990s corruption reached crisis levels throughout Italy in a scandal known as "Tangentopoli." In twenty-first-century Rome, a group of nearly 100 corrupt civic officials and mafia leaders, the "Mafia Capitale," are under investigation for systematically laundering money through a cartel of sham companies contracted to carry out public works and social services. Projects for roads, migrant reception centers, public transit, and sanitation stagnated, along with garbage collection, until the scheme was finally exposed, beginning in 2014. All the same, progress remains slow.

Even the 1909 Sanjust Plan's sensible housing, public parks, public transit, and regional planning proposals proved quixotic. It was ignored repeatedly – when conservative, moneyed interests ousted Ernesto Nathan's liberal administration in the 1913 election; when World War I halted infrastructure projects; and when the Fascists rescinded public housing funding in 1923. This pattern persisted through Mussolini's regime; he even disregarded his own 1931 master plan when something new, such as EUR '42, struck his fancy.

Efforts to launch a new *piano regolatore* began in 1947, but Mussolini's 1931 document remained stubbornly in force for 15 more years. No document met approval until the PRG, *Piano regolatore generale* of 1962, but it was not enacted until 1966, and by then it was toothless as well. The projected growth the PRG should have regulated had already occurred; Rome's population had doubled since 1931. Paradoxically, this plan met rampant population growth with stubborn resistance; it essentially banned new construction in the historic center.

The PRG proposed 12 somewhat autonomous satellite extramural urban centers. Despite this promise of new homes, unmet housing demand remained crippling; and as always, illegal development outpaced planning. While property values rose near the center, developers looked outside the new planning zones for cheaper land, on which they built extremely dense speculative subdivisions, many lacking neighborhood amenities such as schools, sewerage, and shopping. Now, instead of 5- and 6-story apartment blocks, resident families – as many as 200 per building – were packed into *intensivi*, 8- to

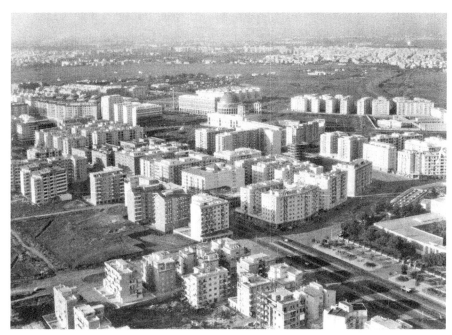

224. Aerial of Tuscolano Don Bosco.
Source: Aerofototeca AM.o.150.Prosp. 11.6.7623.o.

12-story high-rises plagued by air pollution, inadequate sanitation services, and regular hepatitis outbreaks (Fig. 224).

In 1966, rent control (imposed in 1947) was lifted, driving up rents and propelling Romans into wholly new urban quarters, legal or not, outside the city walls along the vestigial consular roads (Fig. 225). With no new housing in the center, Rome's new or displaced residents had nowhere to go except the periphery. The situation has only worsened in intervening decades. Increasingly, Rome's displaced population includes not only other Italians and Europeans, but like the rest of Mediterranean Europe, hundreds of thousands of political and economic refugees from abroad; 87,000 arrived in Italy between January and July 2014 alone. Thus a century's indifference to the displaced is now compounded by bigotry as well as the entrenched corruption that has siphoned off billions of euros earmarked for housing and refugee services.

Meanwhile, the city's core is treated as a museum: *per favore, non toccare*. The 1962 injunction against development there still stands. With the exception of Richard Meier's controversial Ara Pacis museum, the most important architectural projects – Zaha Hadid's MAXXI Museum, Meier's Jubilee Church, Renzo Piano's Parco della Musica, and Paolo Portoghesi, Vittorio Gigliotti, and Sami Mousawi's Islamic Mosque and Cultural Center, are all outside the walls (Fig. 226). And governments, institutions, and corporations have bought a significant amount of the available residential space in the core to serve, essentially, as hotel space for their guests and personnel.

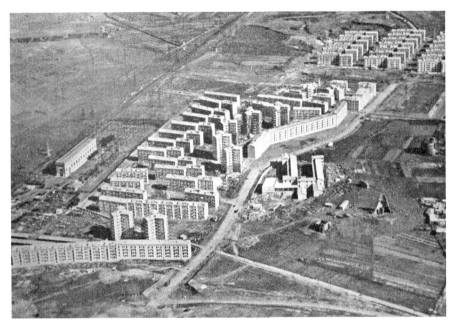

225. Aerial of Borgata Gordiani.
Source: "La villa Gordiani, nuovo quartiere urbano," *Capitolium* 30 (1955), 97–102.

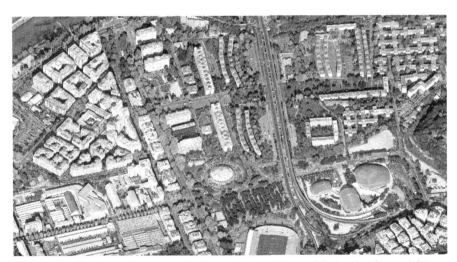

226. Campo Flaminio (left), Olympic Village (center), and Parco della Musica (lower right).
Source: © 2014 Google.

But nothing will stand between Romans and a good spectacle. Whether staging papal funerals or World Cup victories, they are to the manner born (Fig. 227). In 1955, Italy won its bid to host the 1960 Summer Olympics in Rome. It seemed the right place at the right time: the Games would restore Italy's international prominence after the disgraces of the war and boost its

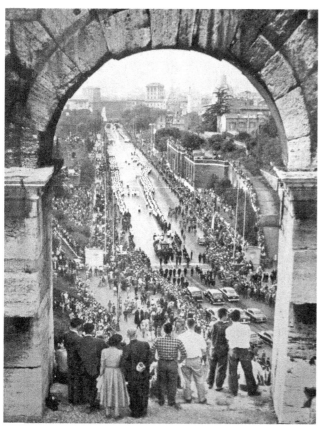

227. Funeral of Pius XII viewed from Colosseum.
Source: U. Cioccetti, "Il morte di Pio XII," *Capitolium* 33.11 (Nov. 1958), 4–17.

stagnant economy. Romans themselves hoped to revive their city as a tourist destination and to modernize its infrastructure. Despite this reconstructive spirit, the Foro Italico and EUR, Mussolini's most bombastic Roman projects, were chosen as the nuclei of the two major sports venues (see Figs. 221, 222).

Because of the Games' importance, the National Ministry of Public Works, the Roman Comune, and the Italian Olympic Committee joined forces to oversee the city's transformation. New high-speed roads were run between the sports venues; an expanded bus system and the Metropolitana subway, opened in 1955, trundled the million visitors from the historic center to EUR; housing intended for athletes (and later for public employees) was built in an Olympic Village (see Fig. 226); long-needed water, electricity, and sewer infrastructures were upgraded and expanded. Fiumicino Airport (now Leonardo da Vinci), although still unfinished, opened early for the Games and historic monuments were cleaned. Rome's Summer Games would be the first televised worldwide. *Capitolium*, a monthly magazine celebrating Rome and its environs, now fizzed with excitement at the palpable transformation: like the god Janus, Rome

looked both forward and back – to a brilliant future built on a venerable past. The Eternal City was ready for its close-up. Rome looked good!

The 1960s indeed marked a turning point. After a long lapse, tourists rediscovered Rome's historic center, arriving by the tens of thousands for the Olympics; some stayed on, captivated by *la dolce vita.* Scores of residences became small hotels, or *pensioni*, to accommodate them. Grand new hotels courted well-heeled visitors. The most notable of these was the Hilton Hotel, built by an American corporation as a kind of colonial business outpost on parkland on Montemario above the Vatican, with views over the historic center. That decision to hand over public land to private speculators still rankles with Romans more than 60 years later.

There were further indications that all was not well. Housing, we have seen already, was a habitual rat's nest. Rent control was reinstated throughout Italy and evictions prohibited in 1969, but by then, thousands of Romans – some with deep family roots in the city – had fled to the periphery (see Figs. 224, 225), often to illegal *borgate*. By the early 1990s, some 800,000 illegal postwar units were interspersed between Mussolini's 12 official *borgate* and the 1962 PRG's 12 peripheral development zones far out on the still-functioning, modernized, but completely inadequate ancient highway system. These teeming tentacles soon stretched for 30 kilometers in most directions over a 1,500-square-kilometer area. Even the legal developments had their detractors. Often oversized, and lacking adequate amenities, job centers, or transit connections, they sat in isolation for decades until infill development finally established a strong tether and public transit reached out to meet them. The infamous Serpentone (Giant Serpent), a high-rise built between 1972 and 1982 for 4,000 residents at Corviale, 8 kilometers southwest of Rome, is a particularly brutal example. Dumped in the fields like a giant, forlorn length of Jersey barrier, the central spine runs for nearly a kilometer. The residents do their best to call it home, but its almost mythically dystopian form bespeaks the desolation and poverty afflicting Rome's periphery.

Transportation too remained a nightmare: every important piazza, even Michelangelo's on the Capitoline, was a parking lot until the 1970s or 1980s (see Fig. 66). Rome's 1955 Metropolitana subway line connected EUR and the new linear suburbs in the northeast to Stazione Termini. A second line, opened in 1980, served the southeast suburbs and the Prati neighborhood near St. Peter's. Termini offered the only interchange, putting even more pressure on the historic center. Yet the Metro, along with ATAC's extensive bus and tram system, have undeniably improved Rome's connectivity, and thus its working life. Such improvement, of course, is never without class or social tensions. From the start – but particularly since 1980, when the Piazza di Spagna station opened within shouting distance of such iconic sites as the Spanish Steps, the Trevi Fountain, and the Pantheon – wealthier Romans living in the core have

criticized the new subway system for its very success, because it provides sub-
urban youths (in Europe, "suburban" often means what "inner city" connotes
to Americans) a cheap way to invade the city in the evenings and on weekends.
In 1986 Rome's first McDonald's opened in Piazza di Spagna – just steps away
from the subway stop, but also adjacent to the headquarters of the distinguished
fashion designer, Valentino. He wanted it shuttered because of the noise and
smell; meanwhile, the local Communist Party feared the Americanization of
Roman culture, which had in fact already begun. But again, the biggest per-
ceived threat to the establishment was the invasion of young people from the
city's fringes.

Perpetual political instability has forced repeated compromise, bred volatil-
ity, and fostered corruption throughout Italy's labyrinthine political system.
Constantly challenged by Socialists, Communists, and Neo-Fascists, the new
Christian Democratic Party managed to control national government from 1945
to 1981 through coalitions and a string of nine prime ministers between 1953 and
1960. During this period, student and worker demonstrations over housing and
public services erupted throughout Italy. In 1970 many of Rome's *borgata* residents
moved into unoccupied or unfinished buildings, demanding new housing. The
demonstrations were part of a broader national agenda that gave political voice to
people left behind by the Economic Miracle, yet who remained unaffiliated with
the Communists or Neo-Fascists, who had grown frightening to many.

In the late 1960s Neo-Fascists tried to destabilize the government through tar-
geted violence. Their tactic, known as the Strategy of Tension, resulted in regular
bombings of banks, trains, government offices, and even the Vittorio Emanuele II
monument. Although the bombings were blamed on leftist students, it is widely
believed that forces within the Italian military and secret service instigated the
attacks to provoke a military coup. Radical left-wing groups emerged in opposi-
tion, most notoriously the Red Brigades, a Marxist organization formed in 1970.

The period between 1969 and 1980, known as the *anni di piombo*, Years of
Lead, was characterized by escalated bombings and political kidnappings – most
notoriously, the Red Brigades' 1978 kidnapping and murder of Prime Minister
Aldo Moro in Rome. Beset by terrorism from both left and right, hundreds of
establishments deployed armed military guards around Rome. Entries to every
bank, government office, embassy, public utility, and museum – even some
major churches – bristled with ordnance. In many respects, Rome was once
again a medieval city under siege. Yet the tourists, as did pilgrims for centuries
before them, still poured in.

Rome's reputation as a now-perpetual engine of tourism should not detract
from its sincere efforts to sustain the binding agent of *romanità:* Romans and
their own distinctive culture. With a populist zeal befitting an Agrippa, mas-
sive public events have been staged since the 1950s– and more frequently since
the 1970s– to lure Romans back to Rome. There are festivals in the Basilica

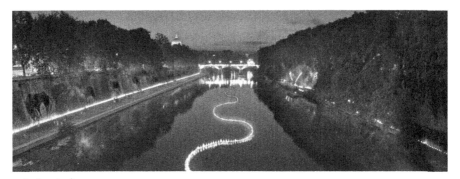

228. *Luminalia.*
Source: Kristin Jones and Daniel K. Brown, 2007. Piazza Tevere, Rome, Italy. © 2007–2015
TEVERETERNO. Image: Daniel K. Brown and Erika Kruger.

of Maxentius, operas in the Baths of Caracalla, rock concerts in the Circus
Maximus, the summertime "River of Culture" events along the Tiber, sum-
mer movie nights on Tiber Island, the *settimana della cultura*, a week when all
museum admissions are free – the "bread and circuses" of modern life. The rare
papal funerals and the increasingly common rock concerts have most success-
fully engaged suburban Romans, in large part because they are free; anyone
can attend for the price of a bus ticket. Other staged events dot the Roman
calendar. Rome's birthday, 21 April, is always marked with citywide events,
some lasting for days. The 2016 celebration was staged at the Tiber itself, with
processions set to original music and staged against a 500-meter-long mural
installation on the river embankment by William Kentridge. Titled "Triumphs
and Laments," it reflected upon the vicissitudes of Rome's 3000-year history.

Now every Sunday Via dei Fori Imperiali is closed to cars, allowing people
to stroll between Piazza Venezia and the Colosseum. Recently Rome began to
mark the summer solstice with art installations at Piazza Tevere along the river
(Fig. 228). As much as these endeavors appeal to tourists, their intended audience is
the hometown crowd of the teeming periphery, even if they attend only as guests
in their own home. The urgent effort to reconnect Romans with Rome, its his-
tory, and its legacy coincides with city initiatives to improve housing, public transit,
shopping, and public parks in the suburbs. The Church, too, is gearing up for
change; Pope Francis' (2013–) encyclical of 2015 calls for a "Jubilee of the Suburbs,"
meant to engage Rome's peripheral churches as engines of urban regeneration.

No longer *caput mundi*, twenty-first-century Rome must be satisfied with its
role as the spiritual capital of the world's 1.27 billion Catholics and the control
center of the megalopolis now sprawling far outside its walls. And of course
it remains the museum city par excellence. The historic center is thick with
tourists who are generally as constrained by set itineraries as were medieval
patrons of the *Einsiedeln Itinerary*, viewing the city as a gallery of curated sym-
bols rather than partaking of its daily life. In many ways the Eternal City is now

little more than a historic theme park of orchestrated experiences and a curiosity cabinet of isolated artifacts suspended in the formaldehyde of their fame. Corporate donors now sponsor restorations of important monuments: Tod's at the Colosseum, Fendi at the Trevi, Bulgari at the Spanish Steps, Valentino at the Temple of Venus and Roma. But Rome thrives on paradox, and lives comfortably even on its own death — which like so much in this city, has been staged for maximum effect.

These chapters have aimed to recognize the inevitability and the revivifying force of urban change in Rome over its 3,000-year history, and not to mourn the erasure of its urban fabric, whether grand or humble. While we can detest the agents — the tyrants, kingpins, wars, famines, and floods that led to these losses — we recognize that the "cumulative agitation" of thousands of small interventions and cataclysmic events over several centuries does not necessarily amount to a net loss. Every phase of Rome's history has witnessed drama, tragedy, creativity, and rebirth, and so it will remain. We cannot waste time on laments. Obsession with a particular past can restrict our ability to see each epoch on its own merits or limit our curiosity about how the present will unfurl into the future. Rome continues to exhibit the kind of environmental schizophrenia it has known for millennia. We have called it, already in its medieval incarnation, a grand and famous city culturally tending toward obsolescence, set against many new identities, none of them able to bestow an urban image that holds the same universal validity that characterized the classical city. Like any major metropolis, Rome is vibrant, chaotic, and frail — moving fast into an uncertain future. Everything flows and nothing abides; even if you wanted to, you could not step into the same Tiber twice.

BIBLIOGRAPHY

Antonio 2015; Baxa 2004; Benevolo 1971; Caracciolo 1999; Cederna 1979; Comune di Roma 1925–1976; Comune di Roma 1959; Comune di Roma 2003; Cuccia 1991; Fried 1973; Governatorato di Roma 1931; "Un inferno chiamato baracca" 1970; Insolera 1959, 2002; Kallis 2012; Katz 2003; Kirk 2005 (vol. 1), 2006; Kostof 1973, 1994; Marcello 2003; Maroi 1937; Muñoz 1935; Painter 2005; Piccinato 2006; Provvidenze per Roma 1962; Salvante 2012; Sanjust di Teulada 1908; Seldes 1935; Singley 2007; Suro 1986; Testa 1932; Trabalzi 2014.

GLOSSARY OF PERSONS, PLACES, AND TERMS

Aedile: An ancient Roman magistracy of middle rank overseeing a wide variety of responsibilities, many of them related to maintaining the city and public morals.

Aemilius Lepidus, Marcus (ca. 230–152 B.C.E.): Roman statesman; appointed censor in 179 B.C.E. with Marcus Fulvius Nobilior.

Aeneas: Trojan hero of Greek myth who was adopted into Roman mythology as the founder of the Roman people.

Agrippa, Marcus Vipsanius (63–12 B.C.E.): Roman statesman and close friend of Augustus.

Agrippina the Younger (15–59): Mother of Nero and empress (49–54).

Alaric (ca. 370–410): As king of the Visigoths from 395 to 410 he waged war throughout Italy and besieged Rome in 410.

Alexander V: Pope, 1492–1503.

Alexander VII: Pope, 1655–1667.

Alexander Severus: Emperor, 222–235.

Alexandria: An Egyptian metropolis near the mouth of the Nile founded by Alexander the Great.

Anio River (modern Aniene): A tributary of the Tiber north of Rome.

Annibaldi: A powerful noble family in the medieval and Renaissance periods.

Annona: The annual grain shipment to Rome.

Antonine dynasty (138–193 C.E.): The dynasty of Roman emperors consisting of Antoninus Pius, Marcus Aurelius, Lucius Verus, and Commodus.

Antoninus Pius: Emperor, 138–165 C.E.

Antony, Mark (Marcus Antonius, 83–30 B.C.E.): Roman statesman and general; member of the Second Triumvirate.

Apennines: The principal mountain range forming the central spine of Italy.

Apollo: Roman god of light, the arts, and inspiration.

Appius Claudius Caecus (ca. 340–273 B.C.E.): Roman politician; elected censor in 312 B.C.E.

Archaic period: Ca. 580–480 B.C.E.

Area: Cemetery or collective burial place.

Arianism: A sect rivaling orthodox Christianity, particularly popular among Germanic tribes.

Atrium house: A type of house characteristic of ancient Italy that features a large inner court (*atrium*) with a funnel-shaped rectangular roof converging on a rectangular opening (*compluvium*) suspended over a basin (*impluvium*).

Attic: An upper story of a façade, often with a continuous surface.

Attis: Companion god of Cybele.

Augustus (63 B.C.E.–14 C.E.): Emperor, 27 B.C.E. –14 C.E.; first emperor of Rome.

Aurelian: Emperor, 270–275 C.E.

Avignon, France: The seat of papal government between 1309 and 1376 during the period known as the Avignon Papacy.

Bandi: Printed legal prohibitions posted in public streets and piazzas.

Baraccanti: Residents of illegal encampments.

Baracche: Illegal settlements at the city's edges.

Baroni: Noble Roman families often claiming imperial lineage.

Basilica: A large, oblong public building with a central nave flanked by aisles. Before the fourth century, it was exclusively a civic structure without religious connotations.

Basilica subteglata: A U-shaped cemeterial basilica at the site of a martyr's tomb.

Belisarius (ca. 505–565): Greek general of the Eastern Roman Empire under the Byzantine emperor Justinian I. He occupied (536) and defended Rome (537–538).

Benedict XIV: Pope, 1740–1758.

Bonaparte, Napoleon (1769–1821): Emperor of France, 1804–1814 and 1815.

St. Boniface IV: Pope, 608–615.

Boniface VIII: Pope, 1294–1303.

Boniface IX: Pope, 1389–1404.

Borgata: (1) A general term for a spontaneous slum; (2) an officially sanctioned semiurban settlement.

Borgo: The area near the Vatican within the Leonine Walls. See also "Lateran Borgo."

Burgus Sancti Petri: The medieval city at the Vatican; also called Civitas Leonina.

Byzantine: Referring to the continuation of the Roman Empire in the East under emperors based in Constantinople. From the sixth to the eighth century, the Byzantine court frequently controlled Rome and other parts of Italy.

Cacus: Mythological herdsman-king of Rome killed by Hercules.

Cadastral map: A property map made for the purpose of taxation or to fulfill some other administrative requirement.

Caesar, Julius (100–44 B.C.E.): Roman general and statesman; member of the First Triumvirate.

Caligula, Gaius: Emperor, 37–41 C.E.

Callixtus: Pope, 217–222.

Campagna: The countryside surrounding Rome.

Caput mundi: Head of the world.

Caracalla: Emperor, 198–217 C.E.

Castor and Pollux: Divinized twin brothers of Greek myth noted for their horsemanship. Also called the Dioscuri or the Castors.

Cato the Elder (Marcus Porcius Cato, 234–149 B.C.E.): Roman patrician statesman.

Censor: A high magistrate of Rome responsible for various duties, often including taking a census. In the republic, the censors, elected in pairs, were the chief sponsors of monumental building.

Ceres: Roman goddess of grain and fertility.

Charlemagne (Charles the Great, ca. 740–814): King of the Franks, 768–814; Holy Roman Emperor, 800–814.

Christogram: A monogram combining letters of the name of Jesus Christ.

Cicero, Marcus Tullius (106–43 B.C.E.): Roman orator and statesman.

Civitas Leonina: See "Burgus Sancti Petri."

Classical period: Ca. 480–330 B.C.E.

Claudius: Emperor, 41–54 C.E.

Clement V: Pope, 1305–1314.

Clement VII: Pope, 1523–1534.

Clement VIII: Pope, 1592–1605.

Clement X: Pope, 1670–1676.

Clement XI: Pope, 1700–1721.

Clement XII: Pope, 1730–1740.

Clement XIV: Pope, 1769–1774.

Clodius Pulcher, Publius (93–52 B.C.E.): Roman politician and reformer.

Cola di Rienzo (ca. 1313–1354): Leader of a popular insurrection against the Roman nobility on the part of the Comune in 1347.

Colonna: A powerful noble family in the medieval and Renaissance periods.

Columbarium: A type of ancient tomb consisting of an interior space whose walls are completely occupied by rows and columns of niches for cinerary urns.

Comitia: Assemblies of the citizens of ancient Rome. The Comitia Centuriata met in the Campus Martius, the Comitia Tributa in the Comitium on the Forum.

Commodus: Emperor, 177–192 C.E.

Compagnia dei Raccomandati al S. Salvatore ad sanctum sanctorum: An organization sponsored by the Colonna family that supervised the Lateran hospital.

Comune: The city government from the twelfth through early-fifteenth century. It often stood as a counterweight to the papacy.

Comune di Roma: The city government since 1870.

Concordia: Allegorical Roman goddess of concord between the patrician and plebeian orders.

Constans II: Byzantine emperor, 641–668.

Constantine the Great: Emperor, 306–337, and the first to favor Christianity; patron of churches at Rome and founder of Constantinople.

Constantinople (modern Istanbul): The ancient city of Byzantium, refounded by Constantine as a Christian capital.

Constantius Chlorus: See "Tetrarchy."

Consul: A senior magistrate in ancient Rome.

Corinthian: Of the architectural order characterized by slender columns with elaborate, leafy capitals.

Council of Trent (1545–1563): An assembly of bishops and theologians convened by Pope Paul III to clarify church doctrine during the Reformation. It led to the Counter Reformation.

Crypta: Vaulted corridors.

Cura aedium sacrarum et operum publicorum: Urban commission overseeing sacred buildings and public works.

Cura aquarum: Urban water commission. The later supplemental title *et Miniciae* indicates the additional responsibility of overseeing grain distribution.

Cura operum publicorum: Urban commission of public works.

Cura riparum et alvei Tiberis: Urban commission for maintaining the Tiber River and its banks.

Cura viarum: Urban commission of streets and roads.

Curator: Superintendent or commissioner.

Curtes: Extramural property in the Campagna; later a name for some large family compounds located in Rome.

Cybele (Magna Mater, "Great Mother"): A goddess of Asia Minor whose cult was imported to Rome in 204 B.C.E.

Dacia: See "Dacian Wars."

Dacian Wars: The emperor Trajan's two successful campaigns in Dacia north of the Danube concluding with the annexation of the region as a new Roman province.

De Mérode, Frederick Francis (1820–1874): Military adviser to Pope Pius IX and wealthy property speculator.

Diana: Roman goddess of the hunt and the countryside.

Diocletian: Coemperor, 284–305; cofounder of the Tetrarchy.

Divus: Deified.

Domitian: Emperor, 81–96.

Domus: A single-family townhouse, often of two stories.

Domus cultae: Land tilled and cultivated by the church.

Doric: Of the architectural order characterized by columns with simple, flat capitals usually surmounted by a partitioned frieze.

Einsiedeln Itinerary: A late-eighth-century guide to Rome surviving in a thirteenth-century copy.

Elagabalus: Emperor, 218–222.

Empire: The form of Rome's government succeeding the republic, controlled by an emperor or coemperors.

Episcopium: Papal residence.

Esposizione Universale di Roma: Mussolini's partially built but unrealized proposal for an exposition of art, science, and work to be held in 1942; it became the nucleus of a new Roman suburb.

Etruscans: An ancient Italian people who controlled Etruria (Tuscany) and parts of Latium prior to Rome's rise to dominance in Italy.

EUR '42: See "Esposizione Universale di Roma."

Exarchate: A political regime lasting from 584 to 752 C.E. during which parts of Italy, including Rome, were controlled by Byzantine emperors through governors based in Ravenna.

Exedra: A recess, often semicircular or rectangular, opening off of a larger space.

Falda, Giovanni Battista (1643–1678): Italian printmaker and cartographer.

Fascism: See "National Fascist Party."

Fasti: Festival days.

Faustina the Elder: Wife of Antoninus Pius; empress, 138–140.

St. Felix IV: Pope, 526–530.

Flaminius Nepos, Gaius (active 230s–210s B.C.E.): Roman statesman and advocate of the plebeian order.

Flavian dynasty (69–96 C.E.): The Roman imperial dynasty comprising the reigns of Vespasian, Titus, and Domitian.

Francis: Pope, 2013–.

Frangipane: A powerful noble family in the medieval and early Renaissance periods.

Frigidarium: A room in a Roman bath for bathing in cold water.

Frontinus, Sextus Julius (ca. 40–103 C.E.): Water commissioner under Trajan; author of a treatise on aqueducts.

Frumentationes: Distribution of free grain to registered citizens in the city.

Fulvius Nobilior, Marcus: Roman statesman and general; appointed censor in 179 B.C.E. with Marcus Aemilius Lepidus.

Gabii: An ancient city of Latium east of Rome.

Galerius: Coemperor 305–311. See "Tetrarchy."

Gauls: Celtic peoples inhabiting or originating from Gaul (modern France).

St. Gelasius I: Pope, 492–496.

Ghetto: An enclosure in which a specific population is forced to live.

Ghibellines: In the twelfth and thirteenth centuries, supporters of the Holy Roman Emperor; opposed to the Guelphs.

Gracchus, Gaius Sempronius (154–121 B.C.E.): Brother of Tiberius; tribune of the plebs in 123–122 B.C.E.

Gracchus, Tiberius Sempronius ("The Elder," ca. 217–154 B.C.E.): Roman politician and general; father of the tribunes Tiberius and Gaius.

Gracchus, Tiberius Sempronius ("The Younger," ca. 165–133 B.C.E.): Brother of Gaius; tribune of the plebs in 133 B.C.E.

Grand Tour: An extended period of European travel, usually culminating at Rome, undertaken by educated gentlemen.

St. Gregory I (the Great): Pope, 590–604.

St. Gregory III: Pope, 731–741.

St. Gregory VII: Pope, 1073–1085.

Gregory XI: Pope, 1370–1378.

Gregory XIII: Pope, 1572–1585.

Guelphs: In the twelfth and thirteenth centuries, supporters of the pope; opposed to the Ghibellines.

Guiscard, Robert (1015–1085): Mercenary who captured Rome in 1084; founder of the Norman Kingdom of Two Sicilies.

Gymnasium: In antiquity, an institution for the education and physical conditioning of young men.

Hadrian: Emperor, 117–138.

Hadrian I: Pope, 772–795.

Helena (ca. 250–ca. 330): Mother of Constantine, later sainted; she reputedly found remnants of the Cross of the Crucifixion while in Jerusalem, which she took to Rome.

Hellenistic: Pertaining to Greek culture between the late fourth and late first centuries B.C.E.

Hercules: Popular hero–god of Greek and ancient Italian mythology. The cult of Hercules Musarum celebrated his association with the Muses.

Holy Year: See "Jubilee."

Honorius I: Western Roman emperor, 393–423.

Horrea: Warehouse. Same form used for singular and plural.

Hortus: A large urban garden or park. Often in the plural (*horti*).

Imperial: Pertaining to the empire or emperor of ancient Rome.

Innocent II: Pope, 1130–1143.

Innocent III: Pope, 1198–1216.

Innocent VIII: Pope, 1484–1492.

Innocent X: Pope, 1644–1655.

Innocent XII: Pope, 1691–1700.

Innocent XIII: Pope, 1721–1724.

Insula: In ancient Rome: (1) a city block; (2) a residence within an apartment block.

Isis: Popular Egyptian goddess with a widespread cult in the Roman world.

Istituto Romano per le Case Popolare (ICP): A state-run housing agency.

Janus: Two-faced Roman god with a shrine in the Forum.

Jewish War (First, 66–73 C.E.): Conflict in Judaea between Rome and the Jews; Vespasian and Titus commanded the Roman forces.

John V: Pope, 685–686.

John VII: Pope, 705–707.

John XI: Pope, 931–935.

John XXII: Pope, 1316–1334.

Jubilee: A celebratory period during which any person who traveled to Rome would be granted forgiveness for all sins; first proclaimed by Boniface III in 1300.

Judaea: The ancient homeland of the Jews, corresponding to parts of modern Israel.

Julio-Claudian dynasty: Rome's first imperial dynasty, combining the Julian family of Augustus and the Claudian family of Livia. The Julio-Claudian emperors following Augustus were, in sequence, Tiberius, Caligula, Claudius, and Nero.

Julius I: Pope, 337–351.

Julius II: Pope, 1503–1513.

Juno: Queen of the gods, wife of Jupiter. Also worshiped with various epithets, such as Regina and Lucina.

Jupiter: King of the Roman gods, principally worshiped at Rome as Jupiter Optimus Maximus, "Best and Greatest."

Jupiter Feretrius: The god in his guise as guarantor of contracts and tutelary spirit of the Spolia Opima, the spoils of war reputedly dedicated by Romulus.

Jupiter Stator: The god in his guise as a founding spirit of Rome.

Justinian I (483–565): Byzantine emperor, 527–565.

Lateran Borgo: The papal complex surrounding the Lateran basilica.

Latium: The region of central Italy to which ancient Rome belonged.

Lazio: The modern administrative region of Italy for which Rome is the capital.

St. Leo I (the Great): Pope, 440–461.

St. Leo III: Pope, 795–816.

St. Leo IV: Pope, 847–855.

Leo X: Pope, 1513–1521.

Liber pontificalis: A semiofficial biography of popes from St. Peter through the fifteenth century.

Libitina: An urban organization of the Roman period, under the tutelage of Venus Libitina, that oversaw the disposal of the dead.

Livia Drusilla (58 B.C.E.–29 C.E.): Wife of Octavian/Augustus; empress, 27 B.C.E.–14 C.E.

Livy (Titus Livius Patavinus, 59 B.C.E.–17 C.E.): Roman historian; contemporary of Augustus.

Lucius II: Pope, 1144–1145.

Lucullus, Lucius Licinius (118–56 B.C.E.): Wealthy Roman statesman and general.

Ludi: Public games or festivals.

Macedonian Wars: A series of wars that Rome waged against Greek kingdoms between 214 and 148 B.C.E. resulting in the expansion of Rome's sphere of control into the Greek world.

Maecenas, Gaius Clinius (68–8 B.C.E.): Friend of Augustus and important Roman patron of the arts.

Maestri delle strade: Citizens appointed by the Roman Comune and Senate and charged with maintaining urban order during the medieval and early modern periods.

Marcus Aurelius: Emperor, 161–180.

Mark: Pope, 336.

Mars: Roman god of war.

Martin V: Pope, 1417–1431.

Martyrium: A martyr's grave.

Mattei: A powerful noble family in the medieval and Renaissance periods.

Maxentius: Coemperor, 306–312. Rival of Constantine for control of the Western Empire (see "Tetrarchy"), he was defeated at the Battle of the Milvian Bridge in 312.

Maximian: Coemperor, 286–305. See "Tetrarchy."

Mensa: Movable funeral table.

Messalla Corvinus, Marcus Valerius (64 B.C.E.–8 C.E.): Powerful friend of Augustus; the first *curator aquarum* of Rome.

Minerva: Roman goddess of war and wisdom.

Mithras (Mithra): Ancient Persian god popular from the second to the fourth centuries C.E.

Mithraeum: A shrine of Mithras constituting an oblong underground chamber lined with masonry dining couches for devotees.

Mussolini, Benito (1883–1945): Founder and leader of the National Fascist Party; prime minister, 1922–1943.

Napoleon: See "Bonaparte, Napoleon."

Nathan, Ernesto (1848–1921): Rome's first nonelite mayor, 1907–1913.

National Fascist Party: A right-wing political party characterized by a highly authoritarian brand of extreme nationalism. It was founded in Italy by Mussolini in 1921.

Naumachia: (1) A naval battle, often to the death, staged for an audience; (2) a special venue for such spectacles.

Nero: Emperor, 54–68.

Nerva: Emperor, 96–98; adoptive father of Trajan.

Nicholas III: Pope, 1277–1280.

Nicholas V: Pope, 1447–1455.

Nolli, Giovanni Battista (1701–1756): Cartographer who published *La Pianta Grande di Roma* in 1748.

Octavian (Gaius Octavius): Birth name of Augustus.

Orsini: A powerful noble family in the medieval and Renaissance periods.

Ostia: An ancient Roman town at the mouth of the Tiber; in the imperial period it became an important administrative center for provisioning Rome.

Ostrogoths: A Germanic tribe that controlled large parts of Italy in the late fifth and sixth centuries C.E.

Palestrina (ancient Praeneste): A town east of Rome noted for its monumental Roman architecture.

Patrician: Belonging to Rome's ancient aristocratic class. During the republic the codified privileges of the patrician order gradually eroded, but membership in a patrician family remained prestigious.

Paul II: Pope, 1464–1471.

Paul III: Pope, 1534–1549.

Paul IV: Pope, 1555–1559.

Paul V: Pope, 1605–1622.

Pax: Peace, an allegorical goddess of the Romans.

Peperino: A gray volcanic tuff speckled with pepperlike inclusions.

Peristyle: See "Portico."

Piano regolatore: An urban master plan.

Piranesi, Giovanni Battista (1720–1778): Italian printmaker and architect.

Pius II: Pope, 1458–1464.

Pius IV: Pope, 1559–1565.

St. Pius V: Pope, 1566–1572.

Pius VI: Pope, 1775–1799.

Pius VII: Pope, 1800–1823.

Pius IX: Pope, 1846–1878.

Plebeian: Referring to the plebs, that is, the common people of Rome who did not belong to patrician families.

Plebeian tribuneship: See "Tribune of the plebs."

Podium: A raised platform, as for a building.

Polybius (ca. 200–ca. 118 B.C.E.): Greek historian who chronicled the rise of Rome.

Pomerium: A religious boundary inscribing the city. Periodically it was expanded.

Pompey the Great (Gnaeus Pompeius Magnus, 106–48 B.C.E.): Roman statesman and general; member of the First Triumvirate.

Portico: A corridor bounded by a row of columns or an arcade. Often the term (Latin *"porticus"*) refers to a peristyle, a rectangular enclosure surrounded by porticoes.

Portus: A town by Ostia that developed around the artificial ports of Claudius and Trajan.

Possesso: A ritual procession from St. Peter's to the Lateran taken by the newly crowned pope.

Post-Tridentine: Referring to the period immediately after the conclusion of the Council of Trent in 1562.

Pozzolana: A special kind of volcanic sand used in Roman concrete.

Pozzuoli: Roman city on the Bay of Naples. Before the establishment of Portus in the first century C.E., it was the chief port city of Rome.

Praefectus annonae: Commissioner of the *annona*, the imported grain supply of Rome.

Praetorian guard: The emperor's personal bodyguard, consisting of several thousand elite soldiers.

Punic Wars: A series of three wars between Rome and the Carthaginian (Punic) empire between 264 and 146 B.C.E. resulting in Roman territorial expansion.

Regio: An urban district of ancient Rome. Initially there were four, and after Augustus's reforms 14.

Regionary catalogs: Two lists of the mid-fourth century C.E. cataloging topographical features of the city of Rome.

Republic: The form of participatory government prevailing at Rome between 509 B.C.E. and the onset of the empire in 31 B.C.E.

Rione: One of 12 districts in Rome devised in the eleventh century. These were expanded to 13 districts in the thirteenth century, to 14 in the sixteenth, and to 22 in 1921.

Risorgimento: The period of the reunification of Italy into a nation in the nineteenth century, culminating with the establishment of Rome as the capital in 1871.

Rocca dei Frangipane: A medieval papal refuge on the Palatine.

Romanità: A post-1870 national sentiment translated as "Romanness."

Roman period: The phase of the history of Rome extending from about the eighth century B.C.E. to the downfall of autonomous imperial control of the Western empire in the fifth century C.E.

Romulus and Remus: Twin brothers of Roman myth; Romulus slew his brother and founded the city, reputedly on 21 April, 753 B.C.E. He became the first of seven legendary kings of Rome.

Sabine War: A quasi-mythical conflict between Rome and the Sabines during the prerepublican period.

Sabines: An ancient people of Italy dwelling north and east of Rome. Legend casts them as antagonists of Rome in its early history.

Sacrum palatium: Seat of the pope's temporal dominion on the Lateran.

Samnite Wars (343–290 B.C.E.): A series of three conflicts between Rome and a group of Italic tribes known as the Samnites, resulting in Rome's domination of peninsular Italy.

Saracen: The medieval Roman term for a Muslim.

Saturn: Ancient local agrarian god of the Romans.

Schola: (1) A place, often in the form of an exedra, for instruction or contemplation; (2) a hospice organization serving a national community at the Vatican.

Scholae militia: Twelve military districts established by the Byzantine reorganization of Rome.

Scipio Aemilianus Africanus, Publius Cornelius ("Scipio Africanus the Younger," 185–129 B.C.E.): Roman general and politician.

Scipio Africanus, Publius Cornelius ("the Elder," 236–183 B.C.E.): Roman general and politician; father of Scipio Aemilianus.

Senate: Rome's chief deliberative body, consisting (variably) of 300 or 600 members.

Serapis: Egyptian god associated with Alexandria, often paired with Isis in Roman contexts.

Sergius III: Pope, 904–911.

Servius Tullius: Legendary sixth king of Rome, putatively in the sixth century B.C.E.

Severan dynasty (193–235 C.E.): The Roman imperial dynasty comprising the rules of Septimius Severus, Caracalla, Elagabalus, and Alexander Severus.

Severan marble plan: A large marble map of the city of Rome dating to the early third century C.E. originally displayed in the Templum Pacis.

Simplicius: Pope, 468–483.

St. Sixtus III: Pope, 432–440.

Sixtus IV: Pope, 1471–1484.

Sixtus V: Pope, 1585–1590.

Spolia: Materials extracted from one building and reused in another.

SPQR: *Senatus populusque Romanus*, the Senate and the People of Rome.

Strabo (63 B.C.E.–ca. 24 C.E.): Greek geographer of the Roman period.

Suetonius Tranquillus, Gaius (69–ca. 125): Roman historian and biographer.

Sulla, Lucius Cornelius (138–78 B.C.E.): Roman general and politician.

St. Sylvester I: Pope, 314–335.

St. Symmachus: Pope, 498–514.

Synod: A church council.

Tacitus, Publius Cornelius (ca. 56–after 117): Roman historian.

Tarquin the Proud (Tarquinius Superbus): Last of the seven legendary kings of ancient Rome.

Tetrarchy: The combined rule of four tetrarchs (coemperors) established by Diocletian and Maximian in 293 C.E. The pair divided the Roman Empire between East (led by Diocletian) and West (Maximian), and each appointed a colleague (Galerius; Constantius Chlorus) as his junior coemperor. After the war with Maximian's son and successor Maxentius in 312–313, Constantine dissolved the institution.

Theodore I: Pope, 642–649.

Thermae: Large, imperially sponsored bathing complexes.

Tiberius: Emperor, 14–37 C.E.

Titulus: An administrative parish church.

Titus: Emperor, 79–81 C.E.

Tivoli (ancient Tibur): A town in the Anio River valley celebrated for the Roman villas established in its vicinity.

Totila (died 552): King of the Italian Ostrogoths, 541–552.

Trajan: Emperor, 98–117 C.E.

Travertine: A porous limestone quarried east of Rome near Tivoli.

Tribune of the plebs: Roman magistrate of plebeian standing who during the republic often served as a powerful advocate of the common people.

Triumph: In ancient Rome, the celebration of a military victory punctuated by a parade through the city.

Triumvirate: An alliance of three powerful men.

Trivium: A trident of streets; an urban design strategy designed to facilitate movement first employed at Piazza del Popolo in the 1530s.

Tuff: Soft stone formed from volcanic ash.

Tuscolani: A family from ancient Tusculum southeast of Rome who seized Rome and took control of the Church in the tenth century.

Tyrrhenian Sea: The spur of the Mediterranean Sea along the west coast of Italy.

St. Urban I: Pope, 222–230.

Urban VIII: Pope, 1622–1643.

Urban cohorts: A militarized police force established by Augustus to maintain law and order in Rome.

Urban prefect: Commissioner of the urban cohorts.

Vandals: An Eastern Germanic tribe.

Vault: A masonry roof of varying form, but always with an arched or peaked profile.

Veduta: Image of a cityscape or landscape.

Veii: An Etruscan city near Rome, conquered by the Romans in 396 B.C.E.

Venus: Goddess of love, favored by the Romans under various epithets including Genetrix ("Mother") and Victix ("Victorious").

Venus Libitina: The goddess in her guise as tutelary spirit of burials and the dead.

Vespasian: Emperor, 69–79 C.E.

Vesta: Roman goddess of the hearth and home.

Vestal Virgins: Priestesses of Vesta who dwelled at the Atrium Vestae on the Forum.

Vicus: (1) A secondary street; (2) a neighborhood of ancient Rome. From Augustus's time, each of these was officially recognized and belonged to a *regio*.

Vigiles: The ancient urban fire brigade.

Visigoths: a Christian tribe of Eastern Germanic origin.

Vitruvius Pollio, Marcus (ca. 80 B.C.–ca. 15 B.C.): Roman architect and author of a treatise on architecture.

Western Schism (1378–1417): A political division within the Catholic Church following the Avignon Papacy during which rival factions elected their own popes.

Xenodochium: A charitable institution providing food and shelter.

St. Zachary: Pope, 741–752.

WORKS CITED

I. ABBREVIATIONS AND SHORT TITLES

AJA	*American Journal of Archaeology.*
ArchCl	*Archeologia classica.*
ArchMed	*Archeologia medievale.*
ASRSP	*Archivio della R. Società Romana di Storia Patria.*
BollettinoMMGP	*Bollettino dei Monumenti, Musei e Gallerie Pontificie.*
BullCom	*Bullettino della Commissione Archeologica Comunale di Roma.*
CARR	Evans, J. D., ed. 2012. *A Companion to the Archaeology of the Roman Republic.* Hoboken, NJ.
FUR	Lanciani, R. 1893–1901. *Forma urbis Romae.* Milan.
JdI	*Jahrbuch des Deutschen Archäologischen Instituts.*
JECS	*Journal of Early Christian Studies.*
JRA	*Journal of Roman Archaeology.*
JRS	*Journal of Roman Studies.*
JSAH	*Journal of the Society of Architectural Historians.*
LRI	*La Rome impériale: démographie et logistique.* Rome 1997
LTUR	Steinby, E. M., ed. *Lexicon topographicum urbis Romae.* Rome, 1993–2000.
LTUR Suburbium	La Regina, A., ed. *Lexicon topographicum urbis Romae. Suburbium.* Rome, 2001–2008.
MAAR	*Memoirs of the American Academy in Rome.*
MEFRA	*Mélanges de l'Ecole Française de Rome (Antiquité).*
MEFRM	*Mélanges de l'Ecole Française de Rome (Moyen âge).*
NSc	*Notizie degli scavi di antichità.*
NTDAR	Richardson, L. Jr. 1992. *A New Topographical Dictionary of Ancient Rome.* Baltimore and London.
OpRom	*Opuscula romana: Annual of the Swedish Institute in Rome.*
PBSR	*Papers of the British School at Rome.*
RAC	*Rivista di archeologia cristiana.*
SDFUP	*Stanford Digital Forma Urbis Project, http://formaurbis.stanford.edu*

2. REFERENCES

Ackerman, J. 1954. *The Cortile del Belvedere.* Vatican City.

Ackerman, J. 1961. *The Architecture of Michelangelo.* London.

Adams, E. 2013. *The Earliest Christian Meeting Places: Almost Exclusively Houses?* London and New York.

363

Adinolfi, P. 1881. *Roma nell'età di mezzo*. 2 vols. Rome.

Ajello Mahler, G. 2012. *Afterlives: The Reuse, Adaptation, and Transformation of Rome's Ancient Theaters*. Ph.D. dissertation, New York University.

Albers, J. 2008. "Das Marsfeld. Die Entwicklung der urbanen Struktur aus topographischer, traditioneller und rechtlicher Perspektive." In Albers/Grasshof/Heinzelmann/Wäfler, 13–28.

Albers, J. 2013. *Campus Martius: Die urbane Entwicklung des Marsfeldes von der Republik bis zur mittleren Kaiserzeit*. Wiesbaden.

Albers, J., G. Grasshof, M. Heinzelmann, and M. Wäfler, eds. 2008. *Das Marsfeld in Rom*. Bern.

Alberti, L. B. 1988. *On the Art of Building in Ten Books*. Translated by J. Rykwert, N. Leach, and R. Tavernor. Cambridge, MA.

Albertini, F. 1510. *Opusculum de mirabilibus novae et veteris urbis Romae*. Rome.

Albertoni, M., and I. Damiani. 2008. *Il tempio di Giove e le origini del Colle Capitolino*. Milan.

Aldrete, G. 2007. *Floods of the Tiber in Ancient Rome*. Baltimore.

Alexander, S. S. 1971 and 1973. "Studies in Constantinian Church Architecture." *RAC* 47 (1971), 281–330; 49 (1973), 33–44.

Alfarani, T. 1914. *De basilicae vaticanae antiquissima et nova structura*. Rome.

Amadei, E. 1932. *Le torri di Roma*. Rome.

Ammerman, A. J. 1990. "On the Origins of the Forum Romanum." *AJA* 94, 627–45.

Ammerman, A. J. 1996. "The Comitium in Rome from the Beginning." *AJA* 100, 121–36.

Ammerman, A. J. 2012. "Looking at Early Rome with Fresh Eyes: Transforming the Landscape." In *CARR*, 169–80.

Ammerman, A. J., and D. Filippi. 2004. "Dal Tevere all'Argileto: nuove osservazioni." *BullCom* 105, 7–28.

Ammerman, A. J., I. Iliopoulos, F. Bondioli, D. Filippi, J. Hilditch, A. Manfredini, L. Pennisi, and A. N. Winter. 2008. "The Clay Beds in the Velabrum and the Earliest Tiles in Rome." *JRA* 21, 7–30.

Ampolo, C. 2013. "Il problema delle origini di Roma rivisitato: concordismo, ipertra-dizionalismo acritico, contesti. I." *Annali della Scuola Normale Superiore di Pisa, Classe di lettere e filosofia* ser. 5, 217–84.

Anderson, J. C., Jr. 1984. *The Historical Topography of the Imperial Fora*. Brussels.

Anderson, J. C., Jr. 1985. "The Date of the Thermae Traiani and the Topography of the Oppius Mons." *AJA* 89, 499–509.

André, N., F. Villedieu, and P. Gros. 2004. "Vom 'schwebenden Garten' zum Tempelbezirk – Die Untersuchungen der École Française de Rome in der Vigna Barberini." In Hoffmann/Wulf, 112–43.

Andres, G. M. 1976. *The Villa Medici in Rome*, 2 vols. New York.

Anonymous. 1542–1570. *Speculum romanae magnificentiae*. Rome.

Anonymous. *Mirabilia urbis Romae (Marvels of the City of Rome)*. In C. D'Onofrio, 1988, *Visitiamo Roma mille anni fa: la città dei mirabilia*. Rome.

Antinori, A. 2008. *La magnificenza e l'utile: progetto urbano e monarchia papale nella Roma del Seicento*. Rome.

Antonetti, S. 2005. "L'assistenza come forma di politica nella Roma medievale." *La ricerca Folklorica*, n. 52: *La devozione dei laici: confraternite di Roma e del Lazio dal Medioevo ad oggi*. Brescia, 15–16.

Antonio, S. 2015. "Pope Francis the urbanist." In *Citiscope*, 21 July 2015. http://citiscope.org/story/2015/pope-francis-urbanist.

Arce, J. 2010. "Roman Imperial Funerals in *effigie*." In Ewald/Noreña, 309–23.

Arena, M. S., P. Delogu, L. Paroli, M. Ricci, L. Saguì, and L. Venditelli. 2001. *Roma dall'antichità al medioevo. Archeologia e storia*. Milan.

Armellini, M. 1891. *Le chiese di Roma dal secolo IV al XIX*, 2nd ed. Rome.

Arnaldi, A. 1986. "L'approviggionamento di Roma e l'amministrazione del 'Patrimonio di S. Pietro' al tempo di Gregorio Magno." *Studi romani* 34, 25–39.

Ashby, T. 1935. *The Aqueducts of Ancient Rome*. I. A. Richmond, ed. Oxford.

"L'attività edilizia in Roma." 1925. *Capitolium* 1.1, 44–49.

Audebert, N. 1981. *Voyage d'Italie*. A. Olivero, ed., 2 vols. Rome.

Augenti, A. 1996. *Il Palatino nel medioevo: archeologia e topografia (secoli VI–XIII)*. Rome.

Bacci, A. 1558. *Del Tevere: della natura, & bonta dell'acque & delle inondationi Libri II*. Rome.

Baiani, S., and M. Ghilardi, eds. 2000. *Crypta Balbi, Fori imperiali: archeologia urbana e interventi di restauro nell'anno del Grande Giubileo*. Rome.

Ball, L. F. 2003. *The Domus Aurea and the Roman Architectural Revolution*. Cambridge and New York.

Barker, E. R. 1913. *Rome of the Pilgrims and Martyrs: A Study of the Martyrologies, Itineraries, Syllogae, and Other Contemporary Documents*. London.

Bartoli, A. 1911. *Il Palatino*. Rome.

Bartoli, A. 1929. *Scavi del Palatino (Domus Augustana)*. Rome.

Baxa, P. 2004. "Piacentini's Window: The Modernism of the Fascist Master Plan of Rome." *Contemporary European History* 13.1, 1–20.

Beacham, R. C. 1999. *Spectacle Entertainments of Early Imperial Rome*. New Haven and London.

Beard, M. 1998. "Imaginary *horti*: Or Up the Garden Path." In Cima/La Rocca, 23–32.

Beard, M. 2007. *The Roman Triumph*. Cambridge, MA.

Beard, M., J. North, and S. R. F. Price. 1998. *Religions of Rome*, 2 vols. Cambridge and New York.

Beltrani, G. 1880. *Leonardo Bufalini e la sua pianta topografica di Roma*. Florence.

Beneš, M. 1989. *Villa Pamphilj (1630–1670): Family, Gardens, and Land in Papal Rome*, 3 vols. Ph. D. dissertation, Yale University.

Benevolo, L. 1971. *Roma da ieri a domani*. Bari.

Benocci, C., and E. Guidoni. 1993. *Il ghetto*. Rome.

Berlan-Bajard, A. 2006. *Les spectacles aquatiques romains*. Rome.

Bernardini, B. 1777. *Descrizione del nuovo ripartimento de' rioni di Roma*. Reprint of 1744 edition. Rome.

Bertolini, O. 1947. "Per la storia delle diaconiae romane nell'alto medioevo sino alla fine del secolo VIII." *ASRSP* 70, 1–145.

Bevilacqua, M. 1988. *Il monte dei Cenci: una famiglia romana e il suo insediamento urbano tra Medioevo ed età Barocca*. Rome.

Bevilacqua, M., and M. Fagiolo, eds. 2012. *Piante di Roma dal Rinascimento ai catasti*. Rome.

Birch, D. 1998. *Pilgrimage to Rome in the Middle Ages: Continuity and Change*. Woodbridge, UK and Rochester, NY.

Boatwright, M. T. 1987. *Hadrian and the City of Rome*. Princeton.

Boatwright, M.T. 2010. "Antonine Rome: Security in the Homeland." In Ewald/Noreña, 169–97.

Bober, P. P. 1977. "The Coryciana and the Nymph Corycia." *Journal of the Warburg and Courtauld Institutes* 40, 223–39.

Bodel, J. 1994. *Graveyards and Groves: A Study of the Lex Lucerina*. Cambridge, MA.

Bodel, J. 2000. "Dealing with the Dead: Undertakers, Executioners, and Potter's Fields in Ancient Rome." In E. Marshall and V. Hope, eds., *Death and Disease in the Ancient City.* London, 128–51.

Bodel, J. 2008. "From Columbaria to Catacombs: Communities of the Dead in Pagan and Christian Rome." In Brink/Green, 177–242.

Bonamente, G., and F. Fusco, eds. 1993. *Costantino il Grande: dall'antichità all'umanesimo.* Macerata.

Bonnemaison, S., and C. Macy, eds. 2008. *Festival Architecture.* London and New York.

Bordini, G. F. 1588. *De rebus praeclare gestis a Sixto V.* Rome.

Borg, B. 2013. *Crisis and Ambition: Tombs and Burial Customs in Third-Century CE Rome.* Oxford.

Bosio, A. 1632. *Roma sotterranea.* Rome.

Bovini, G. 1948. *La proprietà ecclesiastica e la condizione giuridica della Chiesa in età precostantiniana.* Milan.

Bowersock, G. W. 2005. "Peter and Constantine." In Tronzo, 5–15.

Bowes, K. 2008. "Early Christian Archaeology: A State of the Field." *Religion Compass* 2, 575–619.

Bradley, M., and K. R. Stow, eds. 2012. *Rome, Pollution and Propriety.* Cambridge.

Brancia di Apricena, M. 2000. *Il complesso dell'Aracoeli sul Colle Capitolino (IX–XIX secolo).* Rome.

Brandenburg, H. 2005. *Ancient Churches of Rome from the Fourth to the Seventh Century.* Turnhout.

Brandizzi Vittucci, P. 1991. "L'emiciclo nel Circo Massimo nell'utilizzazione post classica." *MEFRM* 103.1, 7–40.

Brandt, O. 1997–1998. "Il battistero lateranense da Costantino a Ilaro. Un riesame degli scavi." *OpRom* 22–23, 7–65.

Brandt, O. 2004. "Jews and Christians in Late Antique Rome and Ostia: Some Aspects of Archaeological Evidence." *OpRom* 29, 7–27.

Brandt, O. 2014. "The Archaeology of Roman Ecclesial Architecture and the Study of Early Christian Liturgy." *Studia Patristica* 71, 21–52.

Brenk, B. 1996. "Spolien und ihre Wirkung auf die Ästhetik der varietas. Zum Problem alternierender Kapitelltypen." In J. Poeschke, ed., *Antike Spolien in der Architektur des Mittelalters und der Renaissance.* Munich, 49–92.

Brentano, R. 1991. *Rome before Avignon: A Social History of Thirteenth-Century Rome.* Berkeley.

Brink, L., and D. Greene, eds. 2008. *Roman Burial and Commemorative Practices and Earliest Christianity.* Berlin and New York.

Brocchi, G. 1820. *Dello stato fisico del suolo di Roma.* Rome.

Broise, H., and V. Jolivet. 1996. "Dalle antiche terrazze del Pincio." In L. Cardilli Alloisi and A. M. Cerioni, eds., *La scalinata di Trinità dei Monti.* Milan, 7–42.

Broise, H., and V. Jolivet. 1998. "Il giardino e l'acqua: l'esempio degli horti Luculliani." In Cima/La Rocca, 189–202.

Bruun, C. 1991. *The Water Supply of Ancient Rome: A Study in Roman Imperial Administration.* Helsinki.

Bruun, C. 1999. "Imperial Procuratores and Dispensatores: New Discoveries." *Chiron* 29, 29–42.

Bruun, C. 2003. "The Antonine Plague in Rome and Ostia." *JRA* 16, 426–34.

Bruun, C. 2006. "Der Kaiser und die stadtrömischen 'curae': Geschichte und Bedeutung." In A. Kolb, ed., *Herrschaftsstrukturen und Herrschaftspraxis.* Berlin, 89–114.

Bruun, C. 2007. "Aqueductium e statio aquarum. La sede della cura aquarum." In Leone/ Palombi/Walker, 1–14.

Bufalini, L. 1911. *Roma al tempo di Giulio III: la pianta di Roma di Leonardo Bufalini.* Rome.

Burgarella, F. 2002. "Presenze greche a Roma: aspetti culturali e religiosi." In *Roma fra Oriente e Occidente.* Spoleto, 943–88.

Burroughs, C. 1990. *From Signs to Design.* Cambridge, MA.

Burroughs, C. 1994. "Absolutism and the Rhetoric of Topography: Streets in the Rome of Sixtus V." In Çelik/Favro/Ingersoll, 189–202.

Buzzetti, C. 1968. "Nota sulla Topografia dell'Ager Vaticanus." *Quaderni dell'Istituto della Università di Roma* 5, 105–11.

Cacchiatelli, P. 1863. *Le scienze e le arti sotto il pontificato di Pio IX.* Rome.

Cafà, V. 2010. "The Via Papalis in Early Cinquecento Rome: A Contested Space between Roman Families and Curials." *Urban History* 37.3, 434–51.

Cajano, E. 2006. *Il sistema dei forti militari a Roma.* Rome.

Camerlenghi, N. 2007. *The Life of the Basilica of San Paolo Fuori le Mura in Rome: Architectural Renovations from the Ninth to the Nineteenth Centuries.* Ph.D. dissertation, Princeton University.

Cancellieri, F. 1802. *Storia de' solenni possessi de' sommi pontefici.* Rome.

Cancellieri, F. 1811. *Il mercato, il lago dell'acqua vergine, ed il Palazzo Panfiliano nel Circo Agonale detto volgarmente Piazza Navona.* Rome.

Capgrave, J. 1911. *Ye Solace of Pilgrims: A Description of Rome, circa A.D. 1450.* London.

Capogrossi Guarna, B. 1873. *I mercati di Roma.* Rome.

Caracciolo, A. 1999. *Roma capitale: dal Risorgimento alla crisi dello stato liberale,* 5th ed. Rome.

Carafa, P. 1998. *Il Comizio di Roma dalle origini all'età di Augusto.* Rome.

Carandini, A. 1985. "Hortensia. Orti e frutetti intorno a Roma." In R. Bussi and V. Vandelli, eds., *Misurare la terra: centuriazione e coloni nel mondo romano: città, agricoltura, commercio.* Modena, 66–74.

Carandini, A. 2011. *Rome: Day One.* Princeton.

Carbonetti Vendittelli, C. 1990. "Documentazione inedita riguardante i magistri edificiorum urbis e l'attività della loro curia nei secoli XIII e XIV." *ASRSP* 113, 169–88.

Carettoni, G., A. M. Colini, L. Cozza, and G. Gatti. 1960. *La pianta marmorea di Roma antica: forma urbis Romae.* Rome.

Cariou, G. 2009. *La naumachie: morituri te salutant.* Paris.

Cassio, A. 1756–1757. *Corso dell'acque antiche, portate da lontane contrade fuori e dentro Roma sopra XIV acquidotti, e delle moderne in essa nascenti,* 2 vols. Rome.

Cassiodorus. 1886. *The Letters of Cassiodorus.* Introduction by T. Hodgkin. London.

Castagnoli, F. 1969. *Topografia e urbanistica di Roma antica.* Bologna.

Castagnoli, F. 1992. *Il Vaticano nell'antichità classica.* Vatican City.

Cecchelli, C. 1951. *La vita di Roma nel Medio Evo.* Rome.

Cederna, A. 1979. *Mussolini urbanista: lo sventramento di Roma negli anni del consenso.* Rome and Bari.

Ceen, A. 1986. *The Quartiere de' Banchi: Urban Planning in Rome in the First Half of the Cinquecento.* New York.

Ceen, A. 1991. *Rome 1748: la pianta grande di Roma di Giambattista Nolli in facsimile,* 2nd ed. Highmount, NY.

Ceen, A. 2009. "The Urban Setting of the Pantheon." In G. Grasshoff, M. Heinzelmann, and M. Wäfler, eds., *The Pantheon in Rome: Contributions.* Bern, 127–38.

Çelik, Z., D. Favro, and R. Ingersoll, eds. 1994. *Streets: Critical Perspectives on Public Space.* Berkeley.

Cerasoli, F. 1900. "Notizie circa la sistemazione di molte strade di Roma nel secolo XVI." *BullCom* 28, 342–62.

Chastagnol, A. 1960. *La prefecture urbaine à Rome sous le Bas-Empire.* Paris.

Chastel, A. 1983. *The Sack of Rome, 1527.* Princeton.

Chiesa, A., and B. Gambarini. 1746. *Delle cagioni e de' rimedi delle inondazioni del Tevere.* Rome.

Choay, F. 2001. *The Invention of the Historic Monument.* New York.

Ciampi, N. 1955. "La Villa dei Gordiani." *Capitolium* 30.4, 97–102.

Ciancio Rossetto, P. 2006. "Il nuovo frammento della forma severiana relativo al Circo Massimo." In Meneghini/Santangeli Valenzani 2006, 127–41.

Cifani, G. 2008. *Architettura romana arcaica.* Rome.

Cima, M. 1998. "Gli horti Liciniani: una residenza imperiale della tarda antichità." In Cima/ La Rocca, 425–52.

Cima, M., and E. La Rocca, eds. 1986. *Le tranquille dimore degli dei: la residenza imperiale degli Horti Lamiani.* Venice.

Cima, M., and E. La Rocca, eds. 1998. *Horti romani. Atti del convegno internazionale, Roma, 4–6 maggio 1995.* Rome.

Cima, M., and E. Talamo. 2008. *Gli horti di Roma antica.* Milan.

Cioccetti, U. 1958. "Il morte di Pio XII." *Capitolium* 33.11, 4–17.

Claridge, A. 1993. "Hadrian's Column of Trajan." *JRA* 6, 5–22.

Claridge, A. 1998. *Rome: An Oxford Archaeological Guide.* Oxford.

Claridge, A. 2007. "Hadrian's Lost Temple of Trajan." *JRA* 20, 55–94.

Clauss, M. 2000. *The Roman Cult of Mithras: The God and His Mysteries.* New York.

Closs, V. M. 2013. *While Rome Burned: Fire, Leadership, and Urban Disaster in the Roman Cultural Imagination.* Ph.D. dissertation, University of Pennsylvania.

Coarelli, F. 1971–1972. "Il complesso pompeiano nel Campo Marzio e la sua decorazione scultorea." *Rendiconti della Pontificia Accademia di Archeologia* 44, 99–122.

Coarelli, F. 1977. "Public Building in Rome between the Second Punic War and Sulla." *PBSR* 45, 1–23.

Coarelli, F. 1986. "L'urbs e il suburbium." In Giardina, 1–58.

Coarelli, F. 1987. "La situazione edilizia di Roma sotto Severo Alessandro." In *L'Urbs,* 429–56.

Coarelli, F. 1988. *Il Foro Boario dalle origini alla fine della Repubblica.* Rome.

Coarelli, F. 1992. *Il Foro Romano,* 2 vols., 3rd ed. Rome.

Coarelli, F. 1993. "I luci del Lazio: la documentazione archeologica." In *Les bois sacrés: Actes du colloque international.* Naples, 45–52.

Coarelli, F. 1997a. *Il Campo Marzio dalle origini alla fine della Repubblica.* Rome.

Coarelli, F. 1997b. "La consistenza della città nel periodo imperiale: pomerium, vici, insulae." *LRI,* 89–109.

Coarelli, F. 1999. "L'edilizia pubblica a Roma in età tetrarchica." In W. V. Harris, ed., *The Transformations of Urbs Roma in Late Antiquity.* Portsmouth, RI, 23–33.

Coarelli, F. 2007a. "Horrea Cornelia?" In Leone/Palombi/Walker, 41–46.

Coarelli, F. 2007b. *Rome and Environs: An Archaeological Guide.* Berkeley.

Coarelli, F. 2011. *Le origini di Roma: la cultura artistica dalle origini al III secolo a.C.* Milan.

Coarelli, F. 2012. *Palatium. Il Palatino dalle origini all'impero.* Rome.

Coates-Stephens, R. 1996. "Housing in Early Medieval Rome, 500–1000 AD." *PBSR* 64, 239–59.

Coates-Stephens, R. 1997. "Dark Age Architecture in Rome." *PBSR* 65, 177–232.

Coates-Stephens. 1998. "The Walls and Aqueducts of Rome in the Early Middle Ages, A.D. 500–1000." *JRS* 88, 166–78.

Coates-Stephens, R. 2004. *Porta Maggiore: Monument and Landscape: Archaeology and Topography of the Southern Esquiline from the Late Republican Period to the Present.* Rome.

Coates-Stephens, R. 2007. "The Reuse of Ancient Statuary in Late Antique Rome and the End of the Statue Habit." In F. A. Bauer and C. Witschel, eds., *Statuen in der Spätantike.* Wiesbaden, 171–87.

Cocchioni, C., M. De Grassi, and A. M. Vittori, eds. 1984. *La casa popolare a Roma: trent'anni di attività dell'I.C.P.* Rome.

Coffin, D. 1979. *The Villa in the Life of Renaissance Rome.* Princeton.

Coffin, D. 1991. *Gardens and Gardening in Papal Rome.* Princeton.

Cohen, E. S. 1998. "Seen and Known: Prostitutes in the Cityscape of Late Sixteenth-Century Rome." *Renaissance Studies* 12.3, 392–409.

Cohen, T. V., and E. S. Cohen. 1993. *Words and Deeds in Renaissance Rome: Trials before the Papal Magistrates.* Toronto.

Coleman, K. M. 1990. "Launching into History: Aquatic Displays in the Early Empire." *JRS* 83, 48–74.

Coleman, K. M. 2000. "Entertaining Rome." In Coulston/Dodge, 210–58.

Coleman, K. M. 2003. "Euergetism in Its Place: Where Was the Amphitheatre in Augustan Rome?" in K. Lomas and T. Cornell, eds., *'Bread and Circuses': Euergetism and Municipal Patronage in Roman Italy.* London, 61–88.

Colini, A. M., and I. Gismondi. 1944. *Storia e topografia del Celio nell'antichità.* Rome.

Collins, J. L. 2004. *Papacy and Politics in Eighteenth-Century Rome: Pius VI and the Arts.* Cambridge and New York.

Comune di Roma. 1883. *Piano regolatore e di ampliamento della città di Roma.* Rome.

Comune di Roma. 1925–1976. *Capitolium: rassegna mensile del Governatorato di Roma.* Rome.

Comune di Roma. 1959. *Piano regolatore generale della città di Roma.* Rome.

Comune di Roma. 2003. *Piano regolatore generale di Roma.* Rome.

Connolly, P., and H. Dodge. 1998. *The Ancient City: Life in Classical Athens and Rome.* Oxford and New York.

Connors, J. 1989. *Alliance and Enmity in Roman Baroque Urbanism.* Tübingen.

Connors, J., and L. Rice, eds. 1991. *Specchio di Roma barocca: una guida inedita del XVII secolo,* 2nd ed. Rome.

Conway, C. P. M. 2006. "Aurelian's Bellum Monetariorum: An Examination." *Past Imperfect* 12. http://ejournals.library.ualberta.ca/index.php/pi/article/view/1578/1104.

Cooper, K., and J. Hillner, eds. 2007. *Religion, Dynasty, and Patronage in Early Christian Rome, 300–900.* Cambridge and New York.

Cornell, T. J. 1995. *The Beginnings of Rome: Italy and Rome from the Bronze Age to the Punic Wars (ca. 1000–264 B.C.).* London and New York.

Cornell, T. J. 2000. "The City of Rome in the Mid-Republic." In Coulston/Dodge, 42–60.

Costambeys, M. 2001. "Burial Topography and the Power of the Church in Fifth- and Sixth-Century Rome." *PBSR* 69, 169–89.

Coulston, J., and H. Dodge, eds. 2000. *Ancient Rome: The Archaeology of the Eternal City.* Oxford.

Courtenay, W. T. 2003. Un fiume per Roma Capitale: *The Socio-Political Landscape of the Tiber Embankment, 1870-1910.* Master's thesis, University of Wisconsin-Madison.

Cozza, L., and P. L. Tucci. 2006. "Navalia." *ArchCl* 57, 175–202.

Crescimbeni, G. M. 1719. *Stato della basilica diaconale, collegiata, e parrocchiale di S. Maria in Cosmedin di Roma nel presente anno MDCCXIX.* Rome.

Cristofani, M., ed. 1990. *La grande Roma dei Tarquini*. Rome.

Crocco, M. 2002. *Roma, Via Felice: da Sisto V a Paolo V*. Rome.

Cross, F. L. and E. Livingstone, eds. 2005. *The Oxford Dictionary of the Christian Church*. 3rd ed. Oxford and New York.

Cuccia, G. 1991. *Urbanistica, edilizia, infrastrutture di Roma capitale, 1880–1990: una cronologia*. Rome and Bari.

Cullhed, M. 1994. *Conservator Urbis Suae: Studies in the Politics and Propaganda of the Emperor Maxentius*. Stockholm.

Curran, B., A. Grafton, P. Long, and B. Weiss. 2009. *Obelisks: A History*. Cambridge, MA.

Curran, J. R. 2000. *Pagan City and Christian Capital: Rome in the Fourth Century*. Oxford and New York.

Daguet-Gagey, A. 1997. *Les "opera pvblica" à Rome (180–305 ap. J.-C.)*. Paris.

D'Ambra, E. 2010. "The Imperial Funerary Pyre as a Work of Ephemeral Architecture." In Ewald/Noreña, 289–308.

Dandelet, T. 2001. *Spanish Rome, 1500–1700*. New Haven and London.

Danti, A. 2001. "L'indagine archeologica nell'area del tempio di Giove Capitolino." *BullCom* 102, 323–46.

Darwall-Smith, R. 1996. *Emperors and Architecture: A Study of Flavian Rome*. Brussels.

Davies, P., D. Hemsoll, and M. Wilson Jones. 1987. "The Pantheon: Triumph of Rome or Triumph of Compromise?" *Art History* 10, 133–53.

Davies, P. J. E. 2000. *Death and the Emperor: Roman Imperial Funerary Monuments from Augustus to Marcus Aurelius*. Cambridge and New York.

Davies, P. J. E. 2006. "Exploring the International Arena: The Tarquins' Aspirations for the Temple of Jupiter Optimus Maximus." In C. Mattusch and A. Donohue, eds., *Common Ground: Proceedings of the XVIth International Congress of Classical Archaeology*. Oxford, 186–89.

Davies, P. J. E. 2007. "The Personal and the Political." In S. Alcock and R. Osborne, eds., *Classical Archaeology*. Chichester and West Malden, MA, 307–34.

Davies, P. J. E. 2012a. "The Archaeology of Mid-Republican Rome: The Emergence of a Mediterranean Capital." In *CARR*, 441–58.

Davies, P. J. E. 2012b. "Pollution, Propriety and Urbanism in Republican Rome." In Bradley/Stow, 67–80.

DeLaine, J. 1997. *The Baths of Caracalla: A Study in the Design, Construction and Economics of Large-Scale Building Projects in Imperial Rome*. Portsmouth, RI.

Delogu, Paolo. 2000. "The Papacy, Rome and the Wider World in the Seventh and Eighth Centuries." In Smith 2000, 197–220.

Delumeau, J. 1957–1959. *Vie économique et sociale de Rome dans la seconde moitié du XVIᵉ siècle*, 2 vols. Paris.

De Rossi, G. B. 1864. *La Roma sotterranea cristiana*. Rome.

De Santis, A., G. Mieli, C. Rosa, R. Matteucci, A. Celant, C. Minniti, P. Catalano, F. De Angelis, S. Giannantonio, C. Giardino, and P. Giannini. 2010. "Le fasi di occupazione nell'area centrale di Roma nell'età protostorica: nuovi dati dagli scavi nel Foro di Cesare." *Scienza dell'antichità* 16, 259–84.

Deseine, F. 1704. *Beschryving van ous en niew Rome*. Amsterdam.

D'Espouy, H., and G. Seure. 1910–1912. *Monuments antiques relevés et restaurés par les architectes pensionnaires de l'Académie de France à Rome*, 3 vols. Paris.

Dey, H. 2008. "Diaconiae, Xenodochia, Hospitalia and Monasteries: 'Social Security' and the Meaning of Monasticism in Early Medieval Rome." *Early Medieval Europe* 16.4, 398–422.

Dey, H. 2011. *The Aurelian Wall and the Refashioning of Imperial Rome, 271–855.* Cambridge and New York.

Dilke, O. A. W. 1985. *Greek and Roman Maps.* Ithaca.

Di Martino, V., and M. Belati. 1980. *Qui arrivò il Tevere: le inondazioni del Tevere nelle testimonianze e nei ricordi storici (lapidi, idrometri, cronache, immagini).* Rome.

D'Onofrio, C. 1978. *Castel Sant'Angelo e Borgo tra Roma e Papato.* Rome.

D'Onofrio, C. 1980. *Il Tevere: l'isola tiberina, le inondazioni, i molini, i porti, le rive, i muraglioni, i ponti di Roma.* Rome.

D'Onofrio, C. 1986. *Le fontane di Roma.* 3rd ed. Rome.

D'Onofrio, C. 1992. *Gli obelischi di Roma: storia e urbanistica di una città dall'età antica al XX secolo.* Rome.

Dosio, G. A. 1561. *Sebastianus a regibus clodiensis.* Rome.

Drijvers, J. W. 2007. "Eusebius' *Vita Constantini* and the Construction of the Image of Maxentius." In H. Amirav and R. B. ter Haar Romeny, eds., *From Rome to Constantinople: Studies in Honour of Averil Cameron.* Leuven and Dudley, MA, 11–27.

Duchesne, L. 1886–1892. *Le Liber pontificalis,* 2 vols. Paris.

Dumser, E. 2005. *The Architecture of Maxentius: Architectural Design and Urban Planning in Early Fourth-Century Rome.* Ph.D. dissertation, University of Pennsylvania.

Dupérac, Etienne. 1575. *I vestigi dell'antichità di Roma.* Rome.

Dupérac, Etienne. 1577. *Nova urbis Romae descriptio.* Rome.

Dyson, S. 2010. *Rome: A Living Portrait of an Ancient City.* Baltimore.

Eck, W. 1992. "*Cura viarum* und *cura operum publicorum* als kollegiale Ämter im frühen Prinzipat." *Klio* 74, 237–45.

Eck, W. 1997. "Cum dignitate otium: Domus in Imperial Rome." *Scripta Classica Israelica* 16, 162–90.

Eck, W. 2009. "The Administrative Reforms of Augustus: Pragmatism or Systematic Planning?" In Edmondson, 229–49.

Edlund-Berry, I. 2012. "Early Rome and the Making of 'Roman' Identity through Architecture and City Planning." In *CARR,* 406–25.

Edmondson, J., ed. 2009. *Augustus.* Edinburgh.

Egger, H., and C. Hülsen, eds. 1913–1916. *Die römischen Skizzenbücher von Marten van Heemskerck.* Berlin.

Egger, H., C. Hülsen, and A. Michaelis, eds. 1906. *Codex Escurialensis: Ein Skizzenbuch aus der Werkstatt Domenico Ghirlandaios.* Vienna.

Egidi, R. 2010. "L'Area di Piazza Venezia: nuovi dati topografici." In Egidi/Filippi/Martone, 93–127.

Egidi, R., F. Filippi, and S. Martone, eds. 2010. *Archeologia e infrastrutture: il tracciato fondamentale della linea C della metropolitana di Roma: prime indagini archeologiche.* Florence.

Ehrle, F. 1890. *De historia palatii Romanorum Pontificium Avenionensis commentatio.* Rome.

Ehrle, F. 1935. *Der vaticanische Palast und seiner Entwicklung bis zur Mitte des XV. Jahrhunderts.* Vatican City.

Ehrle, F. 1956. *Piante e vedute di Roma e del Vaticano dal 1300 al 1676.* Vatican City.

Economou, A. J. 2007. *Byzantine Rome and Greek Popes: Eastern Influences on Rome and the Papacy from Gregory the Great to Zacharias, A. D. 590–752.* Lanham, MD.

Ensoli, S., and E. La Rocca, eds. 2001. *Aurea Roma: dalla città pagana alla città cristiana.* Rome.

Erdkamp, P., ed. 2013. *The Cambridge Companion to Ancient Rome.* Cambridge and New York.

Esch, A. 2000. *Rome entre le Moyen Age et la Renaissance.* Stuttgart.

Esposito, A., L. Palermo, and A. Esch. 2005. *Economia e società a Roma tra Medioevo e Rinascimento*. Rome.

Etlin, R. A. 1991. *Modernism in Italian Architecture, 1890–1940*. Cambridge, MA.

Evans, H. B. 1985. "Agrippa's Water Plan." *AJA* 86, 401–11.

Evans, H. B. 1994. *Water Distribution in Ancient Rome: The Evidence of Frontinus*. Ann Arbor.

Evans, H. B. 2002. *Aqueduct Hunting in the Seventeenth Century: Raffaello Fabretti's* De aquis et aquaeductibus veteris Romae. Ann Arbor.

Evelyn, J. 1955. *Diary*, 6 vols. Oxford.

Ewald, B. C., and C. F. Noreña, eds. 2010. *The Emperor and Rome: Space, Representation, and Ritual*. Cambridge.

Fabretti, R. 1680. *De aquis et aquaeductibus veteris Romae dissertationes tres*. Rome.

Fagiolo dell'Arco, M. 1997. *La festa barocca*. Rome.

Fagiolo, M., M. L. Madonna, and L. Armenante. 1985. *Roma sancta: la città delle basiliche*. Rome.

Falda, G. B. 1669. *Il terzo libro del novo teatro delle chiese di Roma*. Rome.

Falda, G. B. 1670. *Li giardini di Roma*. Rome.

Falda, G. B. 1676. *Nuova pianta della città di Roma con tutte le strade, piazze, e edificii de tempii*. Rome.

Falesiedi, U. 1995. *Le diaconie: i servizi assistenziali nella Chiesa antica*. Rome.

Fant, J. C. 2001. "Rome's Marble Yards." *JRA* 14, 167–98.

Fauno, L. 1548. *Delle antichità della città di Roma*. Venice.

Favro, D. 1994. "The Street Triumphant: The Urban Impact of Roman Triumphal Parades." In Çelik/Favro/Ingersoll, 151–64.

Favro, D. 1996. *The Urban Image of Augustan Rome*. Cambridge and New York.

Favro, D. 2005. "Making Rome a World City." In K. Galinsky, ed., *The Cambridge Companion to the Age of Augustus*. Cambridge and New York, 234–63.

Favro, D. 2014. "Moving Events: Curating the Memory of the Roman Triumph." In K. Galinsky, ed., *Memoria Romana: Memory in Rome and Rome in Memory*. Rome, 85-102.

Fea, C. 1832. *1. Storia delle acque antiche sorgenti in Roma perdute, e modo di ristabilirle; 2. Dei condotti antico-moderni delle acque Vergine, Felice, e Paola, e loro autori*. Rome.

Ferrari, G. 1957. *Early Roman Monasteries: Notes for the History of the Monasteries and Convents at Rome from the V Through the X Century*. Vatican City.

Ferrua, A. 1975. *Coemeteria in viis Latina, Labicana et Praenestina*. Vatican City.

Ferrua, A. 1990. *La basilica a la catacomba di San Sebastiano*. Vatican City.

Filippi, F. 2010. "Le indagini in Campo Marzio occidentale: nuovi dati sulla topografia antica: il ginnasio di Nerone (?) e l' Euripus." In Egidi/Filippi/Martone, 39–92.

Filippi, G. 2004. "La tomba di San Paolo e le fasi della basilica tra il IV e VII secolo." *BollettinoMMGP* 24, 187–224.

Finch, M. 1991. "The Cantharus and Pigna at Old St. Peter's." *Gesta* 30, 16–26.

Fiocchi Nicolai, V. 2009. "The Origin and Development of Roman Catacombs." In V. Fiocchi Nicolai, F. Bisconti, and D. Mazzoleni, eds., *The Christian Catacombs of Rome: History, Decoration, Inscriptions*, 3rd ed. Regensburg, 9–69.

Fiocchi Nicolai, V., and P. Pergola. 1986. "Il territorio della catacomba di Pretestato sulla via Appia: progetto di studio." In Giardina, 349–50, 489–90.

Florio, G. 1939. "La mostra dell'abitazione dell'E42." *Capitolium* 14.8–9, 371–96.

Foglietta, G. B. 1878. "Discorso del mattonato o selicato di Roma." *ASRSP* 109, 141–50.

Fontana, D. 1590. *Della trasportazione dell'obelisco Vaticano et delle fabriche di nostro signore Papa Sisto V*. Rome.

Forcella, V. 1885. *Tornei e giostre, ingressi trionfali e feste carnevalesche in Roma sotto Paolo III*. Rome.

Fortini, P., and M. Taviani, eds. 2014. *In Sacra Via: Giacomo Boni al Foro Romano. Gli scavi nei documenti della Soprintendenza*. Milan.

Fosi, I. 2002. "The Court and the City in the Ceremony of the *Possesso* in the Sixteenth Century." In Signorotto/Visceglia, 31–52.

Fragnito, G. 1993. "Cardinal's Courts in Sixteenth-Century Rome." *Journal of Modern History* 65.1, 26–56.

Franzini, F. 1643. *Descrittione di Roma antica e moderna*. Rome.

Fried, R. C. 1973. *Planning the Eternal City: Roman Politics and Planning Since World War II*. New Haven.

Frier, B. 1982. "Roman Life Expectancy: Ulpian's Evidence." *Harvard Studies in Classical Philology* 86, 213–51.

Frommel, C. L. 1973. *Der Römische Palastbau der Hochrenaissance*, 3 vols. Tübingen.

Frosini, P. 1977. *Il Tevere: Le inondazioni di Roma e i provvedimenti presi dal governo italiano per evitarle*. Rome.

Frugoni, A. 1957. *Vita di Cola di Rienzo*. Florence.

Frugoni, A. 1999. *Il giubileo di Bonifacio VIII*. Rome.

Fulminante, F. 2014. *The Urbanization of Rome and Latium Vetus: From the Bronze Age to the Archaic Era*. Cambridge and New York.

Fulvio, A. 1527. *Antiquitates urbis*. Rome.

Fulvio, A. 1588. *L'antichità di Roma (Antiquitates urbis)*. Annotated by G. Ferrucci. Venice.

Funiciello, R., A. Praturion, and G. Giordano. 2008. *La geologia di Roma dal centro storico alla periferia*. Florence.

Gabucci, A., and F. Coarelli, eds. 2001. *The Colosseum*. Los Angeles.

Gagliardo, M. C., and J. F. Packer. 2006. "A New Look at Pompey's Theater: History, Documentation, and Recent Excavation." *AJA* 110, 93–122.

Gamrath, H. 1987. *Roma sancta renovata: Studi sull'urbanistica di Roma nella seconda metà del sec. XVI con particolare riferimento al pontificato di Sisto V (1585–1590)*. Rome.

Gasparri, S. 2001. "Roma e i Longobardi." In *Roma nell'alto Medioevo*, 219–47.

Gatti, E. 1917. "Roma. Scoperte di antichità a Piazza Colonna." *NSc* (1917), 9–20.

Gatti, G. 1934. "Il Mausoleo di Augusto: studio di ricostruzione." *Capitolium* 10.9, 457–64.

Gatti, G. 1936. "L'arginatura del Tevere a Marmorata." *BullCom* 64, 55–82.

Gatti, G. 1979. "Il teatro e la crypta di Balbo in Roma." *MEFRA* 91, 237–313.

Geiger, J. 2008. *The First Hall of Fame: A Study of the Statues in the Forum Augustum*. Leiden and Boston.

Gensini, S., ed. 1994. *Roma capitale (1447–1527)*. Rome.

Gentilcore, D. 2012. "Purging Filth: Plague and Responses to It in Rome, 1656–7." In Bradley/Stow, 153–68.

Giardina, A., ed. 1986. *Società romana e impero tardoantico*. Vol. 2: *Roma: politica, economia, paesaggio urbano*. Bari.

Giavarini, C., and C. M. Amici, eds. 2005. *The Basilica of Maxentius: The Monument, Its Materials, Construction, and Stability*. Rome.

Gigli, G. 1958. *Diario romano (1608–1670)*. Rome.

Giglioli, G. Q. 1937. "Il problema archeologico del Teatro di Pompeo e il Corso del Rinascimento–Parere dell'on. prof. Giulio Quirino Giglioli." *Capitolium* 12.2, 105–6.

Girardi, F., G, Spagnesi, and F. Gorio. 1974. *L'Esquilino e la Piazza Vittorio: una struttura urbana dell'Ottocento*. Rome.

Gjerstad, E. 1941. "Il Comizio romano dell'età repubblicana." *Opuscula archaeologica* 2, 97–158.

Gjerstad, E. 1953–1973. *Early Rome,* 6 vols. Lund.

Gleason, K. L. 1994. "Porticus Pompeiana: A New Perspective on the First Public Park of Ancient Rome." *Journal of Garden History* 14, 13–27.

Gleason, K. L., ed. 2014. *A Cultural History of Gardens in Antiquity.* London.

Goidanich, P. G. 1943. "L'iscrizione arcaica del Foro Romano e il suo ambiente archeologico." *Atti della Reale Accademia d'Italia, Memorie della Classe di Scienze Morali,* ser. 7, 3, fasc. 7 (1943), 317–501.

Gosselin, J. E. A. 1853. *The Power of the Pope during the Middle Ages.* Translated by M. Kelly. London.

Governatorato di Roma. 1931. *Piano regolatore di Roma anno IX.* Milan/Rome/Treves/Treccani.

Grasshoff, G., M. Heinzelmann, and M. Wäfler, eds. 2009. *The Pantheon in Rome: Contributions to the Conference, Bern, November 9–12, 2006.* Bern.

Gregorovius, F. 1894–1902. *History of the City of Rome in the Middle Ages.* 8 vols. London.

Grimal, P. 1984. *Les jardins romains.* 3rd ed. Paris.

Gros, P., and M. Torelli. 2007. *Storia dell'urbanistica: il mondo romano,* 3rd ed. Rome and Bari.

Gross, H. 1990. *Rome in the Age of Enlightenment.* Cambridge and New York.

Guarini, E. F. 2002. "Rome, Workshop of All the Practices in the World." In Signorotto/Visceglia, 53–77.

Guicciardini, L. 1993. *The Sack of Rome.* Translated by J. McGregor. New York.

Guidobaldi, F. 1986. "L'edilizia abitativa unifamiliare nella Roma tardoantica." In Giardina, 165–237.

Guidoni, E., ed. 2007. *L'urbanistica di Roma dal Medioevo al novecento.* Rome.

Günther, H. 1989. "La nascita di Roma moderna: urbanistica del Rinascimento a Roma." *Publications de L'Ecole Française de Rome* 122, 381–406.

Gütschow, M. 1938. *Das Museum der Prätextat-Katakombe.* Vatican City.

Habel, D. M. 2002. *The Urban Development of Rome in the Age of Alexander VII.* New York.

Habel, D. M. 2013. *'When All Rome Was Under Construction': The Building Process in Baroque Rome.* University Park, PA.

Hales, S. 2013. "Republican Houses." In *CARR,* 50–66.

Hamilton, B. 1961. "The City of Rome and the Eastern Churches in the Tenth Century." *Orientalia christiana periodica* 27, 5–26.

Hamilton, B. 1962. "The Monastic Revival in Tenth-Century Rome." *Studia monastica* 4, 35–68.

Hamilton, B. 1979. *Monastic Reform, Catharism and the Crusades, 900–1300.* London.

Hansen, M. F. 2003. *The Eloquence of Appropriation: Prolegomena to an Understanding of Spolia in Early Christian Rome.* Rome.

Harries, J. 1992. "Death and the Dead in the Late Roman West." In S. Bassett, ed., *Death in Towns: Urban Responses to the Dying and the Dead, 100–1600.* Leicester and New York, 56–65.

Harris, W. V., ed. 1999. *The Transformations of Urbs Roma in Late Antiquity.* Portsmouth, RI.

Hartswick, K. 2004. *The Gardens of Sallust: A Changing Landscape.* Austin.

Haselberger, L. 1995. "Deciphering a Roman Blueprint." *Scientific American* (June 1995), 56–61.

Haselberger, L., D. G. Romano, and E. A. Dumser, eds. 2002. *Mapping Augustan Rome.* Portsmouth, RI.

Heiken, G., R. Funiciello, and D. De Rita. 2005. *The Seven Hills of Rome: A Geological Tour of the Eternal City.* Princeton.

Heilmann, C. H. 1970. "Acqua Paola and the Urban Planning of Paul V Borghese." *The Burlington Magazine* 112. 656–63.

Hertling, L., and E. Kirschbaum. 1956. *The Roman Catacombs and Their Martyrs.* Milwaukee.

Hesberg, H. von. 1987. "Planung und Ausgestaltung der Nekropolen Roms im 2 Jh. n. Chr." In Hesberg/Zanker, 43–60.

Hesberg, H. von. 2004. "Die Domus Imperatoris der neronischen Zeit auf dem Palatin." In Hoffmann/Wulf, 59–74.

Hesberg, H. von and P. Zanker, eds. 1987. *Römische Gräberstrassen.* Munich.

Hetland, L. 2007. "Dating the Pantheon." *JRA* 20, 95–112.

Hibbard, H. 1962. *The Architecture of the Palazzo Borghese.* Rome.

Hibbert, C. 1985. *Rome, the Biography of a City.* New York.

Hillner, J. 2007. "Families, Patronage, and the Titular Churches of Rome." In Cooper/Hillner, 225–61.

Hodge, A. T., and D. Blackman, eds. 2001. *Frontinus' Legacy: Essays on Frontinus'* De aquis urbis Romae. Ann Arbor.

Hoffmann, A., and U. Wulf. 2004. "Bade- oder Villenluxus? – Zur Neuinterpretation der 'Domus Severiana.'" In Hoffmann/Wulf, 153–71.

Hoffmann, A., and U. Wulf, eds. 2004. *Die Kaiserpaläste auf dem Palatin in Rom.* Mainz.

Holloway, R. R. 1994. *The Archaeology of Early Rome and Latium.* London and New York.

Holloway, R. R. 2004. *Constantine and Rome.* New Haven.

Hölscher, T. 2009. "Monuments of the Battle of Actium: Propaganda and Response." In Edmondson, 310–33.

Homo, L. 1934. *Rome médiévale, 476–1420: histoire – civilisation – vestiges.* Paris.

Hoogewerff, G. J. 1947. "Friezen, Franken en Saksen te Rome." *Mededelingen van het Nederlandsch Historisch Instituut te Rome,* 3.5, 1–70.

Hopkins, J. N. 2012a. "The 'Sacred Sewer': Tradition and Religion in the Cloaca Maxima." In Bradley/Stow, 81–102.

Hopkins, J. N. 2012b. "The Temple of Jupiter Optimus Maximus and the Effects of Monumentality on Roman Temple Design." In G. E. Meyers and M. L. Thomas, eds., *Monumentality in Etruscan and Early Roman Architecture: Ideology and Innovation.* Austin, 111–38.

Hopkins, J. N. 2016. *The Genesis of Roman Architecture.* New Haven.

Hopkins, K. 1983. "Death in Rome." In *Death and Renewal: Sociological Studies in Roman History.* Cambridge, 201–56.

Hopkins, K. 1998. "Christian Number and Its Implications." *JECS* 6.2, 185–226.

Hopkins, K., and M. Beard. 2005. *The Colosseum.* Cambridge, MA.

Hostetter, E., and J. R. Brandt, eds. 2009. *Palatine East Excavations,* Vol. 1. Rome.

Houston, G. 2003. "Galen, His Books and the Horrea Piperataria at Rome." *MAAR* 48, 45–51.

Howe, E. D. 1992. "Alexander VI, Pinturicchio, and the Fabrication of the Via Alessandrina in the Vatican Borgo." In Millon/Munshower, 1.65–93.

Hubert, E. 1990. *Espace urbain et habitat à Rome: du X^e siècle à la fin du XIII^e siècle.* Rome.

Hubert, E., and C. Carbonetti Vendittelli. 1993. *Rome au XIII^e et XIV^x siècles: cinq études.* Rome.

Hülsen, C. 1886. *Das Septizodium des Septimius Severus.* Berlin.

Hülsen, C. 1905. *Das Forum romanum: seine Geschichte und seine Denkmäler.* Rome.

Hülsen, C. 1907. *La pianta di Roma dell'anonimo einsidlense.* Rome.

Hülsen, C., ed. 1924. *S. Agata dei Goti.* Rome.

Hülsen, C. 2000. *Le chiese di Roma nel Medio Evo.* Rome, reprint of 1927 edition.

Humphrey, J. H. 1985. *Roman Circuses and Chariot Racing.* Berkeley.

Humphries, M. 2007. "From Emperor to Pope? Ceremonial, Space, and Authority at Rome from Constantine to Gregory the Great." In Cooper/Hillner, 21–58.

Hunt, J. 2016. *The Vacant See in Early Modern Rome: A Social History of the Papal Interregnum.* Leiden.

Hyde-Minor, H. 2011. *The Culture of Architecture in Enlightenment Rome.* College Station, PA.

"Un inferno chiamato baracca." 1970. *Capitolium* 45.1, 7–15.

Infessura, S. 1890. *Diario della città di Roma.* O. Tommasini, ed. Rome.

Ingersoll, R. 1985. *Ritual Use of Public Space in Renaissance Rome.* Ph.D. dissertation, University of California, Berkeley.

Ingersoll, R. 1994a. "Piazza di Ponte and the Military Origins of Panopticism." In Çelik/Favro/Ingersoll, 177–88.

Ingersoll, R. 1994b. "From the Center of the World to the Edge of the City." Unpublished.

Insolera, I. 1959. "Storia del primo piano regolatore di Roma 1870–1874." *Urbanistica* 27, 74–94.

Insolera, I. 1993. *Roma moderna: un secolo di storia urbanistica, 1870-1970,* revised ed. Turin.

Insolera, I. 2002. *Roma: immagini e realtà dal X al XX secolo.* 6th edition. Roma and Bari.

Insolera, I. 2011. *Roma moderna: da Napoleone I al XXI secolo,* revised ed. Turin.

Jacks, P. 2008. "Restauratio and Reuse: The Afterlife of Roman Ruins." *Places* 20.1, 10–20.

Jacobs, P. W., and D. A. Conlin. 2014. *Campus Martius: The Field of Mars in the Life of Ancient Rome.* Cambridge and New York.

Johnson, M. J. 1997. "Pagan-Christian Burial Practices of the Fourth Century: Shared Tombs?" *JECS* 5.1, 40–49.

Johrendt, J. 2012. *Il capitolo di San Pietro: i papi e Roma nei secoli XI–XIII.* Vatican City.

Jolivet, V. 1997. "Croissance urbaine et espaces verts à Rome." In *LRI,* 193–208.

Jones, K. B. 2009. "Rome's Uncertain Tiberscape: Tevereterno and the Urban Commons." In K. Rinne, ed., "*Aquae Urbis Romae:* Waters of Rome," Occasional Papers, no. 6. http://www3.iath.virginia.edu/waters.

Kalas, G. 2015. *The Restoration of the Roman Forum in Late Antiquity.* Austin.

Kallis, A. 2012. "The 'Third Rome' of Fascism: Demolitions and the Search for a New Urban Syntax." *Journal of Modern History* 84.1, 40–79.

Kardos, M.-J. 2001. "L'Vrbs de Martial. Recherches topographiques et littéraires autour des Épigrammes V, 20 et V, 22." *Latomus* 60, 387–413.

Karmon, D. 2007. "Printing and protecting ancient remains in the 'Speculum Romanae Magnificentiae.'" In R. Zorach, ed., *The Virtual Tourist in Renaissance Rome.* Chicago, 37–51.

Karmon, D. 2011. *The Ruin of the Eternal City: Antiquity and Preservation in Renaissance Rome.* New York.

Katermaa-Ottela, A. 1981. *Le casetorri medievali in Roma.* Helsinki.

Katz, R. 2003. *The Battle for Rome: The Germans, the Allies, the Partisans and the Pope, September 1943–June 1944.* New York.

Kellum, B. 1999. "The Spectacle of the Street." In B. Bergmann and C. Kondoleon, eds., *The Art of Ancient Spectacle.* New Haven and London, 283–99.

Kessler, H., and J. Zacharias. 2000. *Rome 1300: On the Path of the Pilgrim*. New Haven and London.

Kinney, D. 2005. "Spolia." In Tronzo, 16–47.

Kinney, D. 2006. "Rome in the Twelfth Century: *Urbs fracta* and *renovatio*." *Gesta* 45, 199–220.

Kinney, D. 2010. "Edilizia di culto cristiano a Roma e in Italia centrale dalla metà del IV secolo al VII secolo." In S. De Blaauw, ed., *Storia dell'architettura italiana da Costantino a Carlo Magno*, 2 vols. Milan, 1.54–97.

Kirk, T. 2005. *The Architecture of Modern Italy*. New York.

Kirk, T. 2006. "Framing St. Peter's: Urban Planning in Fascist Rome." *Art Bulletin* 88.4, 756–76.

Koslofsky, C. 2011. *Evening's Empire: A History of Night in Early Modern Europe*. Cambridge and New York.

Kostof, S. 1973. *The Third Rome, 1870–1950: Traffic and Glory*. Berkeley.

Kostof, S. 1976. "The Drafting of a Master Plan for 'Roma Capitale': An Exordium." *JSAH* 35.1, 4–20.

Kostof, S. 1994. "His Majesty the Pick: The Aesthetics of Demolition." In Çelik/Favro/ Ingersoll, 9–22.

Krause, C. 2004. "Die Domus Tiberiana – Vom Wohnquartier zum Kaiserpalast." In Hoffmann/Wulf, 32–58.

Krautheimer, R. 1937–1976. *Corpus basilicarum christianarum Romae: le basiliche cristiane antiche di Roma (sec. IV–IX)*. Vatican City.

Krautheimer, R. 1969. "Mensa, coemeterium, martyrium." In *Studies in Early Christian, Medieval, and Renaissance Art*. New York, 35–58.

Krautheimer, R. 1975. *Christian and Byzantine Architecture*. Harmondsworth, Eng.

Krautheimer, R. 1982. *Roma Alessandrina: The Remapping of Rome under Alexander VII, 1655–1657*. Poughkeepsie, NY.

Krautheimer, R. 1983. *Three Christian Capitals: Topography and Politics*. Berkeley.

Krautheimer, R. 1986. *Early Christian and Byzantine Architecture*, 4th ed. New Haven.

Krautheimer, R. 1993. "The Ecclesiastical Building Policy of Constantine." In Bonamente/ Fusco, 509–52.

Krautheimer, R. 2000. *Rome: Profile of a City*. Reprint. Princeton.

Krautheimer, R., E. Josi and W. Frankl. 1952. "S. Lorenzo Fuori Les Mura in Rome: Excavations and Observations." *Proceedings of the American Philosophical Society* 96.1 (Feb. 29, 1952), 1–26.

Krencker, D. 1929. *Die Trierer Kaiserthermen*. Augsburg.

Kuttner, A. L. 1999. "Culture and History at Pompey's Museum." *Transactions of the American Philological Association* 129, 343–73.

Labrousse, M. 1937. "Le 'pomerium' de la Rome impériale." *MEFRA* 54, 165–99.

Lampe, P. 2003. *From Paul to Valentinus: Christians at Rome in the First Two Centuries*. Minneapolis.

Lancaster, L. C. 1998. "Building Trajan's Markets." *AJA* 102, 238–308.

Lancaster, L. C. 1999. "Building Trajan's Column." *AJA* 103, 419–39.

Lancaster, L. C. 2005. *Concrete Vaulted Construction in Imperial Rome: Innovations in Context*. Cambridge and New York.

Lanciani, R. 1880. *Topografia di Roma antica*. Rome.

Lanciani, R. 1883. "Il codice barberiniano XXX, 89 contenente frammenti di una descrizione di Roma del secolo XVI." *ASRSP* 6, 223–240; 445–495.

Lanciani, R. 1891. *Itinerario di Einsiedeln e l'ordine di Benedetto canonico*. Rome.

Lanciani, R. 1892. *Pagan and Christian Rome*. Boston and New York.

Lanciani, R. 1902. "La via del Corso dirizzata e abbellita nel 1538 da Paolo III." *BullCom* 30, 229–55.

Lanciani, R. 1906. *The Golden Days of the Renaissance in Rome: From the Pontificate of Julius II to That of Paul III*. Boston.

Lanciani, R. 1988. *Notes from Rome*. London.

Lanciani, R. 1989–2002. *Storia degli scavi di Roma e notizie intorno le collezioni romane di antichità*. L. Malvezzi Campeggi, ed. Rome.

La Padula, A. 1969. *Roma e la regione nell'epoca napoleonica. Contributo alla storia urbanistica della città e del territorio*. Rome.

La Rocca, E. 1984. *La riva a mezzaluna: culti, agoni, monumenti funerari presso il Tevere nel Campo Marzio occidentale*. Rome.

La Rocca, E. 1990. "Linguaggio artistico e ideologia politica a Roma in età repubblicana." In C. Ampolo, ed., *Roma e l'Italia: Radices imperii*. Milan, 289–498.

La Rocca, E., ed. 1995. *I luoghi del consenso imperiale: il Foro di Augusto; il Foro di Traiano*. Rome.

La Rocca, E. 1998. "Premessa." In Cima/La Rocca, v–vi.

Lauer, P. 1911. *Le palais de Latran: étude historique et archéologique*. Paris.

Laurence, R. 2007. *Roman Pompeii: Space and Society*, 2nd ed. London and New York.

Lavedan, P., and J. Hugueney. 1974. *L'urbanisme au Moyen Age*. Paris.

Lee, E., ed. 1985. *Descriptio Urbis: The Roman Census of 1527*. Rome.

Lefevre, R, 1960. "La 'gloriosa piazza de Colonna' a metà del500." *ASRSP* 83, 73–98.

Le Gall, J. 1953. *Le Tibre: fleuve de Rome dans l'antiquité*. Paris.

Le Gall, J. 2005. *Il Tevere: fiume di Roma nell'antichità*. C. Mocchegiani Carpano and G. Pisani Sartorio, eds. Rome.

Lehmann, T. 2003. "'Circus basilicas,' 'coemeteria subteglata,' and the church buildings in the suburbium of Rome." *Acta ad archaeologium et artium historiam pertinentia* 42.3, 57–77.

Lenzi, M. 1999. "Forme e funzioni dei trasferimenti patrimoniali dei beni della Chiesa in area romana." *MEFRM* 111.2, 771–859.

Leon, H. 1960. *The Jews of Ancient Rome*. Philadelphia.

Leonardi, R., S. Pracchia, S. Buonaguro, M. Laudato, and N. Saviane. 2010. "Appendice: Sondaggi lungo la tratta T2: caratteri ambientali e aspetti topografici del Campo Marzio in epoca romana." In Egidi/Filippi/Martone, 82–92.

Leone, A., D. Palombi, and S. Walker, eds. 2007. *Res bene gestae: ricerche di storia urbana su Roma antica in onore di Eva Margareta Steinby*. Rome.

Leone, S. C. 2008. *The Palazzo Pamphilj in Piazza Navona: Constructing Identity in Early Modern Rome*. London.

Lestocquoy, J. 1930. "Administration de Rome et diaconies du VIIe au IXe siècle." *RAC* 7, 261–98.

Liverani, P., ed. 1998. *Laterano: scavi sotto la Basilica di S. Giovanni in Laterano*. Vatican City.

Liverani, P. 1999. *La topografia antica del Vaticano*. Vatican City.

Liverani, P. 2010. *The Vatican Necropoles: Rome's City of the Dead*. Turnhout and Vatican City.

Llewellyn, P. 1993. *Rome in the Dark Ages*. London.

Lo Cascio, E. 1990. "L'organizzazione annonaria." In S. Settis, ed., *Civiltà dei romani*, Vol. 1: *La città, il territorio, l'impero*. Milan, 229–49.

Lo Cascio, E. 1997. "Le procedure di recensus dalla tarda repubblica al tardo antico e il calcolo della popolazione di Roma." *LRI*, 3–76.

Lo Cascio, E. 1998. "Registri dei beneficiari e modalità delle distribuzioni nella Roma tar-doantica." *La mémoire perdue. Recherches sur l'administration romaine.* Rome, 365–85.

Long, P. G. 2008. "Hydraulic Engineering and the Study of Antiquity: Rome: 1557–1570." *Renaissance Quarterly* 61, 1098–1138.

Lott, J. B. 2004. *The Neighborhoods of Augustan Rome.* Cambridge and New York.

Luce, T. J. 2009. "Livy, Augustus, and the Forum Augustum." In Edmondson, 399–415.

Lusnia, S. 2004. "Urban Planning and Sculptural Display in Severan Rome: Reconstructing the Septizodium and Its Role in Dynastic Politics." *AJA* 108, 517–44.

Lusnia, S. 2014. *Creating Severan Rome: The Architecture and Self-Image of L. Septimius Severus (A.D. 193–211).* Brussels.

MacDonald, W. L. 1976. *The Pantheon: Design, Meaning, and Progeny.* Cambridge, MA.

MacDonald, W. L. 1982. *The Architecture of the Roman Empire,* Vol. 1: *An Introductory Study.* New Haven and London.

Maggi, G. 1915. *Roma al tempo di Urbano VIII: la pianta di Roma Maggi-Maupin-Losi.* Reprint. Rome.

Magnuson, T. 1958. *Studies in Quattrocento Roman Architecture.* Stockholm.

Magnuson, T. 2004. *The Urban Transformation of Medieval Rome, 312–1420.* Stockholm.

Maier, J. 2006. Imago Romae: *Renaissance Visions of the Eternal City.* Ph.D. dissertation, Columbia University.

Maier, J. 2007. "Mapping Past and Present: Leonardo Bufalini's Plan of Rome." *Imago Mundi* 59.1, 1–23.

Maier, J. 2015. *Rome Measured and Imagined: Early Modern Maps of the Eternal City.* Chicago.

Maischberger, M. 1997. *Marmor in Rom: Anlieferung, Lager- und Werkplätze in der Kaiserzeit.* Wiesbaden.

Manacorda, D. 2000. *Crypta Balbi: Museo Nazionale Romano.* Milan.

Manacorda, D. 2001. *Crypta Balbi: archeologia e storia di un paesaggio urbano.* Milan.

Marazzi, F. 2000. "Rome in Transition: Economic and Political Change in the Fourth and Fifth Centuries." In J. M. H. Smith, 21–41.

Marcello, F. 2003. *Rationalism versus Romanità: The Changing Role of the Architect in the Creation of the Ideal Fascist City.* Ph.D. dissertation, University of Sydney.

Marchetti-Longhi, G. 1938. "Il quartiere greco-orientale di Roma nell'antichità e nel Medio Evo." *Atti del IV Congresso Nazionale di Studi Romani,* Vol. 1. Rome, 169–85.

Marchetti-Longhi, G., and F. Coarelli, eds. 1981. *L'Area Sacra di Largo Argentina.* Rome.

Marchi, G. 1844. *Monumenti delle arti cristiane primitive nella metropolis del cristianesimo.* Rome.

Marder, T. 1978. "Sixtus V and the Quirinal." *JSAH* 37.4, 283–94.

Marder, T. 1991. "Alexander VII, Bernini, and the Urban Setting of the Pantheon in the Seventeenth Century." *JSAH* 50.3, 273–92.

Marder, T., 1998. *Bernini and the Art of Architecture.* New York.

Marder, T., and M. Wilson Jones, eds. 2015. *The Pantheon from Antiquity to the Present.* New York.

Marliani, B. 1534. *Antiquae Romae Topographia.* Rome.

Marlowe, E. 2006. "Framing the Sun: The Arch of Constantine and the Appropriation of the Roman Cityscape." *Art Bulletin* 88, 223–42.

Marlowe, E. 2010. "Liberator Urbis Suae: Constantine and the Ghost of Maxentius." In Ewald/Noreña, 199–219.

Maroi, L. 1937. "Sviluppo demografico della città di Roma." *Capitolum* 12.3, 181–87.

Martin, G. 1969. *Roma sancta (1581)*. G. B. Parks, ed. Rome.

Martinelli, F. 1644. *Roma ricercata nel suo sito e nella scuola di tutti gl'antiquarij*. Rome.

Martinelli, F. 1968. *Roma nel seicento*. C. D'Onofrio, ed. Florence.

Martini, A. 1965. *Arti mestieri e fede nella Roma dei papi*. Bologna.

Martinori, E. 1933–1934. *Lazio turrito*, 3 vols. Rome.

Marucchi, O. 1909. *Monumenti del Cimitero di Domitilla sulla via Ardeatina*. Rome.

Massimo, C.V. 1836. *Notizie istoriche della Villa Massimo alle Terme Diocleziane*. Rome.

Mattingly, D., and G. Aldrete. 2000. "The Feeding of Imperial Rome: The Mechanics of the Food Supply System." In Coulston/Dodge, 142–65.

Mazzoleni, D. 1975. "Le catacombe ebraiche di Roma." *Studi romani* 23, 289–302.

McGinn, T. 2006. "Zoning Shame in the Roman City." In C. A. Faraone and L. McClure, eds., *Prostitutes and Courtesans in the Ancient World*. Madison, 161–76.

McPhee, S. 2012. "Rome 1676: Falda's View." Bevilacqua/Fagiolo, 232–43.

Meijer, C. 1685. *L'arte di restituire a Roma la tralasciata navigatione del suo Tevere*. Rome.

Meneghini, R. 1991. *Il Foro di Nerva*. Rome.

Meneghini, R. 1999. "Edilizia pubblica e privata nella Roma altomedievale: due episodi di riuso." *MEFRM* 111.1, 171–82.

Meneghini, R. 2000. "Roma – strutture alto medievali e assetto urbano tra le regioni VII e VIII." *ArchMed* 27, 303–10.

Meneghini, R. 2001. "Il Foro di Traiano nel Medioevo." *MEFRM* 113, 149–72.

Meneghini, R. 2002. "Nuovi dati sulla funzione e le fasi costruttive delle 'biblioteche' del Foro di Traiano." *MEFRA* 114.2, 655–92.

Meneghini, R. 2009. *I fori imperiali e i Mercati di Traiano: storia e descrizione dei monumenti alla luce degli scavi recenti*. Rome.

Meneghini, R., and R. Santangeli Valenzani. 1995. "Sepolture intramuranee a Roma tra V e VII secolo d.C.: aggiornamenti e considerazioni." *ArchMed* 22, 283–90.

Meneghini, R., and R. Santangeli Valenzani. 2004. *Roma nell'altomedioevo: Topografia e urbanistica della città dal V al X secolo*. Rome.

Meneghini, R., and R. Santangeli Valenzani, eds. 2006. *Formae urbis Romae: Nuovi frammenti di piante marmoree dallo scavo dei fori imperiali*. Rome.

Meneghini, R., and R. Santangeli Valenzani. 2007. *I fori imperiali: gli scavi del comune di Roma (1991–2007)*. Rome.

Michel, A. 1952. "Die griechischen Klostersiedlungen zu Rom bis zur Mitte des 11. Jahrhunderts." *Ostkirchliche Studien* 1, 32–45.

Millar, F. 1998. *The Crowd in Rome in the Late Republic*. Ann Arbor.

Millon, H. A., and S. S. Munshower, eds. 1992. *An Architectural Progress in the Renaissance and Baroque: Sojourns In and Out of Italy: Essays in Architectural History Presented to Hellmut Hager on His Sixty-Sixth Birthday*, 2 vols. University Park, PA.

Minor, H. H. 2011. *The Culture of Architecture in Enlightenment Rome*. University Park, PA.

Minor, V. H. 2006. *The Death of the Baroque and the Rhetoric of Good Taste*. New York.

Moatti, C., ed. 1998. *La mémoire perdue: recherches sur l'administration romaine*. Rome.

Monaco, E. 2000. "Il Tempio di Venere e Roma. Appunti sulla fase del IV secolo." *Aurea Roma*, 58–60.

Monciatti, A. 2005. *Il Palazzo Vaticano nel Medioevo*. Florence.

Montaigne, M. de. 1903. *The Journal of Montaigne's Travels in Italy by Way of Switzerland and Germany in 1580 and 1581*, 3 vols. London.

Moore, J. 1995. "Prints, Salami, and Cheese: Savoring the Roman Festival of the Chinea." *Art Bulletin* 77, 584–608.

Morley, N. 1996. *Metropolis and Hinterland: The City of Rome and the Italian Economy, 200 BC–AD 200*. Cambridge.

Morley, N. 2005. "The Salubriousness of the Roman City." In H. King, ed., *Health in Antiquity*. London and New York, 192–204.

Morstein-Marx, R. 2004. *Mass Oratory and Political Power in the Roman Republic*. Cambridge and New York.

Moscati, L. 1980. *Alle origini del comune romano: economia, società, istituzioni*. Rome.

Moss, C. R. 2013. *The Myth of Persecution: How Early Christians Invented a Story of Martyrdom*. New York.

Mouritsen, H. 2001. *Plebs and Politics in the Late Roman Republic*. Cambridge and New York.

Muffel, N. 1999. *Descrizione della città di Roma nel 1452: delle indulgenze e delle luoghi sacri di Roma*. Bologna.

Mulryan, M. 2014. *Spatial 'Christianisation' in Context: Strategic Intramural Building in Rome from the 4th–7th C. AD*. Oxford.

Muñoz, A. 1935. *Roma di Mussolini*. Milan.

Müntz, E. 1878. *Les arts à la cour des papes pendant le XVe et le XVIe siècle*. Paris.

Mura Sommella, A. 2000. "La grande Roma dei Tarquini. Alterne vicende di una felice intuizione." *BullCom* 101, 7–26.

Murray, P. 1972. *Five Early Guides to Rome and Florence*. Farnborough, UK.

Narducci, P. 1889. *Sulla fognatura della città di Roma: descrizione tecnica*. Rome.

Nestori, A. 1975. *Repertorio topografico delle pitture delle catacombe*. Vatican City.

Newbold, R. F. 1974. "Some Social and Economic Consequences of the A.D. 64 Fire at Rome." *Latomus* 33, 858–69.

Nibby, A. 1838–1841. *Roma nell'anno MLCCCXXXVIII*. Rome.

Nicassio, S. V. 2005. *Imperial City: Rome, Romans, and Napoleon, 1796–1815*. Welwyn Garden City, UK.

Nicholls, M. C. 2011. "Galen and Libraries in *Peri Alupias*." *JRS* 101, 123–42.

Niederer, F. J. 1952. "Early Medieval Charity." *Church History* 21, 285–95.

Nippel, W. 1995. *Public Order in Ancient Rome*. Cambridge and New York.

Noble, T. F. X. 1984. *The Republic of St. Peter: The Birth of the Papal State, 680–825*. Philadelphia.

Noble, T. F. X. 2001. "Topography, Celebration, and Power: the Making of a Papal Rome in the Eighth and Ninth Centuries." In M. De Jong and F. Theuws, eds., *Topographies of Power in the Middle Ages*. Leiden, 45–91.

Nolli, G.B. 1991. *Rome 1748: The Pianta Grande di Roma of Giambattista Nolli in Facsimile*. Highmount, NY.

Nortet, Abbé. 1900. *Les Catacombes romaines. Cimetière de Saint-Calliste*. Rome.

Rome AD 300–800: Power and Symbol, Image and Reality. Rome, 2003.

Nussdorfer, L. 1992. *Civic Politics in the Rome of Urban VIII*. Princeton.

Nussdorfer, L. 1997. "The Politics of Space in Early Modern Rome." *MAAR* 42, 161–86.

Orbaan, J. A. F. 1910. "La Roma di Sisto V negli Avvisi." *ASRSP* 33, 277–312.

Orbaan, J. A. F. 1911. *Sixtine Rome*. London.

Orbaan, J. A. F. 1920. "La Roma di Paolo V negli Avvisi." In J. A. F. Orbaan, ed., *Documenti sul Barocco in Roma*. Rome, 39–272.

Ortenberg, V. 1990. "Archbishop Sigeric's Journey to Rome in 990." *Anglo-Saxon England* 19, 197–246.

Östenberg, I., S. Malmberg, and J. Bjørnebye, eds. 2015. *The Moving City: Processions, Passages and Promenades in Ancient Rome*. London.

Packer, J. E. 1994. "Trajan's Forum Again: The Column and the Temple of Trajan in the Master Plan Attributed to Apollodorus (?)." *JRA* 7, 163–82.

Packer, J. E. 1997. *The Forum of Trajan in Rome*, 3 vols. Berkeley and Los Angeles.

Packer, J. E. 2001. *The Forum of Trajan in Rome: A Study of the Monuments in Brief.* Berkeley.

Packer, J. E. 2003. "*Templum Divi Traiani Parthici et Plotinae.* A Debate with R. Meneghini." *JRA* 16, 109–36.

Packer, J. E. 2008. "The Column of Trajan: The Topographical and Cultural Contexts." *JRA* 21, 471–78.

Painter, B. W. 2005. *Mussolini's Rome: Rebuilding the Eternal City.* New York.

Palmer, R. E. A. 1980. "Customs on Market Goods Imported into the City of Rome." In J. H. D'Arms and E. C. Koppf, eds., *The Seaborne Commerce of Ancient Rome: Studies in Archaeology and History.* Rome, 217–34.

Palmer, R. E. A. 1981. The Topography and Social History of Rome's Trastevere: Southern Sector. *Proceedings of the American Philosophical Society* 125, 368–97.

Palmer, R. E. A. 1990. *Studies in the Northern Campus Martius in Ancient Rome.* Philadelphia.

Palombi, D. 1997. *Tra Palatino ed Esquilino: Velia, Carinae, Fagutal. Storia di tre quartieri di Roma antica.* Rome.

Panciera, S. 2000. "Netezza urbana a Roma. Organizzazione e responsabili." In X. Dupré Raventós and J. A. Remolà Vallverdú, eds., *Sordes urbis: la eliminación de los residuos en la ciudad romana.* Rome, 95–105.

Panciera, S., and C. Virlouvet. 1998. "Les archives de l'administration du blé public à Rome à travers le témoignage des inscriptions." In Moatti, 247–66.

Pani Ermini, L. 1972. "L'ipogeo detto dei Flavi in Domitilla." *RAC* 48, 235–69.

Panvinio, O. 1561. *De gente nobili Matthaeia Liber.* Rome.

Panzram, S. 2008. "Domitian und das Marsfeld. Bauen mit Programm." In Albers/Grasshof/Heinzelmann/Wäfler, 81–102.

Partner, P. 1972. *The Lands of St. Peter: The Papal State in the Middle Ages and the Early Renaissance.* Berkeley.

Partner, P. 1976. *Renaissance Rome, 1500–1559: A Portrait of a Society.* Berkeley.

Pastor, L. von. 1968–1969. *The History of the Popes from the Close of the Middle Ages.* Reprint, 40 vols. Nendeln, Liechtenstein.

Patterson, J. R. 2000. "Living and Dying in the City of Rome: Houses and Tombs." In Coulston/Dodge, 259–89.

Pavolini, C., U. Fusco, C. Cupitò, and S. Dinuzzi. 2003. "L'area compresa fra il Tevere, l'Aniene e la Via Nomentana." In P. Pergola, R. Santangeli Valenzani, and R. Volpe, eds., *Suburbium: Il suburbio di Roma dalla crisi del sistema delle ville a Gregorio Magno.* Rome, 47–95.

Pecchiai, P. 1950. *Il Campidoglio nel Cinquecento.* Rome.

Pecchiai, P. 1958. *Roma nel Cinquecento.* Bologna.

Pensabene, P. 1993. "Il riempiego nell'età costantiniana a Roma." In Bonamente/Fusco, 749–68.

Pensabene, P. 2002. "Venticinque anni di ricerche sul Palatino. I santuari e il sistema sostruttivo dell'area sud ovest." *ArchCl* 53, 65–163.

Pergola, P. 1998. *Le catacombe romane: storia e topografia.* Rome.

Piccinato, G. 2006. "Rome: Where Great Events Not Regular Planning Bring Development." In D. Gordon, ed., *Planning Twentieth-Century Capital Cities.* London and New York, 213–25.

Pietrangeli, C. 1990. *San Giovanni in Laterano.* Florence.

Pinto, J. 1986. *Trevi Fountain.* New Haven.

Piranesi, G.B. 1747–1778. *Vedute di Roma*. Rome.

Piranesi, G.B. 1756. *Le antichità romane*. Rome.

Podestà, B. 1878. "Carlo V a Roma nell'anno 1536." *ASRSP* 1, 303–44.

Priester, A. 1993. "Bell Towers and Building Workshops in Medieval Rome." *JSAH* 52.2, 199–220.

Priester, S. 2002. *Ad summas tegulas. Untersuchungen zu vielgeschossigen Gebäudeblöcken mit Wohneinheiten und Insulae im kaiserzeitlichen Rom*. Rome.

"Provvidenze per Roma." 1962. *Capitolium* 37.2, 58–63.

Purcell, N. 1987a. "Tomb and Suburb." In Hesberg/Zanker, 25–41.

Purcell, N. 1987b. "Town in Country and Country in Town." In E. B. MacDougall, ed., *Ancient Roman Villa Gardens*. Washington, DC, 185–203.

Purcell, N. 2001. Review of *Horti romani*. *JRA* 14, 546–56.

Purcell, N. 2007. "The horti of Rome and the Landscape of Property." In Leone/Palombi/Walker, 361–78.

Rainbird, J. S. 1986. "The Fire Stations of Imperial Rome." *PBSR* 54, 147–69.

Re, C. 1880. *Statuti della città di Roma*. Rome.

Re, E. 1920. "Maestri di strada." *ASRSP* 43, 5–102.

Rea, R., and G. Alföldi. 2002. *Rota Colisei: la valle del Colosseo attraverso i secoli*. Milan.

Rebillard, E. 1999. "Les formes de l'assistance funéraire dans l'Empire romain et leur evolution dans l'antiquité tardive." *Antiquité tardive* 7, 280–82.

Rebillard, E. 2009. *The Care of the Dead in Late Antiquity*. Ithaca.

Redig de Campos, D. 1967. *I Palazzi Vaticani*. Bologna.

Reekmans, L. 1964. *La tombe du pape Corneille et sa région cémétériale*. Vatican City.

Rehak, P. 2006. *Imperium and Cosmos: Augustus and the Northern Campus Martius*. Madison.

Reimers, P. 1991. "Roman Sewers and Sewerage Networks – Neglected Areas of Study." In A.-M. L. Touati, E. Rystedt, and Ö. Wikander, eds., *Munuscula Romana: Papers Read at a Conference in Lund* (October 1–2, 1988). Stockholm, 111–16.

Richardson, C. M. 2009. *Reclaiming Rome: Cardinals in the Fifteenth Century*. Leiden and Boston.

Richardson, L. Jr. 1976. "The Villa Publica and the Divorum." In L. Bonfante and H. von Heintze, eds., *In Memoriam Otto J. Brendel*. Mainz, 159–63.

Richmond, I. A. 1930. *The City Wall of Imperial Rome*. Oxford.

Rickman, G. 1971. *Roman Granaries and Store Buildings*. Oxford.

Rickman, G. 1980. *The Corn Supply of Ancient Rome*. Oxford.

Ridley, R. 1992. *The Eagle and the Spade: Archaeology in Rome during the Napoleonic Era, 1809–1814*. Cambridge and New York.

Rinne, K. 2001–2002. "The Landscape of Laundry in Late Cinquecento Rome." *Studies in the Decorative Arts* 9.1, 34–60.

Rinne, K. 2005. "Hydraulic Infrastructure and Urbanism in Early Modern Rome." *PBSR* 73, 199–232.

Rinne, K. 2007. "Between Precedent and Experiment: Restoring the Acqua Vergine in Rome, 1560–1570." In L. Roberts, S. Shaffer, and P. Dear, eds., *The Mindful Hand: Inquiry and Invention from the Late Renaissance to Early Industrialization*. Amsterdam, 94–115.

Rinne, K. 2010. *The Waters of Rome: Aqueducts, Fountains, and the Birth of the Baroque City*. New Haven and London.

Rinne, K. 2012. "Urban Ablutions: Cleansing Counter Reformation Rome." In Bradley/Stow, 182–201.

Rinne, K. Forthcoming. "Designing *salus publica* in Post-Tridentine Rome." In J. Locker, ed., *Art after Trent.* New York.

Robbins, D. 1994. "Via della Lungaretta: The Making of a Medieval Street." In Çelik/Favro/Ingersoll, 165–76.

Robinson, O. F. 1992. *Ancient Rome: City Planning and Administration.* London and New York.

Roca De Amicis, A. 1984. "Studi su città e architettura nella Roma di Paolo V Borghese." *Bollettino del Centro di Studi per la Storia dell'Architettura* 31, 1–97.

Roddaz, J.-M. 1984. *Marcus Agrippa.* Rome.

Rodocanachi, E. 1894. *Les Corporations ouvrières à Rome depuis la chute de l'empire romain,* 2 vols. Paris.

Rodocanachi, E. 1912. *La Première Renaissance: Rome au temps de Jules II et de Léon X, la cour pontificale, les artistes et les gens de lettres, la ville et le peuple, le sac de Rome en 1527.* Paris.

Rodríguez Almeida, E. 1981. *Forma urbis marmorea: aggiornamento generale 1980,* 2 vols. Rome.

Rodríguez Almeida, E. 1984. *Il Monte Testaccio: ambienti, storia, materiali.* Rome.

Rodríguez Almeida, E. 2002. *Formae urbis antiquae: Le mappe marmoree di Roma tra la Repubblica e Settimio Severo.* Rome.

Rohault de Fleury, G. 1877. *Le Latran au Moyen Age.* Paris.

Rollo-Koster, J., and A. Hollstein. 2010. "Anger and Spectacle in Late Medieval Rome: Gauging Emotion in Urban Toography." In C. Goodson, A. E. Lester, and C. Symes, eds., *Cities, Texts, and Social Networks, 400–1500,* Farnham, UK and Burlington, VT, 149–74.

Roma nell'alto medioevo: 27 aprile–1 maggio 2000. Spoleto 2001.

Romanini, A. M. 1983. *Roma anno 1300: atti della IV Settimana di studi di storia dell'arte medievale dell'Università di Roma "La Sapienza."* Rome.

Romano, P. 1939. *Campo Marzio: (IV Rione).* Rome.

Royo, M. 2001. "Le Palatin entre le IIe et le VIe siècle apr. J.-C.: évolution topographique." *Revue S archéologique* 31, 37–92.

Rubin, L. 2004. De incendiis Urbis Romae: *The Fires of Rome in Their Urban Context.* Ph.D. dissertation, SUNY-Buffalo.

Russell, A. 2014. "Memory and Movement in the Roman Fora from Antiquity to Metro C." *JSAH* 73, 478–506.

Rutgers, L. V. 1992. "Archaeological Evidence for the Interaction of Jews and Non-Jews in Late Antiquity." *AJA* 96, 101–18.

Rutledge, S. 2012. *Ancient Rome as a Museum: Power, Identity, and the Culture of Collecting.* Oxford.

Salerno, L., L. Spezzaferro, and M. Tafuri. 1973. *Via Giulia: una utopia urbanistica del 500.* Rome.

Salvante, M. 2012. "Delinquency and Pederasty: 'Deviant' Youngsters in the Suburbs of Fascist Rome." In Bradley/Stow, 241–57.

Sanfilippo, I. L. 2001. *La Roma dei romani: arti, mestieri e professioni nella Roma del Trecento.* Rome.

Sanfilippo, M. 1992. *La costruzione di una capitale: Roma 1870–1911.* Cinisello Balsamo.

San Juan, R. M. 2001. *Rome: A City out of Print.* Minneapolis.

Sanjust di Teulada, E. 1908. *Piano regolatore della città di Roma, 1908.* Rome.

Santangeli Valenzani, R. 1994. "Tra la 'Porticus Minucia' e il 'Calcarario': l'area sacra di Largo Argentina nell'altomedioevo." *ArchMed* 21, 57–98.

Santangeli Valenzani, R. 1996–1997. "Pellegrini, senatori e papi: gli xenodochia a Roma tra il V e il IX secolo." *Rivista dell'Istituto Nazionale d'Archeologia e Storia dell'Arte*. Ser. 3, 19/20, 203–26.

Santangeli Valenzani, R. 1999. "Strade, case e orti nell'alto medioevo nell'area del foro di Nerva." *MEFRM* 111.1, 163–69.

Santangeli Valenzani, R. 2007. "Public and Private Space in Rome during Late Antiquity and the Early Middle Ages." *Fragmenta* 1, 63–81.

Savio, P. 1972. "Ricerche sulla peste di Roma degli anni 1656–1657." *ASRSP* 95, 113–42.

Schedel, H. 1493. *Roma. Liber chronicarum*. Nuremberg.

Scheidel, W. 1994. "Libitina's Bitter Gains: Seasonal Mortality and Endemic Disease in the Ancient City of Rome." *Ancient Society* 25, 151–75.

Scheidel, W. 2003. "Germs for Rome." In C. Edwards and G. Woolf, eds., *Rome the Cosmopolis*. Cambridge, 158–76.

Schröter, M.-G. 2008. "Der Theaterkomplex des Pompeius Magnus in Kontext seiner Politik." In Albers/Grasshof/Heinzelmann/Wäfler, 29–46.

Scobie, A. 1986. "Slums, Sanitation and Mortality in the Roman World." *Klio* 68, 399–433.

Scrinari, V. S. M. 1991. *Il Laterano imperiale*, 3 vols. Vatican City.

Sear, F. 2006. *Roman Theatres: An Architectural Study*. Oxford and New York.

Segarra Lagunes, M. M. 2004. *Il Tevere e Roma; storia di una simbiosi*. Rome.

Seldes, G. 1935. *The Fascist Road to Ruin*. New York.

Shaw, B. D. 1996. "Seasons of Death: Aspects of Mortality in Imperial Rome." *JRS* 86, 100–38.

Shipley, F. W. 1933. *Agrippa's Building Activities in Rome*. St. Louis.

Signorotto, G., and M. A. Visceglia, eds. 2002. *Court and Politics in Papal Rome, 1492–1700*. Cambridge.

Simoncini, G. 1990. *Roma restaurata: rinnovamento urbano al tempo di Sisto V*. Florence.

Simoncini, G. 2004. *Le trasformazioni urbane nel Quattrocento*. Florence.

Singly, P. 2007. "Roma Macchiata: the Stain of White." *Log; Observations on architecture and the Contemporary City* 10, 129–36.

Sinnigen, W. G. 1957. *The Officium of the Urban Prefecture during the Later Roman Empire*. Rome.

Sirks, A. J. B. 1991. *Food for Rome: The Legal Structure of the Transportation and Processing of Supplies for the Imperial Distributions in Rome and Constantinople*. Amsterdam.

Smith, C. J. 2000. "Early and Archaic Rome." In Coulston/Dodge, 179–206.

Smith, C. J. 2005. "The Beginnings of Urbanization in Rome." In R. Osborne and B. Cunliffe, eds., *Mediterranean Urbanization, 800–600 BC*. Oxford, 91–111.

Smith, G. and J. Gadeyne, eds. 2013. Perspectives on Public Space in Rome from Antiquity to the Present Day. Farnham, Surrey and Burlington, VT.

Smith, J. M. H., ed. 2000. *Early Medieval Rome and the Christian West: Essays in Honour of Donald A. Bullough*. Leiden and Boston.

Smith, S. A. 1877. *The Tiber and Its Tributaries: Their Natural History and Classical Associations*. London.

Snyder, G. F. 1985. *Ante pacem: Archaeological Evidence of Church Life before Constantine*. Macon, GA.

Sonnino, E., and R. Traina. 1982. "La peste del 1656–1657 a Roma: organizzazione sanitaria e mortalità." In *La demografia storica delle città italiane*. Bologna, 433–52.

Sordi, M. 1965. *Il cristianesimo e Roma*. Bologna.

Spagnesi, G. 1982. "L'immagine di Roma barocca da Sisto V a Clemente XII: la pianta di G. B. Nolli del 1748." In M. Fagiolo and G. Spagnesi, eds., *Immagini del Barocco: Bernini e la cultura del Seicento*. Rome, 145–56.

Spagnesi, G. 1992. *La pianta di Roma al tempo di Sisto V (1585–1590)*. Rome.

Specchi, A. 1699. *Il quarto libro del nuovo teatro delli palazzi in prospettiva di Roma moderna*. Rome.

Spera, L. 1999. *Il paesaggio suburbano di Roma dall'antichità al medioevo: Il comprensorio tra le vie Latina e Ardeatina dalle Mura Aureliane al III miglio*. Rome.

Spera, L. 2003. "The Christianization of Space along the via Appia: Changing Landscape in the Suburbs of Rome." *AJA* 107, 23–43.

Sperandio, A., and P. Zander. 1999. *La tomba di San Pietro: restauro e illuminazione della Necropoli Vaticana*. Milan.

Spezzaferro, L., and Tittoni, M. E., eds. 1991. *Il Campidoglio e Sisto V*. Rome.

Stambaugh, J. 1988. *The Ancient Roman City*. Baltimore and London.

Stasolla, F. R. 1998. "A proposito delle strutture assistenziali ecclesiastiche: gli xenodochi." *ASRSP* 121, 5–45.

Steinby, E. M. 1986. "l'industria laterizia a Roma nel tardo antico." In Giardina, 99–164.

Steinby, E. M. 1987. "La necropolis della Via Triumphalis. Pianificazione generale e tipologia dei monumenti funerari." In Hesberg/Zanker, 85–110.

Steinby, E. M. 2012. *Edilizia pubblica e potere politico nella Roma repubblicana*. Milan.

Stinger, C. L. 1998. *The Renaissance in Rome*. Bloomington, IN. Reprint with new preface of the 1985 edition.

Stow, K. 2001. *The Theater of Acculturation: The Roman Ghetto in the Sixteenth Century*. Seattle.

Stow, K. 2012. "Was the ghetto cleaner …?" In Bradley/Stow, 169–81.

Sturgis, M. 2011. *When in Rome: 2000 Years of Roman Sightseeing*. London.

Styger, P. 1933. *Die römischen Katakomben*. Berlin.

Suro, M. D. 1986. "Romans protest McDonald's." 5 May 1986, *New York Times*, Style section. http://www.nytimes.com/1986/05/05/style/romans-protest-mcdonald-s.html

Swain, S., S. Harrison, and J. Elsner, eds. 2007. *Severan Culture*. Cambridge and New York.

Tafuri, M. 1959. "La prima strada di Roma moderna: Via Nazionale." *Urbanistica* 27, 95–108.

Tafuri, M. 2006. *Interpreting the Renaissance: Princes, Cities, Architects*. New Haven.

Tarquini, S. 2005. "Pellegrinaggio e assetto urbano di Roma." *Bullettino dell'Istituto Storico Italiano per il Medio Evo* 107, 1–133.

Taylor, R. 1997. "Torrent or Trickle? The Aqua Alsietina, the Naumachia Augusti, and the Transtiberim." *AJA* 101, 465–92.

Taylor, R. 2000. *Public Needs and Private Pleasures: Water Distribution, the Tiber River, and the Urban Development of Ancient Rome*. Rome.

Taylor, R. 2002. "Tiber River Bridges and the Development of the Ancient City of Rome." In K. Rinne, ed., "*Aquae Urbis Romae*: Waters of Rome," Occasional Papers, no. 2. http://jefferson.village.virginia.edu/waters.

Taylor, R. 2003. *Roman Builders: A Study in Architectural Process*. Cambridge and New York.

Taylor, R. 2004. "Hadrian's Serapeum in Rome." *AJA* 108, 223–66.

Taylor, R. 2010. "Bread and Water: Septimius Severus and the Rise of the *Curator aquarum et Miniciae*." *MAAR* 55, 199–220.

Taylor, R. 2014. "Movement, Vision, and Quotation in the Gardens of Herod the Great." In K. Coleman, ed., *Le jardin dans l'antiquité*. Geneva, 145–94.

Taylor, R. Forthcoming. "The Soft-Core City: Ancient Rome and the Wandering Tiber." In T. Way and J. Beardsley, eds., *River Cities: Historical and Contemporary.* Washington, DC.

Tempesta, A. 1915. *Urbis Romae Prospectus 1593.* Reprint by H. Schück. Uppsala.

Temple, N. 2011. *Renovatio urbis: architecture, urbanism, and ceremony in the Rome of Julius II.* Abingdon, Oxon and New York.

Terrenato, N. 2010. "Early Rome." In A. Barchiesi and W. Scheidel, eds., *The Oxford Handbook of Roman Studies.* Oxford and New York, 507–18.

Terrenato, N. 2011. "The Versatile Clans: Archaic Rome and the Nature of Early City-States in Central Italy." In N. Terrenato, and D. Haggis, eds., *State Formation in Italy and Greece: Questioning the Neoevolutionist Paradigm.* Oxford, 231–44.

Testa, V. 1932. "L'urbanistica e il Piano Regolatore di Roma." *Capitolium* 8.4, 173–85.

Testini, P. 1970. *Les catacombes chrétiennes à Rome.* Rome.

Thacker, A. T. 2007. "Rome of the Martyrs: Saints, Cults and Relics, Fourth to Seventh Centuries." In É. Ó Carragáin and C. Neuman de Vegvar, eds., *Roma Felix: Formation and Reflections of Medieval Rome.* Aldershot and Burlington, VT, 13–50.

Thomas, R. G. 1989. "Geology of Rome, Italy." *Bulletin of the Association of Engineering Geologists* 26.4, 415–76.

Tice, J. 2013. "The Interactive Nolli Map Website." nolli.uoregon.edu

Tice, J., and J. Harper, eds. 2010. *Giuseppe Vasi's Rome: Lasting Impressions from the Age of the Grand Tour.* Eugene, OR.

Tolotti, F. 1970. *Il cimitero di Priscilla: studio di topografia e architettura.* Vatican City.

Tomassetti, G. 1979–1980. *La campagna romana antica, medioevale e moderna.* Chiumenti, L., and F. Bilancia, eds., 7 vols. Florence.

Tomei, M. A. 2004. "Die Residenz des ersten Kaisers – Der Palatin in augusteischer Zeit." In Hoffmann/Wulf, 6–17.

Tomei, M. A., and P. Liverani, eds. 2005. *Carta archeologica di Roma. Primo quadrante.* Rome.

Torelli, M. 2006. "The Topography and Archaeology of Republican Rome." In N. Rosenstein and R. Morstein-Marx, eds., *A Companion to the Roman Republic.* Malden, MA, and Oxford, 220–61.

Torelli, M. 2007. "L'urbanistica di Roma regia e repubblicana. La città medio-repubblicana." In Gros/Torelli, 81–157.

Toynbee, J., and J. Ward-Perkins. 1956. *The Shrine of St. Peter and the Vatican Excavations.* London.

Trabalzi, F. 2014. "Marginal Centers: Learning from Rome's Periphery." In I. Clough Marinaro and B. Thomassen, eds., *Global Rome: Changing Faces of the Eternal City.* Bloomington, IN, 219–31.

Triff, K. 2000. *Patronage and Public Image in Renaissance Rome: Three Orsini Palaces.* Ph.D. dissertation, Brown University.

Trimble, J. 2007. "Visibility and Viewing on the Severan Marble Plan." In Swain/Harrison/Elsner, 368–84.

Tronzo, W., ed. 2005. *St. Peter's in the Vatican.* Cambridge and New York.

Tucci, P. L. 2004. "Eight Fragments of the Marble Plan of Rome Shedding New Light on the Transtiberim." *PBSR* 72, 185–202.

Tucci, P. L. 2008. "Galen's Storeroom, Rome's Libraries, and the Fire of A.D. 192." *JRA* 21, 133–49.

Tucci, P. L. 2011–2012. "The Pons Sublicius: A Reinvestigation." *MAAR* 56–57, 177–212.

Twyman, S. 2004. "The 'Romana Fraternitas' and urban processions at Rome in the twelfth and thirteenth centuries." In F. Andrews, C. Egger, and C. Rousseau, eds., *Pope, Church, and City: Essays in Honour of Brenda M. Bolton*. Leiden and Boston, 205–21.

Ungaro, L. 2007. *The Museum of the Imperial Forums in Trajan's Market*. Milan.

L'Urbs: espace urbain et histoire (Ier siècle av. J.-C.–IIIe siècle ap. J.-C.). Rome. 1987.

Valentini, R., and G. Zucchetti, eds. 1940–1953. *Codice topografico della città di Roma*, 4 vols. Rome.

Valone, C. 1994. "Women on the Quirinal Hill: Patronage in Rome, 1560–1630." *Art Bulletin* 76.1, 129–46.

Valtieri, S. 1984. "La zona di Campo de' Fiori prima e dopo gli interventi di Sisto IV." *L'Architettura. Cronache e storia* 30, 346–72, 648–60.

Van den Hoek, A., and J. J. Herrmann. 2013. "Paulinus of Nola, Courtyards, and Canthari: A Second Look." In *Pottery, Pavements, and Paradise: Iconographic and Textual Studies on Late Antiquity*. Leiden and Boston, 9–64.

Varagnoli, C. 1996. "I palazzi dei Mattei: il rapporto con la città." In *Palazzo Mattei di Paganica e L'Enciclopedia Italiana*. Rome, 135–89.

Vasi, G. 1747–1761. *Delle Magnificenze di Roma*, 10 vols. Rome.

Vasi, G. 1763. *Itinerario istruttivo diviso in otto stazioni o giornate per ritrovare con facilità tutte le antiche e moderne magnificenze di Roma*. Rome.

Vauchez, A., ed. 2001. *Storia di Roma, 2: Roma medievale*. Rome.

Ventriglia, U. 1971. *La geologia della città di Roma*. Rome.

Verdi, O. 1997. *Maestri di edifici e di strade a Roma nel secolo XV*. Rome.

Verri, A. 1915. *Carta geologica di Roma*. Novara.

Verzone, P. 1976. "La distruzione dei palazzi imperiali di Roma e di Ravenna e la ristrutturazione del Palazzo Lateranense nel IX secolo nei rapporti con quello di Costantinopoli." In H. Belting, ed., *Roma e l'età carolingia*. Rome, 39–54.

Vielliard, R. 1959. *Recherches sur les origines de la Rome chrétienne*. Rome.

Vigueur, J.-C. M. 2001. "Il comune romano." In Vauchez, 117–57.

Villedieu, F. 2001. *Il giardino dei Cesari: dai palazzo antichi alla Vigna Barberini sul Monte Palatino*. Rome.

Virlouvet, C. 1985. *Famines et émeutes à Rome des origines de la République à la mort de Néron*. Rome.

Virlouvet, C. 1995. *Tessera frumentaria: Les procedures de distribution du blé public à Rome à la fin de la République et au début de l'Empire*. Rome.

Virlouvet, C. 1997. "Existait-il des registres de décès à Rome au Ier siècle ap. J.-C.?" In *LRI*, 77–88.

Vismara, C. 1986. "I cimiteri ebraici di Roma." In Giardina, 351–92.

Von Stackelberg, K. T. 2009. *The Roman Garden: Space, Sense, and Society*. London and New York.

Waddy, P. 1990. *Seventeenth-Century Roman Palaces: Use and the Art of the Plan*. New York.

Waley, D. P. 1961. *The Papal State in the Thirteenth Century*. London and New York.

Walker, S. 2000. "The Moral Museum: Augustus and the City of Rome." In Coulston/Dodge, 61–75.

Wallace-Hadrill, A. 2008. "Housing the Dead: The Tomb as House in Roman Italy." In Brink/Green, 39–78.

Ward-Perkins, B. 1984. *From Classical Antiquity to the Middle Ages: Urban Public Building in Northern and Central Italy, AD 300–850*. Oxford.

Ward-Perkins, B. 2005. *The Fall of Rome and the End of Civilization*. Oxford and New York.

Ward-Perkins, J. B. 1981. *Roman Imperial Architecture*, 2nd ed. Harmondsworth and New York.

Wasserman, J. 1963. "The Quirinal Palace in Rome." *Art Bulletin* 45.3, 205–44.

Webb, M. 2001. *The Churches and Catacombs of Early Christian Rome*. Portland, OR.

Weil-Garris Brandt, K., and J. D'Amico. 1980. "The Renaissance Cardinal's Ideal Palace: a Chapter from Cortesi's 'De Cardinalatu.'" In Millon, H., ed., *Studies in Italian Art and Architecture, 15th through 18th Centuries*. Rome, 45–123.

Welch, K. E. 2003. "A New View of the Origins of the Basilica: The Atrium Regium, Graecostasis, and Roman Diplomacy." *JRA* 16, 5–34.

Welch, K. E. 2007. *The Roman Amphitheatre from Its Origins to the Colosseum*. Cambridge and New York.

Westfall, C. W. 1974. *In This Most Perfect Paradise: Alberti, Nicholas V, and the Invention of Conscious Urban Planning in Rome, 1447–1455*. University Park, PA.

White, L. M. 1990. *Building God's House in the Roman World: Architectural Adaptation among Pagans, Jews, and Christians*. Baltimore.

White, L. M. 1997. *The Social Origins of Christian Architecture*, 2 vols. Valley Forge, PA.

Wickham, C. 2015. *Medieval Rome. Stability and Crisis of a City, 900–1150*. Oxford.

Wilson, A. I. 2001. "The Water-Mills on the Janiculum." *MAAR* 45, 219–246.

Winter, N. A. 2009. *Symbols of Wealth and Power: Architectural Terracotta Decoration in Etruria and Central Italy, 640–510 BC*. Ann Arbor.

Winter, N. A., I. Iliopoulos, and A. J. Ammerman. 2009. "New Light on the Production of Decorated Roofs of the 6th c. B.C. at Sites in and around Rome." *JRA* 22, 7–28.

Wisch, B. 1992. "The Colosseum as a Site for Sacred Theatre: A Pre-History of Carlo Fontana's Project." In Millon/Munshower, 1.94–111.

Wiseman, T. P. 1974. "The Circus Flaminius." *PBSR* 42, 3–26.

Wiseman, T. P. 1993. "Rome and the Resplendent Aemilii." In H. Jocelyn, ed., *Tria Lustra: Essays and Notes Presented to John Pinsent*. Liverpool, 181–92.

Wiseman, T. P. 1998. "A Stroll on the Rampart." In Cima/La Rocca, 13–22.

Wiseman, T. P. 2008. *Unwritten Rome*. Exeter.

Witcher, R. 2005. "The Extended Metropolis: Urbs, Suburbium, and Population." *JRA* 18, 120–38.

Yawn. L. 2013. "Fields of Dreams: Sacred Visions in Mosaic on Medieval Roman Portals and Church Façades." In G. Cipollone, and M. S. Boari, eds. *VIII Centenario del Mosaico di San Tommaso in Formis (1210–2010)*. Vatican City, 169–192, figs. 46–56.

Zanker, P. 1988. *The Power of Images in the Age of Augustus*. Ann Arbor.

Zanker, P. 2004. "Domitians Palast auf dem Palatin als Monument kaiserlicher Selbstdarstellung." In Hoffmann/Wulf, 86–99.

Zeiller, J. 1904. "Les églises ariennes de Rome à l'époque de la domination gothique." *Mélanges d'archéologie et d'histoire* 24, 17–33.

Ziolkowski, A. 1992. *The Temples of Mid-Republican Rome and Their Historical and Topographical Context*. Rome.

INDEX

abitato, 209, 253, 255, 264, 273, 281, 286, 288, 290, 319

administration, ancient. *See also* Agrippa; archives; banishment and sequestration; libraries; maps; regions (*regiones*); taxes, tariffs, customs, and fees; warehouses; wharves

 Augustan reorganization of, 40–41, 47–48

 censuses and public surveys, 19, 24, 82, 114–17, 122, 125

 codes, laws, and restrictions, 27, 29, 47, 63–65, 114, 162

 against permanent theaters, 57–58

 of burial, 37, 117–20, 128, 154, 187

 districts and boundaries, 41, 45, 49, 67–69, 116, 128. *See also pomerium*; regions (*regiones*); *vici*; Aurelian Wall; Leonine Wall; wharves

 grain, flour, or bread procurement and distribution, 27, 89, 96–100, 102, 115, 117, 124, 166, 171, 177, 182, 184–85

 frumentationes, 46, 97

 headquarters of administrative offices, 81, 85, 114–17, 214

 maps, administrative use of, 115–16. *See also* maps and mapping

 offices, magistrates, and magistracies, 81

 aedile, 24, 35, 36, 41, 48, 114, 115

 censor, 19, 21, 22, 24, 114, 115, 124

 consul, 19, 29

 cura(tor) aedium sacrarum et operum publicorum (commission of sacred buildings and public works), 47, 132, 139, 162

 cura(tor) aquarum (et Miniciae), water commission later merged with grain distribution authority, 40, 47, 97, 113, 115, 116–17, 124. *See also* Frontinus, Sextus Julius; water supply; aqueducts; etc.

 cura(tor) operum maximorum (commission of monumental works), 162

 cura(tor) riparum et alvei Tiberis (commission of the Tiber), 51

 cura(tor) viarum (roads commission), 48

 magistrates of the *vici* (*vicomagistri*), 48, 91

 Praetorian Prefect and Guard, 60, 96, 99, 101, 115, 116, 135, 139, 154. *See also* Castra Praetoria

 urban prefect and prefecture, 76, 116, 124, 135, 139, 163, 166, 171

 vigiles (fire brigade), 66, 85, 96, 116, 122, 124

 police and policing, 5, 100, 114–16, 122, 144, 171

 Severan reorganization of, 96–98

 staff and minor officials, 48, 91, 116, 126, 175, 215

 zones and zoning, 6, 38, 84, 85, 126, 127

administration, medieval

 charitable institutions, 158, 169, 179–87, 191, 201, 299

 Church. *See* Church, as administrative body

 clergy, staff, and minor officials, 158, 184, 199

 codes, laws, and restrictions

 of burial, 143, 145–46, 187, 225, 232, 279

 districts and boundaries. *See also curtes; diaconia; rione*

 scholae, 196, 201–3

 scholae militiae, 183, 186, 187, 202

 grain, flour, or bread procurement and distribution, 166, 225, 245

 monasteries and convents, 273

Made in the USA
Middletown, DE
11 October 2020